Art *and* Spiritual Transformation

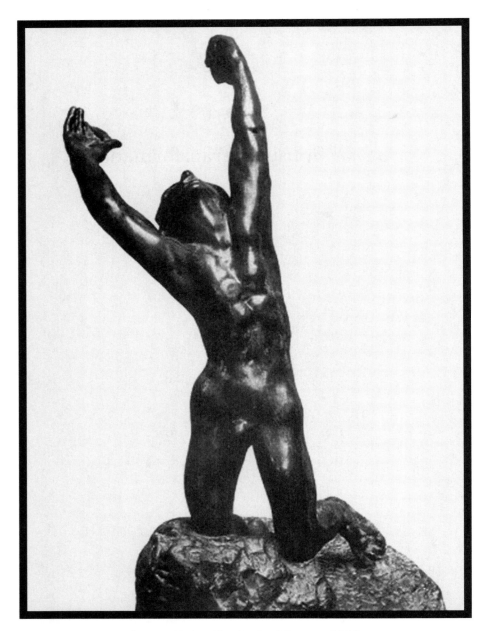

Auguste Rodin, *The Prodigal Son,* ca. 1885

ART *and* SPIRITUAL TRANSFORMATION

The Seven Stages of Death and Rebirth

Finley Eversole, Ph.D.

Inner Traditions
Rochester, Vermont

Inner Traditions
One Park Street
Rochester, Vermont 05767
www.InnerTraditions.com

Library of Congress Cataloging-in-Publication Data
Eversole, Finley.
 Art and spiritual transformation : the seven stages of death and rebirth / Finley Eversole.
 p. cm.
 Includes bibliographical references and index.
 ISBN 978-1-59477-281-8 (pbk.)
 1. Art, Modern—20th century. 2. Art, Modern—21st century. 3. Spirituality in art. 4. Transcendence (Philosophy) in art. I. Title. II. Title: Seven stages of death and rebirth.
 N6490.E87 2009
 709.04—dc22
 02009000290

Printed and bound in the United States by the P. A. Hutchison Company

10 9 8 7 6 5 4 3 2 1

Text design and layout by Jon Desautels
This book was typeset in Sabon with Baskerville used as the display typeface

To send correspondence to the author of this book, mail a first-class letter to the author c/o Inner Traditions • Bear & Company, One Park Street, Rochester, VT 05767, and we will forward the communication.

To all who seek the Light

Never was there a more powerful and universal teacher than art; and great is the influence we exert in the world through its mysterious language, the meaning of which, while often incomprehensible to the intellect, seldom fails to reach the soul.

WILL L. GARVER

To send light into the darkness of men's hearts—such is the obligation of the artist.

ROBERT SCHUMANN

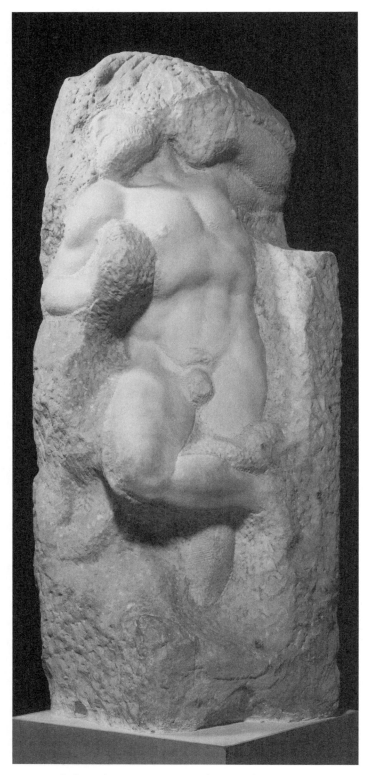

Michelangelo Buonarroti, *Awakening Slave*, ca. 1536

I am persuaded that in the end democracy diverts the imagination from all that is external to man and fixes it on man alone. Democratic nations may amuse themselves for a while with considering the productions of nature, but they are excited in reality only with a survey of themselves. . . . It may be foreseen in like manner that poets living in democratic times will prefer the delineation of passions and ideas to that of persons and achievements. . . . This forces the poet constantly to search below the external surface which is palpable to the senses, in order to read the inner soul; and nothing lends itself more to the delineation of the ideal than the scrutiny of the hidden depths of the immaterial nature of man. . . . The destinies of mankind, man himself taken aloof from his country and his age, and standing in the presence of Nature and of God, with his passions, his doubts, his rare propensities and inconceivable wretchedness, will become the chief, if not the sole, theme of poetry.

ALEXIS DE TOCQUEVILLE

When formulated religion loses its sovereignty in a total culture, the manifestations of religious intent still continue to appear in art, no matter how antithetical and anarchic its abstractions may be.

JAMES BAIRD

Dissolution is a fact, but neither Existentialism nor modern art produced it. Nor is "dissolution" synonymous with "decadence." A society coming apart at top and bottom, or passing over into another form, contains just as many possibilities for revelation as a society running along smoothly in its own rut.

WILLIAM BARRETT

Contents

Part III

The Creative Promise of the Coming Age

Acknowledgments

Art and Spiritual Transformation is based on my 1976 doctoral dissertation, which I've revised, adding a new final chapter on the creative life of the artist. Most of my doctoral committee has since passed on, but one member in particular was especially supportive of this project—humanistic psychologist Myron "Mike" Aarons, a protégé of Abraham Maslow. I value our discussions and the support Mike provided at the time.

My special thanks to artists Walter Gaudnek, Arlé Sklar-Weinstein, Alex Grey, and Ernst Fuchs for permission to reproduce their works. Jim Crane has allowed use of several of his cartoons, and Paul Heussenstamm has graciously allowed the use of his *White Mandala* in the cover design. Thanks also to the Adolph and Esther Gottlieb Foundation and its executive director, Sanford Hirsch, for a grant to help defray some of the costs associated with this project. Artist Robert Ferré, a leader in the labyrinth movement in the United States, also gave generously of his time to read and comment on my chapter on the labyrinth. And I owe a special debt of gratitude to Helena Moore, whose assistance in helping me care for my ninety-seven-year-old mother allowed me time to write this book.

I also want to thank my publisher, Ehud Sperling, for his support of this project from the outset; Jon Graham, acquisitions editor; Jeanie Levitan, managing editor; my project editor, Jamaica Burns, for her meticulous attention to the many details of this project; and lastly Jon Desautels for his excellent design for the book.

Preface

One of the great privileges of my life was getting to know and work with Alfred H. Barr, Jr., founder and director of New York's Museum of Modern Art. One day, as Barr and I sat lunching at the museum, he asked, "Finley, why are you still thinking and writing about the Abstract Expressionists?" I replied that I did not think their work had as yet been adequately understood. After a brief pause Barr said, "I think you're right." To understand the cultural and spiritual transformations that are preparing us for the awakening of humanity many of us believe to be in the making, a study of art can be an invaluable aid. Artists work intuitively, often unconscious of the forces working through them, which makes them invaluable barometers of social, psychological, and spiritual change. The soul sees the road ahead and, when allowed expression through the creative arts, can bring forth works of deep prophetic insight. The works studied here demonstrate, I believe, that the world is undergoing a profound spiritual transformation.

Of the main works I've chosen for study, six belong to Abstract Expressionism—a movement that placed American art on the world map for the first time, a movement that had its major influence between 1945 and the mid-sixties; one belongs to Primary Sculpture; one to Psychedelic Art; one to Earthworks; and three are the works of a contemporary symbolist painter, Walter Gaudnek. Works of other movements such as Pop, Op, and Minimal art have not been included. Hence the question: On what basis have the choices of the works under study been made? Considerations governing my choices include: (1) a conviction that the works discussed have yet to be viewed in any real depth, their true significance remaining largely hidden to us; (2) a belief that the works chosen are representative of the artists

and movements of the era and serve as a valid mirror of the "soul" of our time; (3) the relation of these works to the stages of spiritual transformation it is my purpose here to explore; and (4) the location of seven of the works in one place—The Museum of Modern Art, New York—making them more accessible to viewers. The other works are scattered or in private collections. These works are not the only ones that could have been selected. Practical considerations of space and time require some limits be set. But the works of Franz Klein, Robert Motherwell, Clifford Still, Robert Rauschenberg, Ernest Trova, Isaac Abrams, and others might also have been chosen. However, if my purpose is achieved, readers should be able to view the art of other artists and interpret for themselves.

This work is an interpretative "trialogue" between me, the artworks, and the cultural context in which I and the works of art came to be what we are.[1] My approach to art may be described as a process of phenomenological meditation or reflection upon the art and the inner experiences or states of consciousness to which the works give rise—both occurring within a given cultural, intellectual, and spiritual context. Like great music, great art is inexhaustible. With each new viewing, new insights are born. Much has been said against interpreting art. Susan Sontag has said, "Interpretation is the revenge of the intellect upon art. . . . To interpret is to impoverish, to deplete the world—in order to set up a shadow world of 'meanings.' . . . Interpretation is . . . the compliment that mediocrity pays to genius."[2] But interpretation is fundamental to the human enterprise. Aeschylus interpreted the Greek mysteries in his plays, Plato interpreted Eastern metaphysics for the West, Thomas Aquinas interpreted Aristotle, Friedrich Nietzsche interpreted Greek tragedy, Sigmund Freud interpreted psychological phenomena, Arnold Toynbee interpreted history, Mircea Eliade interpreted mythology, and so forth. Interpretation unifies experience and makes it meaningful. Without it, experience is like undigested food, incapable of giving us the needed nourishment. Those who deny interpretation to works of art seem to fear interpre-

[1] For a scholarly historical analysis that accords with my thesis, see Stephen Polcari, *Abstract Expressionism and the American Experience.*

[2] Susan Sontag, *Against Interpretation,* 7–9.

tation will make the artwork into something else. Sontag says, "It is always the case that interpretation . . . indicates dissatisfaction (conscious or unconscious) with the work, a wish to replace it with something else."[3] For Sontag, the artwork *is* its formal composition, devoid of any depth dimension. She cannot conceive of interpretation as a process of entering into the inner life of the artwork. The discovery of analogies and relationships with a work of art serve only to further illuminate the truths of which the work itself is a revelation. It does not and cannot convert the work into "something else," for any work of art which is authentic will remain so in the face of all interpretation, just as it does in the face of blindness, philistinism, and dilettantism. To deny a work of art relationship with other cultural works, ideas, and experiences is nonsense. Nothing exists in a vacuum. Every true work of art is itself the final judge of genuine relevance of the relationships we seek to establish with it. Only by means of interpretation do we save art from a self-absorption that would condemn it to personal and cultural irrelevance.

"The most characteristic trait of a genuine culture," said Rudolf Arnheim, "is the integration of concrete everyday experience with guiding philosophical ideas." Whether the spiritual transformations I and many believe to be taking place in our world today are occurring, only time will determine. Nevertheless, studying art in the context of social and spiritual transformation helps make art itself more meaningful. Art, by its very nature, is a transformative process, an act of re-creation. It carries within itself the seeds of cultural change, and, when viewed in depth, can tell us a great deal about the spiritual situation in which we find ourselves.

One of the foremost questions of our age has been that of the meaning of existence. I propose that it is to the *renewal of existence* that we should look for its meaning—that is, life is meaningful insofar as it is continually regenerating, transforming, and unfolding itself by way of expansion and self-transcendence. Only by growth, by continuous evolution, do we truly discover the mystery of those creative powers in man which make him unique among the creatures of earth. Art

[3] Susan Sontag, *Against Interpretation*, 10.

is nothing if not creative. It is a place where the possibilities of growth are kept open. The Existentialists (especially Martin Heidegger) spoke of man's "being-toward-death." The time has come, in my view, when we should think and speak more in terms of our *being-toward-rebirth,* about the regenerative and transforming powers inherent in the inner depths of human nature that constitute the essence of life and of creativity, and that cry out to be awakened!

Which brings me to my next point: I am concerned above all with the role played by the visual arts in the transformation of consciousness. My theme is the transformation, regeneration, illumination, and ultimate liberation of consciousness and inner life and the release through art of those creative forces that aid consciousness in unfolding and releasing its own higher creative powers. Nor can it be said that I have used art for illegitimate ends, for the awakening of the creative, intuitive powers of the inner self is at the very heart of art. It is the natural gift of art to evolving mankind. All high art functions within the context of human evolution as an elevating, liberating, and spiritualizing force.

Perhaps the closest of all experiences to the mystical is the aesthetic. The experience of awe, beauty, unity, enhanced vision, and creative power that great works of art confer upon us approaches in kind the moment of mystical Illumination. Every genuine experience of a work of art becomes an awakening in miniature foreshadowing another, higher Awakening yet to come. Intuitive moments in the presence of great art prepare us, through similarity of experience, for the ecstasy of spiritual Awakening. Art is a joyous foreshadowing of Illumination. One of the principal virtues of art, therefore, is as a path of preparation by which the soul is moved toward the realization of its own supreme destiny.

The food of the soul is truth.
To the discovery of it the eyes
contribute greatly.
Marsilio Ficino

Introduction

The stages of spiritual transformation in terms of which I shall attempt an interpretation of our culture and selected works of art came to me in a series of dreams between 1964 and 1966. Subsequent interpretation of my dreams and investigations of the process of rebirth that they revealed show these stages to be in universal manifestation, indeed archetypal.[1] What the dreams revealed was the morphology of the regenerative process. In my own life the dreams proved prophetic, for in the years since the first dream, I've found myself unwittingly caught up in a journey of transformation.

With a single exception, no sharp demarcation between stages has been experienced. Rather, each stage seems to have evolved naturally and unselfconsciously from the one preceding. Only as each new stage has come clearly to dominate my experience have I been able to recognize it. In the case of the earlier "dark" stages, recognition came well *after* the experiences had been fully passed through. Blindness is an occult law of the spiritual path, requiring us to immerse ourselves in and master each stage of experience prior to taking the next step in our spiritual journey.

Objective scholarship would require that I validate my seven-stage regenerative cycle with an exhaustive study of mythology, cultural history, religious experience, and the psychological processes of growth and transformation. A reasonable amount of investigative work has been done along these lines. Something must be said, however, for the subjective experience of taking the journey oneself. "Understanding is clearly a subjective process," says Jung. To know anything truly, it must be lived. True knowledge can be acquired firsthand only through experience, via intuition, or by direct union

No man can be absent from his culture.

Jacob Landau

Sow yourself, cast the inert part of yourself in the furrow. You will recover yourself later in your work.

Miguel de Unamuno

To exist is to change, to change is to mature, to mature is to go on creating oneself endlessly.

Henri-Louis Bergson

[1] Joseph Campbell says, "By heeding, interpreting, and following dreams we are led to the large, transpersonal fields of archetypal vision." *The Mythic Dimension*, 212.

1

of one's being with that which we would know.[2] Otherwise, we may accept an idea on authority or merely because it is reasonable, but it is not our own. We have not made it our reality. Only through direct knowledge is doubt overcome. One can read and dream about love forever, but only being in love teaches us love's true nature. Hence the age-old saying that experience is the best of all teachers. By entering subjectively into each of the stages of transformation, one acquires that mode of knowledge which comes of merging one's being with the thing known. In this respect, both the Existentialist and the mystic experiencing the Light of transcendent Being gain the knowledge of which they speak firsthand. Direct experience of the stages of transformation has the further advantage of enabling one to enter more deeply into the inner dynamics of any myth, symbol, work of art, social event, or psychological experience in which any of the stages is operative or manifest.

This question of knowledge and subjectivity is so important that we cannot proceed without making certain additional points. If true knowledge is subjective, inner knowledge, what is known then depends upon the subjective condition of the knower. Attention, sensitivity, psychological type, one's stage of evolutionary development—all affect what can be known. This being so, all advances in knowledge depend upon personal growth and the further awakening of consciousness. Both William James and Aldous Huxley made this point. "Knowledge we could never

[2] Andrew M. Greeley writes in his *Ecstasy: A Way of Knowing,* "The great heresy of the contemporary Western world is that the only kind of knowledge that is to be taken seriously and trusted is discursive, cognitive knowledge, that which is acquired by man's practical or technical reason. Concomitant with this are the assertions that the only kind of truth is that which can be empirically verified, and the only kind of language fit for human communication that of logically validated prose. In other words, that knowledge and language which is appropriate for discourse in the empirical sciences is the only one that is really worth developing in man, because it is the only one that can have any demonstrable validity. . . . One need only read the writings of the logical positivists and those who have been influenced by them to rule out the mythopoetic, the metaphysical, and of course the mystical as valid human forms of knowledge" (p. 58).

attain, remaining what we are," says James, "may be attained in consequence of higher powers and a higher life."[3] And Huxley:

> Knowledge is a function of being. Where there is a change in the being of the knower, there is a corresponding change in the nature and amount of knowledge. . . . It is only by making physical experiments that we can discover the intimate nature of matter and its potentialities. [Analogously,] it is only by making psychological and moral experiments that we can discover the intimate nature of mind and its potentialities.[4]

Myron Aarons often used the analogy of a boy of ten reading *Gulliver's Travels* and seeing in it only a delightful story of little men and big, then rereading it again in the mature years of adulthood and seeing its satirization of humanity, its exposé of the pettiness, grossness, foibles, and insignificance of man. With growing maturity comes deepening insight and comprehension. The mind's capacity to understand expands. What occurs between childhood and adulthood in Mike Aarons's analogy is paradigmatic of the evolution of consciousness—of man's progress from ignorance to wisdom, from finite consciousness to illumination and infinite awareness. The scope and validity of subjective knowledge depends, therefore, upon awakening and unfolding the inner life.

Two important consequences can be derived from this view of knowledge. First, by expanding the faculties of the mind, maturing the personality so that depth and balance are achieved, and by removing ignorance and freeing oneself of glamour and illusions, one's capacity for knowledge can be greatly expanded. Second, we can expect to find "levels" of knowledge corresponding to various stages of human growth— each level being transcended as further growth opens up higher faculties and expands capacity. In Vedanta philosophy, for example, we find just such a "hierarchy of knowledge," ranging from ignorance and illusion at the lowest level to absolute knowledge of Brahman—Essential Being,

[3] Quoted in Aldous Huxley, *The Perennial Philosophy.*

[4] Aldous Huxley, *The Perennial Philosophy*, vii, lx.

the Boundless All—at the highest.[5] Plotinus also set forth a hierarchy of unfolding knowledge, saying, "Knowledge has three degrees—Opinion, Science, Illumination. The means or instrument of the first is sense; of the second, dialectic; of the third, intuition." Huxley has pointed out that we can have no sufficient basis for truth in the sciences until we have apprehended the essential nature of consciousness itself. This would suggest that true science ultimately requires a fully awakened consciousness! Between the two poles of ignorance and illumination, then, we must see man's subjective knowledge as growing, changing, evolving. Accordingly, we need an epistemology based not on frozen principles defined by unawakened minds but a *science of knowledge* that encompasses the evolution of consciousness! We need also to understand how to evolve consciousness *at will*, and we need a view of knowledge, intuition, and wisdom that allows us to recognize the "unfolding stages" by which the One Truth reveals itself progressively to an ever-evolving humanity. It is the return of such teachings that lies behind the resurgence of the Wisdom Teachings. Every truth knowable to man[6] is

[5] See Eliot Deutsch, *Advaita Vedanta: A Philosophical Reconstruction.* Ravi Ravindra also writes in *The Gospel of John in the Light of Indian Mysticism,* "I am persuaded that the major division in the human psyche is not horizontal or regional, dividing the Eastern from the Western soul, but rather vertical and global, separating the few from the many, and the spiritual, inner, and symbolical way of understanding from the material, outer, and literal one—culturally as well as in each human soul" (pp. 1–2).

[6] *Man:* Unless otherwise indicated, wherever the term *man* is used in this work, it refers to its etymological origins, the gender-neutral Sanskrit noun *manas,* meaning "mind," and the Sanskrit verb *man,* meaning "to think." Philosophically viewed, "man" is that being (both male and female) in the scale of planetary and cosmic evolution who is unfolding the latent faculties of the mind and the power of thought. Other Sanskrit terms such as *buddhi* refer to the intuitive powers and Love-Wisdom of the spiritual soul, *atma* to the eternal Spirit in man, and so forth. Both men and women are embraced by the term *man* in the Wisdom Tradition. Lama Anagarika Govinda expresses a view that accords with my own, writing, "Female activity is activity by way of reproduction and transformation, while male activity is activity by way of intensification or direction. Female activity is inwardly centered, male activity is outward-directed. . . . The higher the state of spiritual development, the greater is the conscious interpenetration of male and female properties. The greatest artists, poets, and thinkers are able to express with equal perfection the psyche of man and woman, which means that they are able to express the male and the female within themselves." *Creative Meditation and Multi-Dimensional Consciousness,* p. 164.

capable of infinite expansion, like concentric circles spreading out endlessly from a central point.

At the very heart of the transformative process lies the idea of man's liberation from all that is finite and imperfect in his nature. Transformation and regeneration present themselves, therefore, as the keys by which to unlock the doors to a new epistemology. In dealing here with the transformation of the inner being of man, and by looking at it in terms of universal, archetypal patterns, we are endeavoring to lay the groundwork for a science of knowledge that will permit us to get at the universal elements in subjective experience and see these in terms of cosmic law and creative processes.

It is therefore important to keep in mind:

In all esoteric philosophies, Eastern and Western, the subjective mind is viewed as one with the Universal Mind. G. de Purucker states this beautifully:

> The inmost of us is the inmost of the universe: every essence, every energy, every power, every faculty, that is in the boundless All is in each one of us, active or latent. All the great sages have taught the same verity: "Man, know thyself," which means going inward in thought and feeling, in ever-greater measure allying ourselves self-consciously with the divinity at the core of our being—the divinity which also is the very heart of the universe. There, indeed, is our home: boundless, frontierless Space.[7]

The inmost center of our constitution—our monadic essence, the root of our being and consciousness—links us with eternal Reality, the boundless All, and is our assurance that enlightenment and, ultimately, cosmic consciousness is possible.

Every woman and man is not only linked to the Universal Mind, but each is a *center* of the same—that is, each of us dwells precisely at the point where subjective knowledge is infinite. In Blake's words, "If the doors of perception were cleansed man would see everything as it is, infinite."

[7] G. de Purucker, *Fountain-Source of Occultism*, 62.

Why, then, are we unaware of the infinite within? Take the analogy of a mirror which, if smoky or dirty, sends back only distorted and fragmented images of what it reflects. Because man's outer nature is finite and his mind unawakened, he reflects the Cosmic Mind like a smoky mirror incapable of clearly reflecting the divinity within. "Ignorance and delusion," says Swami Prabhavananda, "are characteristic of the unregenerated mind." It is only as we are able to cleanse the mirrors of the mind that it can reflect Reality as it is without distortion. Because our vision is clouded, we dispute over subjective knowledge, preferring objective or public knowledge to the inner wisdom of the soul. As a result we possess many facts, but little true wisdom.

To achieve true insight and wisdom, man must evolve and awaken his inner, hidden, latent powers. The journey begins with striving for emotional maturity, mental balance, psychological integration, and the development of an attitude of undefensive open-mindedness and accurate self-knowledge. A mature personality is the indispensable foundation of a spiritual life that in time leads to transfiguration, illumination, and liberation: first the journey of self-discovery, then the journey of self-transformation, and finally the journey of self-transcendence. Only by means of clear vision can we get to the essence of things. Only as illumined ones shall we see and know things as they are! Our task, therefore, is to free our consciousness of all inner distortions and thereby gain an ever-deepening contact with the subjective or Universal Mind. Eventually, having cleansed the mirrors of the mind, we shall see and know all things truly and without distortion.

Once the mind is rid of ignorance and illusions, we discover that what is *inwardly known* is a Truth that is universal. All who travel the spiritual path, regardless of the spiritual tradition to which they belong, find themselves in substantial agreement, for on contacting the Universal Mind all discover that they behold the same Truth. A Hindu, Buddhist, Christian, Taoist, poet, musician, or psychologist will each use the symbol structure with which he or she is most familiar to interpret transcendent experience, but once it is encountered, all experience the same Reality. Heraclitus says simply, "Those who are

awake are in the same world, but those who sleep are each in a separate world." What we view initially as our own inner private world, when pursued to its uttermost depths, turns out to be the most public of worlds—one where we contact Universal Wisdom and are united each to all by a profound sense of Universal Brotherhood.

Spiritual enlightenment solves one of the most difficult problems of science and speculative philosophy, but in a way neither science nor philosophy has been willing to accept. When at last one encounters

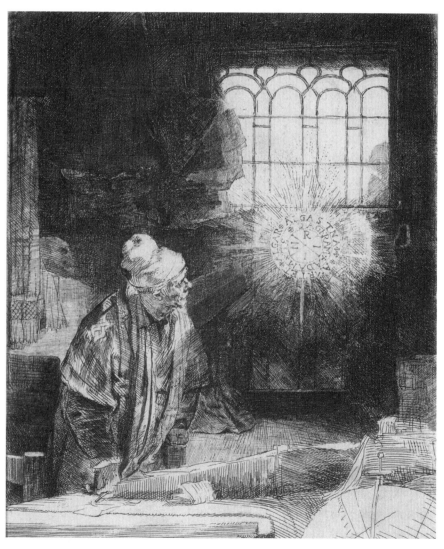

Rembrandt van Rijn, *Doctor Faust*, ca. 1652

Reality, its Truth is an essential part of the experience itself. It would be easier to doubt one's own existence than to doubt Reality once it has been experienced. Once glimpsed, Truth is self-validating. A man or woman in love *knows* he or she is in love. No external proof is required. *Knowledge of love comes with loving.* So also with the experience of the higher Realities. The Truth that reveals itself to the inner consciousness of an Illumined One requires no external proving. So profound is the sense of Reality which accompanies enlightenment that all doubt is forever annihilated. "This is the character of truth," said Voltaire. "It is for all men, it has only to show itself to be recognized, and no one can argue against it. A long dispute means that *both* parties are wrong."

The self-validation that comes with inner illumination does not mean one has entered upon some irrational experience at odds with the visible world. The truth that comes via the awakening of the subjective, Universal Mind is a *universal truth* that is in harmony with all that is true in every domain of life, inner and outer. It follows universal law and has only to be put to the test. The problem is that the world has been unwilling to put the Wisdom of the sages and seers of the ages to the crucial test of determining whether it does indeed work! We prefer the ways of ignorance, compounded error, glamorous illusions, and the knowledge of test tubes to the Wisdom of the soul. But such unwillingness to give Wisdom a try is itself supremely unscientific! None can judge accurately of what he does not know. Whether our reluctance is due to prejudices, laziness, or the adolescence of the race may be open to question, but the fact remains that we cannot judge the validity of Inner Truth so long as we refuse to put it to the test. Those who *have* tested it throughout the ages have discovered that indeed, when made the basis of a committed and disciplined life, it does lead in due time to the highest Wisdom and supreme Enlightenment. The history of the world is replete with examples of those who have triumphed and returned to teach us the Way. Their sheer numbers and appearance in all ages on all continents among widely diverse cultures is irrefutable proof of the timeless validity of what they have found.

Returning to our theme of transformation, the death-rebirth process accomplishes several things: by plunging us into the uttermost depths of our being, it puts us in touch with the subjective or Universal Mind, leads toward a vast expansion of consciousness, radically alters what we know and how we know it, and transforms our very being so that we know because we have become one with the wisdom we sought. We are transfigured when we live the vision of what, in our essential being, we truly are. Hence, if we would validate inner truth, we must undergo the process of transformation that liberates the inner being and produces Inner Awakening. To think we can be given access to the Supreme Wisdom of the cosmos without making the necessary effort and proving ourselves worthy and responsible is the ultimate self-delusion. One who has not gone through medical school, properly specialized in surgery, and undergone an internship cannot enter a hospital and perform heart surgery. One can't get a driver's license without proving oneself a responsible driver. In the entire universe there is no such thing as something for nothing. *Every advance must be earned.* By aspiration, self-discipline, and the selfless use of such knowledge as one possesses, one earns the right to further knowledge. Only when one has undergone the necessary process of death and spiritual rebirth is one allowed access to the spiritual realms of our universe, for nothing unworthy may enter.[8] Only then comes the moment of supreme Awakening. In that moment, *knowing* and *being* merge and are one.

The artworks and cultural events discussed here coincide with my lifetime and are a part of my personal experience. While something may be gained from the mere fact of distance from the events one seeks to interpret, so likewise is there something to be gained from participation in those events. History, in the final analysis, is based upon *interpretation*, which relies on personal and social *insight*, which depends in turn upon one's psychological makeup, values, and philosophy of history. Toynbee says, "Men see largely what they expect to see, and they record what seems to them important."[9] He adds, "Neither history nor any other human activity can be definitive so long as the human race continues to exist."[10] New experiences and

[8] "In truth, in very truth I tell you, no one can see the kingdom of God unless he is begotten from Above" (John 3:3).

[9] Arnold Toynbee, *A Study of History,* 16.

[10] Ibid., 14.

expanded insight will always enable one to revise one's understanding of the past. What is gained by personal participation in the cultural events one seeks to interpret is the same thing gained by all subjective or existential experience: knowledge comes of *being there!* One who has never been imprisoned for his beliefs or convictions can scarcely comprehend the experiences of an Aleksandr Solzhenitsyn or Nelson Mandela. A bachelor viewing the domestic life of his married friends cannot know what it means to love and work within the context of marriage. Experience has no equal as a teacher.

Perhaps a few autobiographical comments may help illumine the direction of this work. In December 1964, I decided to end my marriage, leave the profession for which I had trained, quit my job, and return to graduate school to prepare for a new career. These decisions came quickly, all on the same day with little conscious premeditation. For several weeks, like a melody one can't forget, two lines of a Dylan Thomas poem had been ringing in my mind:

> *Do not go gently into that good night.*
> *Rage, rage against the dying of the light.*[11]

Six weeks previously I'd written my first poem:

The Orphic Way

What Orphic traveler dares choose the Pit,
The gods of Night and darkest Hell?
What Orphic hero with eyes afire
Can choose the Chaos, therein to dwell?

To choose our death and Underworld,
To leave the sun and stars behind
And tread the spiraling whirlwind down
Into the regions of the blind,

[11] "Do Not Go Gently into That Good Night," from *The Poems of Dylan Thomas.* © 1952 by Dylan Thomas. Reprinted by permission of New Directions Publishing Corp.

To seek the Kingdom's darkest side
Where neither mirth nor tears survive,
Where sky and sea are blackest ink
And the Abyss alone seems alive,

To pass beyond all love and faith
And dwell forever in the Night
And know that Hell alone is hope
Requires of man a Titan's might.

But go we must into the Void,
Into those regions dark, unknown,
To face down death and meet the gods
Whose Underworld is but our own.

The poem was written on October 23, 1964. On December 3, I made a radical break with my entire past—wife, profession, religious beliefs. I assumed I was embarking on a new life and career. Little did I realize that this severing of my past was but the first or *dismemberment* stage of a cycle of changes which, in their course, would take me through the worst hell of my life. A couple months later, after taking up residency in New York City, the first of my dreams came. It was as follows: In a large building adjacent (in my dream) to the New York Coliseum, a flower show was in progress. I attended the show, then entered the Coliseum. A Stravinsky symphony and ballet were in progress, with the production of which I seemed to have something to do. I listened to the music and watched the ballet, but to my surprise the ballet-concert was only a prelude to the main event—a magic show. A renowned magician—the philosopher Plato, whose dress and appearance were reminiscent of Salvador Dali—appeared on stage to perform a feat for which he had attained world acclaim. A young blond woman in her early twenties then came on stage. Plato proceeded to cut off her left hand at the wrist. Even though she could still move and obey Plato's instructions, the severed hand produced immediate death, whereupon

she was placed in a wooden coffin by assistants, who nailed the lid tightly shut. Plato waved his hand quickly over the coffin. Instantly, it stood open, and the young girl stepped out alive and whole. The audience roared with applause. Plato proceeded to perform this astonishing feat a second time—severing the girl's left hand, placing her in the coffin, then resurrecting her alive and restored to wholeness. More vigorous applause. Again, a third time, Plato performed his famed feat. But when he waved his hand and the coffin opened, to his great surprise the girl had vanished. From my omniscient position as dreamer I learned that the Oracle of Delphi had prophesied earlier to the young girl that she would die and be resurrected three times and that, on the third occasion, she would descend into the Underworld. My dream concluded as I saw the girl in the Underworld where she appeared quite happy. Then a voice said, "Nothing in the Underworld ever dies."

For several days I puzzled over this strange dream, unable to make sense of it. Then, still without realizing its personal significance for me, I recognized in it several of the basic motifs of all myths of regeneration—the motifs of dismemberment, death and containment, and descent into the Underworld (the unconscious) as a place where "nothing ever dies." The flower show, music, and ballet—symbols of life and vitality—provided the context and set the stage for the several dreams of death and rebirth that were to follow. Thus the end was foreshadowed in the beginning: "The universal mythology of the dream symbolism of death and rebirth," says Andrew Greeley, "indicates that a conviction of hopefulness is built into the structure of the human condition."[12]

By late spring 1965, my hopes of returning to graduate school had come to an end due to financial difficulties. The next two years were lived in a kind of limbo—writing freelance marketing programs and leading something of a playboy existence. Inwardly I felt lost, empty, dead, walking through my days like a somnambulant, convinced eventual death was the end of all human endeavors. Nothing held meaning. In retrospect, I came to see this as my period of *death and containment*.

[12] A. M. Greeley, *Ecstasy: A Way of Knowing*, 62.

Anything, it seemed, would be better than the meaninglessness that I felt. So I began to involve myself in the new youth culture, chiefly the music, getting to know and becoming friends with a number of prominent young musicians and even trying my hand at managing a folk singer. But instead of improving, things only seemed to get worse. The anxiety, misery, and loneliness of that period became almost unbearable, and I began to think about suicide. When a friend made three near-successful suicide attempts, I went into a state of complete physical and psychological collapse. This period most assuredly marked my *descent into hell,* or the Underworld.

The time had come for therapy and facing my problems. For several months the depression was such that I was unable to hold a job. But the therapy proved highly beneficial. Following this period, I assumed the position and responsibilities of director of the Society for the Arts, Religion, and Contemporary Culture, nominated for the post by MoMA's Alfred H. Barr, Jr. It was also at this time that I became intensely interested in the psychology of creativity. In short, my search was on! After therapy and twenty-five months as director of ARC, I resigned, put all my belongings in storage, and spent three-and-a-half months hitchhiking fifteen thousand miles around the United States and Canada. The movie *Easy Rider,* which came out the same summer, paralleled many of my experiences. Returning to New York in September, following Woodstock and the moon landing, my externalized quest turned inward and took on a greater intensity. The more deeply I explored the workings of my consciousness, the more absorbed I became in the search for my own identity. Looking back, I came to see that three-and-a-half years as a period of *wandering in the labyrinth in search of the Way out of the Underworld.*

In May 1970, I had a spontaneous mystical experience. As I sat one afternoon visiting with a friend and listening to music, the room suddenly began to glow, becoming brighter and brighter, until, all at once, everything appeared as pure light! Then, as though a veil had fallen away, I saw the universe consisting of flowing streams and rivers of Living Light entering and passing through the myriad

Every day the cracks get a little deeper

ever-changing forms of manifest life. Forms changed and faded, but the Light of Life within them circulated ever onward, never ceasing. Immediately I knew *there is no death!* No longer aware of the music on the stereo, I now heard only the purest music—a music beyond imagination, the indescribable OM or celestial song of the cosmos, and I felt and knew that all is a manifestation of an Infinite Love. Vision after vision followed for about an hour, then the experience ended as abruptly as it had begun. Never before or since have I experienced such a profound sense of peace! In the few notes I scribbled following the experience, I wrote, "Consciousness *lights up* Reality. The total Universe shines. Everyone is Christ!" In that hour I witnessed the Dance of Life.

By December 1970, I had discovered the mystical and esoteric traditions and plunged myself into the study of the Wisdom Literature of the ages. On January 1, 1971, I took up the discipline of meditation in the hope one day of reexperiencing the Vision beyond the veil. Since that time I've been engaged in the long and often difficult journey and search for the Divine Self within—that Self which unites us all. This is a journey that has a beginning, but no end. The road of divine self-unfolding is eternal.

So much for my personal odyssey.

I feel justified in drawing on my own experience for keys to interpret art and culture because I have lived through so many of the events of our time, deliberately involving myself in them. Perhaps I have developed some ability to attune myself to the forces of change at work in our culture. Or perhaps the reverse is true, and the changes impacting our society have affected my life at deep levels as a way of preparing me for the shifts occurring in our culture. Either way, if parallels exist, the stages of transformation in which I find myself caught up may be operating in like manner in the depths of society in order to bring about a profound spiritual transformation of this age and of humanity. This, at least, is my thesis. Personal, cultural, and archetypal experience appears to be approaching a point of con-

vergence in our time. Just as a global society is emerging from the political, economic, cultural, technological, and communications interdependence of our world today, individual experience appears also to be taking on a more universal or archetypal quality. Pointing to the essential unity of personal and archetypal or metaphysical experience, Joseph Campbell says:

> The key to the modern systems of psychological interpretation . . . is this: the metaphysical realms = the unconscious. Correspondingly, the key to open the door the other way is the same equation in reverse: the unconscious = the metaphysical realm. "For," as Jesus states it, "behold, the kingdom of God is within you."[13]

Turning now to the artists and works of art to be studied, it must be noted that the intuitive sensitivity of the artist often makes him or her a Seer of things to come. Fyodor Dostoyevsky anticipated the Russian Revolution, Wassily Kandinsky the outbreak of the First World War, and Paul Klee the rise of Nazism in Germany. We have to address here the prophetic element in creative intuition. If the artist can anticipate external events, how much more so inner events, changes of a psychological and spiritual nature. As I view the visual art of the United States since 1945, I see all the stages of transformation at work. It is as though our artists unknowingly foresaw a profound death and rebirth about to take place in American society. What follows is a study of selected but representative works of American art spanning the years between 1945 and 1975 in which various stages of spiritual transformation stand revealed. Chief emphasis has been placed upon the Abstract Expressionists and the work of the 1940s and '50s because the artists of this style and period were aware of and more attuned to their own unconscious processes. Having survived the Great Depression and the catastrophes of two world wars, they brought to their art a deeper intuition of the radical nature of the changes ahead, beyond their own lifetimes. Other artists and movements are also considered, but by the time Psychedelic Art appears in

[13] Joseph Campbell, *The Hero with a Thousand Faces,* 259.

the youth subculture of the 1960s, the radical nature of social change was already beginning to surface from the subconscious and become conscious. From the early sixties on, we are dealing with an emerging, growing awareness of personal, social, and spiritual rebirth. The civil rights movement, the women's movement, and rock music were among its first manifestations.

Just as there is victory for the individual experiencing spiritual rebirth, so also is there for a society or an age. If, as many believe, ours is a time of profound change, of death and renewal, then for all the agony, suffering, and heartache the world is passing through, the ultimate result will be a new and better world, a world on its way toward Universal Brotherhood. "The old Universe with its Gods is sunk," said Thomas Carlyle, "but it is not final death: there is to be a new Heaven and a new Earth." "We have it in our power to begin the world over again," Thomas Paine said at the time of the American Revolution. Indeed, we do.

A Note on Viewing and Interpreting Art

If one is to take more than a superficial approach to art, one must first learn to *see*. Seeing in depth, seeing with the whole of one's inner being, is no simple matter. Bringing one's entire inner life and sensitivity to the viewing of works of art requires, as the Oracle of Delphi put it, that one *know oneself*. It requires that one's inner perception or spiritual eyes be open. Some years ago I gave a lecture titled "Seeing Art with the Eyes of the Soul." Here I offer only hints of that process.

First, one must come to a work of art with an open, receptive consciousness. Works of art are living things, endowed with the life of their creators and the inspirations that give them birth. When you open yourself to them, they can create in you a new depth of vision and insight, stir your imagination, expand your awareness, and awaken within you latent creative powers that have lain dormant awaiting this particular work of art to call them forth. All too often art historians or critics come to a work of art with a mind burdened with names, dates, styles, techniques, and criteria of judgment—all of which stand between the viewer and *authentic seeing*. In meditation, as long as the thinking process is active, the gibberish of the mind prevents the awakening of the intuitive powers that make possible direct perception of the innermost Self. In like manner, reliance on historical and critical judgments of a work of art prevents the work itself from speaking and being seen, from awakening our intuition and calling to our soul. *Openness and receptivity are the first requirements of seeing.*

My approach to art may be likened to a four-stage process of meditation by means of which the artwork brings about a progressive

Works of art are of an infinite loneliness and with nothing so little to be reached as with criticism. Only love can grasp and hold and be just toward them.

RAINER MARIA RILKE

17

awakening of the higher faculties and, in turn, allows consciousness to penetrate to ever deeper and higher levels of the work.

1. Begin meditating on the objective, formal aspects of the work—e.g., shapes, lines, images, materials, composition, colors, light and shadow, texture and stylistic elements. Whatever inner meaning a work of art can reveal is inseparably bound up with the art object—the painting or sculpture, the artist's creation. It is a fundamental law in meditation that *as one concentrates, so one receives.* If I'm able to hold my attention on an idea or work of art for only a few seconds, I will learn little compared to what I may receive if am able to give it undivided attention for several minutes, even hours. One must learn to give full attention to the formal elements of a work if the underlying life and purpose that gave it birth are to reveal themselves. *Inner* and *outer* are one life.

2. All forms are manifestations of *energy.* The art object is alive and pulsating with the inner dynamics of shape and image, tensions and resolutions, color harmonies and contrasts, and more. The physical artwork is the out-picturing of *fields of energy,* and these energies interact with consciousness during the act of perception. A study of Gestalt psychology is useful here.[1] Second-stage meditation on a work of art involves seeing and feeling the dynamics of its compositional elements *as energies,* much as one feels the energy of music. Van Gogh's art is excellent for training this sensitivity. In this way the artwork is brought to life for the viewer, consciousness is rendered more sensitive to the work, and an active interaction is set up between the viewer and the artwork.[2]

3. "Art at last must speak," says John A. F. Taylor.[3] The truth of art is no more exhausted by its physical manifestation than a man

[1] The leading interpreter of art from a Gestalt perspective is Rudolf Arnheim. See *Toward a Psychology of Art* and *Art and Visual Perception.*

[2] Optical (Op) Art was chiefly occupied with the dynamics of the relationship between the viewer and the work. Among the best known Op artists are Victor Vasarely, Bridget Riley, and Richard Anuszkiewicz.

[3] John Taylor, *Design and Expression in the Visual Arts,* 7.

by his body; both have inner lives, expressive souls, and transcendent origins. Just as the human soul incarnates itself in physical vehicles, so do the ideas and intuitions of the artist "incarnate" themselves in works of art. The Law of Correspondence—"As above, so below"— ever holds true in all manifest forms. Hence, there is no such thing as a meaningless form. Every form, whether natural or manmade, is the out-bodying of some life or idea. In learning to concentrate on the artwork and its energies, observing details that might go unnoticed in a hasty glance, we initiate a process of seeing that opens inevitably, in time, to the inner life and meaning of the work. A good way of connecting to the inner levels of a work of art is to step inside it by an act of imagination and *identify* oneself with the work. For example, when viewing Van Gogh's *Starry Night* (plate 22), step into the picture and *become Starry Night*. At some time in our lives, we have identified with other people, tried to think and feel as they feel, and it is not too difficult to imagine oneself as a favorite animal—a beloved cat or a graceful gazelle. By stepping into a work of art one *takes on its inner life* and comes to know it by living that life imaginatively within oneself. I've done this many times and find I can almost feel the creative moment, emotions, and thoughts of the artist in the act of giving birth to the work. Imaginative identification is likewise good for overcoming the subject/object dichotomy in consciousness and awakening the synthetic-intuitive faculties.

This third stage of meditation on art is one of attuning oneself to the inner life and meaning of the work—the insights, intuitions, ideas, inspirations, and revelations that gave it birth. It is not necessary that the artist have been conscious of all that went into his work, for in our creative moments we are often vehicles for the soul's wisdom—for a "knowing" beyond our knowledge. But no work of art can be said to be truly seen until we can enter its inner realms and perceive something of its inner life.

4. The fourth and final stage of meditation is done with eyes closed and consciousness turned inward. By this stage one should be so familiar with the artwork that every detail can be inwardly

Before a picture, as before a prince, every one must stand, waiting to see whether and what it will speak to him; and, as in the case of a prince, so here he must not himself address it, for then he would only hear himself.
SCHOPENHAUER

The image itself will show you the way.
CORPUS HERMETICUM

visualized. A mental picture of the work is now re-created in the mind's eye and held for a few moments as one silently expresses a desire to know the innermost mysteries of the work. Then, with an out-breath, the image is dismissed from consciousness and the mind made calm and receptive. One now awaits such revelations of the "soul" of the work as one is able to receive. As Arthur Schopenhauer said, "In art the best of all is too spiritual to be given directly to the senses; it must be born in the imagination of the beholder, although begotten by the work of art."[4] The *spiritual* meaning of art belongs to the realm of the subjective or superconscious mind. Only when the objective mind is stilled, rendered quiet and receptive, does the subjective mind increase its sensitivity and powers and "make contact" with that which we wish truly to know. Slowly the deeper, more subtle meanings of the artwork—the spiritual forces and archetypes behind its creation—may begin to dawn in consciousness.

Still-born Silence! thou that art
Floodgate of the deeper heart.

ROBERT FLECKNOE

What began as concentration on the objective artwork leads in time to an unveiling of its inner dimensions and a union of our consciousness with the creative life of the work—a life bestowed on it by the artist during the act of creation. Once this inner synthesis takes place, the artwork becomes our own. In the case of a great work of art, we are often deepened, expanded, enriched, and even transformed by its creative power and vision. What higher compliment could any of us pay any artist than to say to her or him, "Your work has expanded and enriched my life"?

The task confronting any interpreter of a work of art is that of entering into the life of the work itself. Only then is one a true "art lover" who, aided with insight, can help others enter more deeply into and experience the art for themselves. To do this, however, one must interpret wisely. Interpretation should not seek to lift the veil of the

[4] Arthur Schopenhauer, *The World as Will and Idea,* selections in A. Hofstadter and R. Kuhns, eds., *Philosophies of Art and Beauty,* 453–54.

unspoken in art but should serve as a guide to that region where the unspoken reigns supreme, where the mystery of seeing entrances the soul and a certain light breaks into consciousness that is ever untranslatable. The language of poetry, myth, and symbol—a language that, as Friedrich Hölderlin says, "works down into the depths and opens out and illumines"—is perhaps best able to conjure the powers of the imagination and reverberate in the chambers of the soul, thereby avoiding those too-literal efforts at art interpretation that destroy the real magic of art. As Joseph Conrad noted, "*Words* also belong to the sheltering conception of light and order which is our refuge." So, when talking of art, the only error is to speak where silence would better serve.

A NOTE ON VIEWING AND
INTERPRETING ART

The Overview

To return to patterns of initiation: we can still recognize them . . . in the imaginative and dream life of modern man. But we recognize them too in certain types of real ordeals that he undergoes—in the spiritual crises, the solitude and despair through which every human being must pass in order to attain to a responsible, genuine, and creative life. Even if the initiatory character of these ordeals is not apprehended as such, it remains true nonetheless that man becomes *himself* only after having solved a series of desperately difficult and even dangerous situations; that is, after having undergone "tortures" and "death," followed by an awakening to another life, qualitatively different because regenerated.

MIRCEA ELIADE

The western world stands on the verge of a spiritual rebirth, that is, a fundamental change of attitude toward the values of life. After a long period of outward expansion, we are beginning to look within ourselves once more.

GARY F. BAYNES

1 Dreaming the Myth Onward: Art Since 1945

The most we can do is dream the myth onward and give it a modern dress.

CARL JUNG

"The man who has survived being struck by lightning," says Mircea Eliade, "acquires a 'sensibility' not attainable at the level of ordinary experience. . . . He feels himself to be not only dead and re-born, but *born into existence* which, while it is lived to all appearances in this world of ours, is framed in other existential dimensions."[1]

Anyone who has lived through even a portion of the past century—the Great Depression, World Wars I and II, the *angst* of the post-war years and "death of God" experience, the Vietnam War, the Kent State killings, the tragedy of 9/11, the wars in Iraq and Afghanistan, the spread of terrorist activities throughout the world, genocide, world hunger, AIDS, unemployment, environmental disasters, and all the rest—may well feel he has been struck by lightning. Indeed, it is this sense of profound shock that is responsible not only for the political radicalizing of many people throughout the world but also—and more important for the evolution of human consciousness—explains the growing spiritual search one encounters everywhere today, especially among the young. As with Hermann Hesse's young Siddhartha, we find "dreams and a restlessness of the soul" all around us. This is our lot today from which no one of us, even if he chooses, can fully

[1] Mircea Eliade, *Myths, Dreams and Mysteries.*

Hey, man, don't you feel the rhythm of the tensions of our times?

One is always contemporary with a myth.

MIRCEA ELIADE

Modern painting is indeed the most striking expression of the universal process by which one cultural epoch with a long history yields its place to another. It bears witness to the decline of an old conception of reality and the emergence of a new one.

WERNER HAFTMANN

escape. As Jacob Landau said, "No man can be absent from his culture." If the forces of violence and disintegration around us seem too great at times and the road into the future too uncertain, we might do well to remember Govinda's response when Siddhartha asked, "Well, Govinda, are we on the right road?" "We have learned much, Siddhartha," Govinda replied. "There still remains much to learn. We are not going in circles, we are going upward. The path is a spiral; we have already climbed many steps."[2]

Within our lifetime, American art has given us images, like precognitions in dreams, of a radical transformation of man and of civilization—a transformation that is just beginning to reach us at conscious levels. This art recapitulates the complete cycle of death and spiritual rebirth found in all ancient myths of initiation. If the thesis developed in this work proves valid, we may conclude that civilization is itself undergoing an "initiation" into a higher consciousness such as that experienced in the past by individuals, but never before by an entire age or civilization.

Since I'm approaching the study of art by means of the mythic cycle

[2] Hermann Hesse, *Siddhartha*, 19.

of death and transformation, let us begin with a definition of *myth*. The philosopher Georg Wilhelm Friedrich Hegel taught modern man to think of myths as fabrications of the imagination, hence as *untrue*. Thus the saying, "Oh, it's just a myth." Before Hegel reduced consciousness to mere reasoning, humanity understood myths and symbols as keys to the deeper mysteries of life. Thanks to modern myth-scholars such as Sir James Frazer, Jane Harrison, Edith Hamilton, Mircea Eliade, and Joseph Campbell, philosophers such as Ernst Cassirer and Suzanne Langer, psychologists such as Otto Rank, Carl Jung, and Erich Neumann, and literary scholars such as Philip Wheelwright and Northrop Frye, the twentieth century witnessed a revival of interest in myths and symbols, furthered by a growing interest in Eastern philosophy and the reemergence of the Ageless Wisdom.

After giving my definition of myth, I quote from two noted scholars —Campbell and Eliade. Direct access to the loftiest spiritual truths is denied us in our relatively unevolved state because, on one hand, the knowledge acquired would prove both meaningless and incomprehensible; and, on the other, the highest Wisdom is a carrier of powers man is as yet ill equipped to handle. Such Wisdom in the possession of selfish, unevolved men would prove more dangerous than giving nuclear weapons to children. However, to ensure that man never be cut off from his destiny and the powers that govern his evolution, spiritual truths have been preserved and given to him *under a veil,* by indirect means. This indirect communication of spiritual realities takes the form of myths, symbols, parables, fables, fairy tales, and allegories. Within these mythic narratives and symbol-structures, the eternal truths are protected and preserved. Hidden within them are psychic forces in the form of controlled archetypal powers that release into the inner life of man those energies and insights needed to make successful his journey from lesser or finite life into the greater Life of the Infinite. Myth links us to these cosmic forces. Putting it poetically, through myth, consciousness is "granted an audience" with eternal truths. "Myth," said one of the church fathers, "is what is believed always, everywhere, by everybody." Through myths the psychic energy of the individual taps

Chosen are those artists who penetrate to the region of that secret place where primeval power nurtures all evolution . . . who is the artist who would not dwell there? In the womb of nature, at the source of creation, where the secret key to all lies guarded.

PAUL KLEE

the power stations of the cosmic. Hence the possibility of *regeneration,* of finite man experiencing himself infused and transformed by powers greater than himself.

In Campbell we find the emphasis upon psychic transformation.

It is the business of mythology proper, and of the fairy tale, to reveal the specific dangers and techniques of the dark interior way from tragedy to comedy. Hence the incidents are fantastic and "unreal": they represent psychological, not physical, triumphs. Even when the legend is of an actual historical personage, the deeds of victory are rendered, not in lifelike, but in dreamlike figurations; for the point is not that such-and-such could be done on earth; the point is that, before such-and-such could be done on earth, this other, more important, primary thing had to be brought to pass within the labyrinth that we all know and visit in our dreams. The passage of the mythological hero may be overground, incidentally; fundamentally it is inward—into the depths where obscure resistances are overcome, and long lost, forgotten powers are revivified, to be made available for the transfiguration of the world.[3]

Mircea Eliade's definition of myth points us to the *source* of the revivifying powers—the archetypal realms of creation.

Myth narrates a sacred history; it relates an event that took place in primordial Time, the fabled time of the "beginnings." In other words, myth tells us how, through the deeds of Supernatural Beings, a reality came into existence, be it the whole of reality, the Cosmos, or only a fragment of reality—an island, a species of plant, a particular kind of human behavior, an institution. Myth, then, is always an account of a "creation"; it relates how something was produced, began to be. Myth tells only of that which really happened, which manifested itself concretely. . . . In short, myth describes the various and sometimes dramatic breakthroughs of the sacred (or the "supernatural") into the World.[4]

[3] Joseph Campbell, *The Hero with a Thousand Faces*, 29.

[4] Mircea Eliade, *Myth and Reality*, 5–6.

Eliade's definition is closely related to Heidegger's concept of art as a "world-building" event, a view we shall examine later.

Myths are closely related to archetypes, dreams, and symbols. Myth may be defined as *symbolic narrative*—a composite symbol or set of symbols given dramatic form. "Symbols," said Jung, "are never thought out consciously; they are always produced from the unconscious in the way of so-called revelation, or intuition."[5] The chief characteristic of myths and symbols is that they are never the products of the rational, wakeful mind but well up from below as insights, intuitions, revelations, visions, and dreams. For this reason dream-states,[6] reverie,[7] certain mind-manifesting drugs,[8] ecstasy, and meditation have all been found to be conducive to symbolic perception. The irruption into consciousness of myths and symbols is often experienced as a "sudden knowing" because these states of expanded perception are typically experienced as self-transcending moments of archetypal attunement. Myths and symbols may be further defined as *manifestations of transpersonal experience* that tend toward the revelation of universal insights and truths. These symbolic, synthesized insights act as *energy transformers,* making available to us heightened psychic energies. Hence, Campbell's "long lost, forgotten powers" that reemerge via myth to revivify us.

Our subject is the creative arts of painting and sculpture, so let us note briefly the relationship of myth and symbol to the creative imagination. The poet William Blake, our chief spokesman for the creative imagination, addresses us, saying, "You have the same intuition as I, only you do not trust or cultivate it. You can *see* what I do if you choose." Imagination—literally, *image*-creation—is universal. We all dream in images, and most visual artists think visually the way musicians think musically.[9] Visualization in the deepest sense is

[5] Quoted by Morris Philipson, *Outline of a Jungian Aesthetic*, 23.

[6] See Manly P. Hall, *Studies in Dream Symbolism*.

[7] See Gaston Bachelard, *The Psychoanalysis of Fire*.

[8] See Claudio Naranjo, *The Healing Journey*.

[9] See Rudolf Arnheim, *Visual Thinking*.

an occult science,[10] meaning it obeys known universal laws and gives one mastery of specific creative powers. What is the nature of the visual image and the role of the creative imagination in its creation? Visual imagery is born of the interplay between the mind and the data of sense experience. *Chitta,*[11] "mind stuff" or thought-matter—the energy-substance in which mental ideas are formed—is given shape by the concrete intelligence of man using the form-building powers of that intelligence.[12] All matter and energy is electromagnetic. In the creative process, therefore, man is always dealing with electrical phenomena. Thought-forms or images are electrically charged and, like all energies, radiate their influence, producing effects either good or ill according to the motive of the thinker and the nature of the image created. All the subjects under discussion in this work have an esoteric side—which is to say, a *scientific* side—which, for the most part, will not be discussed, though references to sources may occasionally be given. The technical aspects of the symbolic and creative powers of the mind are vast and complex and will only be truly useful in an age that is more spiritually awakened and has greater use of its higher powers. Our primary objective here is to achieve a few insights into the art and culture of our own time. In his discussion of the Cosmic Tree, Roger Cook gives a fine poetic description of the nature of imagination.

> The Tree of Life, or Cosmic Tree, penetrates the three zones of heaven, earth and the underworld, its branches penetrating the celestial world and its roots descending into the abyss. Like the Tree, imagination unites heaven and earth; it is "rooted" both above and below. Uniting the luminous world of consciousness to the dark underworld of the

[10] See A. Besant and C. W. Leadbeater, *Thought Forms;* and A. A. Bailey, "The Use of Form in Meditation," in *Letters on Occult Meditation,* 140–202.

[11] *Chitta*—Sanskrit meaning mind-stuff or mental matter, the substance of the lower, concrete mind of man or "mental body." As the most ancient and precise of all surviving languages, Sanskrit often conveys ideas and meanings entirely absent in English.

[12] See Swami Vivekananda, *Rāja-Yoga;* A. Besant, *Thought Power;* and H. W. Percival, *Thinking and Destiny.*

unconscious, and drawing nourishment from both the "heavenly-immaterial" world of intelligible meaning and the "earthly-material" world of sensory perception, it creates the "magical" intermediary world of images. It is this lively mediation between these opposed worlds that accounts for the multiplicity of symbolism. . . . Like the Tree, imagination is a source of endless regeneration.[13]

Finally, let us touch briefly on archetypes. The notion of archetypes or primordial ideas received its first extended treatment in the philosophy of Plato and later in the work of Plotinus. Archetypal ideas underlay the Neoplatonic philosophy of Renaissance philosopher Marsilio Ficino—who had a great influence on Michelangelo and Leonardo da Vinci—then reemerged prominently in the modern world in the psychology of Carl Jung. Jung defined archetypes as primordial patterns consisting of inherited ideas and predispositions belonging to the racially inherited unconscious: "So far as the collective unconscious contents are concerned we are dealing with archaic or . . . primordial types, that is, with universal images that have existed since the remotest times."[14] Further on he says, "In that respect [they] correspond in every way to the instincts."[15] Since, as Jung says elsewhere, "It is only as an empiricist, and never as a philosopher, that I have been concerned with depth psychology,"[16] I would like to raise a crucial philosophical question regarding the Jungian interpretation of archetypes. What Jung gives us is a phenomenological study of archetypes based on observations of them in dreams, myths, symbols, works of art, culture, religion and alchemy, and so forth. He traces them back to prehistoric man, through culture, and down into the depths of the unconscious, noticing their persistent and universal recurrence. Yet he does not deal with the philosophical significance of that *transcendental wholeness* that every archetype reveals in and through all specific manifestations. All human experience is partial and finite compared to the larger-than-life quality we find in the archetypal myth. Since the lesser cannot be greater than the greater, this largeness of the archetype cannot be adequately accounted for in purely phenomenologi-

[13] Roger Cook, *The Tree of Life*, 8–9.

[14] C. G. Jung, *The Archetypes and the Collective Unconscious.*

[15] Ibid., 79.

[16] Preface by C. G. Jung to Erich Neumann, *Depth Psychology and a New Ethic*, 11.

cal terms. I can best make my position clear by drawing an analogy to Gestalt psychology. Wilhelm Wundt held that the field of visual perception consists of numerous individual elements that our seeing holds together in mosaic fashion—a view designated as "elementalism." Max Wertheimer came along and discovered that consciousness or perception brings to the act of seeing an ordered wholeness that, in the order of genesis if not of time, is *prior to* our perception of the individual elements of the visual field. To account for the psychological process that he had observed and tested, Wertheimer proposed in 1922 that "a procedure 'from above' is required, *not* a procedure 'from below upward.'"[17] I shall not enter here into the esoteric view of archetypes or cosmic ideas, which is abstract and complex, except to say that archetypes, and those myths and symbols that give expression to them, govern all evolution *from above*. Archetypes are the "molds" according to which our experience is shaped, not vice versa. The wholeness that archetypes express and that represent the unfolding potential of life and consciousness is anterior to the evolutionary process, and therefore will be found influencing it at every stage of development, from the most archaic times onward. Hence Jung's discovery of archetypes as archaic or primordial *types*. To draw from phenomenological studies the assumption that archetypes are an "archaic residue" of past racial experiences is like saying that love is the "residue" of lovers. In our experiences of archetypal myths, we find that their language is intuitional and revelatory and that the truths revealed are metaphysical. "It would not be too much," says Campbell, "to say that myth is the secret opening through which the inexhaustible energies of the cosmos pour into human cultural manifestation."[18] It speaks to us *from* above of what *is* Above, and by its wholeness and power reveals to us a greatness and a unity transcending all that we have hitherto known. The supreme value to us of archetypal myth is not as primordial or sacred history, but as a revelatory foreshadowing of destiny and a promise of hidden greatness residing in the depths of our being.

The presence of archetypal myths and symbols in the unconscious, out of which they occasionally erupt in dreams and art, is our assurance

[17] Quoted by Robert I. Watson in *The Great Psychologists*, 452.
[18] Joseph Campbell, *The Hero with a Thousand Faces*, 3.

that we have not and cannot throw off the life-messages they bring to us from Mother Nature and the Creative Logos. In other words, no matter how scientific or civilized we view ourselves as being, we cannot outgrow the eternal truths that find expression in myths and symbols. "The most we can do," says Jung, "is to *dream the myth onward* and give it a modern dress." We should not be surprised, then, to find modern artists *dreaming the myth onward,* albeit subconsciously and often in the abstract iconography of the modern style. On the surface our society and civilization would appear to be in decline à la Toynbee's criteria.[19] Yet it is my intention to show in what follows that American artists since 1945 have made contact with and reveal to us those long-lost, forgotten powers that can be revivified and "made available for the transfiguration of the world."

To understand the situation in which we have found ourselves for the past sixty-plus years, let us look briefly at the "modern world" and what happened to it in the century preceding and leading up to the post–World War II years. The radical nature of the events, ideas, and creations of the past several decades will then become much clearer.

[19] Arnold Toynbee, *A Study of History.* See Part IV, "The Breakdown of Civilizations," and Part V, "The Disintegration of Civilizations."

2 The End of the Modern World

Our age is aware of the reality of the deliberate destructiveness in the human spirit and our age is troubled to its very depths. Therein lies its greatest opportunity: to grasp the truth by breaking away from the optimisms of the modern mind.

ROMANO GUARDINI

The terms *modern man* and *modern world* have specific historical references. They are no longer applicable to us or the culture that began with the second third of the twentieth century. It was Erich Kahler, I believe, who first employed the term *postmodern man* to describe the new human being. Who then was modern man, and what was the nature of that culture designated as the modern world?

A NEW RELATIONSHIP TO NATURE. In the medieval world, man's primary relationship was with a God separate from and above the world, who had created the world, then revealed himself to it through a special revelation. With the rise of the modern world, beginning with the Renaissance, nature came to signify that which was immediately sensible and accessible to the mind. In the art of Michelangelo, we find an uneasy restlessness as his nude figures still sense their relationship to, as well as their separation from, the Creator. In Goethe and the eighteenth century, she—Mother Nature—is still divine. Writing in 1782 for the *Tiefurter Journal,* he says:

> Nature! We are surrounded and embraced by her. We are without power to rise out of her and without power to plunge deeper into her. . . .
>
> We live in her center and are strangers to her. She converses with

Modern man began to come into his own at the time of the Renaissance. By the eighteenth century, he dominated the mind and the heart of the West. By then Nature had become an infinite womb from whence were born both human personality and human culture. The three together— nature, personality, culture— constituted the whole of being. Follow nature: develop your personality: become cultured! These were the battle cries of modern man.

FREDERICK D. WILHELMSEN

33

us endlessly and she does not reveal her secrets to us. We try to submit her to our wishes and we have no power over her.

She, the Mother, is the only Artist and she fashions the most simple matter to the most subtle and lofty contrasts; with no sign of exertion she raises matter to the highest perfection. . . .

She is benevolent, and I praise her in all her works. She is wise and silent. . . .

She put me here; she will lead me away. I place my trust in her. She may dispose of me as she wills.[1]

With the rise of industry, modern man objectified nature, endowed it with perfection, and then identified himself with its objective goodness.

AN OPTIMISTIC BELIEF IN INEVITABLE PROGRESS. Undeniable advances in science and learning and the achievements of industrialism led inevitably to a belief in ongoing progress. Taking the notion from the sphere of science and industry, Henri de Saint-Simon applied the idea

Modern man following in the footsteps of Mother Nature

[1] Quoted by Romano Guardini in *The End of the Modern World*. See also the chapter "Goethe and and the Idea of Scientific Truth" in Erich Heller's *The Disinherited Mind*.

to society itself, holding that man aimed consciously at "the golden age that is not behind us but in front of us and that will be realized by the perfection of the social order."[2]

BELIEF IN THE RATIONALITY OF MAN. Along with the idea of progress came belief in the reasonableness of man. Belief that the mind of man could understand all things was part of the "religion of science" and found expression in the need of modern man to create an *ordered whole* of his knowledge.

EMPHASIS ON INDIVIDUALITY AND CREATIVE GENIUS. With the Renaissance, for the first time, the individual personality became important. Human dignity and achievements were seen with a new awareness, and individual genius became the ultimate standard of human values and judgments. The new idea of genius found its first embodiment in Michelangelo. H. W. Jansen says:

> The concept of genius as divine inspiration, a super-human power granted to a few rare individuals and acting through them, is nowhere exemplified more fully than in the life and work of Michelangelo (1475–1564). Not only his admirers viewed him in this light; he himself, steeped in the tradition of Neo-Platonism, accepted the idea of his genius as a living reality, although it seemed to him at times a curse rather than a blessing. The element that brings continuity to his long and stormy career is the sovereign power of his personality, his faith in the subjective rightness of everything he created. Conventions, standards, and traditions might be observed by lesser spirits; he could acknowledge no authority higher than the dictates of his genius.[3]

THE EXPANSION OF WEALTH AND POWER. The expansion of wealth and power was regarded as right and desirable in itself. Political science viewed society as a living, growing organism. From the Renaissance on, the national states emerged and matured, devoting their energies and resources to global expansion, inventions, techniques for mastering nature, and developing free economic competition. Modern man

[2] Quoted in Floyd W. Matson, *The Broken Image*, 17.

[3] H. W. Jansen, *History of Art*, 357.

A New Age is upon us

came to believe that increased wealth and power would lead inevitably to greater security, usefulness, and vitality.

THE CREATION OF CULTURE. Pre-Renaissance man submitted himself to the Work of God. With the new emphasis upon personality and creative genius, man began to see himself as a creator in his own right, and the creation of "culture" came to be regarded as the essence of the work of man. The arts of sculpture, painting, poetry, drama, and music began to flourish. "At the Renaissance," says Alexandre Koyré, "there was no criterion of the impossible."

ETHICS AND VALUES. The new emphasis upon culture and rationality gave birth to a new set of values. With the rationalism of the Enlightenment came a belief that morality and justice should be as unmistakable and universal as Newton's laws. This view is best expressed in Immanuel Kant's categorical imperative: "Under this condition alone the will can be called absolutely good without qualification. . . . That is, I should never act in such a way that I could not also will that my maxim should be a universal law."[4] The values of culture also reigned supreme. Rousseau is said to have wept contemplating beauty.

Modern man truly believed himself on the way to creating a paradise on earth. Guardini says:

> Modern man had convinced himself that he stood at last before reality as it was. The springs of existence would be opened before him. The energies of a nature now accessible to his understanding would blend with those of his own nature and the "great life" would be realized. Knowledge, commerce, production, each would perfect itself according to its own laws. All the spheres of reality would be united into an overwhelming harmony. Yet that achieved whole— "culture" itself—would continue to expand and within it man would fulfill himself.[5]

By the middle of the nineteenth century it began to appear that something was drastically wrong, that modern man's naive faith in the

[4] Immanuel Kant, *Foundations of the Metaphysics of Morals*, 18.

[5] R. Guardini, *The End of the Modern World*, 94.

redemptive power of science, reason, and culture had been misplaced. By 1864, Dostoyevsky, in his *Notes from the Underground,* had his Underground Man asking of modern man's utilitarian utopianism:

> Advantage, indeed? What, after all, is advantage? Would you, gentlemen, undertake exactly to define wherein human advantage consists? . . . Can human interests ever be properly reckoned up? May there not always remain interests which never have been, never can be, included in any classification? . . . May there not, therefore, exist something which to most men is ever dearer than their true interests? Or, not to infringe the logical sequence, may there not exist some supreme interest of interests (the additional interest of which I am speaking) which is greater and more absorbing than any other interest, and for which man, if the need should arise, is ready to contravene every law, and to lose sight alike of common sense, honor, prosperity and ease—in a word, of all the things which are fair and expedient—if haply he can gain for himself that primal, that supreme, advantage which he conceives to be the dearest thing on earth?[6]

By the summer of 1946, World War II was over and our troops home. Radical unrest was beginning, and the turning of consciousness homeward was accompanied by another turning—inward. The Hitler experience had made it conclusively clear that the values and beliefs of "modern man" were in collapse. Let's briefly review the changes in attitude.[7]

The veneration of nature that we found in Goethe, and in a more naive form in the Romanticists, vanished with the spread of technology.

[6] Quoted in Geoffrey Clive, *The Romantic Enlightenment,* 102. For the complete work in another translation, see: F. Dostoevsky, *Letters from the Underground.*

[7] Among the works in which we find the critique of modern man are: Romano Guardini's *The End of the Modern World;* Geoffrey Clive's *The Romantic Enlightenment;* Floyd W. Matson's *The Broken Image;* Erich Heller's *The Disinherited Mind;* C. G. Jung's *Civilization in Transition;* Paul Tillich's *The Religious Situation;* Erich Neumann's *Depth Psychology and a New Ethic;* and C. G. Jung's *Modern Man in Search of a Soul.*

Increasingly, technology was turned to the exploitation of nature. More significantly, it alienated man himself from nature. With new discoveries in physics, nature lost its concreteness. Buckminster Fuller noted that 99 percent of all scientific knowledge today belongs to realms (microscopic and macroscopic) that lie beyond the range of our physical senses.[8] This "invisibility" of nature extended also to technology as man increasingly planned and executed projects that he could not see. From a divine, nurturing Mother, nature came to be only a set of inorganic (statistical) abstractions, devoid of emotion and the qualities of real experience. By the mid-twentieth century, man could no longer approach nature directly but had to resort increasingly to the abstractions of mathematics.

The idea of inevitable progress was built upon the crude mechanistic models of science and industry. It failed to recognize that the inner life of man cannot be satisfied by science alone. The result was a split into what C. P. Snow later called "two cultures"—one still dedicated to the ideals of science and progress, the other "cut off" and turning increasingly inward to the neglected depths of man himself. The Romantic despair over the inability of science to bring man happiness became, in Dostoyevsky, the despair of a mind that had conquered all but its relationship to itself.

Belief in the rationality of man was radically challenged in the nineteenth century. Kant and Hume had shown the limits of reason. Then came exposure of the irrational depths of man by Dostoyevsky, Nietzsche, Kierkegaard, Ludwig Feuerbach, and Freud. The unmastered, the unknown, and the demonic in man suddenly began to erupt from their hidden depths. Irrational man[9] revealed his full capacity for diabolical action in Nazi Germany (should we not also include Hiroshima and Nagasaki along with Dachau and Buchenwald?).[10]

With the emphasis upon individuality and genius, man came to think of himself as lord of his own being. Descartes' "I think, therefore, I am" established man's sense of self. In philosophy, the thinking subject became the measure of all concepts. Then came industrialized man, followed by labor unions, mass markets, opinion polls—

[8] R. Buckminster Fuller and John McHale, *World Design Science Decade, 1965–1975*, Phase I, Document 1, 13.

[9] See William Barrett, *Irrational Man*.

[10] See William L. Shirer, *The Third Reich*; and John Hersey, *Hiroshima*.

depersonalization. "Mass man," unionized man, was absorbed by technology and the industrial complex and soon found himself a "soulless" entity in a bureaucratic society. Autonomy became suspect and the self-made creative personality inimical. "Mass man," says Guardini, "has no desire for independence or originality in either the management or the conduct of his life."[11] Mass education effectively killed off the impulse toward "genius" and taught man how to fit into the system.

The "self-evident" values of expanding wealth and power were also called into question as it became increasingly clear that uncontrolled free enterprise led to exploitation of the masses. Marxism, while revolting against capitalist expansion, simply reintroduced the economic optimism of modern man in a new guise. As for the increased security and usefulness that the increase of power was supposed to bring, modern man failed to recognize his capacity to use power for evil ends. Why did it take men four-and-a-half centuries to learn what Machiavelli had tried to teach them at the birth of the Renaissance?

> Men rise from one ambition to another: first they seek to secure themselves against attack, and then they attack others. . . .
>
> The fear to lose stirs the same passions in men as the desire to gain, as men do not believe themselves sure of what they already possess except by acquiring still more; and, moreover, these new acquisitions are so many means of strength and power for abuses.[12]

Morally uncontrolled, the inherent demands of power for self-expansion become increasingly demonic. The abuse of power has become one of the major challenges facing humanity today. The world is divided into "power blocks," each fighting for dominance on the world stage.

We may speak of the breakdown of modern culture as a revolution from within—a revolt against all external human values. "The

[11] Guardini, *The End of the Modern World*, 78.

[12] Quoted in W. T. Jones, *A History of Western Philosophy*, 556.

THE END OF THE MODERN WORLD

question," said Ortega y Gasset, "is not to paint something altogether different from a man, a house, a mountain, but to paint a man who resembles a man as little as possible. . . . For the modern artist, aesthetic pleasure derives from such a triumph over human matter."[13] Franz Kafka's Gregor Samsa, in *The Metamorphosis,* who awakens one morning to find that he is no longer a human being but a man-sized cockroach, clearly signals the abandonment of the optimism of the humanist tradition. When Rousseau, decrying the evils of culture, proposed that man return to nature, surely he had nothing so Freudian in mind. One of the crucial turning points in my life came when I read Herman Melville's *Moby Dick,* followed a few months later by James Baird's *Ishmael.*[14] Baird argues that the impulse toward primitivism in Melville and in an artist such as Gauguin represented a "journey to the East," symbolized by Oceanic cultures. If we can equate "primitivism" and the "East" with introspection and the unconscious, we see in the revolt against modern culture a turning inward to the inner depths on the part of Western man. The turn toward primitivism deeply influenced modern art.[15]

"The ultimate disease of our time," says Abraham Maslow, "is valuelessness."[16] The virtues of truth that belonged to the religion of reason and the values of beauty, kindness, and decency praised by bourgeois culture were first called into question by the Romantic hero who, like Goethe's Faust, violates moral law out of an insatiable desire for experience. As science became more objective, it increasingly emphasized moral and ethical neutrality. The cultural studies of anthropologists led many to a belief in ethical relativism. The final result of all this was a void in the realm of values, to which the Existentialists then addressed themselves. "The greatest enemy of morality," wrote Geoffrey Clive, "is not passion but insensitivity, not licentiousness but self-deception."[17] Of this immorality, Eichmann and Hitler had become the supreme symbols by the mid-twentieth century.

The values, concepts, and beliefs that gave birth to "modern man" and "the modern world," beginning with the Renaissance and peaking with the Enlightenment, underwent a century of decline between the

[13] Ortega y Gasset, *The Dehumanization of Art,* 21.

[14] James Baird, *Ishmael.*

[15] See Robert Goldwater, *Primitivism in Modern Art;* and Stephen Polcari, *Abstract Expressionism and the Modern Experience.*

[16] Abraham Maslow, *Religions, Values and Peak Experience.*

[17] G. Clive, *The Romantic Enlightenment,* 38.

mid-nineteenth and mid-twentieth centuries. Such values and concepts as the modern world produced cannot be said to have been without their benefits to humanity, but their limitations have become all too clear to "postmodern man." As Geoffrey Clive says:

> The very fact that there is another possibility of human fulfillment besides individual and collective materialism damns the idea of progress. . . . Certain it is that progress in the modern world has left a huge void, and that next to its familiar advantages it has been responsible for unprecedented vulgarity, uprootedness, and self-alienation.[18]

A New Age is upon us?

[18] G. Clive, *The Romantic Enlightenment*, 35.

3 Creativity and the Extreme Situation

For the supreme artists the depths and heights of human experience invariably make transcendent contact.

GEOFFREY CLIVE

In his work *Civilization in Transition,* Carl Jung says, "There are times when the spirit is completely darkened because it needs to be reborn."[1] Since the post–World War II era, in Western culture and in the United States, we have experienced a darkening of spirit without parallel in our history, and the evidence of it stands forth clearly in our creative arts.

To get at the "darkening" of these times we must turn to one of the age's most "illuminating" philosophies—Existentialism—the philosophy of man's extreme situation, of his experiences at the boundaries of existence. Having cut himself off from God and metaphysical realities, Existential or Underground Man sought to push himself to the furthest limits of his being and experience fully and in "nakedness" the anxiety, doubt, fear, guilt, despair, and meaninglessness of his existence. "Man is capable of despair," said Gabriel Marcel, "capable of hugging death, of hugging his *own* death. . . . Any metaphysic ought to take up its position just there, face to face with despair."[2] In short, Underground Man, having abandoned modern man's belief in progress and success, went underground to seek the answers to his own being in the realms of the tortured soul. For only in extreme self-

[1] Carl Jung, *Civilization in Transition,* 499.

[2] Gabriel Marcel, *Being and Having,* 104.

confrontation could man rediscover his individuality and recover his authentic selfhood.

As Geoffrey Clive said in another context, "The question is not merely what man can know but how he decides to live."[3] Modern, rational man sought knowledge. Existentialism sought to interpret life from within through an attitude of seriousness about living. "My design," Plutarch had said, "is not to write histories, but lives." For the Existentialists, biography was central. *Lives* took center stage. To borrow a metaphor from Søren Kierkegaard, authentic biography assumed the properties of a nettle which, when you touched it, would make you more aware of yourself than of the nettle. A similar concept exists today in encounter groups and psychodrama: as the protagonist on the "hot seat" painfully reenacts and unfolds the dramas of his or her own inner existence, achieving self-enlightenment, other participants in the drama find their own inner, hidden worlds also being illuminated.

Existentialism, born in part out of the Neo-Romanticism of the nineteenth century,[4] constituted postmodern man's first step on the journey inward, which, as I propose to show, leads ultimately to rebirth and self-transformation. For now, let us focus on the extreme or boundary situation itself and the new freedom and responsibility it entails—a freedom that makes man his own self-creator.

"To be or not to be" is indeed *the* Existentialist question. The etymology of *exist* is "to stand out of Being." For Existentialists it became both the glory and the curse of man that he could sense the possibility of *non*being. "There is but one truly serious philosophical problem," Albert Camus wrote in *The Myth of Sisyphus,* "and that is

Whatever is visible to the
Generated Man
Is a Creation of mercy &
love from the Satanic
Void.
WILLIAM BLAKE

[3] G. Clive, *The Romantic Enlightenment,* 33.

[4] To fully understand Existentialism, it is good to study the Romanticism of the nineteenth century. Recommended works: Harry Levin, *The Broken Column: A Study in Romantic Hellenism;* Mario Praz, *The Romantic Agony;* M. H. Abrams, *The Mirror and the Lamp;* Erich Heller, *The Disinherited Mind;* Harry Levin, *The Power of Blackness;* Eric Newton, *The Romantic Rebellion;* Gwendolyn Bays, *The Orphic Vision;* Wallace Fowlie, *Age of Surrealism;* D. H. Lawrence, *Studies in Classical American Literature;* and Erich Kahler, *The Tower and the Abyss.*

suicide." Therefore, if man is to exist he must face the possibility of his nonexistence, of nihilism. In his quest for a new ethical humanism, Camus began with a confrontation of nihilism, the void. Early in his career he wrote:

> The *malaise* which concerns us is that of an entire epoch from which we do not wish to separate ourselves. We want to think and live in our own history. We believe that the truth of our century cannot be reached without going all the way to the end of our own drama. If the epoch has suffered from nihilism, then it is not in ignoring nihilism that we shall find the ethic that we need.[5]

From the earliest Greek thinkers and even earlier Vedic thinkers of India, men have asked: "Why is there something rather than nothing? How can that which *is* arise out of nonbeing, and how does it return to nonbeing? How does that which *is* maintain itself against the contrary possibility of nonbeing or nothingness? In other words, how are being and nonbeing related?"[6] In *The Courage to Be,* Paul Tillich wrote:

> Nonbeing is ontologically[7] as basic as being. The acknowledgment of this fact does not imply a decision about the priority of being over nonbeing, but it requires a consideration of nonbeing in the very foundation of ontology.[8]

And again:

> If one is asked how nonbeing is related to being-itself, one can only answer metaphorically: being "embraces" itself and nonbeing. Being has nonbeing "within" itself as that which is eternally present and eternally overcome in the process of the divine life. The ground of everything that is is not a dead identity without movement and becoming; it is living creativity. Creatively it affirms itself, eternally conquering its own nonbeing. As such it is the pattern of the self-affirmation of every finite being and the source of the courage to be.[9]

[5] Albert Camus, *Actuelles: Chroniques 1944–1948,* 112.

[6] Questions such as these were explored with great subtlety and profundity by Heidegger in *Being and Time* and in *An Introduction to Metaphysics;* and by Jean-Paul Sartre in *Being and Nothingness.*

[7] Ontology—the philosophy or science of essential Reality or true Being.

[8] Paul Tillich, *The Courage to Be,* 32.

[9] Ibid., 34.

Tillich notes that for Plotinus, nonbeing made possible the self-loss of the human soul.

For Existential Man, the threat of nonbeing had to be faced, and this could only be done by leaping courageously into the void each person finds concealed in the depths of his or her own being. In this sense, Goethe's Faust is the perfect Existential Man:

> *Only resolve with courage stern and high,*
> *Thy visage from the radiant sun to turn!*
> *Dare with determin'd will to burst the portals*
> *Past which in terror others fain would steal!*
> *Now is the time, through deeds, to show that*
> *mortals*
> *The calm sublimity of gods can feel;*
> *To shudder not at yonder dark abyss,*
> *Where phantasy creates her own self-torturing*
> *brood,*
> *Right onward to the yawning gulf to press,*
> *Around whose narrow jaws rolleth hell's fiery*
> *flood;*
> *With glad resolve to take the fatal leap,*
> *Though danger threaten thee, to sink in endless*
> *sleep!*[10]

Only by finding in oneself the courage to leap into the abyss can one ever discover whether, beneath all, any solid Ground exists. Hence we have that fundamental quality of the Existentialist: *risk*—the risk of *not* being!

The chief artists of our epoch, because they have possessed the courage to face a world threatened by nihilism and meaninglessness, speak to us most eloquently of that "terrible aboriginal calamity" that threatened to undo twentieth-century man. If one recoils with a sense of shock or horror before the canvases of an Edvard Munch, a Max Beckmann, Pollock, or De Kooning, we should not judge the artist.

[10] Goethe, *Faust*, Part I.

He merely reveals to us what contemporary man has already done to himself. By his act of disclosure he demonstrates the existential courage that modern, rational man lacked. For all its anguish, there is a blessing given us in the painful images of modern art. As R. G. Collingwood says, "Art is the community's medicine for the world disease of mind, the corruption of consciousness."[11]

Having cast off God[12] and metaphysics, the man of the extreme situation is one who, in Sartre's words, is "condemned to be free." For postmodern man, the ancient Torah has ceased to bind. The Platonic and Thomist metaphysics no longer function. The rational Kantian ethic has been rescinded.[13] With the death of God, as Dostoyevsky put it, "everything is permitted." A new and radical freedom has been thrust upon mankind—the freedom to choose being and nonbeing and the freedom to create for oneself an authentic existence. Both freedom and authenticity imply *responsibility*. When a child comes of age, he is responsible for himself and his actions. Existentialism implies a similar "coming of age" on the part of humanity. Thrust back upon himself, postmodern man has to accept full responsibility for all that he is. "The relation to himself a man cannot get rid of any more than he can get rid of himself, . . . since the self is the relationship to oneself," said Kierkegaard.[14] Any attempt to escape self-confrontation leads to an inauthentic existence. The only abuse of freedom is not to accept responsibility for one's choices, even if that choice be suicide (Camus). The problem of authenticity is stated by Carl Michalson:

> Man's dominant passions are social and centrifugal. The panic of the inner life urges one to move beyond himself to alliances that provide stability which he does not find within him. The danger is rather that the individual, whose passion it is to reach out, will attach himself to inauthentic objects, objects which cannot and ought not support him. Religiously viewed, this would be idolatry. Psychologically viewed, it would be a diseased kind of emotional dependence. Socially viewed, it would be a parasitical kind of welfare-ism.[15]

[11] R. G. Collingwood, *The Principles of Art*, 336.

[12] The theme of "the death of God" will be taken up in the chapter "The Broken Center."

[13] Hegel responded cryptically to Kant's categorical imperative, saying, "I don't want every man in the world wanting to marry my wife." The Existentialists place the emphasis on what they called "situational ethics"—acting according to the requirements of each circumstance.

[14] Søren Kierkegaard, *Fear and Trembling and Sickness unto Death*, 150.

[15] *Christianity and the Existentialists*, ed. by Carl Michalson, 14.

For the Existentialists, to be *with and for another*—to relate authentically to others—means first to be one's true self. Then only is one truly free.

The same radical freedom required to become one's authentic self in the face of the treat of nihilism or nonbeing is also required for the creation of authentic works of art. "Art," says Nicholas Berdyaev—the most passionate spokesman for creative freedom—"is absolutely free. Art is freedom, not necessity."[16] "Like existence itself," says Arturo Fallico, "the art-object is an appearance out of nowhere, a sudden invasion of the world."[17] It is a creation at the boundary between existence and nonbeing, and whatever meaning it has is wrested from the void by the sheer courage of the artist. "Thus the being of the art-object," Fallico declares, "is, and must be, as precariously suspended on the abyss of being and nothingness as existing man himself is."[18]

The authenticity of the artwork is linked to that of the artist. It is free because he is free. Hence, the oft-heard charge against modern art that artists are perpetrating a hoax or a fraud on the public is the exact reverse of the true situation, for the artist today works at

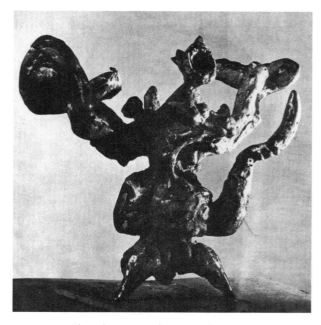

Theodore Roszak, *Anguish*, 1947

[16] Nicolas Berdyaev, *The Meaning of the Creative Act,* 230.

[17] Arturo B. Fallico, *Art and Existence,* 23.

[18] Ibid.

the extremities of existence where authenticity is the only defense left against self-loss.

Existentialism has probed the anguished depths and outer limits of existence. It has accepted the "darkening of the spirit" as a necessary condition for human self-discovery. The nihilism that threatens at the boundaries of existence is matched in turn with a heroic courage and an affirmation of selfhood in spite of anguish and the threat of death. Thus postmodern man proves his right to and earns his freedom and, with that freedom, *the right to create!* Without freedom and authenticity, the creative powers of the artist would continue to lie under a shadow. That shadow might be God or reason or science or state propaganda or just plain ignorance of the deeper self. Whichever, its effect would be an unwanted, unneeded limitation. We shall speak later of the rebirth of mankind into a New Age. Before such an age can come about, however, it is necessary to throw off all limitation, even that posed by the threat of nonbeing. Only so can man enter any new age as himself! According to the Wisdom Teachings, the evolutionary plan requires that man come into the power of doing for himself what, in his racial infancy and adolescence, had been done *for* him by "the gods." Esoteric chronology identifies this present age as the one in which self-liberation is to be undertaken. Existentialism paved the way. Toward what end, we shall come to see.

4 The Wisdom of Death

To fear death is to presume wisdom. It is to assume that one knows that the unknown is a disagreeable estate.

<div align="right">SOCRATES</div>

The Existentialists faced the threat of death as a confrontation with one's own dying. "No man can die another man's death," Martin Luther had said. They also faced death as the threat of nonbeing or the void lurking at the limits of finite existence. Perhaps the Existentialists were too involved with their own finitude, or perhaps for lack of a metaphysical orientation, or perhaps, having lost God, they also lost the deeper wisdom of the soul—for whatever reason, the Existentialists learned to face death but failed to wrest from it the profound wisdom death veils. Or maybe their revolt simply did not go far enough. It is one thing to face the fear of dying courageously, and quite another to give oneself trustingly to death. "The life-eager hero," as Campbell said, "can resist death, and postpone his fate for a certain time."[1] But in the final analysis, if he would discover the revivifying powers hidden in the depths, he must go willingly to his death. He must choose death! Only through death does one make contact with the secret powers of regeneration.

Therefore, we must push our inquiry beyond that of the Existentialists and explore the domain of death itself.

For purposes of our discussion, I shall draw a distinction between

One of nature's laws is that an entity cannot continue the same forever; for it is by exchanging the imperfect for the ever more perfect that we grow; and death is just such a change. The child must die in order to become the man, and the man must die frequently in order to become a god. . . . Except the seed die, the plant cannot come into being. Except the man die, he cannot experience those conditions of thought and consciousness which belong to his inner being, to the celestial spirit which he is in his essence.

<div align="right">G. DE PURUCKER</div>

[1] Joseph Campbell, *Hero with a Thousand Faces*, 359.

negative deaths and *positive* deaths. All death is positive that destroys what has been outgrown and is no longer required. Death thereby releases the indwelling life and consciousness for new experiences on higher planes of being. Of this I shall say more. Here my aim is to distinguish between those "lower" forms of death that we usually experience as negative or fearful and those "higher" deaths that are positive and liberating.

Death comes in many guises. "Death has a hundred hands and walks by a thousand ways," said T. S. Eliot. It may come not only as the approach of physical death, but also as paralyzing fear, as a sense of utter rejection through the loss of love, as a loss of values resulting in a sense of meaninglessness, as the threat of nonbeing leading to self-loss, as spiritual darkness or the "death" of God, and so forth. What all these forms of death have in common is their effect upon the psychospiritual consciousness of man—on the way that man experiences himself vis-à-vis loss. Death is usually thought of as the ultimate, inescapable enemy.[2] That it can also be a welcome friend and the companion of spiritual growth needs to be better understood. Then the death that leads to transformation can be embraced in an attitude of confidence. No longer will it be seen as a dead end. Death, the transformer, is transformed into an open door into a wider, wiser, more joyous mode of living.

NEGATIVE DEATHS

BLINDNESS. For the ancients who believed in the preexistence of the soul, man's birth into the world of matter was accompanied by forgetfulness of one's spiritual origins. In Greek myth one was said to drink at birth from the river of Lethe, forgetting completely one's higher origin. William Wordsworth saw this blindness as coming on more slowly, arriving with adulthood.

> *Our birth is but a sleep and a forgetting:*
> *The Soul that riseth with us, our life's star,*

Death is primarily a change of consciousness, an enlargement of its sphere of action.

G. DE PURUCKER

Death and Initiation produce the same results, therefore it is that all Initiations contain the symbolism of death and burial.

DION FORTUNE

[2] See Karl A. Menninger, *Man Against Himself;* and Ernest Becker, *The Denial of Death.*

Hath had elsewhere its setting,
And cometh from afar:
But trailing clouds of glory do we come
From God, who is our home:
Heaven lies about us in our infancy!
Shades of the prison-house begin to close
Upon the growing Boy,
But he beholds the light, and whence it flows
He sees it in his joy;
The Youth, who daily farther from the east
Must travel, still is Nature's priest,
And by the vision splendid
Is on his way attended;
At length the Man perceives it die away,
And fade into the light of common day.[3]

Whatever one's views of man's spiritual nature, the idea that consciousness is blinded by the material world is exceedingly ancient and widespread. A similar idea appears today in the popular usage of terms such as "thick-headed" and "dense" to describe persons who cannot see things clearly. In the blindness of the mind, something of our higher nature surely dies!

STAGNATION. Stagnation is associated with ideas such as nonflowing, polluted, and lifeless. It is the ennui of lost motivation, a broken will to live, purposelessness, inertia, listlessness, or life-weariness. There are times when most of us feel life is going nowhere. We feel stuck in a rut. It's been said, "A rut is just a grave with the ends knocked out." In stagnant waters, nothing grows. The flow of life has ceased. When stagnant, life seems to stand still. Is this not death?

BONDAGE. Man's sense of his own finitude and captivity in "the prison house of matter" is of ancient origin. The Greeks portrayed this idea via Axion bound to the wheel of fate. In astrology, the sign of Pisces—two fish linked together while trying to swim in opposite directions—represents the bondage of the soul to the earthly personality.

First we must realize that we are asleep; second we must awaken. When we are awake we must die; when we die we can be born. This is the process in detail and the direction.

P. D. OUSPENSKY

[3] William Wordsworth, "Ode on Intimations of Immortality from Recollections of Childhood." The "east" here symbolizes the spiritual knowledge that is being left behind.

Freedom, the opposite of bondage, is one of the great governing ideas of human history. Men seek freedom in many forms: freedom from hunger, disease, fear, political repression, freedom from ignorance and freedom of thought, the inner freedom that comes with psychological maturity and integration, and spiritual freedom—the freedom of man's higher spiritual nature from its earthly limitations. Patrick Henry's "Give me liberty or give me death!" expresses a fundamental drive of humanity.[4]

MEANINGLESSNESS. "A life without meaning is no life at all"—so goes a popular saying. The problem of meaninglessness and the search for meaning lay at the root of the Existentialist problem. It is the central theme of the novels of Franz Kafka. It formed the context for Camus's idea of the absurd and for his revolt—the only meaningful act in a meaningless world. As he put it in *The Rebel:*

> Nothing remains in the absurdist attitude which can help us answer the questions of our time. The absurdist method, like that of systematic doubt, has wiped the slate clean. It leaves us in a blind alley. But, like the method of doubt, it can, by returning upon itself, disclose a new field of investigation. Reasoning follows the same reflexive course. I proclaim that I believe in nothing and that everything is absurd, but I cannot doubt the validity of my own proclamation and I am compelled to believe, at last, in my own protest. The first, and only, datum that is furnished me, within absurdist experience, is rebellion.[5]

Paul Tillich draws a distinction between *meaninglessness* as "the absolute threat of nonbeing to spiritual self-affirmation" and *emptiness* as "the relative threat to it."[6] The anxiety of emptiness is brought about by the meaninglessness of the spiritual life—a spiritual life equated by Tillich with the creative life. Those who have known emptiness and meaninglessness know what it is to feel "spiritually dead."

NEGATIVITY. By negativity, I mean everything from negative attitudes to nihilism and the philosophy of Nothingness.[7] *Thought* is the power that creates or destroys. Destructive thinking produces destruc-

[4] See Rollo May's story "The Man Who Was Put in a Cage" in *Man's Search for Himself*, 145–48.

[5] Albert Camus, *The Rebel*, 16.

[6] Paul Tillich, *The Courage to Be*, 47. For other discussions of the problem of meaninglessness, see Rollo May's *Man's Search for Himself*; Victor E. Frankl, *Man's Search for Meaning: An Introduction to Logotherapy*; and chapter 4 of Edward F. Edinger, *Ego and Archetype*.

[7] See Helmut Thielicke, *Nihilism*.

tive results, reacting upon the thinker to bring about those conditions in his or her life that correspond exactly to the thoughts created.[8] The world mirrors our consciousness. Negativity negates life.

THE THREAT OF NONBEING: THE TRAGIC VISION. The threat of nonbeing or nothingness is the basis of the tragic vision of life. As Richard Sewall defines it:

> The tragic vision is in its first phase primal, or primitive, in that it calls up out of the depths the first (and last) of all questions, the question of existence: What does it mean to be? It recalls the original terror, harking back to a world that antedates the conceptions of philosophy, the consolations of the later religions, and whatever constructions the human mind has devised to persuade itself that its universe is secure. It recalls the original un-reason, the terror of the irrational. It sees man as questioner, naked, unaccomodated, alone, facing mysterious, demonic forces in his own nature and outside, and the irreducible facts of suffering and death. Thus it is not for those who cannot live with unsolved questions or unresolved doubts, whose bent of mind would reduce the fact of evil into something else or resolve it into some larger whole.[9]

The tragic vision has the advantage at least of pushing us toward the wisdom of death. Unamuno, in *The Tragic Sense of Life,* tells of a skeptic who observes Solon weeping for the death of a son and asks him, "Why do you weep thus, if weeping avails nothing?" And the sage answered him, "Precisely for that reason—because it does not avail." Unamuno goes on to say:

> The deep sense of Solon's reply to the impertinent questioner is plainly seen. And I am convinced that we should solve many things if we all went out into the streets and uncovered our griefs, which perhaps would prove to be but one sole common grief. . . . The chiefest sanctity of a temple is that it is a place to which men go to weep in common. A miserare sung in common by a multitude tormented by destiny has

[8] See A. Besant and C. W. Leadbeater, *Thought Forms;* and A. Besant, *Thought Power.*

[9] Richard B. Sewall, *The Vision of Tragedy,* 4–5.

as much value as a philosophy. It is not enough to cure the plague; we must learn to weep for it. Yes, we must learn to weep! Perhaps that is the supreme wisdom.[10]

By learning to *feel* tragedy and death, the way into their meaning is thus opened.[11] All defenses imposed by faith or reason are dropped. Brain-thinking is replaced by what Blaise Pascal called "the reasons of the heart, which reason does not know."[12] The tragedy of death thus opens a man to a knowledge of his own heart, awakening compassion, which is the beginning of wisdom.

POSITIVE DEATHS

"I praise my death, the free death which comes to me because *I* desire it," wrote Nietzsche. To understand the positive side of death, it is necessary to understand that consciousness, which is the self-awareness life has of itself, is not identical with any of the forms through which life manifests.[13] Scientists studying the "triad" of cosmic, biological, and human evolution[14] have focused attention wholly on the form side of life in biological and human evolution, on the organisms in which life manifests. They seek the explanation of life in the physical elements and the evolution of life in the transmutation of forms. It seems not to have occurred to them that the outer form merely serves the

[10] Miguel de Unamuno, *The Tragic Sense of Life,* 17.

[11] Horace Walpole noted: "This world is a comedy to those who think, a tragedy to those who feel." James Joyce, in *A Portrait of the Artist as a Young Man,* says, "Pity is the feeling which arrests the mind in the presence of whatever is grave and constant in human suffering and unites it with the human sufferer. Terror is the feeling which arrests the mind in the presence of whatever is grave and constant in human sufferings and unites it with the secret cause."

[12] Blaise Pascal, *Pensées,* 277.

[13] Djwhal Khul says, "Death . . . is in reality a means of abstracting the life principle, informed by consciousness, from the form or the bodies in the three worlds." Alice A. Bailey, *The Rays and the Initiations,* 163.

[14] See Theodosius Dobzhansky, *The Biology of Ultimate Concern.*

inner life and consciousness, and that these are the motivating factors in evolution.[15] We know from psychosomatic medicine that the physical organism reacts to the inner emotions and mental life of man, which is responsible for up to 90 percent of all illness. Space does not suffice to argue my case in full here[16]—namely, that life and consciousness are the basis of form-life, and that form and consciousness can separate themselves both in life[17] and at death.[18] This thesis will be carefully presented in another book to come.

FORM-DEATH AND EXPANDING CONSCIOUSNESS. Sadly, because we identify life and consciousness with our physical bodies and the material world, we tend to think of bodily death as the terminus of our existence. A religious belief in an afterlife softens the fear of death for many, but few, even among the religious, *know* life does not end with the physical form.[19] Because of a tragic overidentification of life with the body and physical world, any threat to them is seen as a threat to life itself, a threat of annihilation. Conservatism is a common reaction—the line of least resistance. In seeking to hold on to the past, one is attempting to hold on to the familiar forms. In the end, however, conservatism is the path of greatest suffering, for it means that as nature and life evolve,

[15] Environment provides the needed field of experience and stimulation enabling the inner life to unfold, the outer form following the unfolding life within.

[16] As I know of no work that sets forth the views I've been developing, it is my plan to write a book on the subject. As for the priority of life and consciousness over form, one might begin with Paul Brunton's works—*The Quest of the Overself* and *The Wisdom of the Overself.*

[17] See Robert A. Monroe, *Journeys Out of the Body.*

[18] Increasing evidence of the survival of consciousness after bodily death is coming in from the medical profession. For other views of life beyond death, see Benito F. Reyes, *Scientific Evidence of the Existence of the Soul;* Hermes Trismegistus, *The Divine Pymander;* and Gina Germinara, *Many Mansions.*

[19] Herman Feifel's studies of attitudes toward death among the religious and the nonreligious show that religious people are "personally more afraid of death": "The data indicates that even the belief in going to heaven is not a sufficient antidote for doing away with personal fear of death in some religious persons." Also, "The religious person in our studies holds a significantly more negative orientation toward the older years of life than does his nonreligious peer." See *Existential Psychology,* ed. by Rollo May, 68–69.

THE WISDOM OF DEATH

55

they must take from us by force what we have refused to let go of, adding to the natural process of loss the emotional and mental suffering that comes of having our attachments forcibly shattered.

For the indwelling life and consciousness in process of withdrawing from the forms in which they have been manifest, this identification with form-life begins to break up; consciousness knows itself as still alive and "sees" the disintegrating form as a thing apart from itself.[20] Indeed, the form aspect begins to be seen as a limitation from which, in becoming free of it, the subjective consciousness is liberated for wider experience. In this second phase, so to speak, dying is experienced as an exhilarating liberation and widening of the horizons. Doctors find that many people, on being brought back from a near-death experience, resent it and feel it as a return to confinement—as Carl Jung put it, "Now I must return to the 'box system' again."[21]

The relationship between forms—the vehicles of life-consciousness—and the evolving inner life is well expressed by Dion Fortune.

Life, having evolved beyond the capacity of lowly forms to give it expression, builds itself higher forms. The fossilized remains of the abandoned lower forms are found among the debris of life. They have undergone death; their race is extinct; they are no more; but the life has achieved rebirth into a higher type of vehicle. It is only by the abandonment of the simpler form that life can enter the more complex, though the consciousness that is on the plane of the simpler form sees therein a tragedy because *it cannot conceive the higher life* and it sees its own passing prefigured; *but the consciousness which is of the higher life sees the birth of a new manifestation and rejoices, for it sees the fuller expression of its potentialities.*[22]

From the point of view of the form, death means destruction—regression into chaos. But from the perspective of the indwelling life and consciousness, death is a transfiguration that carries life to a higher plane of expression. Tragedy is the vision "from below," comedy the vision "from above."

[20] See Carl Jung's description of the vision that accompanied his 1944 heart attack—*Memories, Dreams, Reflections*, 289–303. See also G. de Purucker, *Fountain-Source of Occultism*, "The Process of Disimbodiment," 543–48; "Physical Death—An Electromagnetic Phenomenon," 560–62; and "Through the Portals of Death," 615–20.

[21] Carl Jung, *Memories, Dreams, Reflections*, 292. Jung also says, "I felt a violent resistance to my doctor because he had brought me back to life" (293).

[22] Dion Fortune, *The Cosmic Doctrine*, 119, my italics.

Detachment: The death of desire. On the emotional and mental planes of life, desire acts as a magnetic force.[23] It attracts to us the objects of our desires. Life enters form for the purpose of gaining experience in the form-worlds, with the aid of which life evolves and consciousness expands. Life and form are held together by means of magnetic attraction—by our desire for life experiences. The Law of Attraction, acting between the planes of life-consciousness and matter-form, makes manifestation possible. Once life has experienced all that a particular form can provide for it, it ceases to be attracted to that form. Desire for that particular form or body ceases.[24] Our physical vehicles then cease to be a source of attraction, a magnetic focal point, and the Law of Attraction ceases its control. In relation to *that form,* the polarity of life changes, freeing life from form and leaving the latter to begin disintegration.

One who achieves an attitude of desirelessness or detachment, who renounces the fruits of his labors and learns to live inwardly in the life of the soul and, later, in the Spiritual Man, gains thereby a mastery over all forms, both the forms of the outer world in which he must continue working and the form of his own body. Those who remember the movie *Little Big Man* were introduced, in a humorous episode with the Indian chief, to voluntary or intentional dying. Robert de Ropp touches on this idea in *The Master Game:*

> Intentional dying is possible only for one who has attained a high degree of mastery over his physical functions, who knows how to project the principle of consciousness out of the physical body, who is able to tell, by certain inner signs, when his time has come, and who is able with full awareness and without artificial aids to *let the life process come to a halt* so far as this particular body is concerned.[25]

De Ropp quotes from *Tibetan Yoga and Secret Doctrines:*

No master of yoga ever dies in the normal manner, unless, perchance, he be killed suddenly and unexpectedly; he merely relinquishes the

[23] The science of consciousness is one of the profound teachings of the Wisdom Sciences and is based upon universal laws, one of which is the Law of Attraction. The subject is addressed in other writings I have undertaken. See also Annie Besant, *A Study of Consciousness.*

[24] See Alice A. Bailey, *A Treatise on Cosmic Fire,* 128–33.

[25] Robert S. de Ropp, *The Master Game,* 217.

physical form which he has come to recognize as no more than a garment to be put on or off as desired, in full consciousness while immersed in the esoteric condition of mind wherein the Clear Light ever shines . . . without suffering any break in the continuity of his consciousness.[26]

Voluntary liberation from the body can be achieved only by transcending selfishness and renouncing desire toward the physical vehicle.[27]

SACRIFICE: THE DEATH OF SELFISHNESS. Most desires of humanity are selfish. Under the law of equal and opposite reaction, our desires bind us to the things we desire and hold us with an intensity equal to those desires. When desires are selfish, they bind us to our own unevolved personalities and a separative existence. Selfishness blocks the path to self-transcendence without which we can never truly know either the Infinite Life or our fellow human beings. Self-sacrifice means the death of selfishness and a reorientation to the common good of all humanity. In Tantra Yoga one learns how to enter subjectively into the thoughts, soul, and life of a loved one. Such union (*yoga* means "union") with another human being is an experience of extraordinary beauty. Sacrifice means dying toward oneself so as to live more fully toward others and to serve others. The great exemplars of self-sacrifice were the Buddha and the Christ. "Achievement," says Djwhal Khul, "is ever followed by sacrifice and the giving of the greater for the lesser. This is an aspect of the Law of Evolution."[28]

THE DEATH OF ILLUSION. Men live by appearances! Very seldom do we seek to penetrate to the inner reality of anything, to know the "soul" of things, as distinct from their outer reflection.[29] The result is superficiality or *surface-seeing*. Mistaking the appearance for the reality is part of the Great Illusion or *maya* of which Hinduism speaks. A consciousness that can see only the appearance of things is necessarily trapped in illusion. *Glamour* is the name we give to the allure of surfaces. How easily we get caught up in a romance with superficiality. Modern man's preoccupation with materialism has served to crystallize glamour and illusion

[26] Robert S. de Ropp, *The Master Game*, 217.

[27] How radically different this view is to that of Freud who held that "It may in general be suspected that the *individual* dies of his internal conflicts" (Sigmund Freud, *An Outline of Psychoanalysis*, 231).

[28] Alice A. Bailey, *The Externalization of the Hierarchy*, 166.

[29] Pondering the mysteries and paradoxes of existence, I've often joked of placing a bumper sticker on my car that reads, THE ILLUSION IS REAL. That would keep the mind busy quite a while.

and make them all the more visible to the discerning soul. This crystallization reveals the stage of evolution reached by our culture while also preparing the way for the shattering of that which has become a prison and limitation for man's aspiring inner life.

As consciousness evolves and man's spiritual life deepens, a crisis point is eventually reached requiring the Great Illusion to be dispelled. In the life of the individual, this crisis is sometimes called "the dark night of the soul" or an encounter with "the Dweller on the Threshold"—a topic to which we shall return. The illusory forms that hitherto held consciousness in bondage must be shattered. All that a man believed real is suddenly taken from him as he pierces the "veil" and recognizes the unreality of his world. The experience can be shattering. "Psychologically," says Evelyn Underhill, "the 'Dark Night of the Soul' is due to the double fact of the exhaustion of an old state, and the growth toward a new state of consciousness."[30]

> Such an interval of chaos and misery may last for months, or even for years, before the consciousness again unites itself and a new center is formed. Moreover, the negative side of this new center, this new consciousness of the Absolute, often discloses itself first. The self realizes, that is to say, the inadequacy of its old state, long before it grasps the possibility of a new and higher state.[31]

It would appear that in the evolutionary ascent from a lower to a higher state of consciousness and being, the lower or negative state must always be encountered first. In short, the old self, with its illusions, must die before the higher life can be found. "It is only by death that we can reap the fruits of life," says Dion Fortune.[32]

Perhaps the crises of our age will make more sense if we see in them the death of the old order, with its limitations on evolving human consciousness, and a challenge to all the illusions by which men have lived. As Djwhal Khul put it, "We are occupied with the Great Illusion which it is the major task of man in this particular world cycle to master and dispel, and so to inaugurate the reign of the Real."[33]

[30] Evelyn Underhill, *Mysticism*, 386.

[31] Ibid., 387.

[32] Dion Fortune, *The Cosmic Doctrine*, 119.

[33] Alice A. Bailey, *Esoteric Astrology*, 131.

THE DEATH OF KNOWLEDGE AND THE "CLOUD OF UNKNOWING." Clearly associated with illusion is the problem of human knowledge.[34] For what does man truly know except the world and outer form of things, and that to a very finite degree? Even when he turns his thoughts inward and seeks to know himself, he runs into immense difficulty. Viktor Frankl compares the self in its efforts at self-understanding to the eye, saying, "Precisely at the place of its origin the retina has its 'blind spot,' as the entrance of the optical nerve is called in anatomy. Likewise, the spirit is 'blind' precisely where it has its origin—precisely where no self-observation, no mirroring of itself is possible."[35] He then quotes the Vedas: "That which does the seeing, cannot be seen; that which does the hearing, cannot be heard; and that which does the thinking, cannot be thought."

The further man presses his knowledge, the more he finds himself faced with the unexplainable. What is energy? What is life? What is the nature of the origin of the universe? The limitations of science were acknowledged by Sir Arthur Eddington when, commenting on the electron, he said, "Something unknown is doing we don't know what." In one sense of the word, *phenomenology*—the descriptive study of phenomena—is a copout. Contenting itself with *what* is seen and experienced, it abandons the tougher questions of *whence, whither, why,* and *how.*

To reach into the higher realms beyond objective knowledge, other ways of knowing must be employed. Not only scientists, but philosophers also experience the limitations of reason. To quote Manly Hall:

> Having lifted his mind to the contemplation of cosmic realities, the philosopher . . . has learned with the Buddha that possession is a curse, desire a snare, and selfishness an illusion. Of such a sage it may be said that he has climbed up from the valleys of worldliness to the high mountain of clear thinking where the panorama of the greater life spreads out before him. Dwelling in his world of thought, the philosopher gradually achieves to the realization that the mind which lifted him out of matter has also been outgrown. The mind

[34] Alice Bailey says, "Illusion is primarily a mental quality and was characteristic of the attitude of mind of those people who are more intelligent than emotional. . . . It is the misunderstanding of ideas and thoughtforms of which they are guilty, and of misrepresentation." *Glamour: A World Problem,* 26.

[35] Viktor Frankl, *Man's Search for Meaning: An Introduction to Logotherapy,* 31.

which made him a man will prevent him from becoming a god; the stone upon which he raised himself thus far has now become a millstone around his neck. Thus as the philosopher first cast off worldliness to dwell in the broader vista of the mind, so ultimately he casts off *mind*fulness that he may enter into the newer and greater vision—the rulership of intellect by spirit.[36]

As consciousness evolves and reaches further and further into the spiritual universe, it encounters the limits of reason and begins to develop another faculty, *intuition,* then dies even to that as it enters upon a still higher state of knowing, *ecstasy.* "Reason dies in giving birth to ecstasy," wrote Richard of St. Victor. And we have St. John of the Cross's poetic account of his rise into "the Superessential Radiance of the Divine Darkness":

> *In solitude profound,*
> *The right way was clear,*
> *But so secret was it*
> *That I stood babbling,*
> *All science transcending.*
>
> *I stood enraptured*
> *In ecstasy, beside myself,*
> *And in every sense*
> *No sense remained.*
> *My spirit was endowed*
> *With understanding, understanding naught,*
> *All science transcending.*
>
> *The higher I ascended*
> *The less I understood.*
> *It is the dark cloud*
> *Illuminating the night. . . .*

[36] Manly P. Hall, *Lectures on Ancient Philosophy,* 93.

This knowing that knows nothing. . . .

This sovereign wisdom
Is of an excellence so high
That no faculty nor science
Can ever unto it attain. . . .

And if you would listen;
This sovereign wisdom doth consist
In a sense profound
Of the essence of God;
It is an act of His compassion,
To leave us, naught understanding,
All science transcending.[37]

Similarly, we find Meister Eckhart saying, "The end of all things is the hidden Darkness of the eternal Godhead, unknown and never to be known."[38] And Djwhal Khul says, "'Darkness is pure spirit.' This recognition, realization, apprehensive, comprehensive (call it what you will) is so overwhelming and all-embracing that distinctions and differences disappear. . . . The only realization left is that of pure Being Itself."[39]

Some have made a distinction between *knowledge* and *wisdom*, saying knowledge concerns the world while wisdom is knowledge of the One Self, infinitely transcendent.[40] It is not my purpose here to pursue the subtleties of mystical or esoteric philosophy, but rather to point out that *the limitations of human knowledge* must be shattered and knowledge die to itself before Supreme Wisdom can be approached.

At every stage of life's journey, death holds hidden the secrets of life. To die is to be born again upon a higher plane. Death is the mediator, the initiator, the one who conducts us to our destiny. As Dion Fortune suggests, it is a true friend.

[37] Quoted in *Mystical Theology and the Celestial Hierarchies*, by Dionysius the Areopagite, 69.

[38] Quoted in ibid., 70.

[39] Alice A. Bailey, *The Rays and the Initiations*, 174.

[40] Eliot Deutsch, in his *Advaita Vedānta: A Philosophical Reconstruction*, distinguishes two kinds of knowledge: "*Parā vidyā*, the higher knowledge, is knowledge of the Absolute . . . ; *aparā vidyā*, the lower knowledge, is knowledge of the world—of objects, events, means, ends, virtues, and vices. *Parā vidyā* has Reality as its content; *aparā vidyā*, the phenomenal world" (81).

Learn to trust death. Learn to love death. Learn to count upon death in your scheme of things, and regularly perform the exercise of visualizing yourself as dead and conceiving how you shall then be, for thus you will learn to build the bridge between life and death, so that it shall be trodden with increasing ease. See yourself as dead and working out your destiny. See yourself as dead and continuing your work from the plane of the dead. Thus shall the bridge be built that leads beyond the Veil. Let the chasm between the so-called living and the so-called dead be bridged by this method, that men may cease to fear death.[41]

Let it be clearly said that death annuls the Law of Limitation and liberates the unfolding powers of the spirit. Death is the law that makes evolution and transcendence possible. The grave is not a blind alley but an open door to higher states of being. "The way into the depths," says Heraclitus, "is the way of ascent."

[41] Dion Fortune, *The Cosmic Doctrine*, 120.

5 Seven Stages of Transformation

I would restore to the philosopher his mythology.

WILLIAM BUTLER YEATS

Life unfolds in stages. In no place or time do we find all four seasons in simultaneous manifesting. High and low tide do not occur conjointly. All life follows a universal law of cycles—a rhythm which determines that now one phase of life shall be in manifestation and now another.[1] To understand these phases or stages, the reason for their sequence, the inner activity which each represents, and the way in which life works through all of them to attain its ends is to be in a position to begin living life more wisely. To enter into a study of the stages of transformation, therefore, is to ask Mother Nature—or Isis, Guardian of the Secrets of the Universe—to reveal to us some of her most profound mysteries. Nature always guards her deepest secrets from those who would misuse them. Yet I believe much can be learned if we approach life's mysteries with purity of purpose, a desire to learn and evolve, and with humility of heart and a willingness to serve others.

What follows is a largely personal interpretation of the cycle of

[1] The scientific study of cycles found in all departments of nature and life is the principal work of the Foundation for the Study of Cycles, Pittsburg, Pa. See E. R. Dewey and Og Mandino, *Cycles: The Mysterious Forces that Trigger Events*. Cyclic law is fundamental to all Wisdom Sciences including, for example, astrological cycles and influences. The Law of Cycles is the time-clock governing all evolution.

Alchemy as a seven-stage process of transformation

The path of growth which
is closed by those whose
capacity for life and
feeling exhausts itself on
the mundane level may be
reopened by a soul that
can see beyond the veil of
mundane appearance to the
distant view of an "other
world" of a supra-mundane
spiritual order. The social
catastrophe of disintegration
thus reveals itself finally as
a crisis of perception in the
individual soul.

ARNOLD TOYNBEE

transformation or rebirth as I have come to understand it, and this in terms of seven stages.[2]

As indicated in my introduction, the stages outlined here came to me in a series of dreams. That the symbolism involved in each stage is universal and can be found in all major cultures—primitive, Eastern, and Western—is, I believe, beyond disproof.[3]

1. DISMEMBERMENT

In the dismemberment motif, we have the symbolism of tearing asunder, mangling, rending limb from limb. Again and again in the great mythologies, we find the theme of the dismembered or crucified god—Osiris, Dionysus, and Christ, for example—each of whom represents, through dismemberment, the *dispersion* of the divine creative force through space and time. In the dismemberment motif we also have the

[2] Jung, in his *Symbols of Transformation*, approaches by a different route. Campbell, in *The Hero with a Thousand Faces*, and P. W. Martin, in *Experiment in Depth*, are somewhat closer to my approach.

[3] See Mircea Eliade, *Rites and Symbols of Initiation*.

⁴ Mircea Eliade, *Myths, Dreams and Mysteries*, 183–84.

theme of sacrifice, of a destruction that becomes the *sine qua non* of creation. Eliade touches on this:

> Creation is completed and perfected either by a hierogamy or else by a violent death; which means that the creation depends both upon sexuality and upon sacrifice, voluntary sacrifice above all.

This is the essential theme: that Creation cannot take place except from *a living being who is immolated*—a primordial androgynous giant, or a cosmic Male, or a Mother Goddess, or a mythic Young Woman. We note, too, that this "Creation" applies on all the levels of existence; it may refer to the Creation of the Cosmos, or of humanity, or of only one particular human race, or of certain vegetable species or certain animals. The mythic pattern remains the same: nothing can be created without immolation, without sacrifice.

> This myth of creation by a violent death transcends, therefore, the mythology of the Earth Mother. The fundamental idea is that Life can only take birth from another Life which is sacrificed. The violent death is creative—in this sense, that the life which is sacrificed manifests itself in a more brilliant form upon another plane of existence. The sacrifice brings about a tremendous transference: the life concentrated in one person overflows that person and manifests itself on the cosmic or collective scale. A single being transforms itself into a Cosmos, or takes multiple re-birth. . . . In other terms, here again we find the well-known cosmogonic pattern of the primordial "wholeness" broken into fragments by the act of Creation.⁴

To understand ourselves psychologically and spiritually and comprehend the cultural transformations at work in our own time, it is necessary to see in dismemberment a universal process at work. All cultural forms, institutions, creeds, philosophies, values, and ways of knowing and experiencing the self and world—all disintegrate once they've served their purpose. From the perspective of the consciousness and integrating

center of values in the old forms, this disintegration takes on all of the characteristics of the dismemberment motif. The passing away of old forms, however well they have served the life within them, is essential to the further progress of the indwelling life. Dismemberment is therefore the first stage of the regenerative process and fundamental to furthering the creative evolution of the life within the form.

2. DEATH—CONTAINMENT—WAITING

Death follows dismemberment. Psychologically speaking, death is synonymous with a return of life to "the darkness behind consciousness" (Jung), symbolized by regression into chaos, being devoured by a monster, returning to the womb, or being swallowed by the cosmic night. Death puts one in touch with something hidden from consciousness—some treasure or secret knowledge or special wisdom veiled by an interior darkness symbolized by the underworld, womb, belly of a whale or giant, or interior of a mountain. To enter this darkness is to discover the secrets of life and its destiny. The wisdom thus gained brings transformation, evolution, liberation, spiritualization, and immortality. Hence, death is never the end of life but a *rite of passage* leading to another plane or dimension. Death abolishes historical time and allows entrance into the "open existence" of timeless Reality. It ends the old order of existence, making it possible to begin life anew, regenerated. It brings us into contact with the primordial forces of creation that hold the keys to regeneration and the founding of a new world or new mode of being. It puts an end to "profane" life. By way of death we leave behind our mundane existence and pass into a higher or more spiritual existence.[5]

[5] Several of these points about the effects of death are derived from Eliade, *Myths, Dreams and Mysteries,* 223–28. In dealing with his concept of self-actualizing persons, one of Abraham Maslow's concerns has been the "desacralizing" of life and the need to "resacralize" it. "Resacralizing means being willing, once again, to see a person 'under the aspect of eternity,' as Spinoza says, . . . that is, being able to see the sacred, the eternal, the symbolic." "Self-Actualization and Beyond," in *Challenges of Humanistic Psychology,* 284.

Every symbol and combination of symbols led not hither and yon, not to single examples, experiments, and proofs, but into the centre, the mystery and innermost heart of the world, into primal knowledge. Every . . . transformation of a myth or religious cult, every classical or artistic formulation was, I realized in that fleeting moment, if seen with a truly meditative mind, nothing but a direct route into the interior of the cosmic mystery, where . . . holiness is forever being created.

HERMANN HESSE

Seen from the perspective of man's lower nature that must die, death has held an almost paralyzing power over the consciousness of humanity. Still, that initiatory or psychological form of death required to release the higher creative powers of the individual can be dangerous, "leading to the disintegration of the personality" (Eliade):

> But, if entering into the belly of a monster is equivalent to a descent into Hell, into darkness among the dead—that is, if it symbolizes a regression to cosmic Night as well as into the darkness of "madness" where all personality is dissolved—and if we take account of all these homologies and correspondences between Death, Cosmic Night, Chaos, Madness as regression to the embryonic condition, etc., then we can see why Death also symbolizes Wisdom, why the dead are omniscient and know the future, and why the visionaries and the poets seek inspiration among the tombs.[6]

The terror often felt facing the threat of death is a fear of self-loss, disintegration, or descent into madness. We should recognize the dangers, yet learn to die without fear. This becomes possible once we recognize the greatness of the gifts death brings—transformation, new life, the release of new creative powers, freedom from the burdens of the past, and a greater attunement to spiritual being. As Hesse says, "Death is the protest of the spirit against the unwillingness of the formed to accept transformation—the protest against stagnation."

An essential element of death's symbolism is the theme of *containment*—being devoured, entombed, placed in a box, imprisoned, shut up in a cave or dungeon, isolated, or buried. Containment is about concentration—setting up limitations that allow the contained forces to gestate, regenerate, increase in potency, and undergo renewal. Steam rising from an open boiler dissipates and accomplishes nothing, but, when confined, builds pressure, which can then be directed to useful purposes. In like manner, all finite forms set limitations, which allow the indwelling life to build strength,

[6] Eliade, *Myths, Dreams and Mysteries*, 225.

mature, and unfold latent creative powers as they struggle against the resistances and limitations of confining forms. *Only what is involved can evolve.* Confinement is an essential aspect of the regenerative process allowing "dead and buried" forces to renew themselves in the depths of the unconscious, away from the light of consciousness. Just as a seed must be buried in the dark earth before it can germinate and send its shoots into the sunlight, so too must the human soul know periods of darkness and confinement if new powers are to awaken and unfold. Without such periods of containment there is no evolution, no rebirth to higher planes of being.

The time equivalent of containment is *waiting*—a theme brilliantly dramatized in Samuel Beckett's play *Waiting for Godot*. These dark winter periods of our lives often seem interminable. Like the characters in Beckett's play, we seem to be waiting for something to happen, for some answer or someone to arrive, but nothing happens and no one comes. Beckett's play hit a nerve in the consciousness of the twentieth century. Humanity longs for a new day and a better world, but the world's problems only seem to become more numerous and complex. We feel trapped in a time of waiting and hoping. We look for creative breakthroughs that never seem to come.

The waiting associated with the "death" stage of transformation is seldom discussed by mythologists, but it is an essential element to the regenerative process. It refers here to those periods of inactivity when life feels frozen in abeyance, stuck in a state of suspended animation. When undergoing the death stage of the renewal process, life seems to stand still. For most of us inactivity is tantamount to death. *Waiting is the hardest of all work.* While containment produces intensification, waiting allows for contact with hidden regenerative forces, a period of incubation, and renewal beyond the glare of consciousness, akin to the regeneration of the body during deep sleep. As the visible world rests, life in its own hidden depth is undergoing a mysterious transformation at its nadir. Something akin to a reversal of polarity appears to take place and death reverses itself, setting in motion once more those life-creating processes that climb the path of ascent. At its zenith, life's

polarity again reverses itself and begins its descent toward death. Life, weaving shuttle-like through this earthly frame, carries out its hidden purpose. Life and death, the twins of Mother Nature, are but veils of Isis. What Wisdom she conceals! How deep and wondrous are the mysteries of transformation!

3. DESCENT INTO THE UNDERWORLD

In the symbolism of descent, we take up one of the major images of our time, one with special relevance to the mythology and psychology of contemporary life. Northrop Frye, in his *Fables of Identity,* talks about the "cosmologies" of poetry. He says:

> For poets, the physical world has been not only a cyclical world but a "middle earth," situated between an upper and lower world. . . . The upper world is reached by some form of ascent, and is a world of gods or happy souls. The most frequent images of ascent are the mountain, the tower, the winding staircase or ladder, or a tree of cosmological dimensions. . . . The lower world, reached by descent through a cave or under water, is more oracular and sinister, and as a rule is or includes a place of torment and punishment. It follows that there would be two points of particular significance in poetic symbolism. One is the point, usually the top of a mountain just below the moon, where the upper world and this one come into alignment, where we look up to the heavenly world and down on the turning cycle of nature. The other is the point, usually in a mysterious labyrinth or cave, where the lower world and this one come into alignment, where we look down to a world of pain and up to the turning cycle of nature.[7]

After examining images of ascent and descent in works of poetry from Dante to Wallace Stevens, Frye says, "In the twentieth century, on the whole, images of descent are . . . in the ascendant."[8] He notes

[7] Northrop Frye, *Fables of Identity: Studies in Poetic Mythology,* 58–59.

[8] Ibid., 62.

that a cosmological reversal took place as a result of modern science, citing a decline in the association of the spiritual world with the starry heavens above, replaced by the "Frankenstein" themes science fiction regularly attaches to outer space. Consequently, Romanticism in the nineteenth century turned toward the underground traditionally associated with hell and death, finding there "the mysterious reservoir of power and life out of which both nature and humanity proceed."[9] He adds, "This world is morally ambivalent, being too archaic for distinctions of good and evil, and so retains some of the sinister qualities of its predecessor."[10]

Two key features of the symbolism of descent interest us:

ENTRY INTO A WORLD OF MYSTERY OR DARKNESS WHEREIN LIES SOME HIDDEN TREASURE. To quote Frye again, "The reward of descent is usually oracular or esoteric knowledge, concealed or forbidden to most people, often the knowledge of the future."[11] The journey into the depths is dangerous. "We must not underestimate the devastating effect of getting lost in the chaos," says Jung, "even if we know that it is the *sine qua non* of any generation of the spirit."

THE CONQUEST OF EVIL OR OPPOSING FORCES, FREQUENTLY SYMBOLIZED AS A DRAGON GUARDING THE GOLD OF A SECRET WISDOM. It is precisely this task the hero takes upon himself on entering a world that is terrifying, chaotic, full of dangers, and utterly lonely.[12] "Easy is the descent to Avernon," says Virgil; "night and day the door of gloomy Dis stands open; but to recall thy steps and pass out to the upper air, that is the task, that is the toil!"[13] In other words, the hero's descent into the underworld is one of taking upon himself all the dark, unknown, destructive powers that reside below the threshold of consciousness. This includes the possibility of encountering the demonic—psychic forces that have not been integrated by the conscious ego and have power to overtake the personality and rule it destructively. Finally, the hero's vision is in one sense tragic, for in discovering the dark, inner, primal void, he is given a momentary glimpse into the transient nature of all manifest existence.

[9] Northrop Frye, *Fables of Identity*, 64.

[10] Ibid., 64–65.

[11] Ibid., 62.

[12] I am not overlooking the female helpmate (Isis as the helpmate to Osiris, etc.) who assists the hero, but as Jung has pointed out, she is in reality the *anima* within the hero himself. James Joyce tells us, "In the economy of heaven . . . there are no more marriages, glorified men, or androgynous angels, being a wife unto himself" (*Ulysses*).

[13] Virgil, *Aeneid*, VI. Translated by H. R. Fairclough.

4. WANDERING THE LABYRINTH AND SEARCHING FOR THE WAY

Finding by his descent that he is suddenly surrounded by chaos and darkness, the hero discovers there are no roadmaps or signposts to guide him back to the upper world. His predicament is that of Dante in the opening line of the *Inferno:* "I came to myself in a dark wood where the straight way was lost." Likewise, we find the knights of King Arthur beginning their journey in search of the Holy Grail, "each entering the forest at that point where it was thickest, where there was no path." Now lost in darkness, the hero must conquer the depths by creating order out of chaos and forging his own path of return where none exists.

The lost way is the labyrinthian way—the way of the wanderer and the seeker. Eliade notes that in prehistoric times the labyrinth was both a place of burial for the dead and a place of initiation. Its fruitful significance for the renewal of life consists in its symbolism as the body of the Earth Mother. "To penetrate into a labyrinth or a cavern was the equivalent of a mystical return to the Mother," says Eliade.[14] The labyrinth or maze symbolizes also the loss of spiritual consciousness during earthly incarnation and the search for a way leading back to spiritual union.

Ancient writers mention five great mazes—that of Egypt, located by Pliny in Lake Moeris; the Cretan labyrinths of Gnossus and Gortyna; the Greek maze on the island of Lemnos; and the Etruscan at Clusium. However complex, every maze resolves itself finally into a spiral that leads the wanderer-turned-seeker to its center—the center being the place where the hero finally overcomes death and escapes the realm of chaos. Nor can we leave the symbology of the labyrinth without noting that its many winding paths symbolize the many earthly incarnations of the soul and the varied experiences of the soul in the realm of material existence.

In terms of contemporary art and society, the theme of the labyrinth represents the alienation, lostness, hopelessness, and meaning-

[14] Mircea Eliade, *Myths, Dreams and Mysteries,* 171.

lessness responsible for the widespread spiritual searching that has characterized our era, especially since World War II.

5. THE DANCE OF LIFE

As students of the psychology of creativity are aware, creative breakthroughs in solving problems, gaining new insights, or making new discoveries are preceded by an *anticipatory excitement*—a subjective awareness that the required solution has been found in the depths of the psyche. The gestation period has done its work, and the needed new idea or insight is ready to surface in consciousness. Prior to the breakthrough a mild ecstasy, a quiet joy, a subtle sense of satisfaction signals the imminent emergence of the solution into the light of consciousness. I call this *the dance of life* in the depths of being—a herald of newly awakening powers and insights. Just as the cosmos dances into being out of the Unmanifest and the sprouting seed dances in the dark earth before rearing its shoots into the sunlight, all that emerges out of the darkness of the creative subconscious alerts us to its approach by a mild inner ecstasy. While one may feel excitement without a breakthrough occurring, there are no breakthroughs not heralded by a sense of anticipatory pleasure.[15] A feeling of renewed vitality, an anticipatory sense of fulfillment—in short, a dance of life—begins "underground" in the subconscious mind once the sought-for insight is found and is ready to surface. In the case of the wanderer-seeker in the labyrinth, his search becomes a dance as his wandering days near their end and the way out of the labyrinth is on the verge of discovery. Jill Purce has said, "The essence of the labyrinth is not its outward form . . . but the movement it engenders."[16]

As a symbol of earthly life, the journey in the labyrinth appears to begin as random movement under the impulse of wandering and indulging the manifold experiences of life. It is then a maze, largely directionless and purposeless. With time, however, aimless wandering and random searching is transmuted into a purposeful quest—a labyrinth.[17] As the quest progresses, it acquires a certain order and rhythm and

[15] The source of these findings is Synectics, Inc., Cambridge, MA. See William J. J. Gordon, *Synectics: The Development of Creative Capacity*, and George M. Prince, *The Practice of Creativity*.

[16] Jill Purce, *The Mystic Spiral*, 30.

[17] The distinctions between a maze and a labyrinth are further discussed in the chapter "The Labyrinthian Search."

eventually manifests as a reawakening dance of life. The underground journey is nearing its end. The Lighted Way will soon appear.

As dance approaches ecstasy, it represents a transmutation of Matter into Spirit. This is especially the case with whirling dervishes. With left foot firmly planted on the ground, the dervish spins on an axis passing through his heart center. His whirling produces *centering,* a centering that spiritualizes as it attunes him to the infinite—a subject to which we shall return. An imitator of the cosmic dance, the dervish, whirling upon his own center, spins on "the cosmic axis":

> By dancing and emulating the macrocosmic creative dance of Shiva, the whirling of the planets or the dance of atoms, man actively incorporates the creative vibrations and ordering movements of the cosmos. His body becomes the universe, his movements its movements, and when these are harmonious, then he is not only in harmony with himself, but with the universe which he has become.[18]

The way out of the labyrinth is found at its center. The wanderer-seeker in the labyrinth experiences a new joy as his wandering days near their end, the lost way behind him. His life attains a new rhythm, a new balance, a new harmony. Exiting the labyrinth is an ecstatic experience. Every such journey ends with a victory dance, celebrating the conquest of the unknown.

6. FINDING THE WAY: RETURN AND REINTEGRATION

However, before man can escape the labyrinth, he must kill his lower or "animal" nature. This is symbolized in the account of Theseus slaying the Minotaur in the Cretan Labyrinth. The Minotaur—a creature with the body of a man and the head of a bull—symbolizes the baser aspect of man. With mythic creatures such as the centaur or sphinx that have the body of an animal and the head of a man, the human head symbolizes the dominance of human qualities—ideas, virtues,

[18] Jill Purce, *The Mystic Spiral,* 30.

intelligence—over the animal nature that man is in the process of outgrowing. In the case of the Minotaur, where the symbolism is inverted, the bull-head informs us that man is under the domination of his animal nature. Theseus symbolizes the hero, the higher self who must enter the labyrinth and vanquish the Minotaur or animal-man. In the initiatory process, the lesser or earthly man is always slain. So pervasive is this idea in initiatory or rebirth myths that one may term it archetypal. Eliade points out that the initiatory rites of primitive peoples include an "injunction to kill a man." He cites the rites of the Paupan Koko, which include this injunction to the neophyte: "Now you have seen the Spirit, and you are a real man. In order to prove that in your own eyes, you must slay a man."[19] Citing other parallels among primitive tribes, Eliade says:

> The act is a religious one, a ritual. The neophyte must kill a man because the god did so before him; furthermore he, the neophyte, has just been killed by the god during initiation; he has known death. He has to repeat what has been revealed to him: the mystery instituted by the gods in mythic time.[20]

In the higher mysteries, the injunction to "kill a man" is understood as an injunction to vanquish one's own earthbound nature. In a modern dramatization of initiation, Will Garver tells how a neophyte found himself among a sinister group of persons into whose ranks one is initiated by committing murder. The neophyte refuses, saying, "I will not take human life; by no man shall man's blood be shed; all life is sacred."[21] The ordeal turns out to be a test. Having passed it, the neophyte meets his initiators and is told:

> You crossed the pool and met the witch. Most truly did she tell you that you must kill a man; no one can enter here who has not accomplished this, but that man is the lower self of him who seeks to enter. When, listening to your inner spirit, you refused to take human life, you killed your lower self; into the grave you put it, and the burial

[19] Mircea Eliade, *Myths, Dreams and Mysteries*, 220.

[20] Ibid.

[21] Will L. Garver, *Brother of the Third Degree*, 208.

brought you peace. Peace brought you resurrection; you ascended to a higher plane and your spirit was enthroned within the form which was a tomb, but which now is a willing instrument of the higher self.[22]

Only as the lower self is slain can the higher or spiritual man emerge. Of this process, the crucified and resurrected Christ is the great archetypal symbol.

As will be noted later, the labyrinth is so constructed that it always returns the seeker to himself. In all his wanderings in search of a way out, he always comes back to himself and is forced to face himself again and again until he finally sees what it is *within himself* that keeps him labyrinth-bound. He learns at last that there is "no exit" except that which lies within his own being. Only as the seeker finds himself does he enter at last upon the Path of Return, which is a path of ascent. Only then does the way down into material existence reverse itself and become the way up and out. Just as the search within the labyrinth leads to centering, so also does the way out end with self-confrontation and the slaying of the Minotaur—the earthbound man.

Another element of the Theseus myth needs elucidation. Theseus is aided in his victory by a helpmate, Ariadne, who provides Theseus with a magic thread that Theseus unwinds behind him as he enters the labyrinth and later follows to find his way out after slaying the Minotaur. In Eastern and Western religions alike, in yoga philosophy and esoteric wisdom, we find again and again the idea of a "thread soul" or "golden cord" that links man during incarnation with his spiritual soul or higher Self. This Self *cannot* incarnate in the material world. Ariadne, the helpmate, is symbolic of Theseus's higher Self, and her magic thread is the means by which Theseus, during his sojourn in the labyrinth (during earthly incarnation), maintains his connection to the spiritual worlds and finds his way back after his victory over the Minotaur. I spoke earlier of "intentional dying." The yogi is able to die at will because he knows where and how this "lifeline" is connected to his earthly vehicles. Once his earthly sojourn is finished, he is able to follow the thread and depart his physical body at will. There is always

[22] Will L. Garver, *Brother of the Third Degree*, 232.

an *inner knowing* when the correct time for withdrawal has come. It is not an arbitrary choice.

The labyrinth is escaped at its center by means of the victory achieved there. The passageways of the labyrinth exist horizontally within the earthly realms and never lead out of this world. To escape the labyrinth one must travel a path of ascent—a path that results in a spiritualization of the earthly man. Many are the ways taught in the spiritual literature of the world whereby this can be accomplished, and each of us goes about it in a somewhat different way,[23] but the work is done chiefly by *centering*, for the center of our being is ever the point of contact with the Infinite Spirit, the Boundless All. In psychological terms, centering begins with *integration*, achieving authentic selfhood. The self-loss symbolized by "the broken center"—the fragmentation of the personality accompanying the first or dismemberment stage of transformation—must eventuate in self-discovery and reintegration and the identification of the incarnate man with his higher or spiritual Self. Edward Edinger describes this encounter between the ego and the Self, saying, "At a certain point in psychological development, usually after an intense alienation experience, the ego-Self axis suddenly breaks into conscious view. . . . The ego becomes aware, experientially, of a transpersonal center to which the ego is subordinate."[24] He then quotes Jung:

> When a summit of life is reached, when the bud unfolds and from the lesser the greater emerges, . . . the man who is inwardly great will know that the long expected friend of his soul, the immortal one, has now really come, "to lead captivity captive" (Ephesians 4:8), that is, to seize hold of him by whom this immortal has always been confined and held prisoner, and to make his life flow into that greater life—a moment of deadliest peril![25]

The long labyrinthian search that leads to the recovery of the ego-Self (Edinger) or cosmic axis (Eliade), reconnecting the subterranean and upper worlds, the earthly and spiritual realms, leads to new wisdom. Finding the way, return, and reintegration upon a higher plane

[23] A student once asked me, "How many ways are there to God?" I asked him, "How many radii can you draw from the circumference to the center of a circle?" He thought a moment and said, "An infinite number." I replied, "That's how many ways there are to God." The life experience of each of us is unique to our own souls, yet all of us can follow the "radius" that leads us to the Infinite at the core of our being.

[24] Edward F. Edinger, *Ego and Archetype*, 69.

[25] Ibid.

of being—the plane of the True Self—brings the wisdom born of self-conquest.

> *Wisdom brings up her own sons,*
> *and cares for those who seek her . . .*
> *for though she takes him at first through*
> *winding ways,*
> *bringing fear and faintness on him,*
> *plaguing him with her disciplines until she can*
> *trust him,*
> *and testing him with her ordeals,*
> *in the end she will lead him back to the straight*
> *road,*
> *and reveal her secrets to him.*[26]

The trials and ordeals of initiatory death reveal a wisdom (the treasure buried in darkness) that can be acquired only by the hero who has undertaken the arduous underground quest and ended by finding himself, his Eternal Self. When we think of all a person must go through to reach this wisdom, we should not wonder at mankind's resistance to truth.

Christ is synonymous with Divine Consciousness ("the true light that enlightens every man," John 1:5, 9) and bears the same relation to man as Krishna ("Of lights I am the radiant sun . . . of the senses I am the mind, and in living beings I am the living force";[27] "Out of compassion for them, I, dwelling in their hearts, destroy with the shining lamp of knowledge the darkness born of ignorance"[28]). Buddha, the Enlightened One, also manifested Divine Consciousness. Many are the Great Ones who have walked with humanity. Concerning the mystery of the inner Christ,[29] Will Garver has written:

This explains the mystery of Christ, the meaning of the crucifixion and the mystery of pain. The black cross, as just explained, represents man's lower nature, this body, a tomb for the spirit and an

[26] *Ecclesiasticus,* quoted in Edinger, *Ego and Archetype,* 93.

[27] Bhagavad Gita 10:21, 23.

[28] Ibid., 10:11.

[29] See my Web essay, "The Call of the Inner Christ," at www.lighteagle.net.

instrument for its torture. Nailed upon or fastened to this cross, or form of flesh, is the Divine Man, Christos, the Son of God. . . . How truly does this symbolize the life of all men of earth; it is a universal symbol, and applies to all men, for every man who feeds his lusts and passions or yields to the lower nature, crucifies the Christ within him. Every evil act we do, every impure thought we think, every evil aspiration or desire, tortures the divine man within ourselves. . . .

But the Universal Christ, the divine in man, has always existed and has never died. All ancient Scriptures have an esoteric meaning, and under the form of allegories and symbols the great truths of the universe and man, the macrocosm and the microcosm, are veiled; but veiled so lightly that all who seek can find their meanings. Paradoxically, the most deeply hidden is the most open; but the blind pass by and will not see. The universe is built upon simplicity, but superficial and selfish minds know not the meaning of this word . . . relying solely on the intellect, they scorn to see philosophy in the simple parables of every-day events. But Jesus thus taught, for parables were his constant method, and his philosophy of human life, thus dimly veiled, was told to his disciples. . . .

If I had ever doubted that knowledge came from the unfolding of an inner faculty, I now doubt it no longer. I was beginning to realize this inner light.[30]

Return and reintegration, finding the Way and centering, lead to Wisdom and Illumination. Yet these also are but steps upon the Eternal Way.

7. ECSTASY AND TRANSFIGURATION

Ecstasy follows centering. As the word suggests (*ek,* out of, plus *stasis,* stand), in ecstasy one steps out of finite existence and experiences union with the transcendent Ground of Being. The boundaries of the earthbound ego are annihilated and consciousness is united with the Universal Mind—hence the term *cosmic consciousness.*[31] In *The*

[30] Will Garver, *Brother of the Third Degree,* 236–39.

[31] As we shall discuss later, Cosmic Consciousness is the highest known state of consciousness, one of Pure Being, but there are many stages of expanded consciousness prior to the Cosmic.

Mystical Theology of Dionysius the Areopagite, a Triple Mystic Path is outlined—the Purgative, the Illuminative, and the Unitive, the latter being the highest. From the standpoint of the ordinary man or woman, as Alice Bailey reminds us, "All progression in the realm of consciousness is naturally by a graded series of awakenings" and "these realizations, or apprehended expansion of consciousness, are under natural law, and come in due course of time to every soul *without exception.*"[32] These awakenings repeat themselves many times on a small scale in the life of every person, each experience leaving us more enlightened, wiser, and standing a bit higher in the ascending scale of evolution. Given a cosmic journey without end, speculation as to the highest states of consciousness remains for us just that—speculation. The Great Ones know vastly more, but even they do not know all, for the Boundless Absolute is unknowable. As used here, Cosmic Consciousness merely indicates an ever-advancing "goal" toward which we are evolving.

Ecstasy and transfiguration have to do with awakened, expanded, and illumined consciousness. Let us cite a few samples of the literature on this exalted subject:

> When we dream we do not know that we are dreaming. . . . Only after we are awake do we know we have dreamed. Finally there comes a great awakening, and then we know life is a great dream. But the stupid think they are awake all the time, and believe they know it distinctly.[33]

> The diamond symbolizes Supreme Cognition, *Bodhi,* Illumination, Absolute Essence, Cosmic Consciousness, which, once it has been attained, is never again lost. It is, like a diamond, unchangeable.[34]

> Cosmic Consciousness, O my son, is like an inward sun illuminating the corridors of the temple of the soul. In its revealing rays ye can see to read clearly and understand the mysteries within the book of knowledge as more and more of its pages are turned. It comes to all who seek within the stillness of their consciousness, unveiling for a

[32] Alice A. Bailey, *Ponder on This,* 51.

[33] Chuang Tzu, *A Source Book in Chinese Philosophy,* 189.

[34] Giuseppe Tucci, *The Theory and Practice of the Mandala,* 39.

fleeting moment the vast mysteries of Nature. It is the inspirational inhaling of the God-thought, the creative essence, to fuse with the human soul, lifting it above the prison bars of the flesh. It is a *knowing,* a force which desires no physical proof but which sustains the seeker in face of all earthly obstacles and sorrows. It is impersonal, yet uniting the consciousness with all the higher forces of spirit as portrayed through the wonders of Nature.[35]

I looked and behold. Lo! a path stretched from earth; yea, upward to the Inner Spheres! Though rayed in seven-toned glory, yet withal was it auraed with white. . . . Then a Voice spoke unto me, saying: "These are the rays of the Seven Gifts of the Spirit; of the Seven Pillars of Wisdom: but the Path is One!" And the Voice made known that this was the Great White Way whose Apex is the Hallowed Abode. . . . And the Voice said: "This is the Straight Path of the Cross. Behold, it traverseth all the Spheres of God. Thou, accordingly, if thou tread therein, shalt gain all experience of all His realms. Moreover, it is the road that leadeth thee direct to the Center, even to the Sanctuary of Love. Wherefore, then, makest thou thine own path tortuous? Doth not the Innermost Abode protect and encrown His Way? And is not the Fullness of Heaven therein? Be heedful then that thou wander not, lest, straying from this Path, thy journey be needlessly prolonged.[36]

Divine Mind or Boundless Intelligence is the Creative Power pervading and guiding all things. The subjective mind of man is ever connected with this Supreme Intelligence which is to the manifest worlds as the center of a circle to the circles emanating from it. One has but to attune oneself to the innermost depths of one's being to awaken this Cosmic Mind within oneself.

So profound is the experience of ecstasy when oneness with the Cosmic is attained that one's life is forever after transformed. History is full of accounts of great men and women—Orpheus, Buddha, Quan Yin, Sankara, Lao-tzu, Moses, Jesus, Zoroaster, Jalaluddin Rumi,

[35] The Teachings of Osiris, 69.
[36] W. H. Dudley and R. A. Fisher, The Mystic Light, 50–51.

and many others, known and unknown, whose transfigured lives have given birth to great ideas and movements that have changed peoples and altered the destinies of nations.

The beauty of the transfigured men and women of the ages is that they point to the latent potentialities in all human beings. What we are, they once were. What they are, we can become. "I say, 'You are gods, sons of the Most High, all of you'" (Psalm 82:6).

The Art

Through art we get to know the soul of things.

<div align="right">THOMAS CARLYLE</div>

The capacity to suffer . . . holds the secret of beauty in manifestation, and its first expression can be seen in the creative perfection of certain phases of art for which man, and man alone, is responsible. No other kingdom in nature creates forms, produces colour and sounds in harmonious relation, except the human; all of this type of creative art is the result of aeons of conflict, pain and suffering.

<div align="right">DJWHAL KHUL</div>

The heroic mythmakers are truly creative figures. Artists have such power. The work of the mythmakers reflects the dying of the old and the creation of the new human spirit in its aspirations, powers, vicissitudes, and wisdom.

<div align="right">STEPHEN POLCARI</div>

Works of art always spring from those who have faced the danger, gone to the very end of an experience, to the point beyond which no human being can go.

<div align="right">RAINER MARIA RILKE</div>

6 The Broken Center

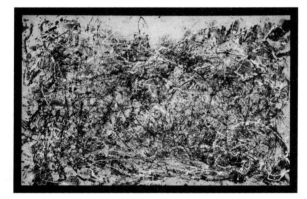

Jackson
Pollock,
*Number 1,
1948*
See plate 1

Jackson Pollock (1912–1956)

Turning and turning in the
 widening gyre
The falcon cannot hear the
 falconer;
Things fall apart, the center
 cannot hold;
Mere anarchy is loosed upon
 the world. . . .
Surely some revelation is at
 hand.

WILLIAM BUTLER YEATS

Alas! If every soul be its own
creator and father, why shall
it not be its own destroying
angels, too?

JEAN PAUL

The new art is in essence
a transition—a bridge to
another type of creativeness.

NICOLAS BERDYAEV

"The human soul must suffer its own disintegration, *consciously,* if ever it is to survive," wrote D. H. Lawrence.[1] Here we have stated not only the central problem of the art of Jackson Pollock (1912–1956), but also of our age. It is the problem of self-loss, willingly undertaken, in order that the deeper spirit of man may come into manifestation. Nor is it merely a case of play-acting, of pretending to die to oneself. Dying is a radical experience. It is our destiny as human beings to explore the furthest limits of human existence, to plumb the utmost depths and heights of the human soul and know in fullness its sorrows and joys. How can we know them if we live in a box? We must be free, and we can be free only if we are willing to risk all! As Janice Joplin sang, "Freedom is just another word for nothing left to lose." To be free requires letting go of ourselves, our world, our crutches, our gods. It means plunging into the abyss. The journey of transformation begins then with the experience of the abyss. But how can the abyss be represented in a work of art?

[1] D. H. Lawrence, *Studies in Classic American Literature,* 74.

84

Any study of American Abstract Expressionism usually begins with a study of the art of Jackson Pollock—its most dramatic painter.[2] Before approaching this study of a work by Pollock, it should be noted that abstraction in modern art is usually dated from 1910, when Kandinsky produced his first totally abstract watercolor. Abstraction itself is not new, as it is to be found in the art of primitive peoples going far back to prehistory. A tendency toward abstraction is characteristic of Celtic, Gothic, and Middle Eastern art, and in the 1890s Art Nouveau approached abstraction in many of its organic designs. What was new about the birth of abstraction in modern Western art was its conscious focus on the spiritualizing qualities of abstraction. While many of the painters and sculptors who pioneered abstraction were conscious of its spiritual implications, the only major work on the subject from an artist continues to be Kandinsky's *Concerning the Spiritual in Art,* written in 1910 and published in 1912.[3] My remarks on the spiritual aspects of art will be limited to the specific works under study here. But it may be said by way of generalization that *all abstraction is a process of spiritualization* based on synthesis[4] and the withdrawal of consciousness from its investment in form-life.[5] We turn now to a discussion of Pollock's art, specifically *Number 1, 1948* (plate 1).

Thou art the cause of my suffering
O non-existing God, for if Thou didst exist
then should I also really exist.
MIGUEL DE UNAMUNO

Whirl is King, having driven out Zeus.
ARISTOPHANES

[2] Jackson Pollock historian Francis V. O'Connor told me in 1975 that, based on his research, I'd written "the first serious article" published on Pollock's art. While working on his article series on Pollock for *Artforum* in the 1960s, William Rubin, curator of painting and sculpture at New York's Museum of Modern Art, said to me, "You have the most unique view of Pollock's art of anyone in the art world. Yet there isn't a single thing you've said about it with which I could disagree."

[3] Other artists such as Kazmir Malevich, Piet Mondrian, Naum Gabo, Constantin Brancusi, and Hans Hoffman did write briefly on the spiritual aspects of abstraction in art. In 1986 the Los Angeles County Museum of Art mounted an exhibition and published a major catalog titled *The Spiritual in Art: Abstract Painting 1890–1985.* The current work, *Art and Spiritual Transformation,* represents the most in-depth study of individual works by Abstract Expressionists of which I am aware.

[4] See R. Bucke, *Cosmic Consciousness.*

[5] See Alice A. Bailey, *Ponder on This,* 399–400.

Pollock came to be known as an action painter. The "drip technique" of his mature style resulted in works of a highly sensitive arabesque design. Pollock approached his canvases, usually stretched out on the floor or tacked to a wall, with a trowel, sticks, brushes, or hands dripping with paint. Immersing himself bodily into the work at hand, he swirled paint with intense speed and force, forming a veritable network of lines which, were it not for his near-classical sense of balance, might well have passed off the canvas into infinity. Viewing the athletic Pollock at work, one is reminded of Picasso's statement that every time he began a painting, he felt as though he were throwing himself into a void. Ellen G. Landau says, "Pollock, under the spell of his creativity, seemed to move around his canvases like a matador or dancer, wholly engaged in an intense dialogue with the drips and splatters he is making."[6] Pollock himself said:

> When I am *in* my painting, I'm not aware of what I'm doing. It is only after a sort of "get acquainted" period that I see what I have been about. I have no fear about making changes, destroying the image, etc., because the painting has a life of its own. I try to let it come through. It is only when I lose contact with the painting that the result is a mess. Otherwise there is pure harmony, an easy give and take, and the painting comes out well.[7]

The frenzied, Dionysian passion of *Number 1, 1948* provides a prime example of Pollock's particular creative genius. The work employs an all-over style of painting derived from Impressionism and Cubism. Its distribution of lines and color *"prevented any climactic emphasis on one point . . .* of his essentially light-dark structured canvases."[8] No one area of the canvas is more important than any other, and the arabesque design is allowed to float freely upon the canvas as though in an empty void,[9] anchored only by the bottom edge of the canvas. The electric speed of Pollock's marvelously sensitive, swirling light and dark lines and the ice-blue terror of the infinite strike a certain terror in the heart. Only the dark, blood-stained handprints

[6] Ellen G. Landau, ed., *Reading Abstract Expressionism: Contest and Critique*, 54.

[7] Jackson Pollock, "My Painting," in Ibid., 140.

[8] William Rubin, "Jackson Pollock and the Modern Tradition," *Artforum*, 19, my italics.

[9] All-over painting treats every part of the canvas as of equal value and rejects all notions of foreground and background, center and limits, perspective, etc.

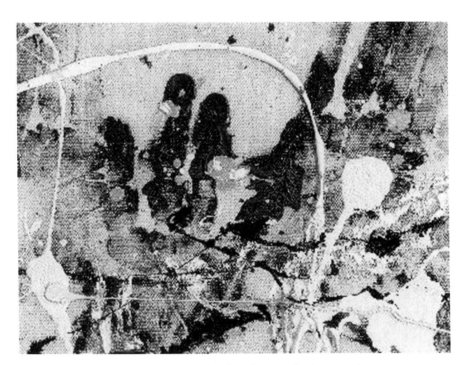

Detail of handprints at top right of Jackson Pollock's *Number 1, 1948*

reaching outward toward the edges of the canvas reveal the full extent of the agony and tragic suffering that must have overwhelmed the artist while creating this work.

Viewing *Number 1* in depth, one is overwhelmed by a sense of vertigo. Georges Bernanos, in his novel *Sous le soleil de Satan,* describes Father Donissan's temptation thus:

> One who, clinging with both his hands to the top of the mast, suddenly loses his equilibrium and sees yawning before no longer the sea but the whole sidereal abyss, with galaxies foaming in travail billions and billions of miles away, beyond that immeasurable void which his fall is about to traverse—this unfortunate could no longer feel in the hollow of his breast a more absolute vertigo. The intrepid man, as though bent and torn away by the tremendous appeal of the Nothing, sees himself lost beyond recovery. And yet, even at this moment, his dominant thought was still dull defiance.

In Pollock's mature art we encounter the return of the Dionysian temperament that characterized much of literature, philosophy, and art beginning in the late nineteenth century. To understand fully the implications of the new art for the shattering of the rationally based culture of the modern world, let us return briefly to Nietzsche's *The Birth of Tragedy*.[10] In his study of the Apollonian-Dionysian duality of Greek tragic drama, Nietzsche interprets the deep warring forces of order and revolution that underlie the making and unmaking of every culture. The Apollonian will, named for the god Apollo, is the will to order, control, selection, condensation, synthesis, and moral law. The Apollonian will is synonymous with culture and, at the aesthetic level, is identified chiefly with the plastic arts of sculpture and architecture. The Dionysian ecstasy, named after the god Dionysus, is the expression of a titanic and barbaric intoxication, of a surging, frenzied ecstasy in opposition to all rational and moral order. The Dionysian exuberance is synonymous with creativity, spontaneity, and freedom and is identified aesthetically with the dynamic arts of dance and music. Greek tragedy, according to Nietzsche, consists of an Apollonian embodiment of Dionysian powers and insights. With the eruption of the Dionysian from the bounds of the Apollonian, Greek tragedy came to an end. The Apollonian demands for self-control, self-knowledge, and moral obedience seem ever unable to hold back the equally fundamental demands of the Dionysian spirit for freedom from artificial controls. Nietzsche said, "Wherever the Dionysiac voice was heard, the Apollonian norm seemed suspended or destroyed."[11]

The whole spectrum of creative movements running from Neo-Romanticism through Dada, Fauvism, Surrealism, Existentialism, and Abstract Expressionism give expression to a rebirth of the Dionysian spirit in our time. Vyacheslav Ivanov, writing of the novels of Dostoyevsky, who first revealed to us the "underground" of modern consciousness, said, "Only some unprecedented Dionysiac form of art could tell how chasms of the soul call to one another."[12]

Put in simple terms, Apollo is *Form*. Dionysus is the indwelling

[10] Friedrich Nietzsche, *The Birth of Tragedy and the Genealogy of Morals*.

[11] Ibid., 35.

[12] Vyacheslav Ivanov, *Freedom and the Tragic Life*, 5.

Life. The relations between these two—life and form—determine all manifestation, evolution, transformation, and the final process of liberation itself. In the conflict between form and life is to be found the key to Pollock's art. So let us draw the distinctions once more, this time in Wilhelm Worringer's terms. In *Form in Gothic,* Worringer speaks of architecture (Nietzsche's symbol of Apollo) as the chief representative of the classical spirit and of the column as "the architectural member most peculiar to Classical architecture."[13] Its roundness "at once evokes the illusion of organic vitality" and reminds us of "the function of support" of tree trunks, human legs, "the flower-stalk which bears the flower," and so forth. He continues:

> Roundness in itself satisfies our natural organic feeling without the need of evoking analogous ideas. We cannot look at anything round without inwardly realizing the process which created that roundness. We seem, as it were, to realize the certainty devoid of all violence, with which the centripetal forces concentrated in the centre, that is to say, the axis of the pillar, holds the centrifugal forces in check and steadies them; we are conscious of the drama of this happy balance, we feel the self-sufficiency of the column, the eternal melody which throbs within its roundness, we feel above all the calm which evolves from this perpetual self-contained movement. Thus the column, like the circle, is the highest symbol of self-contained and perfected organic life.[14]

On the Dionysian side, Worringer would include Gothic "expressionism." He says:

> when the psychologist of style, faced with the matured, historical Gothic, has once grasped the basic character of the Gothic will to form, he can detect this will to form as being active underground . . . where, obscured by more powerful external conditions and hindered in its free expression, it assumes a foreign disguise.[15]

[13] Wilhelm Worringer, *Form in Gothic,* 91.

[14] Ibid.

[15] Ibid., 37.

Our organically tempered sense of vitality recoils before this sense-less rage of expression as from a debauch. When, however, finally yielding to compulsion, its energies flood these lifeless lines, it feels itself carried away in a strange and wonderful manner and raised to an ecstasy of movement, far outstripping any possibilities of organic movement.[16]

The essence of this specific expression of the line is, that it does not represent sensuous, organic values, but values of a nonsensuous, that is to say, a spiritual kind. I does not express organic activity of will, but a psychological, spiritual activity of will, far removed from any connection or conformity with the complexes of organic sensation.[17]

In sum, mass *materializes* the image; line *spiritualizes* it.

Returning to Pollock's *Number 1,* we are confronted with a modern, abstract form of Gothic expressionism—a kind of "spiritual orgy." In it the center, the organizing principle in classical art, has all but vanished. At the horizontal midpoint two-fifths of the way from the bottom of the painting a nearly imperceptible "point" appears, giving the work a faint visual center. Its weakness, however, testifies to the difficulty Pollock had in keeping "the center" from vanishing altogether from his work. Often it did! Pollock struggled heroically to keep a center, frequently hand-painting it in at the conclusion of a work. I began in 1960 to refer to Pollock's art as "an art of the broken center."

> *Things fall apart; the center cannot hold;*
> *Mere anarchy is loosed upon the world.*
>
> W. B. YEATS,
> "THE SECOND COMING"

[16] Wilhelm Worringer, *Form in Gothic,* 41.

[17] Ibid., 43.

The center is the organizing principle in any form or space. But what else, what symbolism gives to the center the supreme importance assigned to it in all cultures, both primitive and highly evolved?[18]

The symbolism of the center concerns the journey inward where unity, infinity, transcendence, and the Absolute reside. It is the "abode" of the supreme principle of the universe, the One Reality. Contemplation of the center unites one with the deathless essence of the manifest cosmos. "The most ancient and at the same time the most complete of all symbols given by the Wise Ones for the edification of man is the circle with a dot at its center."[19] Loss of the center means a *severance of contact with all that the center symbolizes.* An art of "the broken center" is an art of alienation, of finitude, of existence in exile—a truly *existential* art.

With the vanishing of the center in Pollock's art we encounter the first stage of transformation—the *dismemberment* motif. In Egyptian mythology the god Osiris is torn to pieces by the evil Set,

[18] In all cultures, altars and temples are erected "at the center of the world." An interesting example is provided by the Native American Sioux. Hehaka Sapa (Black Elk) describes the consecration of a fire altar thus: "Taking the ax, he (the officiant) pointed it toward the six directions, and then struck the ground to the West. Repeating the same movement he struck the ground to the North, then in the same way to the East and to the South; then he raised the ax skyward and struck the ground twice in the center for the earth, and then twice for the Great Spirit. Having done this, he scratched the soil and, with a stick which he had purified in the smoke and offered to the six directions, he drew a line running from the West to the centre, then from the East to the centre, then from the North to the centre and finally from the South to the centre; then he offered the stick to the heavens and touched the centre, and to the earth and touched the centre. In this way the altar was made; in the manner described, we fixed in this place the centre of the world, and this centre, which in reality is everywhere, is the dwelling place of the Great Spirit." Quoted in Titus Burckhardt, *Sacred Art in East and West,* 30. See also Giordano Bruno, "We can assert with certainty that the universe is all center, or that the center of the universe is everywhere and its circumference nowhere." Also the third-century *Corpus Hermeticum:* "God is an intelligible sphere whose center is everywhere and whose circumference is nowhere"; and Blaise Pascal in *Pensées,* "God is a circle whose center is everywhere and whose circumference is nowhere."

[19] Corinne Heline, *Sacred Science of Numbers,* 90.

For *what the center brings*
Must obviously be
That which remains to the
* end*
And was there from eternity.
GOETHE,
WESTÖSTLICHER DIWAN

The great Tao comes forth
* from the center,*
Do not seek the primordial
* seed outside!*
THE SECRET OF THE
GOLDEN FLOWER

When a Bodhisattva sits
upon . . . the Diamond Seat
which is the ideal centre of
the world and the place of
the Absolute, [he] attains the
Illumination by which he
becomes a Buddha.
GIUSEPPE TUCCI,
THE THEORY AND PRACTICE OF
THE MANDALA

Eadfrith, cross-carpet page from the Lindisfarne Gospels, ca. 700 CE

who scatters his fragments. His scattered pieces are subsequently found and reassembled by Isis, the sister-wife of Osiris.[20] One piece, however, could not be found—the phallus. Isis fashions a new phallus of gold, symbol of the sun. The phallus is a symbol, of course, of procreation (creation) and centering. The deeper meanings of the Osiris myth will emerge as we proceed.

The dismemberment motif in Pollock's art can be illustrated by comparing an arabesque such as *Number I, 1948*, with the Celtic-Germanic Cross Page of the *Lindisfarne Gospels*.[21] In the latter we find a vital menagerie of abstracted animals twisting and curling to form a typically Celtic arabesque. Superimposed on this vitalistic pre-Christian frenzy is a cross serving as the ordering, controlling principle. Jansen says, "It is as if the world of paganism, embodied in these biting and clawing monsters, had suddenly been subdued by the superior authority of the Cross."[22] The cross is a symbol of *generation*, both materially and spiritually.[23] It brings order out of chaos. In dramatic contrast to the *Lindisfarne Gospel* page, no ordering principle appears in Pollock's arabesques. Instead, we have a return to a precreation state. We have a symbolized chaos.[24] Osiris and Dionysus have been

[20] Through dismemberment, the god scatters himself through the "fields" of space, giving birth to the created world. This is his supreme self-sacrifice. Isis, symbolic of the Great Mother and Guardian of the Spiritual Mysteries, has the task of "reassembling the god" and re-creating the "lost center" from which the universe arose. Regarding the phallus of Osiris, one thinks also of the golden apex said to have originally crowned the Great Pyramid of Giza—the pyramid being a symbol of cosmic evolution.

[21] Dating from ca. 700 CE, located in the British Museum, London.

[22] H. W. Jansen, *History of Art*, 197.

[23] Re the symbolism of the cross, see Susan Langer, *Philosophy in a New Key*, 284–85; A. S. Raleigh, *Occult Geometry*, 23–28; and J. E. Cirlot, *A Dictionary of Symbols*, 65–68.

[24] *Symbolized*—for no work of art could exist as such if it were truly a chaos. The compositional principles of a work like *Number 1, 1948*, are in fact highly sophisticated and reveal a profound sensitivity. Of relevant interest here is Ben Shahn's essay "In Defense of Chaos" in the December 14, 1968, issue of *Ramparts*.

torn asunder, dismembered. The dismemberment motif, which had its beginnings in modern art with the Cubists, has reached its apotheosis in Pollock.[25] It is symbolically interesting that "god" in Pollock's art is dismembered *in the absence of the cross.*[26]

We come now to the theme of self-loss in Pollock. Some have argued that the image of man disappeared from modern art as a result of *abstraction*, the human image being thereby abandoned. Such an interpretation is in fact irrelevant. A man is not the bodily form he inhabits but the spirit in which he works. To know the true nature of any woman or man, the inner soul must be contacted and known, and a more spiritual approach to art is ideally suited to that task.

In Pollock, man disappears because the center, with its rich symbolism, is lost. Pollock's arabesques represent a return to a precreation state

[25] Cubism introduced all-over painting and a tilting of planes to create a multi-perspective effect that was achieved at the cost of fragmenting the pictorial plane. It is of interest that the same thing happened to *time* in poetry and music as happened to space in Cubism. An example of this is T. S. Eliot's poem, *The Waste Land* (1922; Cubism was born in 1908). In this poetic fable of the loss of faith by twentieth-century man, time is destroyed and rearranged so that all history and all literature can be made available to the poem. Eliot drew fragments from the myth of Tiresias, the Grail legend, the Upanishads, Thomas Kyd's *Spanish Tragedy*, the theories of James Frazer and Jessie Weston, Shakespeare, and St. Augustine—all of which are juxtaposed with scenes from the sordid events of daily life. The meaning of all these fragments is given to the poem not through any control of their function but through a free, suggestive, surrealistic association. The device of superimposing bits of fiction and fragments of daily life upon one another also developed from the Cubists—a means used to destroy any clear distinction between the work of art or poem and the experiences of mundane existence. In a number of plays, such as Samuel Beckett's *Waiting for Godot,* time is flattened into a monotonous repetition without climax or denouement. The same is true of music. Stravinsky has said, "One characteristic of me in my dreams is that I am forever trying to tell the time, and looking at my wrist watch and finding it isn't there."

[26] The cross, of course, is not a symbol of death, as the popular mind often thinks. It was employed by the Roman Empire as a vehicle of execution precisely because it is a symbol of life. To be put to death on a cross was tantamount to being told, "It would have been better for you had you never been born!" By being crucified, one was sent out of the world by the same "door" by which one had entered it. It is a symbol of death, of course, from the perspective of the Spirit, in the sense that generation or birth into space-time denotes a period of obscuration for Spirit.

that, in man's case, means a return to a preconscious state. Pollock said he painted entirely "from the unconscious." Absent consciousness, man is nothing—merely another manifestation of nature's "blind" forces.[27] The distinguishing characteristic of the ego is its attainment, through a heroic struggle with the devouring forces of the unconscious, of a certain rationality and stability, an egoic center of awareness. In the effort to attain this consciousness, as Neumann points out in *The Origins and History of Consciousness,* the adolescent male must struggle against the forces of the Terrible, Devouring Mother who symbolizes the unconscious, night, the primal sea, and so forth, and who is recognized by her entourage of chthonic, frenzied worshipers. Mythology is replete with myths of son-lovers of the Terrible Mother—Osiris, Dionysus, Adonis, Attis, Zagreus, Tammuz, et al.—who are castrated or dismembered during festivals and orgies in her honor. There's an Orphic saying, "The victim must be torn asunder and devoured." The power of the Terrible Mother consists in her ability to enchant, to turn men into animals (Circe), and to smite with madness. The emotional, passionate nature of the female in wild abandon is a terrible thing for man and his consciousness.

Melville, that great lover of the sea with all its dark, primeval mystery, issued this warning in *Moby Dick:*

> Consider, once more, the universal cannibalism of the sea. . . . Consider all this; and then turn to this green, gentle, and most docile earth; consider them both, the sea and the land; and do you not find a strange analogy to something in yourself? For as this appalling ocean surrounds the verdant land, so in the soul of man there lies one insular Tahiti, full of peace and joy, but encompassed by all the horrors of the half known life. God keep thee! Push not off from that isle, thou canst never return.[28]

To lose ego-consciousness (one's center) is to be "encompassed by all the horrors of the half known life." Symbolically, it is the sacrifice of the phallus to the Terrible Mother. As Neumann pointed out,

[27] Nature, of course, is not blind, but in the absence of self-consciousness, the subhuman kingdoms merely obey universal law. My point here is the distinction between conscious choice and unavoidable responsiveness.

[28] Herman Melville, *Moby Dick,* 270–71.

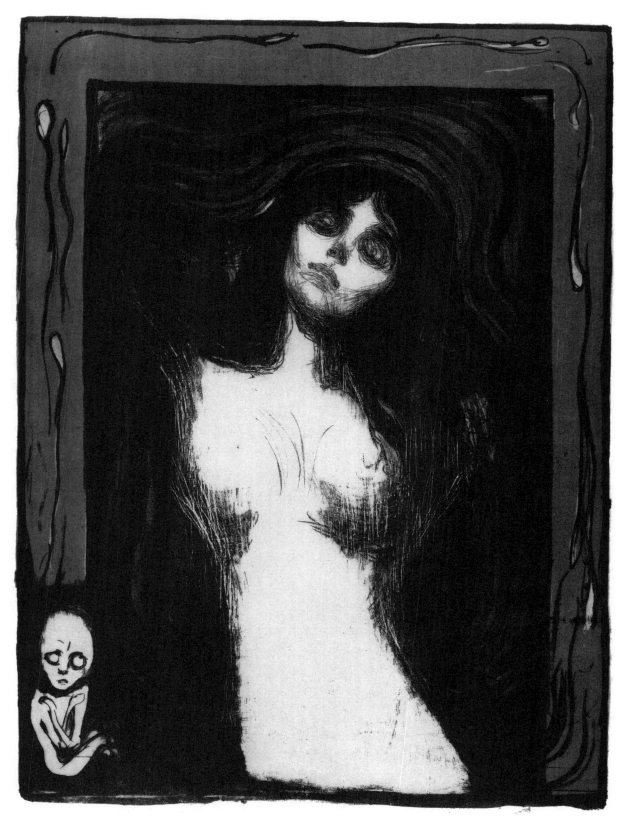

Edvard Munch, *Madonna*, 1895–1902

"Castration symbolism often occurs in those who are overpowered by the spirit," and "Castration symbolism is typical of the hostility of the unconscious to the ego and consciousness."[29] Castration symbolism, it should be noted, refers not merely to sexuality but also to rationality, consciousness—loss of mind. How symbolically ironic that John the Baptist's decapitation was the price he paid for Salome's dance!

The Dionysian art of Jackson Pollock reenacts the drama of Dionysus himself: in an act of artistic frenzy, man's center of consciousness is sacrificed to the brute psychic energy of the unconscious. What distinguishes man *as man* has vanished. The theme of self-loss is certainly played out in Pollock's art. This is clearly evident in *Cut-Out* (1948–50), in which a humanoid shape has been cut from the core of an arabesque drip painting. Though not a successful work of art, in my view, it is highly suggestive of the sense of self-loss Pollock struggled with in so many ways. Lisa Saltzman notes:

> Emptied of its bodily fullness, its corporeality, its life, *Cut-Out* leaves us with nothing other than figuration as a hollow shell, a specter which can only haunt abstraction. Framed by the marginal remains of the splattered, all-over canvas that configures the non-figure, the body which is not a body, the absence at the center of Pollock's *Cut-Out* reads like the missing body signaled by the chalk drawing at the scene of a crime, where blood and indexical traces give way to the tools of representation.[30]

The ambiguity of Pollock's appeal is that he returns us to the primal, psychic *anima,* where the rigorous demands of conscious life are

[29] Erich Neumann, *The Origins and History of Consciousness.* A number of details in Pollock's personal biography suggest that he suffered from a castration complex for which he was always trying to compensate. Norman O. Brown differed from Freud in maintaining that the castration complex derived from the ego's struggle with the mother, not the father. On a symbolic level, at least, this is clearly the case with Jackson Pollock.

[30] Ellen G. Landau, ed., *Reading Abstract Expressionism,* 561.

left behind. If his visual world is terrible in its symbolic infinity, in the lure of its "foaming galaxies" and its vertigo, it nevertheless recalls that primal, undifferentiated "sea" where life began in the safety of the maternal womb and none of the rigorous demands of consciousness were required. Neumann says:

> However much the world forced early man to face reality, it was with the greatest reluctance that he consciously entered into this reality. Even today we can see from primitives that the law of gravity, the inertia of the psyche, the desire to remain unconscious, is a fundamental human trait.[31]

Pollock's art answers our homesickness for a preconscious state. If we wish to affirm ourselves as human and self-conscious—if we wish to know ourselves—Pollock is not our man. His is the art of man's self-loss.

Not only is man dead in Pollock's art, but God also is dead. When we understand fully the spirituality of Pollock's art, we see how apropos to him is Sam Hunter's provocative designation of American Abstract Expressionism as "this latter-day artistic theology without a God."[32]

To speak of the "death of God" in modern art does not mean that God is dead because no *image* of God appears in the art. Anthropomorphic images such as Michelangelo's Creator on the Sistine Chapel ceiling are not required, nor do they assure us of the "presence" of God.[33] Nor need we be put off by the radicalism of a theologian such as Karl Barth, who claims there can be no "theological" visual art: "Since it is an event, the humanity of God does not permit itself to be fixed in images."[34] The Infinite may hide or reveal itself as it pleases. To speak of God's presence or God's "death" is to speak rather about the *consciousness* of an artist or age and what that consciousness perceives. As Howard John Zitko observes, "Only when the consciousness shifts to a higher level of perception does the world itself change—*and then only in you.*"[35] To speak of God's "death" in Pollock's art is to speak of the vanishing center that he struggled to keep but was unable to retain.

[31] Erich Neumann, *Origins and History of Consciousness*, 16.

[32] Sam Hunter, *Art Since 1945*.

[33] The kitsch representations of God in much religious art and literature today is so lacking in spiritual depth and power as to offer no hint of true divinity. What we have instead is an unmistakable *absence of the holy.*

[34] Karl Barth, *The Humanity of God.*

[35] Howard John Zitko, *New Age Tantra Yoga*, 61.

Turning to the problem of "the broken center," another work, *Blue Poles: Number 11, 1952* (plate 2),[36] proves illuminating. In this superb masterpiece we find eight "poles" inclining at various angles—all at various stages of disintegration or absorption by the wildly dancing light-dark drips. At visual center, a small circle has been "dripped" in place. To understand the relation of these poles to the problem of the center, we turn to Mircea Eliade. In *The Myth of the Eternal Return*, Eliade discusses the "sacred center" to which man is forever returning in myth and ritual to renew his being. It is at this center that man meets his gods and discovers the meaning of his existence and his world. Indeed, the center *establishes* his world. In an essay, "The Prestige of the Cosmogonic Myth," Eliade says that myth

> reveals absolute holiness because it recounts the creative activity of divine beings and discloses the sanctified nature of their work. In other words, the myth describes the varied and sometimes dramatic irruption of the sacred into the world. [Hence], in the eyes of religious man, space is not homogeneous: it exhibits fissures; that is to say, portions of space exist that are qualitatively different from others.[37]

The self-manifestation of a god or gods within time and space gives to that space-time a sacred quality that marks it off from the profane. It becomes sacred space, or space-time rooted in Ultimate Reality. Religious man, in his turn, imitates the divine action. According to Eliade:

> This faithful imitation of divine models has a twofold consequence: on the one hand, by imitating the gods, man remains within the sacred and therefore within the confines of reality; on the other, the world is sanctified by the uninterrupted reactualization of divine, exemplary gestures. The religious conduct of man constitutes the maintenance of the world's holiness.[38]

[36] Formerly on loan to the Museum of Modern Art, New York, *Blue Poles: Number 11, 1952*, was purchased from Ben Heller of New York by the National Gallery of Art, Canberra, Australia, in 1973 for $2 million—at the time the largest sum ever paid for a work of modern art. Heller told me he purchased *Blue Poles* from Pollock for $6,000. The current estimated value of *Blue Poles* is $150 million.

[37] Mircea Eliade, "The Prestige of the Cosmogonic Myth," 2–3.

[38] Ibid., 3.

Eliade's concept of sacred space-time is found in a similar form in the sacramental theology of the world's religions. A single example, from R. H. Daubney, should suffice:

> [The] pattern of the liturgy is both the archetype and the context of redeemed human existence. . . . The significance of the liturgical year and the divine office corresponds to the incorporation of the wider and the narrower aspects of cosmic time into the redeeming act. . . . [The] pattern of the liturgy . . . provides a structure of sacred reality in which the total dimensions of human existence may participate. It is precisely as a pattern that it overcomes the destructive tendencies in existence, and therefore answers the requirements of a *Gestalt* of Grace.[39]

Both space and time are seen as possessing sacred "centers" around which the meaningful patterns of existence are ordered.

In any discussion of sacred space, the center is all-important. It may be symbolized as the "world axis" or a "sacred mountain" or a central point that serves as the "gate of the gods" and a point of passage between the earthly and heavenly worlds. Ascending a sacred mountain or ziggurat, Eliade writes, "the pilgrim approaches the center of the world, and, on the highest terrace, breaks from one plane to another, transcending profane, heterogeneous space and entering a 'pure region.'"[40] He adds, "The center, then, is pre-eminently the zone of the sacred, the zone of absolute reality."[41]

So what happens when the center is "broken" and the sacramental order destroyed? Eliade offers an illuminating illustration from the mythology of an Australian tribe, the Achilpa. According to Achilpa myth, the Holy Being, Numbakula, "cosmocized" their territory, created their ancestors, and established their institutions. From the trunk of a gum tree Numbakula fashioned a sacred stake, anointed it with blood, and ascended by way of it into the heavens. The stake represented for the Achilpa the cosmic axis around which their society and world were ordered. The ritual value of the stake was decisive for

[39] R. H. Daubney, "Some Structural Concepts in Tillich's Thought and the Pattern of the Liturgy," 281–91.

[40] Mircea Eliade, *The Myth of the Eternal Return*, 15.

[41] Ibid., 17.

maintaining their world and determined by its inclinations the direction of their travels. On their journeys, the Achilpa carried the stake with them at all times. In this way, through all their travels they remained within their "world" and in communication with Numbakula. Should the stake be destroyed, catastrophe would ensue. It would mean "the end of the world," regression into chaos.[42] In another legend cited by Eliade, the sacred stake *is* broken. The tribe falls prey to an unbearable anguish, wanders aimlessly for a time, "and finally sat on the ground and allowed themselves to die."[43]

We begin to see that the world axis or sacred center is the *sine qua non,* not only of a meaningful, ordered world, but of contact and communication with the gods or God. The various leaning, disintegrating poles in Pollock's *Blue Poles,* and the vanishing center in his many arabesques, are eloquent testimony of the waning contact between twentieth-century man and the Infinite. The Cubists had desacralized space with their all-over painting. Now, in the Dionysian undifferentiated arabesques of Pollock, no demarcation of sacred from profane space is possible. In this symbolic chaos that harks back to "the time before creation," no god appears to order the world into day and night, heaven and earth, good and evil. With the vanishing of the center, the god's ladder of descent and ascent and means of contact with the world also vanishes. Hence, for a Christian Existentialist such as Kierkegaard, God can still exist only as One who is "Wholly Other," apart from man and the world, to be reached only by means of a radical, irrational, absurd "leap of faith." That man is now radically cut off from the transcendental realms, is succinctly expressed in Kierkegaard's words: "Existence captures the existing individual so that he must remain in existence, while the bridge of immanence and recollection is burned behind him."[44]

For many a twentieth-century woman and man, the Kierkegaardian "leap" proved impossible—Camus being a prime example: "If there is absurdity, it is in man's universe. The instant that this notion is transformed into a spring-board into eternity it is no longer related to human lucidity."[45]

[42] Eliade, "The Prestige of the Cosmogonic Myth," 7.

[43] Ibid.

[44] Søren Kierkegaard, *Concluding Unscientific Postscript,* 243.

[45] Quoted in Thomas Hanna, *The Thought and Art of Albert Camus,* 29.

The "death" of God had been prophesied by Nietzsche more than a century earlier.

Uttering prophetic warnings about what would happen in the 20th century, Nietzsche wrote a parable about the "death of God." It is a haunting story of a madman who runs into the village square shouting, "Where is God?" The villagers did not believe in God, so they laughed and said perhaps he had gone on a voyage or emigrated. The madman then shouted: "Whither is God? I shall tell you! We have killed him—you and I! . . . yet how have we done this? . . . Who gave us the sponge to wipe away the whole horizon? What did we do when we unchained this earth from its sun? . . . Whither do we move now? Away from all suns? Do we not fall incessantly? Backward, sideward, forward, in all directions? Is there yet any up and down? Do we not err as through an infinite naught? Do we not feel the breath of empty space? Has it not become colder? Is not night and more night coming on all the while? . . . God is dead! God remains dead! . . . and we have killed him!" . . . Here the madman became silent and looked again at his listeners. They too became silent and looked at him. . . . "I come too early," he said then . . . "This tremendous event is still on its way."[46]

This is a theme to which we shall return.

Given the broken center, God's death, and man's self-loss in Pollock's art, it is saved from the void, from utter nihilism, only by the pure vitality and intensity of his beautifully fluid, swirling, spiritualizing lines. Vitalism in art is a sure defense against nihilism. Here we encounter life in its purity—formless and undefined.

[46] Quoted by Walter Kaufmann in *Nietzsche*, 75.

7 The Goddess of Death

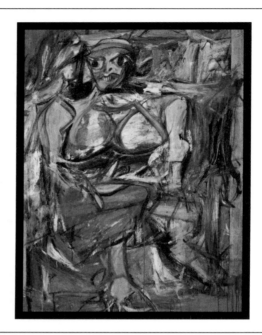

Willem de Kooning, *Woman 1,* 1950–52 See plate 3

Willem de Kooning (1904–1997)

The theme of dismemberment, only symbolized in Pollock through the disappearance of the center, achieves vivid dramatization in the art of Willem de Kooning (1904–1997). De Kooning is the only artist among the Abstract Expressionists who continued to make use of the human figure. In most cases, the figure was that of a woman, and the work that will engage our attention here is *Woman 1,* 1950–52 (plate 3). Thomas B. Hess, in an early study of De Kooning's art, wrote:

> De Kooning draws with ink, charcoal, pencils, brushes, palette knives, spatulas, pastels, crayons, oils on rag-paper, board, old pieces of wrapping paper and endless pads. In the relentless search for form,

drawings are cut apart and stuck together in different combinations, one face on another neck, legs on a different trunk. This creates a jump in space where the drawings meet, and de Kooning says that his wife first pointed out that this jump was carried over into the paintings themselves—like the "impossible" transition between the upper lip and the mouth in *Woman III*. Sliced drawings also are placed in the painting itself.[1]

What we have essentially is the sliced technique of Cubism being carried over in De Kooning as a method of working through "the willed chaos of possibilities."[2] The result is not only a "devouring art, chewing up drawings which enter into the bone and muscle of the structure,"[3] but an art in which the human figure is itself fragmented, indeed, dismembered! Parts of the body become readily interchangeable—a knee exchanges places with a shoulder, and so on.

It is part of the remarkable ambiguity of De Kooning's figures that we cannot tell whether he stands as an artist-hero at the boundaries of existence, seeking to rescue the human image from the extreme situation just before its final disappearance into the primal chaos, or whether his Woman is an image thrown up from psychic depths as a personification of the terrible side of the unconscious. As Neumann has repeatedly pointed out, "The unconscious, i.e., the psychic stratum from which consciousness arises in the course of human history—and in the course of individual development—is experienced in relation to this unconsciousness as maternal and feminine."[4] Because unconsciousness is experienced as hostile to consciousness and the ego, the

The symbolism of the Terrible Mother draws its images predominantly from the "inside"; that is to say, the negative elementary character of the Feminine expresses itself in fantastic and chimerical images that do not originate in the outside world. The reason for this is that the Terrible Female is a symbol of the unconscious.

ERICH NEUMANN

[1] Thomas B. Hess, *Willem de Kooning*, 20.

[2] De Kooning said, "Of all movements I like cubism the most. It had that wonderful unsure atmosphere of reflection—a poetic frame where something could be possible, where an artist could practice his intuition. I didn't want to get rid of what went before." Marika Herskovic, ed., *New York School Abstract Expressionists: Artists Choice by Artists*, 106.

[3] Ibid.

[4] Erich Neumann, *The Great Mother*, 148.

[5] Erich Neumann, *The Origins
and History of Consciousness,*
39–40.

[6] Erich Neumann, *The Archetypal
World of Henry Moore, 7.*

[7] T. Hess, *Willem de Kooning,*
26–27.

latter takes an ambivalent attitude toward the archetypal Feminine.
Neumann says elsewhere:

> The overwhelming might of the unconscious, i.e., the devouring,
> destructive aspect under which it may also manifest itself, is seen
> figuratively as the evil mother, whether as the bloodstained goddess
> of death, plague, famine, flood, and the force of instinct, or as the
> sweetness that lures to destruction.[5]

If we read De Kooning's art from the human side of the equa-
tion, the Existentialist interpretation will likely dominate, and we will
emphasize the threat of annihilation as the key to De Kooning's refusal,
during the Abstract Expressionist era, to give up the human figure. But
it seems to me the quality of grandiosity that distinguishes a work
such as *Woman 1* suggests that an archetypal interpretation is more
appropriate. These interpretations need not be mutually exclusive and
may even be essential to each other in understanding De Kooning. To
quote Neumann once more, "An Archetype, a primordial image, is
always polyvalent; it can express itself and be looked at in any number
of ways."[6]

Let me begin, however, with the archetypal interpretation. I see
in De Kooning's Woman a personification of the "terrible" aspect to
the Great Mother—that is, the Terrible or Devouring Mother. This
interpretation is suggested by a number of features in De Kooning's
art. Whereas Pollock's arabesque drips are of an ecstatic order, De
Kooning's paintings impress us with the frenzied manner in which the
paint is applied. Speaking of the manner in which De Kooning handles
paint, Hess quotes a line from Nietzsche: "The one indispensable psy-
chological condition for any esthetic doing is a frenzy of will—the
tremendous drive to bring out the main features."[7] Next to the over-
powering image of Woman, the thing that most immediately impresses
us about a De Kooning painting is the dynamic force and violence of
his brushwork and the primacy of the paint itself as the matrix within
which his Woman appears. Given the materiality of the paint—the

matter, matrix, *mater* (Latin for mother)—it is suddenly clear that the matriarchal image of *Woman I* and the dominant emphasis on the paint itself are mutually consistent and support the archetypal theme: Mother is Matter or Earth. Taken in the context of our theme of death and transformation, De Kooning's *Woman I* raises the question of the relationship of the Great Mother to the regenerative cycle. Unlike Pollock's arabesque, which is predominantly spiritual, De Kooning's art is predominantly materialistic in the earth-sense just indicated. The drama of Abstract Expressionism played itself out between these two poles of the creative impulse.

In *Woman I* we have one of the best examples of De Kooning's handling of the mouth as a *vagina dentate*. The "sliced" upper lip and protruding teeth become the "gnashing mask" of the Terrible Mother or Goddess of Death. In the language of symbolism, the mouth is also a womb—an "upper womb"—due to its physiological similarity to the vagina and because it is, in Neumann's phrase, "the birth-place of the breath and the word, the Logos."[8] When the emphasis is on the teeth rather than the lips, the emphasis shifts from the nurturing symbolism of the womb to its devouring aspect, and the Great Mother clearly becomes the Devouring Mother. As Neumann puts it, "The destructive side of the Feminine, the destructive and deadly womb, appears more frequently in the archetypal form of a mouth bristling with teeth."[9] Hence, De Kooning's Woman, as Mother and Matter, confronts us in her devouring aspect, and we are warned that we are about to be consumed. But what does it mean to be consumed by Matter-Mother? It means we are granted access to the dark interior region, the underground, where transformation takes place. To quote Neumann again:

> The underworld, the earth womb, as the perilous land of the dead through which the deceased must pass, either to be judged there and to arrive at a chthonic realm of salvation or doom, or to pass through this territory to a new and higher existence, is one of the archetypal symbols of the Terrible Mother.[10]

[8] E. Neumann, *The Great Mother*, 168.

[9] Ibid.

[10] Ibid., 157.

The Terrible Mother is one who takes all forms back into herself by devouring them, by causing them to disintegrate. She is synonymous with death and often takes on the role of Goddess of Death. We who are embraced by her—and all things are!—are dismembered through mastication. Hence, the dismemberment theme, from whichever side it is approached—the Existential or the archetypal—is part of the symbology of *Woman 1.*

Also in *Woman 1,* the eyes figure prominently in the meaning of the work (plate 4). Hess notes that De Kooning used thumb tacks for eyes in a number of his drawings, which may have provided the generative insight that is carried over into *Woman 1* and most of the women of that period of his work. My friend Adrienne Hart pointed out to me the striking similarity between these eyes and the large eyes of the votary statues of Sumerian art. Most folks know the Edgar Alan Poe line: "The eyes are the windows of the soul." The eyes of De Kooning's *Woman 1* impart to us something of that primal terror that being devoured evokes. They have about them a Little Orphan Annie quality, yet are more sinister and unsettling because they seem to peer out at us from some unknown, primordial realm. The left eye addresses us directly with a hypnotic penetration, while the right eye carries us off into the distance, off the left side of the canvas. The left side represents the sinister and unconscious side of the body. These eyes pierce us to our very core and conduct us, willingly or not, into the primal, unconscious depths.

One other feature of *Woman 1* is critical to our understanding of the symbolism of this work. It is the emphasis upon a very large torso and large breast, to which diminutive arms and legs are attached. Such an archetypal representation of the Great Mother is very ancient, as seen in the Venus of Willendorf (ca. 24,000–22,000 BCE; plate 5).[11] The parts of the female body that have to do with fertility are emphasized, while the limbs—which have a male, phallic significance—are largely ignored (perhaps again suggesting an element of the castration symbolism associated with the dismemberment motif). Hence, while De Kooning's *Woman 1* appears to us as the Devouring Mother who

11 According to Stephen Polcari, De Kooning said the *Venus of Willendorf* gave him the idea for *Woman 1.* See S. Polcari, *Abstract Expressionism and the American Experience,* 285.

takes all things back into herself, she still retains her fertility significance! As our opening quote from Eliade suggests (see page 102), the Earth-Mother who requires sacrifice does so in order that the generative life process may continue. Hence, the Terrible Mother is also the Great Genetrix—the Mother of Life.

I shall pass on an Existentialist interpretation of De Kooning's retention of the human (female) figure in his art. To suggest that he wished to save the human being from the void of annihilation is directly contrary to the notion that all things must be dismembered and devoured and pass through the body of the Great Earth Mother in order to be reborn. Sam Hunter, for example, takes the more Existential approach, seeing in the artist the hero of resistance: "Through his poetic creation, the artist is enabled to transcend meaningless experience, and, in a sense, redeem existence. His work seems to represent a heroic attempt to assert himself in the region of the *nihil*." In my view, De Kooning comes closer to the role of the hero who has accepted death in order to be reborn *ex matria*. By retaining the image of the Great Mother, albeit in her Terrible aspect as the Goddess of Death, De Kooning has kept open for his fellow abstractionists and for our age the possibility of regeneration. For without the archetypal Mother, no transformation or rebirth is possible. That one artist should have chosen to retain her in an era of despair over man's destiny seems to me more than an accidental sign that transformation lies at the roots of this age.

8 Deathwatch

One must resign oneself to dying in a dark prison in order to find rebirth in light and clarity.

J. E. CIRLOT

Six foot box. Six foot under.

TONY SMITH

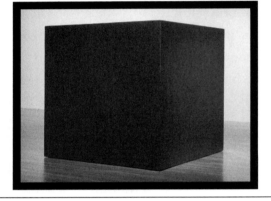

Tony Smith, *Die,*
1962
See plate 6

Tony Smith (1912–1980)

The next work to concern us is *Die,* 1962 (plate 6)—a steel cube 6' × 6' × 6' by Tony Smith (1912–1980). With this work we move from painting to sculpture, from Abstract Expressionism to Minimal Art. The reductionism of Minimal Art seems a natural development from modern abstraction, especially that aspect known as Suprematism (originated by Kazimir Malevich in 1915). The effort to simplify and clarify art and sculpture led, on the one hand, in a sculptor such as Constantin Brancusi, to a mystical emphasis upon essence and transcendental experience; and, on the other, to a concern with the "object quality" of the artwork. Mondrian, a student of Eastern and Western philosophies and a member of the Theosophical Society, also influenced by Rudolph Steiner and Neo-Platonism, sought in his mature art, through use of verticals and horizontals and primary colors, "to express the unity that was the final destination of all beings, the unity that would resolve harmoniously all antitheses between male and female, static and dynamic, spirit and matter."[1] Mondrian's principal

[1] Maurice Tuchman, ed., *The Spiritual in Art: Abstract Painting 1890–1985,* 103. See the discussion of Mondrian, 96–104.

aim was to express *transcendent states of being by concrete means,* leading critics such as Edward Lucie-Smith to mistakenly say Mondrian "had no truck with rhetoric or mysticism; for him, the painting was merely an object which existed in its own right, and which stood in no real need of further exegesis."[2]

With Minimal Art, the all-important element is not the making or creative process but the selection of an object that, in the case of sculpture, is usually handed over to a fabricator for construction—the artist being concerned solely with the conceptual idea. Minimal Art, therefore, leads logically enough to Conceptual Art—that is, an art consisting of ideas only, having no physical embodiment. Minimal Art is intentionally dispassionate and unconcerned with the sensations and perceptions of the viewer. Edward Lucie-Smith comments, "The ingrown preoccupation with the grammar of forms displayed by the minimal artists finds a parallel in the work of modern linguistic philosophers, who may crudely be said to have withdrawn from life into language."[3] Minimal Art itself constitutes a withdrawal from personal and cultural life and serves as a wake or "deathwatch" over the creative life of our age. In denying vitality, symbolism, and meaning, Minimal Art became the symbol of minimal life. The minimalist position is well represented by E. C. Goossen, when he writes in *The Art of the Real*:

> Today's "real" . . . makes no direct appeal to the emotions, nor is it involved in uplift. . . . The contemporary artist labors to make art itself believable. Consequently the very means of art have been isolated and exposed, forcing the spectator to perceive himself in the process of his perception. The spectator is not given symbols, but facts, to make of them what he can. They do not direct his mind or call up trusted cores of experience, but lead him to the point where he must evaluate his own peculiar responses. Thus, what was once concealed within art—the technical devices employed by the artist—is now overtly revealed; and what was once the outside—the meaning of

Surrounding certain recollections of our inner self, we have the security of an absolute casket.
GASTON BACHELARD

No one sees me changing. I am my own hiding place.
JOË BOUSQUET

[2] Edward Lucie-Smith, "Minimal Art," 244. Mondrian himself said, "*I got everything from the Secret Doctrine* (Blavatsky)." He gave talks on his own art to meetings of the Theosophical Society and lamented that even they did not understand him.

[3] Ibid., 252.

its forms—has been turned inside. The new work of art is very much like a chunk of nature, a rock, a tree, a cloud, and possesses much the same hermetic "otherness."[4]

This minimalist attitude is cited precisely because it is my intention to challenge it and show the powerful symbolism at work in a seemingly simple work such as Tony Smith's steel cube, *Die*. Writers like Goossen demonstrate by their remarks a complete ignorance of the symbolism of geometry, the psychology of forms, and the dynamics of space and energy. Otherwise they would realize no form is, has been, or ever can be a "pure object" free of symbolic meanings. Smith himself suggested his "minimal" sculptures have deeper meanings:

> Most of my forms are based on the three proportions that are derived from the cube. . . . I was painting the cube in 1932. I've always liked solids. I like the sphere too, and am more interested in the cube or sphere than in the cylinder or cones, where there are more elements to be decided. . . . I'd go to a cube instead of a sphere though, because I'm civil-minded. A sphere is unnecessarily exclusive; it's the most intense form, turning everything else *out*. Flat sides allow things to exist inside as well as outside. The sphere is more of a fortress. . . . You can move around the cube, get in the shadow, see the planes; it's a social form.
>
> *Die* is a complicated piece. It has too many references to be coped with coherently. . . . The actual size of *Die* was determined by Leonardo's drawing [the Vitruvian Man]. . . . Auden has written, "Let us honor if we can the vertical man, though we value none but the horizontal one." Six foot box. Six foot under.[5]

The references to Leonardo da Vinci's *Vitruvian Man* and "six foot under" make clear that *Die* carried for Smith himself the symbolism of death as well as that of man in all his unfathomed mystery. Like all true symbols, the meaning of the cube faces "below" and "above." Let us explore its symbolism historically, psychologically, and metaphysically.

[4] E. C. Goossen, *The Art of the Real*, 7, 11.

[5] Quoted in Lucy R. Lippard, "Homage to the Square," 53.

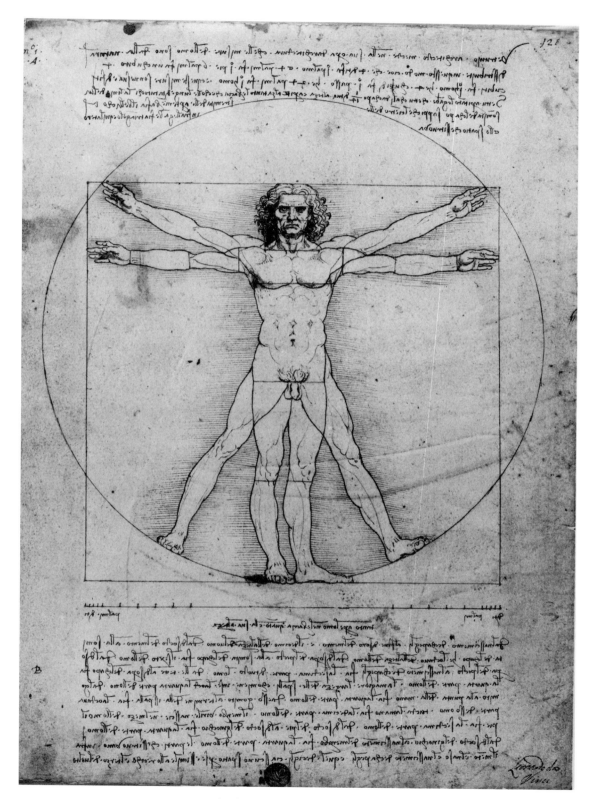

Leonardo da Vinci, *Vitruvian Man*, ca. 1492

From ancient times the square and cube have stood as symbols of the earth, the material universe, solidity, stability, the four directions of space, the four elements—earth, water, air, and fire—the cornerstone of the temple, and the throne of the gods. The cube is six-sided—six being the number of form-manifestation and the medium through which consciousness is unfolded. When tripled, 666 is the number of the Beast or materialism. It is also the number of the sixth plane of manifestation—the plane of desire that produces physical manifestation. Matter serves as the tomb of the Spirit, obscuring it during cycles of manifestation, and stands for the darkening of the Light.

Material density is one of the first meanings of the cube. It refers to man buried in matter, man who must die, as opposed to the spiritual man who, arising from the tomb of matter, is spiritually free. When unfolded, the cube becomes the cross—the symbol both of man himself and of all manifest being. With arms outstretched, man becomes a cross, and in astrological terms he is crucified successively upon the fixed, mutable, and cardinal crosses over the long course of his evolutionary unfoldment from brute man to divine man. The fixed cross symbolizes the Hidden Christ, the mutable cross the Crucified Christ, and the cardinal cross the Risen Christ.[6]

The cube unfolded
into a cross

[6] See Alice A. Bailey, *Esoteric Astrology*, 501–75.

The sphere concentrates all forces inward into its center, and its surface is a geometric symbol of unity and inclusiveness. With the cube, the emphasis is not on unity but on multifacetedness. Consciousness is not drawn inward toward the center but halted by surfaces. Its surface symbolism concerns outer or external realties. As we noted earlier, our materialistic age has emphasized surface-seeing. A box with a lid and keyhole immediately poses for us the mystery of *opening* and the symbolism of the *interior.* As Gaston Bachelard says, "The power that opens and shuts must possess the power of life, human power, or the power of a sacred animal."[7] But Tony Smith's *Die* is a cube without keyholes or openings. We are shut out, and by being shut out we are denied access to the inner mysteries of life. When Smith suggests that the cube is a "social form" and the sphere "exclusive," has he not perhaps replaced the inclusiveness and unity of the sphere, with its all-powerful unifying center, with a form symbolic of society's materialism and alienation—a form that excludes us from the interior world of meaning, a form that indeed symbolizes death?

All sides of a cube being equal, it lacks dynamism. It cannot move. It is a static form. In all living things, from the simplest cell to the universe itself, the source of life is found in the nucleus or at the center. With the cube we are "walled out"—denied access to its interior, where the germ of life should reside. Even though there is no disequilibrium creating tension in a sphere, still its rounded surface flows! It is alive. With the cube there is no flowing. All is stasis. It is a symbol of death, a tomb.

Yet, mysteriously, it is a death-symbol that promises the very thing it denies us. Any extreme in nature will evoke its antithesis. So totally excluded are we from the inner realm by the cube that a dialectical tension is set up in consciousness. Says Bachelard, "Outside and inside are both intimate—they are ready to be reversed, to exchange their hostility. If there exists a border-line surface between such an inside and outside, that surface is painful on both sides."[8] By pushing against the alienating surfaces of *Die,* we suddenly find ourselves no longer outside, but inside. Denied access to the realms

[7] Gaston Bachelard, *The Poetics of Space,* 82.

[8] Ibid., 217–18.

of meaning and vitality our whole being demands, we suddenly find ourselves among the dead. Consciousness, having pressed relentlessly by way of imagination to get beyond surfaces, experiences a sudden inversion. No longer shut out, we have *become* the cube. We are now closed in, and the symbolism of the cube shifts to that of enclosure. The limitations on consciousness experienced outside the cube are now experienced from within it. We are boxed in, cornered, trapped by walls without openings or exits. Inside, our thought darkens and deepens into an infinite Naught. The interior of the cube (the material world) is one of darkness and blindness. We are shut off from the light of life lying beyond in openness. To be boxed in means having no place to go. Our sense of limitation, of imprisonment, is now complete, and consciousness is driven to its Zero Point. The inside of the cube, like the outside, is one of *stasis,* death. The dialectical interplay of inside and outside comes to the same thing. Life vanishes, and we lie imprisoned by death—immobile, unconscious, trapped in utter darkness. As we shall see later, where there is no light, consciousness ceases, and all passes into Cosmic Night.

Yet another dialectical inversion now takes place. We receive a hint of it from Bachelard's observation, "When the poet closes the casket, inside it, he sets a nocturnal world into motion."[9] The darkness, in which nothing appears, deepens into infinity. All becomes intimate and dimensionless. But are these not the very qualities of true poetic imagination, to be both intimate and dimensionless? Bachelard says, "The imagination can never say: was that all, for there is always more than meets the eye."[10] The nocturnal darkness of the world of death turns out to be the hiding place of the greatest treasures. In Edgar Allan Poe's story "The Gold-Bug," when the casket is opened, it is found to be filled with jewels of inestimable value. The "jewels" of the deep are those that come from shattering the limits of our finitude, accomplished by means of a darkness and death where all limits fade away. "We shall never reach the bottom of the casket," says Jean-Pierre Richard.[11] To dwell in the finite world and have a finite consciousness means having only finite access to the forces of life. Death shatters

[9] Gaston Bachelard, *The Poetics of Space,* 87.

[10] Ibid., 86.

[11] Quoted in Bachelard, *The Poetics of Space.*

finitude and opens a passageway into the infinite that allows us to explore the inexhaustible depths of our unbounded being—the contents of the unconscious, giving to them a vastly heightened potency. To encounter "the hidden in men and the hidden in things" is to "enter into this strange region of the *superlative*," says Bachelard, "which is a region that has hardly been touched by psychology."[12]

We have now the pent-up soul whose symbol of death and containment is the cube-tomb. Boxes and tombs contain mysteries. And the first mystery of containment is *stillness*. As finite, living mortals we seem to lack a capacity for stillness. Our bodies and thoughts race on at full speed, wandering the labyrinth of confusion in which our lives are lived. Solitude, quietness, stillness—these are alien to all but a few. Yet only in stillness can the Infinite be contacted and known.[13] Death brings a stillness that, for a time at least, allows connection with the eternal Ground of Being. As the psalmist says, "Be still, and know that I am God" (Psalm 46:10). "Like can only be known by like" (Empedocles). "Only spirit can understand spirit" (Helvetis). If the soul would know the Infinite it must know stillness, for the Infinite is everywhere at once and requires no movement.[14] Most people are unable to achieve stillness at will. Death temporarily achieves it for us, allowing us a period of rest in the depths of our being. Let me attempt a description of what occurs, keeping in mind that we are speaking symbolically of a deeply mysterious process.

[12] Gaston Bachelard, *The Poetics of Space,* 89.

[13] As Titus Burckhardt points out, the square and cube often take on the reverse symbolism of the immutable Principle, the eternal Reality. See Burckhardt, *Sacred Art in East and West,* 25.

[14] For the best discussion of the relation of the finite and infinite that I know, see Alan Watts, *The Supreme Identity,* 45–73. Speaking of the human effort to think of the infinite in finite spatial terms, Watts says, "But expand, prolong, magnify, and multiply as we may, we are not one fraction nearer to the true infinite than when we began, for the terms of time and space are not applicable to the infinite. . . . Regarding it from the standpoint of space, we shall be able to say that the infinite exists in its entirety at every point of space. Or, to put it in another way, from the standpoint of the infinite every point of space is absolutely *here*. . . . In reality there can be no possibility of the infinite consciousness knowing things at a distance."

Death, like an empty cup, opens itself to receive new life. Negatively polarized to life, it opens itself, becomes magnetically receptive, acts as an open door for the entrance of new life from above. Death represents an out-breathing of the finite self to make way for the in-breathing of more of the Infinite Self. All this occurs at the nadir of existence, when we die to our limitations. We shall return to these events at the nadir several times in our discussion.

With the infusion of new life from the Ground of Life, the process of gestation and regeneration begins anew. All this takes place within the "womb" that death has made, for the tomb of the manifest is also the womb of the unmanifest—the secret hiding place of life in its latent state of boundless potentiality. The tomb of matter, of which the cube is an ageless symbol, is also the womb of the spirit. It provides the confining space required for self-fecundation. We'll return later to this point.

The cube, finally, is a symbol not only of materiality and entombment but also of spiritual transformation. The cube itself is formed by lifting one square above another. In occult symbology the upper square represents a spiritualization of the lower square, which is itself a fourfold differentiation of that unity of the Spirit produced by "squaring the circle"—a symbol well known to Masons. Dion Fortune has pointed out that the sublimation of any force squares its potency.[15] The cube, as a symbol of transformation, also symbolizes the squaring of all powers through regeneration. It represents both containment and transcendence. Referring to the cube as "eight-sided," with seven being the number of the manifest universe, A. S. Raleigh maintains that the square symbolizes *the withdrawal of the manifest universe back into spirit,* adding, "The Cube [is] the symbol of the perfected universe, as well as the perfected man."[16] When meditated upon, the cube can also impart a sense of strength and stability and impose upon us a sense of honesty ("fair and square"). In this way, it becomes the cornerstone of the temple upon which, later, the higher life and the spiritual man can securely stand. In this sense the cube is the throne of gods. How rich and varied are the meanings of all true symbols! Tony Smith did not mean for *Die* to be viewed like a painting on a wall, but to be a work

[15] Dion Fortune, *The Cosmic Doctrine,* 108–9.

[16] A. S. Raleigh, *Occult Geometry,* 69. Hence the symbolism of the cube as the throne of the gods upon which ancient deities are often shown seated. This idea is also found in the use of the square and cube in determining the architectural structure of temples and in the use of the square in determining the "true" proportion of the Buddha image. See Burckhardt, *Sacred Art in East and West,* 176–77.

that engages us, forcing us to walk around and observe it from many angles, just as we have now done with its symbolism. Manifestation, materialism, death, waiting, imprisonment, darkness, isolation, crucifixion, transformation, justice, and empowerment, the immutability of the eternal Principle—these are just a few of *Die*'s meanings. Smith may not have had all of them in mind, but he was attracted to this ageless symbol by some half-known power in his own soul. It held for him, as its symbolism holds for all of us, a hypnotic power that speaks to our unconscious depths.

In terms of cultural analysis, we are dealing with the midnight hour of gods and men, when the old is dead and the new not yet born, and all resides in a time of waiting. T. S. Eliot and Heidegger contributed to this notion. For Heidegger, ours was the *Between* time—the time when the gods had fled:

> It is the time of the gods that have fled *and* of the god that is coming. It is the time of *need,* because it lies under a double lack and a double Not: the No-more of the gods that have fled and the Not-yet of the god that is coming.[17]

In T. S. Eliot's poetry we also find this sense of a time of waiting:

> *I said to my soul, be still, and wait without hope*
> *For hope would be hope for the wrong thing; wait*
> * without love*
> *For love would be love of the wrong things; there is*
> * yet faith*
> *But the faith and the love and the hope are all in the*
> * waiting.*
> *Wait without thought, for you are not yet ready for*
> * thought;*
> *So the darkness shall be the light, and the stillness the*
> * dancing.*[18]

[17] Martin Heidegger, *Existence and Being*, 289.

[18] T. S. Eliot, *The Complete Poems and Plays*, 126–27.

By *Deathwatch,* I mean the period of waiting that contemporary man has experienced following the "death of God." It is not without interest that the two chief spokesmen for the time of waiting were an Anglican poet and a philosopher who sought the way back into the ground of metaphysics. The death phase of the transformation cycles is necessary and unavoidable, individually and culturally. Yet it is but a stage in a journey we have still to fully explore.

9 Nihilism or Pregnant Night?

Ad Reinhardt, *Abstract Painting*, 1960–61
See plate 7

Ad Reinhardt (1913–1967)

The late Munich clown, Karl Vallentin, once enacted the following scene: The curtain rises on a stage that is totally dark except for a small circle of light cast by a solitary street lamp. Vallentin, with a long-drawn and worried face, walks round and round in the circle of light, searching desperately for something. "What have you lost?" asks a policeman who has entered the scene. "The key to my house," replied Vallentin. The policeman joins in the search. After a while, finding nothing, the policeman asks, "Are you sure you lost it here?" "No," answers Vallentin, pointing to a dark corner of the stage, "over there." "Then why on earth are you looking for it here?" "There is no light over there," says Vallentin.[1]

Earlier we quoted the young Camus: "We believe that the truth of our century cannot be reached without going all the way to the end of our own drama. If the epoch has suffered from nihilism, then it is not in ignoring nihilism that we shall find the ethic that we need." Yet Camus failed to carry through the nihilist project that this

[1] Erich Heller, *The Disinherited Mind.*

statement proposed, turning instead to a philosophy of revolt against the world's indifference to man. This subtle but sudden shift from nihilism to revolt is reflected in Camus's first novel, *The Stranger*, which explores the absurdity of a meaningless existence only to end in an outburst of revolt for which the character of the hero failed to prepare us. Camus, like Vallentin, decided to look for the lost key to the house of meaning not in the darkness of nihilism but in the small circle of light provided by human courage, pride ("There is nothing equal to the spectacle of human pride"), and the fraternity of the human condition. Yet nihilism is a fact of experience. Witness Hitler's murder of six million Jews, the National Guard killing of Kent State students, the genocide in Cambodia, Rwanda, and Darfur, and the growth of global terrorism. Hence, the nihilist experience *must* be dealt with. If we would understand human consciousness, we must follow it to its Zero Point. We must look for the key in darkness, as darkness holds the meaning of light, life, and consciousness.

The artist to whom we turn now is Ad Reinhardt (1913–1967), and the work that concerns us is *Abstract Painting* (plate 7), of which numerous copies were made between 1960 and 1966.[2]

A contemporary of the Abstract Expressionists, Reinhardt moved increasingly into formal, geometric, or "pure" painting, working chiefly with colored rectangles and squares. Though he cannot be said to have fathered Minimal Art, which had its roots in color-field painting, Reinhardt did anticipate Minimal Art and remains, in my view, the most radical and thoroughgoing "minimalist" modern art has produced. Reinhardt arrived at his black paintings of 1960 by a process of elimination. He said, "The important thing is the painting out. If you want to be left with nothing, you can't have nothing to begin with."[3]

[2] For more than a decade I knew and had various associations with Reinhardt, during which time we carried on running arguments about art, as we were always at opposite poles in our view of its nature and meaning. Two weeks before Reinhardt's death, I spent a couple hours with him in his studio, where I counted eight black paintings, all identical. One of the black paintings is in the collection of the Museum of Modern Art, New York.

[3] Quoted in Lucy R. Lippard, *Ad Reinhardt: Paintings,* 22.

Reinhardt always considered himself a classicist, not a Romantic, and had little sympathy for the postwar expression of angst by Abstract Expressionists, becoming their self-appointed gadfly. He believed that by eliminating color from art, one eliminated emotions; by eliminating form, image, and symbolism, one purified the picture, removing references beyond the artwork to a world of objects and meanings. His monochrome paintings were an effort to escape fragmentation into unity. Like the Minimalists, Reinhardt held that a painting simply *is*. His philosophy is well expressed in the words of Alain Robbe-Grillet: "Now, the world is neither meaningful nor absurd. It simply is."

In addition to painting, Reinhardt wrote numerous aphorisms concerning his philosophy of art. These are typical:

> Artists-as-Artists value themselves for what they have gotten rid of and for what they refuse to do. . . . Less is more. . . . Darkness in art is not darkness. Light in art is not light. . . . Vision in art is not vision. . . . Mystery in art is not a mystery. . . . Wisdom in art is not wisdom. . . . The meaning of art is not meaning. . . . The spirituality of art is not spirituality. . . . The absolute in art is not absolute.[4]

With Reinhardt and Minimal Artists in general, a problem of interpretation arises. Both hold the view that art simply *is,* that it is neither symbolic nor meaningful, and that engaging in "interpretation" is an illegitimate enterprise. Neither seemed to understand that all forms follow exact laws of expression, and the task of the interpreter is not to make something else out of the artwork but, rather, to engage in phenomenological meditation on the work *as given,* observing those states of consciousness in himself to which the artwork gives rise. The elucidation of these states is the essence of interpretation. It concerns the action of the laws of form, color, light, imagery, symbolism, style, and so forth upon human consciousness. The claim of noninterpretability by the priests of Minimal Art is no more than an appeal for minimal consciousness.

[4] Quoted in G. Battcock, ed., *The New Art,* 200–9.

We are entitled to critical evaluations of the quality, cultural relevance, and so on of an artist's work. Such is Hilton Kramer's critique of the black paintings, which he calls "the most genuinely nihilistic painting I know." He continues:

> It is doubtful if any genuine artist of our time has given us a lower estimate of art's capacities than that suggested by Reinhardt's current work. A style born of a deep contempt for art's involvement with the non-aesthetic ends with an equally profound contempt for art itself. The self-doubt, at times verging on self-hatred, which many artists feel about their role today, has, in Reinhardt's work, been projected onto art and made into a style and an aesthetic commodity. Like many nihilist polemics, Reinhardt's art is a cry of despair disguised as a Utopian manifesto.[5]

I too see nihilism in Reinhardt's art, but I regard his search for the Zero Point in art as a viable creative expression of man at the extremities. That there is none of the Kierkegaardian "sickness unto death" in Reinhardt's despair makes it all the more interesting. We saw in Pollock's art, standing on the brink of the void, that vitalism in art is a defense against nihilism. Reinhardt, consequently, is the more thoroughgoing nihilist—cool, aloof, and thoroughly committed to the elimination of life from art: "Art is always dead, and a 'living' art is a deception. . . . The Love of Life is the Kiss of Death (in art)."[6] Before proceeding to the art itself, one final point worth noting about Reinhardt's work and Minimal Art in general is the "lack of energy" (Lucie-Smith) or *inertia* of the work. Lucy Lippard says of Reinhardt's use of the square, "The square is patently static, man-made, lifeless, inert and inactive. . . . [For] the younger rejective artists, inertia has become an aesthetic desirable as dynamism once was."[7]

To get at the significance of Reinhardt's *Abstract Painting,* we must first discuss the nature of color, light and darkness, and blackness. One of the great theoreticians of color, Edwin S. Babbitt, says, "Color reveals the very dynamics of nature and man, and the most exquisite

[5] Quoted in Lucy R. Lippard, *Ad Reinhardt: Paintings,* 12.

[6] Quoted in Lippard, *Ad Reinhardt: Paintings,* 12.

[7] Lippard, *Ad Reinhardt: Paintings,* 11.

and interior principles of force which reach far into the mysteries of mind and matter."[8] Most everyone has experienced in some measure the sense of self-loss that accompanies being in near-total or total darkness.[9] Many writers, from Charles Baudelaire on, have attributed the angst and melancholia of the Gothic temperament to the dark climate of northern Europe. One of the most interesting discussions of light and darkness is that of Rudolf Steiner, the Goethe scholar and younger friend of Nietzsche. In his book *Color,* Steiner writes:

> We feel an inner kinship between the light and our own essential being. At night, if we wake up in dense darkness we feel we cannot reach our real being; . . . what we receive from the light is a "coming to ourselves." . . . There is a definite connection between the "I", our spiritual being, and this experience of the light shining through us . . . the light gives us something of our own spirit.
>
> Now submerge yourself in black; you are completely surrounded by black—in this black darkness a physical being can do nothing. Life is driven out of the plant when it becomes carbon. Black shows itself alien to life, hostile to life; when plants are carbonized they turn black. Life, then, can do nothing in blackness. And the soul? Our soul life deserts us when this awful blackness is within us. . . . *Black represents the spiritual image of the lifeless.*[10]

Our consciousness, as Schopenhauer pointed out, is the only thing that is *immediately given,* and it is with consciousness that the sense of self—the "I"—is born. We could revise Descartes to say, *I am conscious; therefore, I am.* Now, light has a direct relationship with our consciousness and its illumination. More than a metaphoric relationship is involved in this linking of light and consciousness. But as our present concern is blackness, not light, we shall hold this discussion until we reach Gottlieb's *Blast 1.*

Colors are energy vibrations, with red at the low end and violet at the high end of the color scale. White, the union of all colors, gives us the highest-energy vibration, and black, the absence of all colors,

[8] Edwin S. Babbitt, *The Principles of Light and Color,* 4.

[9] My only experience of absolute darkness took place in Mammoth Cave, Kentucky. Deep beneath the earth, with all lights off, the darkness was absolute. Even holding one's fingers within a fraction of an inch of the eyes, one could see absolutely nothing.

[10] Rudolf Steiner, *Color,* 20–21. Steiner's work on color had a major influence on a number of artists, including Mondrian.

imparts the least energy. Hence the association of black with inertia is quite appropriate, and it is no accident that we associate black with death and mourning. Nietzsche has some cryptic observations about the use of black in formal attire, suggesting we're merely dressing for the grave! Evolution is concerned with the growth and expansion of life, with the ascent of life into ever-higher forms of expression. In man, this evolution is often seen as a progressive enlightenment, leading eventually to a supreme Illumination. Sri Aurobindo typifies this view:

> In the ascending order of the evolution we reach a transition in which we see the light, are turned toward it, reflected in our consciousness and one further step carries us into the domain of the Light. The Truth becomes visible and audible to us and we are in immediate communication with its messages and illuminations and can grow into it and be one with its substance.[11]

Reinhardt's desire to eliminate all color and light from his late art (he used only flat black to prevent any sheen or light reflection) results in an anti-evolutionary—which is to say, a *devolutionary*—art. In the language of mystical symbology, his black paintings may be said to follow the retrograde or "Left Hand Path." Darkness is not simply the absence of light; in the energy structure of nature it is *negatively polarized* to light. It drags us down, devitalizes us, and renders consciousness inert.[12] Viewed in the context of the "science of energy," such art would be seen for what it is—a dangerous use of negative forces that can adversely affect the sensitive evolving consciousness of mankind! Edward Lucie-Smith viewed as "alarming" the "inertia to be found in Minimal Art" and the implications of this inertia "as a base for the future."[13] What we have in Reinhardt's *Abstract Painting* is a kind of devolutionary "black magic" that is anti-life, anti-evolution, anti-consciousness. "Less is more." "Darkness in art is not darkness. Light in art is not light."

As philosophers are wont to say, "At night all cows are black."

[11] Sri Aurobindo, *The Mind of Light,* 117.

[12] Far more people who die natural deaths die at night than during the day. Recently, a nurse told me that of all her dying patients, only one had died during the daylight hours, all the remainder dying at night. Prana, or the life-force, is at its lowest during the night hours.

[13] Edward Lucie-Smith, "Minimal Art," 254.

In other words, in total darkness all things are the same, which is to say nothing stands out or *appears* in its existence. Darkness swallows all in nonbeing. In his desire to eliminate all imagery from his art, Reinhardt gave expression to the *anti-creative* impulse. Visualization or image creation is the means by which man gives form and order to his world and brings forth what is new. Expressed another way, to oppose imagery is to oppose *seeing*. It devalues vision itself. Where there is no vision, creativity becomes impossible, for *expanding seeing* is the field of all creative activity. To absorb all images in blackness is to take away the vision that is essential to the creative life. Where creativity ends, life ends—its flow stops. Hence Emerson's dictum: "Where there is no vision, the people perish." Light is a necessary condition for seeing, for images, for creativity, for life, for evolution!

In Reinhardt's black paintings we find neither vitality of vision nor desperation in the face of the void. Here, darkness is fondly and dispassionately embraced. Nihilism is clearly the preferred state. We have come to the End, the outer limits of the extreme situation, where death is affirmed without passion or fear, without hope or despair, in the calm certainty that it is the final end of all existence. When Reinhardt died at age fifty-four after eight years of painting nothing but black squares, I couldn't help thinking to myself that he'd "painted himself to death"—that in embracing death in his art, he had also embraced it in his life. It was Otto Rank, as I recall, who said all men die as they have lived. Some interesting examples that support this thesis are Artur Rimbaud, Marcel Proust, Kafka, Ernest Hemingway, Dylan Thomas, Pollock, and Camus.

An art critic should be clear-sighted, but not dispassionate. In the interest of humanity, it is his obligation in studying works of art to point out the pro-life and anti-life forces that they express. As Clifford Still said, "Let no man undervalue the implications of this work, or its power for life, or for death, if it is misused."[14] Works of art that are pro-life enhance the evolution of man and consciousness, while anti-life works retard consciousness and often serve as vehicles for the release of demonic forces within the psyche. Hence, I have emphasized

[14] Quoted in G. Battock, ed., *The New Art*, 204.

the retrograde path followed by Reinhardt's black paintings, and their nihilism. But it seems the sword of creativity is always two-edged. The black paintings also show us the *limits of nihilism*. That these black paintings exist shows us that nihilism cannot be expressed nihilistically. Without some creative work standing as close to the void as its existence can endure, the *nihil* would remain "voiceless" and unknown. Just as the unconscious can be known only by the symbols of itself it "throws up" into consciousness, so the abyss can be known only by its power to give birth to creative symbols of the abyss! Yet, in the very act of stimulating creativity, the encounter with Nothingness proves that it is not nothing after all! It, too, is a creative force that serves the generative life by limiting its possibilities. It sets the boundaries of finitude and announces the death of all that is finite. But the void lacks *ultimacy*. We can speak of "finite nonbeing," as when we say that such-and-such does not exist or has ceased to exist. But we can never speak of "infinite nonbeing," since the fact that something exists precludes the possibility of nonbeing ever being total. Nonbeing or nihilism has its limits. Like every true symbol, it embodies the thing it signifies—limitations. Within these limits, we shall find the key to that "renaissance beyond nihilism," as Camus calls it, that lies beyond the twentieth century's experience of the void.

Reinhardt, in his black works, has brought us as close to the Zero Point as anyone in the art world. Nihilism, death, night, the void, utter darkness—by whatever name one chooses to speak of it, the Zero Point marks the nadir of human finitude. At the Zero Point darkness deepens into infinity.[15] The death of which it is the symbol shatters all limitations. It thereby becomes the vehicle of openness, like the zero—0—with its *open center*. Infinite depth and openness—these are the rewards of death or the annihilation of the finite. Once nothing remains to block the way, at the Zero Point, new life is free to flow in from below or above, or through the center itself, and impregnate the void. *Where nothing is, something new can always be born!*

Until now I've refrained from mentioning the almost imperceptible cross appearing in Reinhardt's black paintings. Through the center of

[15] To say that nonbeing is finite but the darkness at the nadir of existence is infinite appears self-contradictory. But if we say, for example, mermaids do not exist, we have an example of finite nonbeing. However, were we to set out in search of these nonexistent creatures, our search could go on forever and find nothing. The nonexistence of mermaids is finite, while a fruitless search to find them would prove infinite.

these works passes a Greek cross, so dark, so near the blackness of the field in which it lies, that even in good light one must look carefully to observe it (it is completely invisible in most reproductions). Yet it is there. Ironically, Reinhardt, who opposed all symbolism, ends by giving us a profound symbol—a symbol of *generation in darkness*. For the cross—the union of opposites—symbolizes generation, creation, manifestation, birth, the coming into being of the Unmanifest. This procreative significance is retained in our use of such terms as *cross-breeding* and *cross-fertilization*. The subtlety with which the cross makes its appearance in the darkness of these works may suggest the difficulty Reinhardt had in acknowledging the implications of his own reductive vision. In all of nature, the sacrifice of life is the generative cause of new life. Yet this subtlety is intuitively correct, for generation takes place in darkness and is imperceptible to our finite eyes. Perhaps this is why we associate mystery with darkness and regard as magical results whose causes we cannot see.

We must conclude, then, on a note of profound mystery and paradox. Life, Light, and Consciousness have always had their birth in the Womb of Darkness, which, in a sense, is the eternal "virgin" womb. For darkness, in its infinite depths, conceals from our sight the mystic union in which what is dark and lifeless gives birth to Light and Life. We ourselves live and are conscious, but we can never know from what profound depths our own being and seeing is given to us. We know only that night, death, and infinite depth form the consenting womb of all our births and rebirths—that the great unknown depths are *pregnant!* Nihilism, no matter how radical and thoroughgoing, can only serve in the end to unite us to that Mothering Darkness whose eternal miracle is the life we encounter ceaselessly in the surrounding cosmos.

10 Agony in the Underground

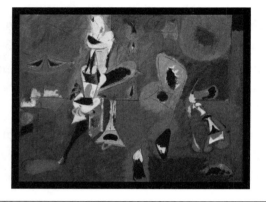

Arshile Gorky,
Agony, 1947
See plate 8

Arshile Gorky (1904–1948)

Under the shadows, every image becomes a symbol. For where shadows deepen, there mind deepens also, making contact with a half-veiled wisdom—a wisdom that reveals in secret the life that all wish openly to know. Hawthorne expressed it: "Truth comes in with the darkness." Yet as the shadows of our life deepen—shadows that prophesy our transition to other states of being—we respond first with sorrow and lostness. The shadows that veil new revelations, before they reveal, also veil others from our sight and leave us alone, deeply buried in a darkness that isolates and imprisons. What deepens us proceeds, therefore, by first of all isolating us—by throwing us back upon ourselves. "When a man is left with nothing but himself to face," says David E. Roberts, "he falls usually into boredom, melancholy, or despair."[1] Hence the shadows veiling the metamorphosis—the death and transformations of our age—have so far been known to us chiefly in terms of the aloneness, alienation, and sense of spiritual exile that modern art and thought have both confirmed and decried. The mood is typically that expressed in Tiutchev's poem, *The Abyss*.

[1] David E. Roberts, *Existentialism and Religious Belief*, 40.

128

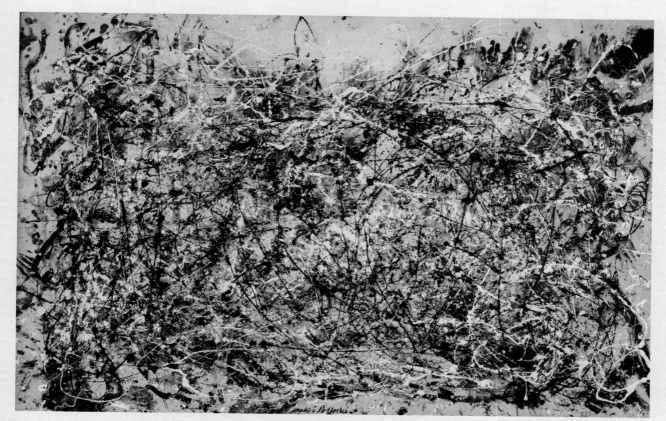

Plate 1. Jackson Pollock, *Number 1, 1948.*
Oil and enamel on unprimed canvas, 68" × 104". The Museum of Modern Art, New York.

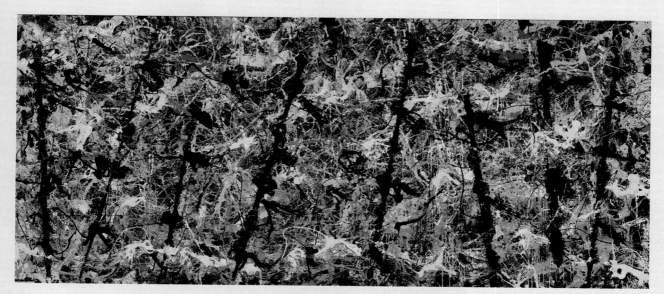

Plate 2. Jackson Pollock, *Blue Poles: Number 11, 1952.*
Enamel and aluminum paint with glass on canvas, 83.5" × 192.5". National Gallery of Australia, Canberra.

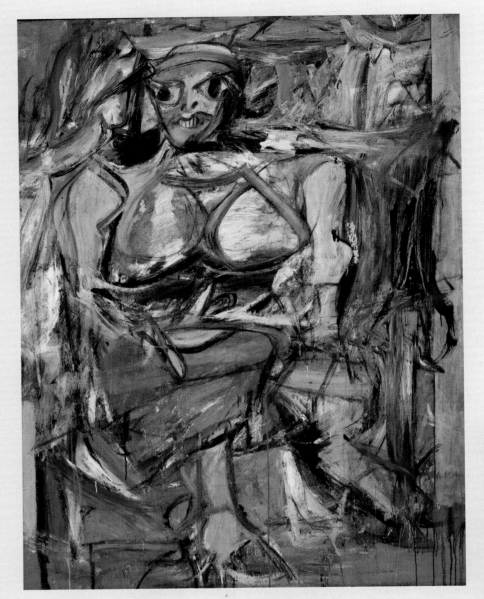

Plate 3. Willem de Kooning,
Woman 1, 1950–52.
Oil on canvas, 6'3⅞" × 58". The
Museum of Modern Art,
New York.

Plate 4. Willem de Kooning,
face detail of *Woman 1*.

Plate 5. *Venus of Willendorf*,
Limestone, Stone Age, Aurignacien,
twenty-fifth century BCE.
Naturhistorisches Museum, Vienna,
Austria.

Plate 6. Tony Smith, *Die,*
1962, fabricated 1998.
Steel, 6' × 6' × 6'. The
Museum of Modern Art,
New York.

Plate 7. Ad Reinhardt,
Abstract Painting, 1960–61.
Oil on canvas, 60" × 60".
The Museum of Modern Art,
New York.

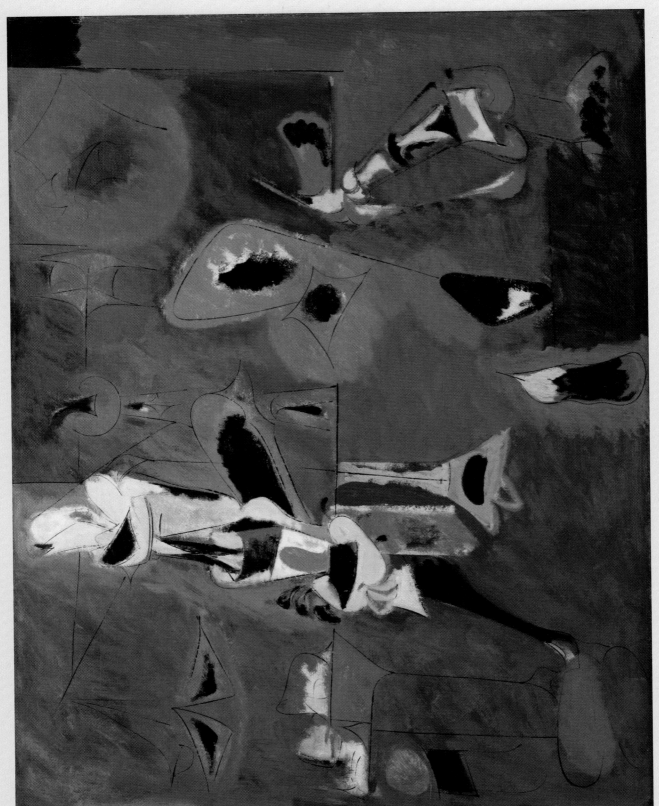

Plate 8. Arshile Gorky, Agony, 1947.

Oil on canvas, 40" x 50½". The Museum of Modern Art, New York.

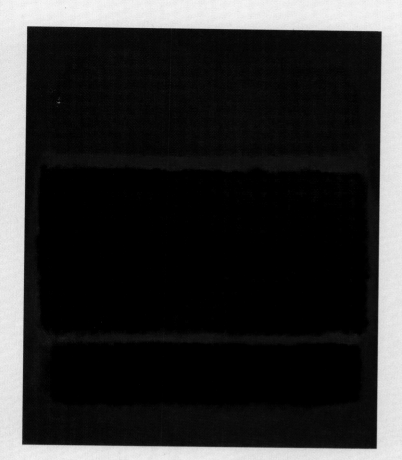

**Plate 9. Mark Rothko, *Black, Brown
on Maroon*, 1957 #20.**
Oil on canvas, 91⅝" × 76".
National Gallery of Australia,
Canberra.

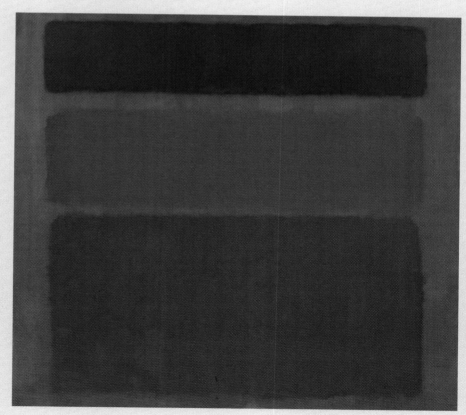

**Plate 10. Mark Rothko, *Red, Brown
and Black*, 1958 #16.**
Oil on canvas, 8'10⅝" × 9'9¼".
The Museum of Modern Art, New
York.

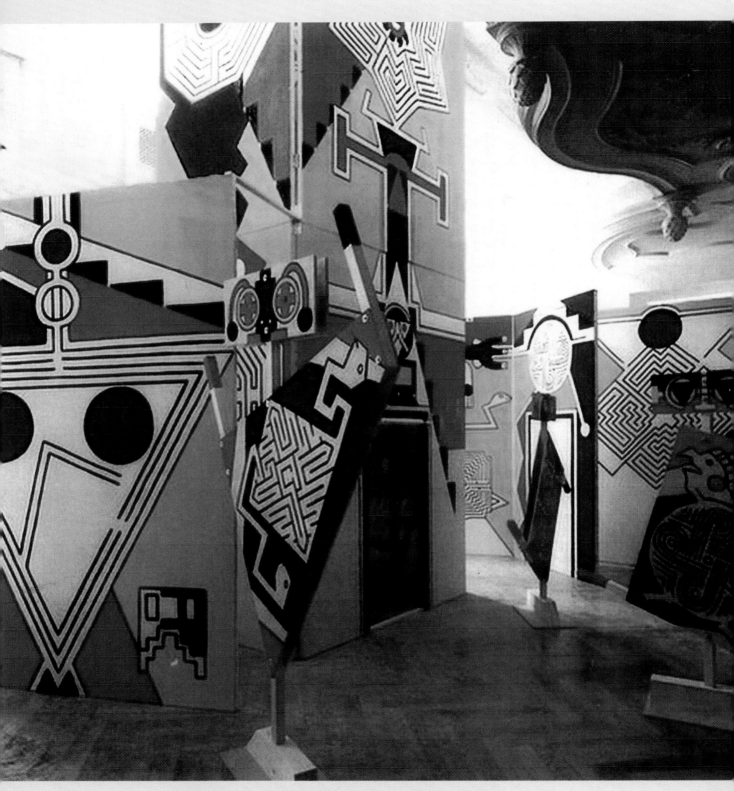

Plate 11. Walter Gaudnek, *Nomaze, Standing Labyrinth*, 1984.
Collection of the artist.

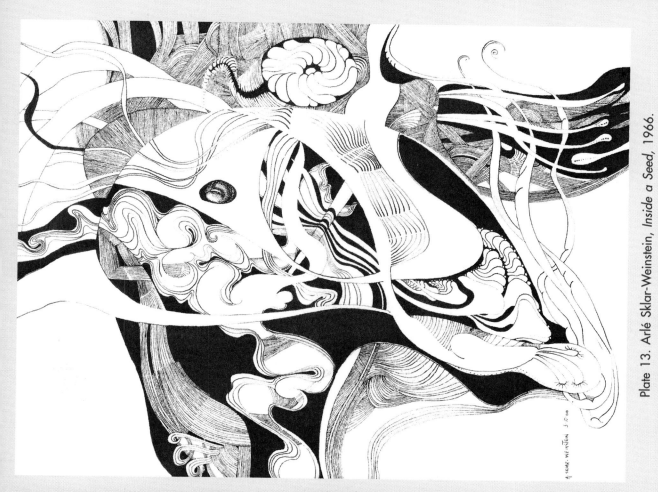

Plate 13. Arlé Sklar-Weinstein, *Inside a Seed*, 1966.

Ink on paper, 9" × 12". Collection of the artist.

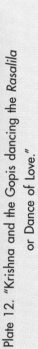

Plate 12. "Krishna and the Gopis dancing the *Rasalila*
or Dance of Love."

Paint on cloth, 32" × 31". Collection of the author.

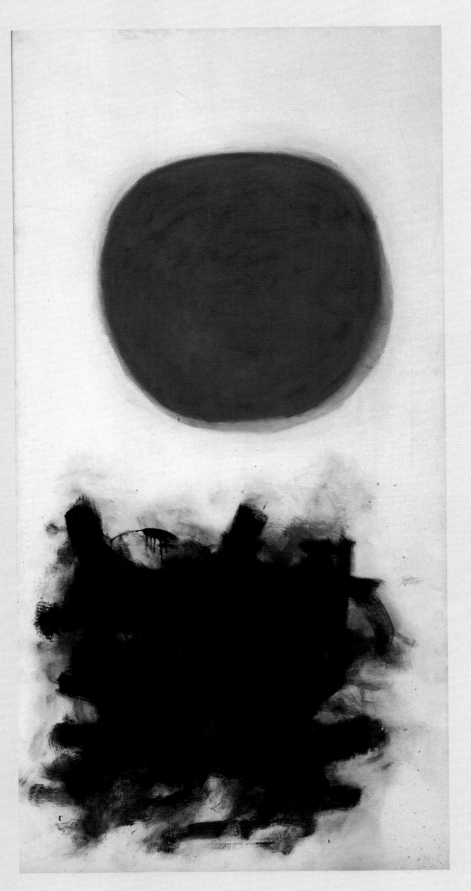

Plate 14. Adolph Gottlieb, *Blast 1*, 1957.
Oil on canvas, 7'6" × 45⅛". The Museum of Modern Art, New York.

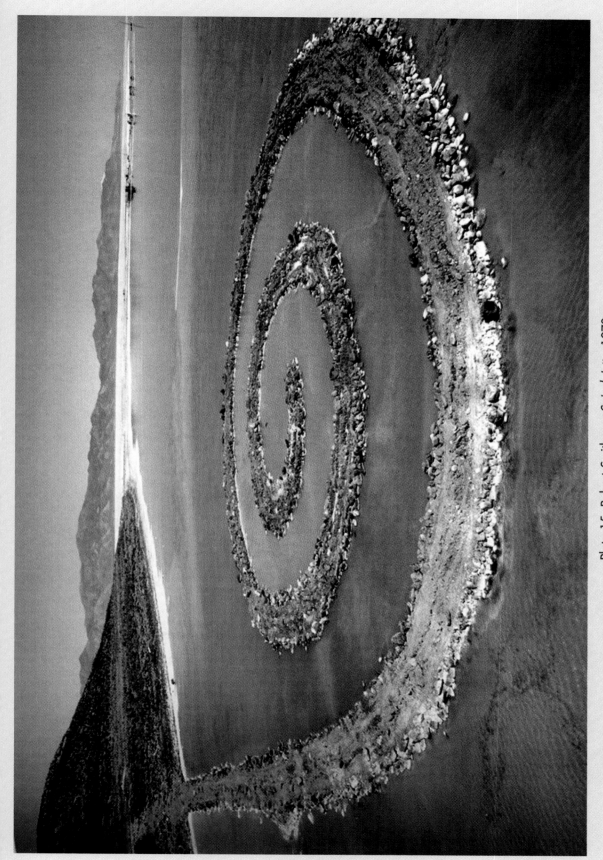

Plate 15. Robert Smithson, *Spiral Jetty*, 1970.
Mud, salt crystals, basalt rocks, and earth, 1500' × 15'. Great Salt Lake near Rozel Point, Utah.

Plate 16. Walter Gaudnek, *Rebirth*, 1961–62.
Acrylic on canvas, 114" × 102". Private collection.

Plate 18. Matsya, *Vishnu as the Fish Avatar,* from a devotional text.

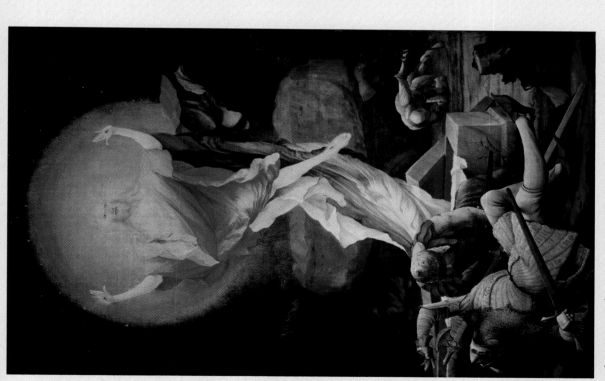

Plate 17. Mathias Grünewald. *Resurrection,* from the Isenheim Altarpiece, ca. 1515.

105⅞" × 120⅞". Musee d'Unterlinden, Colmar, France.

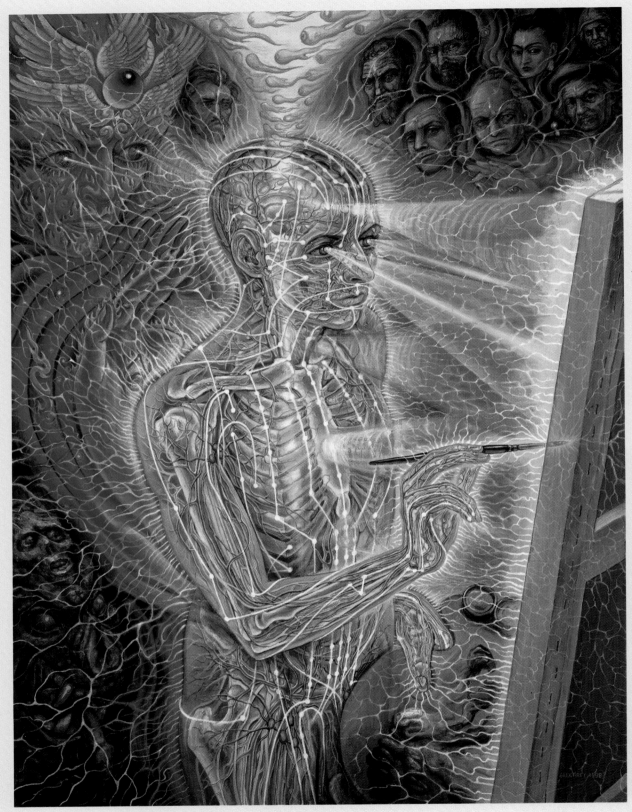

Plate 19. Alex Grey, *Painting*, 1998.
Oil on linen, 30" × 40".

Plate 20. Photographer unknown, "Illumined Crystals, Symbolizing the Creative Mind at Work," date unknown.

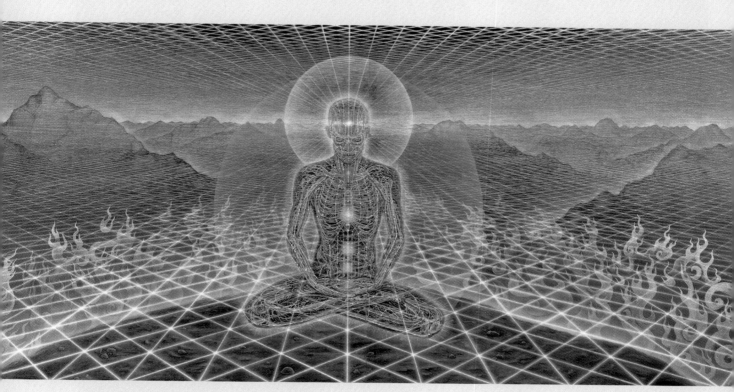

Plate 21. Alex Grey, *Theologue: The Union of Human Consciousness Weaving the Fabric of Space and Time in Which the Self and Its Surroundings Are Embedded,* 1984. Acrylic on linen, 60" × 180".

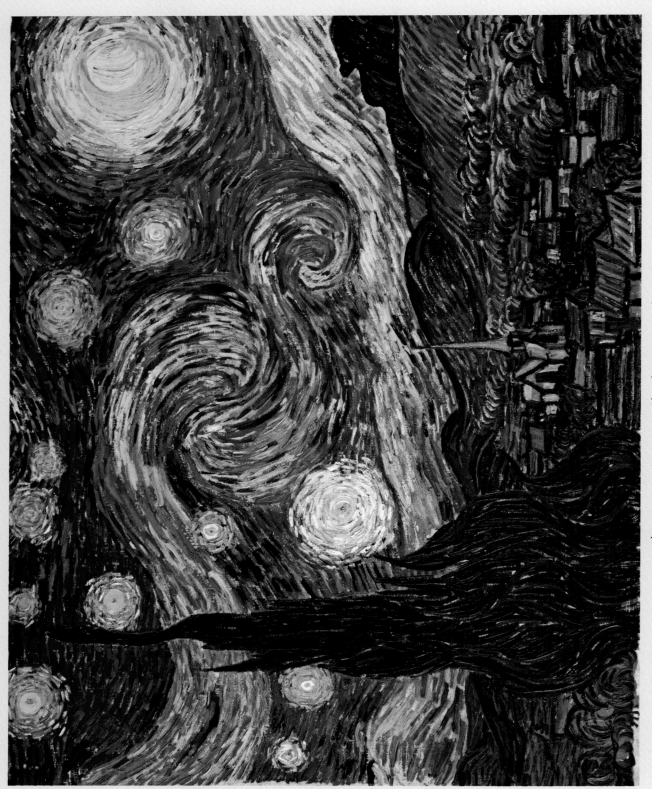

Plate 22. Vincent van Gogh, *The Starry Night*, 1889.
Oil on canvas, 29" × 36¼". The Museum of Modern Art, New York.

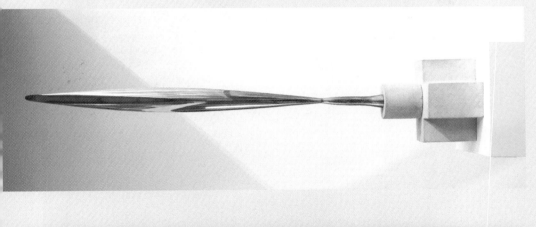

(c) Constantin Brancusi, *Bird in Space*, 1941.
Bronze, 6' high on two-part stone pedestal 17⅜" high. The Museum of Modern Art, New York.

(b) Constantin Brancusi, *Bird in Space*, 1927.
Silver print, 11.73" × 9.41". Musee National d'Art Moderne, Centre Georges Pompidou, Paris, France.

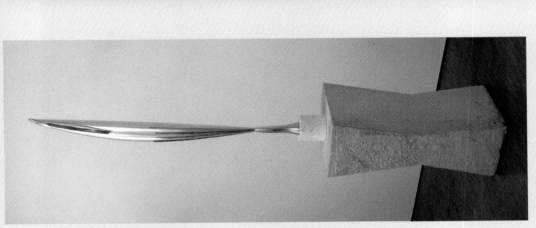

(a) Constantin Brancusi, *Bird in Space*, 1941.
Polished bronze, h. 6.34'. Musee National d'Art Moderne, Centre Georges Pompidou, Paris, France.

Plate 23

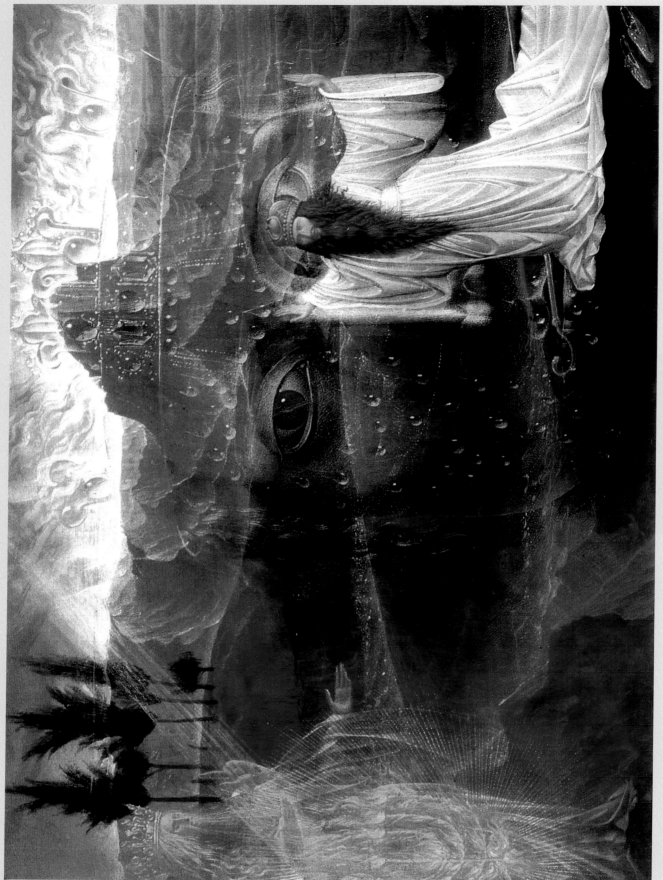

Plate 24. Ernst Fuchs, *Moses and the Burning Bush*, 1956. Oil and tempera on wood.

Behold man, without home,
Orphaned, alone, impotent,
Facing the dark abyss; . . .
And in this strange mysterious night
He sees and knows a fatal heritage.[2]

This mode of isolation, of exile and imprisonment, found many expressions in the arts—in the plays of Beckett, Harold Pinter, and Edward Albee, the novels of Kafka and Camus, and the poetry of T. S. Eliot and Lawrence Ferlinghetti, to name a few. Among the Abstract Expressionists, the artist who represented man's aloneness most sensitively and with a strange tragic beauty was Arshile Gorky (1904—1948). The work on which we shall focus is *Agony,* 1947 (plate 8).

Before viewing the painting, let us take a brief look at the metaphysical anxiety out of which it was born. Following the Second World War, the view was widespread in the United States that metaphysical anguish, as it found expression in Abstract Expressionism and in the theater and novels of the era, was a European import. America—the land of pragmatism, self-assurance, and gregariousness—had become infected by Existentialist doubts. Such a view, however, failed to take note of two important factors: (1) that Existentialism was not a postwar phenomenon at all, its origins going at least as far back as Dostoyevsky, Nietzsche, and Kierkegaard, if not as far back as Pascal; and (2) that metaphysical anxiety is as natural to America as to Europe. Harry Levin, in his book *The Power of Blackness,* makes it abundantly clear that Americans suffer as much from "an ambivalence of anguish" as do Europeans. In his opening chapter, entitled "The American Nightmare," Levin says, "Having been relatively free from those political calamities which Europeans have borne, we seem to face our conflicts internally."[3] We need only go back to the tales of Washington Irving's "headless horseman" or Poe's *Tales of the Grotesque and Arabesque* or look more recently at W. H. Auden's epic poem of modern alienation, *The Age of Anxiety,* or Alfred Hitchcock movies such as *The Birds* to realize that we, too, share in the anguish of

I am no part of a whole, I am not integrated, not included.
SØREN KIERKEGAARD

Art becomes exile too,
A secret and a code studied
in secret,
Declaring the agony of
modern life.
DELMORE SCHWARTZ

[2] Quoted in S. R. Hopper, ed., *Spiritual Problems in Contemporary Literature,* 155.
[3] Harry Levin, *The Power of Blackness,* 6.

modern, Gothic man. Still more recently, we could cite movies exploiting our fear of the demonic (*The Exorcist* and *Fallen*) and apocalyptic terror (*Earthquake, The Towering Inferno,* and the list goes on). Yes, we too have our hidden depths of anguish, our realm of nightmares.

The experience of the extreme situation, defined by the "death of God" and spiritual self-loss, has been variously defined as "exile in the imperfect" (Baudelaire), "cosmic exile" (Harry Slochower), "existential finitude" (Paul Tillich), "metaphysical exile" (Camus), and "ontological solitude" (Nathan Scott). Whatever the terminology, the experience described is that of man's sense of alienation from the ultimate Ground of being and meaning. Contemporary man has found himself cut off, alone, estranged, absurd, an exile within his own soul. Speaking in terms of "quest" and "descent," Stanley Hopper expressed it thus:

> The quest is not outward, but inward. It is a descent into the void of contemporary lostness: a descent in which the moment in time is our only possession, but a time in which there is no fullness . . . only a time which annuls. . . . It is the raw descent of the ego into itself.[4]

The chief artists of the middle third of the twentieth century have felt themselves to be metaphysical exiles, those whom Eugène Ionesco described as "devoid of purpose. . . . Cut off from [their] religious, metaphysical, and transcendental roots . . . lost."[5]

The art of Arshile Gorky is at once more "conscious" and more "internal" than that of the other artists whom we have so far studied. Pollock's raw psychic energy resulted in images of total disintegration, both external and internal. De Kooning's Woman confronted us as a projection from the psychic depths. Tony Smith's cube and Reinhardt's black square had a measure of objective "thing-ness" that offered considerable resistance to penetration. But in the case of Gorky, we have a truly internal and underground art. His images are always inner images. Even when he returns to nature to make sketches based upon his keen observations of organic forms (as in *Virginia Landscape,*

[4] S. R. Hopper, *Spiritual Problems in Contemporary Literature*, 154.

[5] Quoted in Martin Esslin, *The Theatre of the Absurd*, xix.

Naked and alone we come into exile. In her dark womb we did not know our mother's face; from the prison of her flesh have we come into the unspeakable and incommunicable prison of this earth. Which of us has known his brother? Which of us has looked into his father's heart? . . . Which if us is not forever a stranger and alone?
THOMAS WOLFE

1943), the result is still a morphology based upon an inward, psychological vision. Among Abstract Expressionists, Gorky alone may be termed an "abstract surrealist."

In Pollock and De Kooning we saw a Dionysian dance and frenzy, and in Smith and Reinhardt, cool detachment. In Gorky's art we find not only sensitively refined images, but also a melancholy and brooding characteristic of many German and Russian artists (born in Armenia, Gorky emigrated to America at age sixteen). In Pollock's art, the sense of freedom in his arabesques is at times almost lyrical. In Gorky's art, we find objects often suspended weightlessly (a technique learned from Joan Miró and Roberto Matta), but the effect is not one of freedom but, rather, a sense of agony and nausea. One might say Gorky is to painting what Dostoyevsky is to literature—the explorer and cartographer of a new psychological underground. To be sure, the Surrealists before him had explored the subconscious, but primarily in terms of nightmare images and fanciful objects based on observations of the external world. Gorky indulged neither in nightmare nor fantasy in their sense. Rather, following in the abstract tradition of the early Kandinsky, and employing the unerring insights of a deep and sensitive imagination, Gorky plunged directly into the subterranean depths of the psyche itself, revealing to us insights as profound as any to be found in the literature of modern philosophy and psychology.

Before entering the beautiful and tragic world of *Agony*, we should note, with George Wingfield Digby, that "color, for the introverted artist, works as a symbolism."[6] The biomorphic forms in *Agony* float within a field of deep smoldering reds and earth tones that gives us the first clue to the work: we are dealing with an interior or "buried" world—one set within the earth, or underground, as it were. The shapes and lines of the biomorphic forms suggest something part human, part animal, and part mechanical. Left of center and at the lower right, two forms appear that evoke association with primitive fetishes. The running pools of gray and black speak of anxiety and despair, the cool yellows of nausea, and the smoldering and feverish reds of an internal fire that burns without destroying. One is reminded

[6] George Wingfield Digby, *Meaning and Symbol*, 35.

of Mark Rothko's statement, "Without monsters and Gods, art cannot enact our drama." A specter of strange worlds invades the intimacy of a space we feel to be our own, our inner realm. The "fetishes" in *Agony* call to mind lines from W. H. Auden:

> *The Void desires to have you for its creature,*
> *A doll through whom It may ventriloquise*
> *Its vast resentment as your very own,*
> *Because Negation has nor form nor feature,*
> *And all Its lust for power is impotent.*[7]

When viewing paintings such as *Agony, Garden in Sochi* (ca. 1941), or *The Liver Is the Cock's Comb* (1944), we quickly discover that we have entered a world that is on the threshold of procreation, yet is powerless to produce. The scene is set for regeneration and ends in agony. How do we arrive at this? Everything in Gorky's art attests to the fact of his return to nature, that perennial source of health to which man ever returns for each new beginning, each new birth. We've already noted that Gorky literally returned to nature, to "the grass," as he put it, for fresh vision. His biomorphic imagery was born out of periodic renewals of his direct vision of forms in nature. In a profounder sense, however, his development of an inner, psychological art constituted another kind of return to nature—direct contact with the unconscious that "mothers" consciousness. Nature, in her reproductive and life-giving aspects, is further suggested by the heavy overtones of semi-abstract sexual symbolism, the earth tones and the "procreative fires" of the reds, and by the presence of primitive fetish-gods that give a kind of voodoo atmosphere to *Agony*. Yet everything in Gorky's paintings is in suspension. There is no action, no meeting between "phallic" and "vagina" forms. What we're shown is the agony of a world where all life is frozen in abeyance. Let us now make a more detailed examination of *Agony*.

The vision here is of an inner, psychological world. In a "room that is not a room" but the "earth" itself, we begin to feel as spectators

[7] W. H. Auden, *The Collected Poetry of W. H. Auden*, 119.

that we've been *buried alive*. Even though the parallel is not exact, the psychological state produced by *Agony* calls to mind Poe's tale "The Premature Burial."

> The unendurable oppression of the lungs—the stifling fumes of the damp earth—the clinging of the death garments—the rigid embrace of the narrow house—the blackness of the absolute Night—the silence like a sea that overwhelms—the unseen but palpable presence of the Conqueror Worm—these things, with the thoughts of the air and grave above, with memory of dear friends who would fly to save us if but informed of our fate, and with consciousness that of this fate they can never be informed—that our hopeless position is that of the really dead—these considerations, I say, carry into the heart, which still palpitates, a degree of appalling and intolerable horror from which the most daring imagination must recoil.[8]

The images of which *Agony* is composed are of three types—fetishes (gods or demons or, as will be suggested later, primitive dancers), phalluses, and vaginas. To be sure, these images are multiplex, and our poetic designations must not be taken too literally, but since we have no language for the abstract iconography of modern art, we must employ words poetically and rely on imagination to establish the necessary resonance and awaken the needed intuitive insights.

The possibilities of birth, of regeneration, are suggested by the vagina images (soft, semi-abstract) in the upper right-hand corner of *Agony* and immediately below and to the left. The fiery reds reinforce the sexual interpretation. Fire, anthropologists and psychologists tell us, has a long and widespread history of being related to sexual experience.[9] The bluish center in the image at upper right and the receding black in the image below hint of the mystery of birth and the womb. At bottom center a phallus appears encircled by a field of sexualized force, its yellow-golden "head" evoking the sun/fire symbolism associated with masculinity. More subtle, but equally important, is the foot-phallus in the lower left corner. Its unlikely Gorky would have been aware of the

[8] *The Works of Edgar Allan Poe*, 424.

[9] See C. G. Jung, *Symbols of Transformation*, vol. I, 121–70; and Gaston Bachelard, *The Psychoanalysis of Fire*, 43–58.

ancient symbolism of the foot, which attributes to it a fertility significance.[10] Yet the frequency with which feet appear in Gorky's art in conjunction with female genital images shows how powerful this symbolic association is in the subconscious mind. In *Agony* the "foot" is surrounded by a field of earth-browns: if the foot is phallic, it is because the earth on which it walks is procreative! In Goethe's *Faust*, Faust reaches "The Mothers" by stomping on the ground. The fetish images may also be thought of as primitive dancers.[11] Insofar as dance symbolizes the ecstasy of union,[12] the fetishes may serve as "gods" whose presence is intended to bless the union of the procreative forces in *Agony*.

Agony's agony begins to be apparent when we notice that the foot-phallus is turned away from the central drama, being located in the corner opposite the vaginas. The phallus at lower center points to the vaginas, but it is "cut off," isolated. Between phalluses and vaginas no meeting occurs. Everything is in a state of suspended animation. The dancing fetishes no longer dance but are stilled, the skeletal-like "god" at lower right taking on the appearance of a run-down mechanical toy. The ghostly gray of the fetish at left speaks more of death than of the blessing of life. *Agony*'s agony is the angst of a world in which all the essentials of procreation are present, but each element is isolated, exiled. Meetings do not take place. The tension of separation is rendered all the more profound by the stillness that pervades the work, as when Baudelaire says, "Be good, O my Sorrow, and keep more still." *Agony* portrays the suffering of "the wretched dead."

Once again, our work turns out to be a two-edged sword, for containment, as we have repeatedly stated, serves the gestation and expansion of life. I do not think I'm stretching too far when I say *Agony* also

[10] See Jung, *Symbols of Transformation*, vol. I, 126; and vol. II, 276–82, 315.

[11] Jung says, "The foot and the treading movement are invested with a phallic significance, or with that of re-entry into the womb, so that the rhythm of the dance transports the dancer into an unconscious state. The Dancing Dervishes and other primitive dancers offer confirmation of this." Ibid., vol. II, 315.

[12] The rhythmic art-form of the dance is generally regarded as a symbol of the act of creation. See J. E. Cirlot, *Dictionary of Symbols*, 72–73.

exhibits parallels to the alchemical process—alchemy being one of the seven mystical Kabalas in which the secrets of spiritual transformation are veiled.[13] In alchemy, the "sexualized fires" of regeneration are enclosed (contained within the furnace in which the alchemical transformation takes place). Alchemical fire is thought of as "the fire of bachelors," of men without women, whose confined passion and lonely meditations enable the "rod of fire" to be kept in all its heat and intensity. The "rod of fire" refers, of course, to the spinal column and the raising of the "serpent fire" that enables spiritual Illumination to take place.[14] While Gorky surely intended no alchemical references and was, so far as I know, entirely ignorant of alchemy, the mere fact that he has given us a vision of procreative energy internalized and confined, withdrawn from its natural expression and outlet, opens up the possibility of creative forces being put to a more spiritual use. In other words, blocked on one level of expression, the sexual forces become sublimated. I'm not speaking now in Freudian but in esoteric terms in saying *sublimation produces spiritualization*—a raising of the creative forces to higher planes of expression. Gorky did not himself envision these higher possibilities, but his art heralds a spiritual transformation nevertheless. The "locking up" of the procreative fires is agony but is a necessary step in producing rebirth upon a higher plane. In *Agony*, then, we have not an alchemical work but an example of that deep psychological insight that produces parallel discoveries. And we have a work that hints—as it points to the isolation, loneliness, and pent-up-ness of Man Alone[15]—of a stage in the transformative process that, as

[13] Titus Burckhardt also compares the construction of a Hindu temple and the creative process of the artist to an "alchemical transformation." See *Sacred Art in East and West*, 45. For interesting studies of alchemy and Kabalism, see C. G. Jung, *Psychology and Alchemy* (Collected Works); Mircea Eliade, *The Forge and the Crucible*; Dion Fortune, *The Mystical Qabalah*; Fulcanelli, *Fulcanelli: Master Alchemist*; and Gwendolyn Bays's study of "the seer poets from Novalis to Rimbaud" in *The Orphic Vision*.

[14] See Mircea Eliade, *Yoga, Immortality and Freedom*; Hans-Ulrich Rieker, *The Yoga of Light*; and Arthur Avalon (Sir John Woodroffe), *The Serpent Power*.

[15] For a comprehensive study of the nature of modern isolation, see *Man Alone*, edited by Eric Josephson and Mary Josephson.

yet, has been little understood. Via the aloneness of man in this age, he has become "hermetically" sealed off within his own being. He has become the crucible within which the procreative fires, contained, are being intensified for that day when sublimation brings spiritual transformation.

Gorky's vision turns out to be not only sensual, but above all spiritual. It mirrors the spiritual agony of our age. There are obvious references to the inability of many to "make it" across the sexual and personal bridge. On a deeper level, *Agony* points to the social and cultural impotence of our time. At the same time, we are shown that the revivifying powers, at present in a state of suspended animation, are still resident within the inner man. Creativity is still possible! The thawing out of our frozen fires must depend finally upon another and higher passion—the awakening of compassion or spiritual love.

> *In the deserts of the heart*
> *Let the healing fountain start.*
> W. H. AUDEN, *THE AGE OF ANXIETY*

11 Evil and the Mystery of Darkness

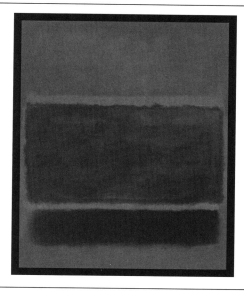

Mark Rothko, *Black, Brown on Maroon,* 1957 #20
See plate 9

Mark Rothko (1903–1970)

No Entity, whether angelic or human, can reach the state of Nirvana, or of absolute purity, except through aeons of suffering and the knowledge of EVIL as well as of good, as otherwise the latter remains incomprehensible.

H. P. BLAVATSKY,
THE SECRET DOCTRINE

"The poet is at the disposal of his night," says Jean Cocteau. So also is humanity in this present age. We are concerned here with a subject vaster and more complex than any single work of art. In this chapter we shall explore a range of issues including evil, the death of God, and metaphysical exile.

If God is dead and the age has plunged itself into moral and spiritual darkness,[1] its only way out of this dilemma is to pass *through* the darkness. The way out of the extreme situation is surely not the way

[1] The moral bankruptcy of our age is made clear in the fact that solutions to all our world problems *already exist* and are ignored or suppressed because of *economic greed* on the part of giant fossil fuel, petrochemical, pharmaceutical, and other industries and the global economic institutions and governments they finance. The planet is in peril and countless millions suffer and die needlessly for no good reason.

So far gone am I on the dark side of earth, that its other side, the theoretic bright one, seems but uncertain twilight to me.

HERMAN MELVILLE,
AHAB IN MOBY DICK

I said to my soul, be still, and
let the dark come upon
you
Which shall be the darkness
of God.

T. S. ELIOT

No power . . . impresses itself as strongly on this art as does the spirit of that numinous dusk in which the gods reveal themselves, and in which man fades out, to be transfigured or sublimated.

ANDRÉ MALRAUX

[2] Édouard Schuré, *The Great Initiates*, 400.

of withdrawal we encountered in Camus, who fled nihilism into a philosophy of revolt. Nor can it be the way of Kierkegaard "absurdly" embracing a "Wholly Other" God. Both attempts to solve the problem of metaphysical alienation can be charged with lack of moral, intellectual, and spiritual integrity. The way chosen here is that of Dante—*through hell* and beyond. So let us face our dark night of the soul and see where it leads. We do not wish to be guilty either of a lack of integrity or any failure of nerve. More importantly, we want to deal with the problem of alienation on its own terms and on its own ground. Looking back from the perspective of ultimate spiritual victory, we understand, as Édouard Schuré put it, that "the Abyss has terrors and tremors that heaven does not know! He does not understand heaven who has not traversed earth and hell!"[2] Baudelaire provides our motto: "Into the deep unknown to find something new."

At mid-century André Malraux proclaimed, "Both God and man are dead." We're left with a shadow-man, a man who does not live from the depths, who knows nothing of himself, whose whole being is *surface*. Instant mass-media communications calling for responses without reflection have rendered thinking and feeling shallow. The contemplative interval between idea and response has evaporated.

> *Between the idea*
> *And the reality*
> *Between the motion*
> *And the act*
> *Falls the Shadow*
>
> *Between the conception*
> *And the creation*
> *Between the emotion*
> *And the response*
> *Falls the shadow*

T. S. ELIOT,
"THE HOLLOW MEN"

Speaking of this "mass production of events," Erich Kahler says, "The result of all this is a crowding of events in the domain of our vision and consciousness, an oppressive closeness and overwhelming shiftiness of events, an excess of details and complexities in every single event—in short, what I would call an *overpopulation of the surfaces*."[3] The revolt against mass-man, surface-man, shadow-man emerged chiefly along three lines: (1) the Existentialist call for authentic selfhood, (2) the indulgence of the arts and radical politics in crimes of violence against bourgeois society, and (3) the efforts of the counterculture to "explode" the mind with psychedelic drugs. One writer, whose identity I don't recall, said his way out of the existential situation was by internal explosion! Our first attempt to deal with the problem of evil will be in terms of the cult of violence. We shall find that it leads into the depths where the problem of God's and man's death resides.

Dostoyevsky warned in *The Brothers Karamazov,* "If God does not exist, then everything is permitted." The assumption here, which later Existentialists challenged, is that ethics and morality cannot survive without a divine sanction. Nevertheless, Nietzsche's concern for the "devaluation of all values" that would follow upon "God's death" and the subsequent rise of dark brotherhoods devoted to crime now seems justified, as we see the spread of drug gangs and terrorism: "Nobody should be surprised," Nietzsche said, "when . . . brotherhoods with the aid of robbery and exploitation of the non-brothers . . . appear on the arena of the future."[4] Our concern with the cult of violence here is not with those dark brotherhoods, which are indeed a matter of profound concern to our nation and world, but with a different form of violence employed in the arts—violence against "the pleasure principle" of bourgeois society. Modern artists and writers have been occupied with penetrating and shattering the morals and psychic defenses of the contented middle class. When Yoko Ono, in *Cut Piece,* allowed the "proper" gentlemen of British society to come on stage and cut and tear her clothing from her body, she proved her point: masquerading beneath a superficial bourgeois morality, one still finds all the crude passions and aggressions of uncivilized man. If a

What is laid upon us is to accomplish the negative.
FRANZ KAFKA

We live in an apocalyptic age, but we are not the first to do so. Apocalyptic periods before us have produced great works of the spirit— works which signaled an emergence from darkness.
SELDEN RODMAN

[3] Erich Kahler, *The Tower and the Abyss,* 95–96.
[4] Quoted in Walter Kaufmann, *Nietzsche.*

EVIL AND THE MYSTERY
OF DARKNESS

139

new consciousness is to be born, we must begin by unmasking the ugliness and dishonesty beneath society's comfortable veneer. This, in Lionel Trilling's view, has been the chief effort and achievement of contemporary literature and, I might add, art. The genius of modern art has been its violence to beauty, its awareness of evil and destruction, and its probing of the unconscious, taking its stand with Freud in proclaiming "the failure of the pleasure principle." Trilling writes:

> The destruction of what is considered to be a specious good is surely one of the chief literary enterprises of our age. Whenever in modern literature we find violence, whether of represented act or of expression, and the insistence upon the sordid and the disgusting, and the insult offered to the prevailing morality or habit of life, we may assume that we are in the presence of the intention to destroy specious good, that we are being confronted by that spirituality, or the aspiration toward it, which subsists upon violence against the specious good.
>
> The most immediate specious good that a modern writer will seek to destroy is, of course, the habits, manners, and "values" of the bourgeois world, and not merely because these associate themselves with much that is bad, such as vulgarity, or the exploitation of the disadvantaged, but for other reasons as well, because they clog and hamper the movement of the individual spirit toward freedom, because they prevent the attainment of "more life."[5]

Wallace Fowlie says, "Both the saint and the poet exist through some prorogation of destructive violence." Destructive violence and the representation of evil in contemporary art have as their goal the shattering of the "over-populated surfaces" and the opening up of the depths, be they demonic or divine. One of the mysteries of evil lies in its power to subvert what is only *apparently* good and not a goodness grounded in authentic selfhood or ontological experience.

The mystery of evil concerns the mystery of the depths themselves. Evil, unlike "specious good," is never a superficial affair. Were it superficial, it might be mischievous, but it would not constitute evil. To deal

[5] Lionel Trilling, "The Fate of Pleasure: Wordsworth to Dostoevsky," in *Romanticism Reconsidered,* ed. by Northrop Frye, 94–95.

with evil is to deal with the radical depths of human nature. When it is a force that disturbs our tranquility and shatters our superficiality, evil is in the service of the good. In showing itself as the antithesis of good, it becomes the "left hand" or helpmate of good, forcing a recognition of conflict between what is and what ought to be. It becomes

> that power which would
> Ever work evil, but engendereth good.
>
> GOETHE, *Faust*

The problem of evil also entails the problem of suffering, and many equate suffering with evil. But just as evil can serve the good, so can suffering. This was the light in which Dostoyevsky viewed the problem: "And yet I think man will never renounce real suffering, that is, destruction and chaos. Why, suffering is the sole origin of consciousness." We might add, it is "the sole origin of consciousness" only so long as men remain relatively unevolved, mentally and spiritually. Several theories of suffering have been offered down the ages. In Vedanta philosophy it is regarded as the product of *maya* or illusion, which does not solve the problem of suffering and its role in human evolution. In Manichaeism, evil and suffering were viewed as the work of an evil God who coexisted eternally in opposition to the good God. They were explained in terms of an ultimate dualism. In Augustinian and Thomist thought, suffering was seen as the penalty for sin—using one's free will to turn away from God. In Irenaeus (ca. 120–202 CE), suffering resulted from the fact that man is created in the image of God but, as an unevolved creature, had yet to attain the "likeness" of God. Suffering served the task of "soul-making" by teaching men to live in harmony with nature's laws and evoking in them noble virtues such as courage, honesty, loyalty, and compassion.

Following somewhat the Irenaean view, I hold that the principal purpose of suffering is *to teach*—to evolve and bring out the hidden beauty of the spiritual nature of man so that he may, through learning, evolve to ever greater heights. Suffering is not inherently evil but

a consequence of error, ignorance, and willful violation of nature's laws. It is a byproduct of ignoring the spiritual dimensions of the inner man. Through suffering we are awakened to our errors, ignorance, and willfulness. Pain and suffering are, therefore, the necessary "birth pangs" of incessant evolution. Without suffering as a goad to progress, growth would cease and life would become stagnant. It is "the poetry of grief" which saves us from "the prose of finitude." Pascal, in his *Pensées,* views man's misery as the measure and testament of his greatness, which greatness is also the source of his misery.

> Wretchedness being deduced from greatness, and greatness from wretchedness, some have inferred man's wretchedness all the more because they have taken his greatness as a proof of it, and others have inferred his greatness with all the more force, because they have inferred it from his very wretchedness. All that one party has been able to say in proof of his greatness has only served as an argument for his wretchedness to the other, because the greater our fall, the more wretched we are and *vice versa.* The one party is brought back to the other in an endless circle, it being certain that in proportion as men possess light they discover both the greatness and wretchedness of man. In a word, man knows that he is wretched. He is therefore wretched, because he is so; but he is really great because he knows it.[6]

Suffering arises when man is out of harmony with the Center within himself. If, as I shall argue, man is an embryonic God, suffering follows from his torture of the divine Self within—a Self that meets resistance in its efforts to unfold into fuller expression. Yet the same suffering aids and furthers soul-unfoldment. "The souls of men are tried out in extremities," said Yeats. Suffering, like evil, shatters the façade of existence and plunges us into its depths. In these depths, we are confronted with the causes of our suffering and made wiser. We are challenged by courage, by honesty. We are taught compassion for humanity, for all men suffer. And from all of this we grow—emotionally, mentally, and spiritually.

[6] Blaise Pascal, *Pensées,* 416.

Ought not these oldest sufferings of ours to be
yielding
More fruit by now? It is not time that, in loving, we
freed ourselves . . .
as the arrow endures the string, to become, in the
gathering out-leap,
something more than itself? For staying is nowhere.
RAINER MARIA RILKE

Finally, suffering tests us in preparation for initiation into higher realms of consciousness and spirit.[7] Rebirth—expanded life—brings with it a new and vaster vision. But before one who is "dead" can be reborn, he must undergo tests and trials, often involving great suffering, designed to test his strength and worthiness for admission into the wisdom that will be imparted to him. As initiatory suffering precedes the wisdom to be imparted, it is typically represented as taking place in darkness, in the underworld, in the belly of a whale, the womb, or in hell. The illusion that suffering is evil may arise from the "blind suffering." But once the sufferings and tests are past and we have gained new insight or experienced initiation into wider life, the meaning of suffering changes, and something of its mystery vanishes. Looking back, we often say, How precious to us now are those sufferings that made us grow the most, that made us stretch ourselves out of our former being and lift our souls upward from those dark depths! We found new life through those old birth pangs. While we have no wish to go back to the agonies of former hours, we learned from them that it is the depths which give birth to the heights.

From this overview of evil and suffering, let us plunge now to the nadir of the night, into the underworld and unconsciousness. Here we will take up our next artist, Mark Rothko (1903–1970). In Rothko's art, the mystery of darkness reveals itself as that numinous night in which both gods and men are transformed.

The words of Jean Cocteau to describe De Chirico fit Rothko—"a religious painter without faith," "a painter of the secular mystery"

[7] See Eliade, *Myths, Dreams and Mysteries*, 198–200.

(*le mystére laic*). His paintings present us with a "secular transcendence."[8] Such secular transcendence, as I propose to show, is at the heart of much contemporary art, philosophy, and psychology. In the deep, brooding darkness of Rothko's later works, we experience in an almost sinister manner the alienation of man from life. Yet in these same works we begin to transcend the situation of metaphysical exile. Rothko provides support to my thesis that the very power of blackness, agony, and despair that threatens contemporary man in the extreme situation provides also his hope of making the journey to the end of night. But first another look at the "death of God."

In the Judeo-Christian tradition, God is conceived primarily as the God of rational thought or reasoned faith, not a God of direct knowledge, personal vision, or inward, ecstatic experience. He became objectified—*a* Being among other Beings, even if the *supreme* Being ("Thou shalt have no other gods before me"). The Judeo-Christian God is defined anthropomorphically, as wiser, more loving, more powerful, jealous of other gods, and so forth. This view rendered God finite, for as long as one thinks in terms of magnitude, one cannot touch the Infinite. Finite concepts cannot define the Infinite. Which is why mystics, both Eastern and Western, have always spoken of God in *negative* terms—God is *not* this, *not* that (*neti, neti*). If humanity today stands on the verge of a great new awakening and expansion of consciousness, as many of us believe, it is natural and inevitable that our old finite, manmade "God" must die. It was this God only of which Nietzsche spoke when he prophesied the death of God. As Walter Kaufmann put it:

[8] In response to Selden Rodman's characterization of his art as abstract color harmonies, Rothko angrily replied: "I'm not interested in relationships of color or form or anything else. . . . I'm interested only in expressing basic human emotions—tragedy, ecstasy, doom, and so on—and the fact that lots of people break down and cry when confronted with my pictures shows that I *communicate* these basic human emotions. . . . The people who weep before my paintings are having the same religious experience I had when I painted them. And if you, as you say, are moved only by their color relationships, then you miss the point!" Quoted in Selden Rodman, *Conversations with Artists*, 93–94.

It seems paradoxical that God, if ever he lived, could have died—and the solution is that Nietzsche's pronouncement does not at all purport to be a dogmatic statement about a supersensible reality: it is a declaration of what he takes to be a historical cultural fact. "God is dead"; "we have killed him"; and "this tremendous event . . . has not yet reached the ears of man"—that is an attempt at a diagnosis of contemporary civilization, not a metaphysical speculation about ultimate reality.[9]

He then quotes Nietzsche: "What differentiates *us* is not that we find no God—neither in history, nor in nature, nor behind nature—but that we do not feel that what has been revered as God is 'godlike.'"[10] It is therefore only man's finite, conceptual God that has died. Those who assert the nonexistence of God as an ontological "fact" do so from a position of finitude. But a man exiled on an atoll in the South Pacific, lacking all contact with Western civilization, is hardly in a position to conclude that Western civilization has expired. Neither can one in an acknowledged position of metaphysical exile render judgments about metaphysical realities. At the moment, all we can conclude is that the "death of God" refers to the death of the objective, anthropomorphic, finite God *in men's minds*. And, indeed, such a God *must die* if the inner God of genuine spiritual experience is to be born. By eliminating the concept of God as an "anthropomorphic projection" (Feuerbach), Western civilization is clearing the way for a new and more profound revelation of the Infinite One within. As always, the death of the finite allows for some greater revelation of the infinite. "Every religion," says Pascal, "which does not affirm that God is hidden is not true." It is the Hidden God dwelling in the hidden depths of human nature whose manifestation is now to be sought. Let us draw an analogy: Christians assert that God incarnated in the historical Jesus, "died" upon the cross—a symbol of earthly and spiritual regeneration—and arose again in a more spiritual manifestation. Why then should one find it strange or difficult to believe that God, "incarnate" in human understanding with all its anthropomorphic ideas of the Infinite, needs

[9] Walter Kaufmann, *The Portable Nietzsche*, 84.

[10] Ibid., 85.

to "die" in those finite conceptions in order to "rise again" in a truer and more spiritual form better suited to the spiritual needs of a more awakened and illumined age? Indeed, such a death-and-resurrection of "God" *must* take place if man is not to outgrow his own ideas of the Infinite and end by viewing them, as Feuerbach and others already have, as mere childish inventions unworthy of further respect. When, at last, we have attained to the ecstasy and illumination that attunes us to the Infinite, uniting us with the Ground of Being, we shall know what it is to stand out of our finite selves and experience the One who can never wholly "incarnate" in any finite form. But I'm getting ahead of my thesis.

With God's death, contemporary man could no longer approach metaphysical reality from above. For twentieth-century man, Transcendent Reality appeared to have closed down operations. Hence the metaphysical alienation already discussed. Only two alternatives were left—secularization, or the formation of a metaphysical underground of angst-ridden metaphysical exiles. Most of the artists we've been discussing fall into the latter group. Rather than accept the no-man's land of scientific and bourgeois secularism, they preferred hell itself!

> *Who, in the dark, has cast the harbor-chain?*
> *This is no journey to a land we know. . . .*
>
> *Bend to the chart, in the extinguished night*
> *Mariners! Make way slowly; stay from sleep;*
> *That we may have short respite from such light.*
>
> *And learn, with joy, the gulf, the vast, the deep.*
> LOUISE BOGAN,
> "PUTTING TO SEA"

Rothko was such a mariner, setting sail for a world that, denied transcendence through ascent, would *transcend by descent. Black, Brown on Maroon*, 1957 (plate 9), and *Red, Brown, and Black*, 1958

(plate 10) are dark paintings that bring us into contact with a diabolical mysticism. The background of both paintings is a deep smoldering maroon, suggestive of a slowly burning fire—a hell so far removed from the world of light that even its fire lacks lighting power. These paintings speak of an internal experience.[11] Within our hidden depths Rothko's fire slowly burns. The agony it generates is neither violent nor tragic; rather, it is the agony of a slow, subdued pain which, as a smoldering fire, burns without end. The black rectangular clouds of the paintings seem to overpower us where we stand, yet pull us in as into a dark abyss. In *Black, Brown on Maroon,* we descend into an increasing darkness. These paintings speak of nothingness. The slow-burning pain of the maroon is reinforced by the emptiness of the void. Located at the top of the canvas in *Red, Brown, and Black,* this void dominates our experience of the work. Beneath the void, at center, a brown cloud, in the earthiness of its tones, suggests an existential reality, an of-this-world-ness, which brings the work home to us all the more forcefully. This earth-tone offers no suggestion of procreative possibilities. It is not the brown of a fertile earth. This reading is further reinforced by the darker brown of the cloud at bottom. This "under-ground" possesses the charred quality of a burned-out land. *Red, Brown, and Black* is almost literally an underworld, a land of eternal fire and night. So powerful is Rothko's diabolical vision here that we almost despair of life itself (Rothko ended his life at sixty-six by suicide). In this gloom of Hades, this land of shadows, all the demons are abstract yet psychologically present, and we should not be surprised if, at any moment, a host of demonic, unrecognizable creatures were to materialize themselves before our very eyes! The fact that no recognizable images appear makes the painting all the more relentlessly diabolical, for instead of *fear* of the known (Tillich) we have *dread* of the unknown (Kierkegaard). *Red, Brown, and Black* is a world without hope—almost, while *Black, Brown on Maroon* seems to take us even further into the night of despair. "'But,' I said, 'if you please, we will commit ourselves to this void, and see whether providence is here also'" (William Blake).

[11] In a lecture delivered at Pratt Institute in 1958, Rothko made clear his preoccupation with death. See Dore Ashton's account of Rothko's lecture in *The New York Times,* October 31, 1958.

Rothko, in his demonic mysticism,[12] has transcended our mundane existence. Engulfed by fire and the void, we are transported into a world beyond comprehension, corresponding to no human experience. It is, if not a world of monsters and gods, a world that takes its essence from their being. It is a world that is foreign and unrecognizable because it lies below the threshold of normal, waking consciousness. It feeds on powers residing in depths that are beyond our control. Its chthonic forces are the demons of our own depths, filling the void of our exiled existence and serving us by reminding us there *are* powers that transcend us. It thereby renders a one-dimensional, secular existence impossible.

Through the power of blackness, agony, and despair, we've encountered the secular mystery that, on the one hand, threatens us with its diabolical powers; and, on the other, holds out our hope of making the journey to the end of night. If we cannot contact God, at least we can contact the nether realms of "the wretched dead." "I am filled with awe in the presence of the religious greatness of the damned," said Thomas Mann. To contact the nether world is to know another kind of greatness. "Great minds are known in extremities," Democritus said. It is there that they are put to the supreme tests. The capacity of twentieth-century culture for damnation becomes the test of its greatness in a godless era. In a remarkable passage in his essay on Baudelaire, T. S. Eliot says:

> So far as we do evil or good, we are human; and it is better, in a paradoxical way, to do evil than to do nothing; at least, we exist. It is true to say that the glory of man is his capacity for salvation; it is also true to say that his glory is his capacity for damnation. The worst that can be said of most of our malefactors, from statesmen to thieves, is that they are not men enough to be damned.[13]

The modern artists of whom we have been speaking have shown themselves men enough to be damned, and therein lies their religious greatness. For in their damnation they have given our nihilistic age a

[12] I've focused here only on Rothko's dark works, which he painted from 1957 to the end of his life. Many of Rothko's earlier paintings reflect a joyous and at times almost angelic spirit. Others are portals that seem to admit us to other worlds or dimensions of being.

[13] T. S. Eliot, *Selected Essays*, 380.

spiritual underground. If our artists have been incapable of religious faith, they have shown themselves equally incapable of unfaith. The situation of our artists is analogous to that of Kafka as described by Erich Heller: "In Kafka's work the symbolic substance, forced back in every attempt to attack from above, invades reality from down below, carrying with it the stuff of Hell," thus showing "two things at once, and both with equal assurance: that there *is* no God, and that there *must* be God."[14]

In the very act of confronting the void, the old question of transcendence is again raised, albeit in a new form. The question of religious faith has been paradoxically inverted, for in the act of total violence, of absolute destruction and evil, have we not again transcended the bounds of finite existence? The agony and spiritual inquietude that man experiences before the abyss reflect his inability to get rid of the question of a reality beyond the isolated, existential self. John Osborn, in his play *Look Back in Anger,* placed on stage a frenzied young man who, at the sound of church bells, would give free reign to his neurotic compulsion to blasphemy. God is dead! Yet the very violence with which it has been declared suggests the matter is not yet closed. As Rimbaud said in *A Season in Hell,* "Hell has no power over pagans." So God's death and the agony of our self-loss before the void force us to ask whether, out of the void itself, we are not met by a power that, though demonic, yet transcends us. In *Modern Man in Search of a Soul,* Jung spoke of the artist's situation today in these terms:

> The experience that furnishes the material for artistic expression is no longer familiar. It is a strange something that derives its existence from the hinterland of man's mind—that suggests the abyss of time separating us from prehuman ages, or evokes a super-human world of contrasting light and darkness. It is a primordial experience which surpasses man's understanding, and to which he is therefore in danger of succumbing. . . . It arises from timeless depths: it is foreign and cold, many-sided, demonic and grotesque. A grimly ridiculous sample of the eternal chaos . . . it bursts asunder our human standards

[14] Erich Heller, *The Disinherited Mind,* 206, 214.

of value and of aesthetic form. The disturbing vision of monstrous and meaningless happenings that in every way exceed the grasp of human feeling and comprehension make quite other demands upon the powers of the artist than do the experiences of the foreground of life. These never rend the curtain that veils the cosmos: they never transcend the bounds of the humanly possible, and for this reason are readily shaped to the demands of art, no matter how great the shock to the individual they may be. But the primordial experiences rend from top to bottom the curtain upon which is painted the picture of an ordered world, and allow a glimpse into the unfathomed abyss of what has not yet become. Is it a vision of other worlds, or of the obscuration of the spirit, or of the beginning of things before the age of man, or of the unborn generations of the future? We cannot say that it is any or none of these.[15]

The images and symbols of the extreme situation that modern artists have given us are, it seems, inverted symbols of the Spirit. The profound metaphysical anxiety that extends from Van Gogh to Rothko bears witness both to the absence *and* the presence of God. For in the anguish of unbelief, man reveals his inability to achieve a wholly secular culture. Failing to become secular, he becomes demonic. Yet evil, as Milton, Goethe, and Melville knew, has also its divinity. "Through indulging a devilish sneer, uttering blasphemies, and pampering with brutish satisfactions the lowest in man," says Henri Peyre of Baudelaire, "the poet also hoped to arouse the angel in him and to incite the sinful creature to stand up and offer some justification for the world."[16]

So it is that the dialectic of the demonic, like the dialectic of the holy, may become an occasion for divine Self-revelation—and that all the more powerfully because of the power of evil against which it must struggle to assert itself. The darker the night, the brighter the light from a newly lit lamp. Dostoyevsky's Underground Man appears to have this theological corollary—the Underground God. If we cannot assert as an absolute fact that God as a metaphysical reality is dead, we may ask whether the Infinite may not in fact be using our experience

[15] Carl Jung, *Modern Man in Search of a Soul*, 156–57.

[16] Henri Peyre, ed., *Baudelaire*, 25.

of "the death of God" as an occasion for a vaster Self-revelation of the One Life. A view of history shows that exiles often go underground, forming a counterculture to the one that exiled them. Likewise with spiritual exiles: the exiled soul of man appears to have formed a spiritual underground that may well prove to be a cosmic counterculture in a materialistic, finite world. Revolutionaries seldom realize the full import of their revolutionary ideals. I, for one, am convinced modern artists had little comprehension of what their art was leading us toward. Look again at Rothko's *Red, Brown, and Black*. What is this mystical darkness if not already a sublimation and spiritualization of the depths themselves—a testament to buried divinity? And what is the urge toward unity—the overcoming of separateness—that pervades Rothko's art, if not a revelation of the synthesizing power that belongs to the One Infinite Life? (The truly demonic always fragments.) *Red, Brown, and Black* shows us how close together the demonic and the divine reside, like insanity and genius or yang and yin. We have in Rothko's work an example of that dark mysticism, that underground synthesis, that *numinous darkness* in which gods are born and men transformed. "We are going toward the *Spirit*," said Rimbaud. "I understand, but not knowing how to express myself without pagan words, I'd rather remain silent."[17]

So spoke Rimbaud in 1873. Silence is no longer appropriate. We must probe still deeper into the numinous darkness and see if we can discover the hidden happenings of the soul. To make conscious the unseen drama of the soul increases the soul's power by adding to unconsciousness the potency of conscious expectation. And in their dialectical interplay, consciousness further impregnates the subconscious with suggestive power. Our task, therefore, is to make as conscious as possible the transformations of the depths. Our language will be analogical and poetic, for "poetry lies where the known verges upon the unknown."

Contemporary man, though cut off from the metaphysical world above, cannot be cut off from below. "The greatest cutting does not sever," says the *Tao Te Ching*. If in our finitude we have lost

[17] Arthur Rimbaud, "A Season in Hell," 175.

consciousness of the Infinite, still the subjective mind does not and cannot lose connection with the Universal Mind[18] or its subjective awareness of the Infinite. To borrow a metaphor, we are like lagoons connected to the cosmic sea by a submerged channel, and even though to all appearances we seem finite (landlocked), nevertheless the subconscious waters of our souls and Spirit rise and fall with the cosmic tides of the Infinite Life. It is this hidden connection between ourselves and the boundless sea we must seek and find.

We turn once again briefly to the mystery of evil. The thesis of Baudelaire and Eliot that man can become good by indulging in evil is a dangerous philosophy. There is no guarantee, as with Columbus, that by traveling west one will eventually arrive at true east! The soul of man *can* become so deeply buried in the darkness of crime and perversion that the silent voice of conscience dies out and one is no longer aware of the possibility of spiritual life. In extreme cases the soul can sever its thread of connection to the personality, producing soulless men. There are such among us. To make the journey successfully to the nadir of night and back again, one needs a map—a symbology—and a perspective on the evils to be endured. Evil is the shadow-side of evolution —the negative side of the evolutionary process that forces growth and expansion. By stirring up the depths, evil serves the expansion of consciousness by not allowing good to become static, complacent. By drawing good forth in active combat with itself, evil forces an expansion of the good. It provides the tension needed for growth. Yet evil in itself is always *anti-evolutionary*—a force tending to nonexistence. Allowed to follow its own path unchecked, it produces chaos. This inherent nihilism of evil is useful to evolution because it makes possible the destruction of all that has been outgrown. Having served their purpose, old forms dissipate and die. This destructive power inherent in finiteness forces us to confront the limited usefulness of all finite forms. By recognizing finitude and the inevitable death of all things finite, we already stand upon a higher ground. Consciousness is ever greater than the thing it comprehends. To view the death of the finite is already to stand above the grave. Evil, by forcing us to see our limi-

[18] Every individual mind is a focal point in, an outlet of, and a gateway into the Universal Mind.

tations, also makes it possible to see ourselves as transcendent beings. So long as conscience is not silent, whenever we do evil we will feel we have betrayed ourselves, our true being; and a counterimpulse arises, a longing to live upon a higher plane. In this way evil aids the further awakening of consciousness. Finally, evil serves us in still another way: as it travels its anti-evolutionary path toward chaos, it lures consciousness into the darkness lying behind consciousness and takes us into those dark depths where wisdom is born. It shatters the limitations that prevent us from seeing more deeply. Evil is therefore a great ally of the soul when its proper place, function, and usefulness are understood. As Alan Watts expressed it in *The Two Hands of God:*

> Hence the wisdom of the proverb, "Give the Devil his due." For the dark side of life, the principle of evil or of man's irreducible rascality, is to be "reckoned with" not merely because it may overwhelm the light, but rather because it is the condition of there being any light at all.
>
> This recognition of the two-sidedness of the One is what makes the difference between the exoteric and esoteric aspects of a religion, and the latter is always guarded and is always mystical or "closed" . . . because of the danger that the opposites will be confused if their unity is made explicit. It is thus that mysticism is never quite orthodox.[19]

Before moving finally to the events at the nadir, one last quotation from Mark Rutherford seems worthwhile: "It may be asked, How are we to distinguish heavenly instigation from hellish temptation? I say, that neither you nor I, sitting here, can tell how to do it. We can lay down no law by which infallibly to recognize the messenger from God."[20]

With God's death and man's self-loss, angst, and destructive evil all serving to drag man down into the depths of utter darkness, we come now to deal with the metamorphosis that occurs at the nadir. We wish to know how it is that God is resurrected and how man, from

[19] Alan Watts, *The Two Hands of God,* 23.

[20] Quoted in G. Clive, *The Romantic Enlightenment,* 25.

the stillness of his dark tomb, is reborn. How worketh this mystery of death?

We have already spoken of the dismembered god (Osiris, Dionysus, Christ, et al.) whose fragmented body, scattered in the fields of space and time, gives rise to the created or generated world. This fragmented god is also our Underground God—God Immanent and *hidden within the world itself*. In short, the Spirit of God sleeps in the world's depths—sleeps the slumber of manifestation, awakening to himself gradually upon the returning arc of evolution. To find God, therefore, it is not necessary to journey out of the world. One can choose instead to be *buried* alongside the Hidden God. One can enter death's tomb and link up with the One who has entombed himself within his creation. Then, as God arises from his slumber in the depths of creation, so one's own soul in union with the Underground God experiences a like resurrection.

> *Near and hard to grasp is the God.*
> *Yet, where peril lies,*
> *Grows the remedy, too.*
>
> FRIEDRICH HÖLDERLIN

> *I want to know you, Unknown One,*
> *You who are reaching deep into my soul*
> *And ravaging my life, a savage gale.*
> *You inconceivable yet related one!*
> *I want to know you—even serve.*
>
> FRIEDRICH NIETZSCHE

The great mystery is that the metamorphosis of God and man is one and the same. Man's transformation is God's transformation, for man mirror-images God, and every expansion of man's consciousness permits an expanding revelation of God and every new divine revelation stimulates a further unfolding of the latent divinity in man. "Now the remarkable thing," says Jung, "is that it is not [man] who passes through death and emerges reborn, as might be expected, but the god.

It is not man who is transfigured into a god, but the god who undergoes transformation in and through man." In other words, man himself is the bearer of those transpersonal powers for good and evil that, once loosed, bring forth a profound transformation both of the individual and of society—and often at a cost of unimaginable suffering. The gods who rule over man, over his psyche, over culture, and who once seemed independent of him now show themselves to be intimately bound up and identified with his being and destiny. Men and gods share their fate. Human consciousness is the door by which the gods pass in and out of manifestation. A profound psychological transformation or a profound cultural shift that reflects the composite psyche of an age or race necessarily produces a corresponding transformation of its gods. When an old order dies, the gods of that order die with it. And when a new order is born, bringing a new consciousness within man, a "new" God—which is to say, a profounder and more appropriate manifestation of the One Infinite Reality—comes into being. Human consciousness is the portal through which divine revelation enters our world. "I am he who will create God," Verlaine boasted.

The veiled mystery is that God, in an age of great transformation, is no longer known *as God* in the old familiar ways. First we undergo self-transformation. Then God is seen as the One who has brought about the renewal of being upon a higher plane. Neumann says:

> The situation as we find it in myth and ritual is that, simultaneously with the ego's experience of its death, a revivifying self appears in the form of a god. The hero myth is fulfilled only when the ego identifies with this self, in other words, when it realizes that the support of heaven at the moment of death means nothing less than to be begotten by a god and born anew.[21]

[21] E. Neumann, *The Origins and History of Consciousness*, 254–55.

The stages of depth-transformation, as I perceive them, include:

EGO-LOSS; FRAGMENTATION OF THE SELF. In the first or dismemberment stage, the ego is shattered. Personality breaks up, followed by a sense of self-loss, anxiety, and so on. During ego disintegration,

consciousness is more or less reabsorbed by the unconscious. Spatio-temporal disorientation sometimes follows.

THE BROKEN CENTER AND GOD'S DEATH. With the loss of the center —the place of divine manifestation—God's "death" follows. The point of union between the human and divine worlds vanishes. But do not forget that the "dismembered God" is *he whose center is everywhere.* Because the fragments of God are scattered and buried throughout the manifest worlds, there is no place where the Infinite is not fully present in its boundless Oneness. The whole of the Infinite is to be found at every point of space and time, present in all its Being, and in no sense "divided" between things—which is to say that the whole of Infinite Being is present in this and every moment of time, in every human being, every cell and atom of nature, and at every single point of the cosmos! Were it not so, Being would be less than Infinite. While such a thought is staggering almost beyond compre-hension, this is what Giordano Bruno meant when he said, "We must assert with certainty that the universe is all center, or that the center of the universe is everywhere and its circumference nowhere." It is only when finite man's consciousness loses contact with its Center that God can appear to him as fragmented or hidden. Yet the mystery and paradox of the broken center and the dismembered God is that *the Infinite is everywhere.*

THE FRAGMENTED SELF AND THE DISMEMBERED GOD. In their hour of mutual death, veiled in holy darkness, the fragmented self of man and the dismembered God make contact, recognize opportunity, and see in each other a time for Self-transformation. "Like can only be known by like" (Empedocles); "Nothing can be touched by anything unlike itself" (Ficino); "Only spirit can understand spirit" (Helvetis). At the nadir of existence, the Zero Point, man's consciousness, freed by death from its former limitations, prepares for resurrection. It is an occult fact that the Infinite, being infinite *everywhere,* requires no movement. "Tao is ever inactive," says the *Tao Te Ching,* "and yet there is nothing that it does not do." Death brings stillness, and in that stillness the soul is united with the Ground of Being, the Infinite Presence: "Be still, and

know that I am God" (Psalm 46:10). In that moment like attracts like, and finite man and the Infinite One meet and are joined. Their contact takes place in that numinous darkness out of which men and gods are reborn. The nadir of existence, the Zero Point, turns out to be the Center, a point of contact with the Infinite. Paradoxically, the emptiness of man allows the fullness of God to manifest. Of this miracle of divine-human union, Emerson's words would seem to apply: "If we are related, we shall meet. It was a tradition of the ancient world that no metamorphosis could hide a god from a god."[22] Extremes meet—finite man and the eternal Ground of Being, the nadir with the apex, the Zero Point and the Infinite. The uroboric serpent of the cosmos is once again seen swallowing its own tail.

WHY THE ENCOUNTER WITH THE DIVINE DEPTHS SOMETIMES APPEARS "DEMONIC." Anyone visiting mental institutions cannot help noticing the number of patients who seem obsessed or "possessed" by religious or demonic impulses. When the fragmented ego of man encounters the Underground God and becomes chthonically charged by the God-power resident in the depths, the result is sometimes an intensification of the sense of ego-fragmentation, producing states akin to schizophrenia.[23] In such cases, rather than experiencing the divine as a beneficent force, the Underground God may be experienced "demonically" as the One intensifying the fragmentation (*Demon est Deus inversus*).

THE MYSTERY OF THE NIGHT: UNION WITH THE PRIMAL GROUND. A period of darkness ever precedes true revelation. During his sojourn in the night man is reunited with the Primal Ground, every descent into the underworld denoting a return to the primal state. In this divine darkness, this numinous night, transformation takes place unseen and unrecognized until the light of revelation at last breaks forth. During the "deathwatch"—when stillness pervades all—a mysterious transformation takes place in the depths of being. The Infinite floods the finite, death-governed form and imbues it with something of its own living indestructibility, setting in motion the forces of rebirth. All death is therefore a spiritualizing process that

[22] Ralph Waldo Emerson, *Essays*, 340.

[23] See R. D. Lang's studies of schizophrenia in *The Divided Self* and *The Politics of Experience*.

brings with it a greater inflow of spiritual Being. The breakthrough from the depths of the Underground God is a profoundly sacralizing event, signaling a divine re-creation of the world from the Ground up. It defines a new reality and establishes the new world that will manifest this reality. While divine revelation may be said to descend from above, man and the world are always transformed from below. Transformation comes upon us unseen. Its genesis takes place in darkness. From below we experience the infusion of Cosmic Power that further lifts the creative tides of evolution. In the hidden depths, the resident God-power, the power that transforms whatever comes into contact with it, sets in motion those forces which beget man anew. Thus the process of rebirth is begun, but it is not yet an accomplished fact. What man encounters in the underground is the shadow side of God, not yet the God of Light and Liberation. In its underground union with the divine, the mind is still enclosed in darkness. Illumination remains as yet a distant hope; man has yet far to go to achieve Enlightenment. The desired Illumination can come only after a long and arduous process of inner growth by means of which man reassembles his fragmented self, now God-infused, and finds his way to his Higher Self, the God-man within. The underground union with the Primal Ground serves only to provide a solid foundation on which to build the temple that eventually houses the God of Light. The underground becomes the Divine Ground when man penetrates to the utmost depths of his being and unites himself with the Infinite Self of All. Then only has he found the sure foundation that naught in all eternity can destroy. The numinous darkness is the gestation chamber within which men and gods alike are regenerated and reborn.

In Pollock's art we saw the cosmic center broken and the cosmic seed dispersed, without which we may never have learned that the center is everywhere, expressed by the ubiquitous spirituality of his arabesques. We have in consequence another vital feature of the depths—namely, that in the depths there is no hierarchical structuring of the sacred, no differentiation between God and man. What we

find instead is a democracy of the deep unconscious in which God and men meet as equals and man is transmuted into a god. This is a point of supreme importance for man's spiritual life, but it also has consequences for social and cultural life. Democracy, as practiced in the West, has resulted in an equalization of the masses based on the lowest common denominator and has contributed to the further creation of mass-man. Its effects are anti-evolutionary and anti-spiritual. The democracy of the deep unconscious unites all men as equals, *but only in terms of their divine potentiality.* It is the democracy of what Thomas Wolfe called "the buried life, the fundamental structure of the great family of earth to which all men belong." The awakening of this divine potential, however, entails a progressive unfolding and ascent within an evolutionary, hierarchical Chain of Being that embraces all lives, from the tiny atom up to and including vast solar and cosmic Intelligences. There are grades and levels and stages of Self-unfoldment, just as there is a hierarchy of sound in the notes of the music scale. If all notes were equal, we would have no music. In the future, our educational systems must find a way to reconcile these fundamental truths and allow for the maximum self-actualization of each student rather than forcing all into a one-size-fits-all pattern of conformity.

We have now gazed into the Abyss and discovered that the God who died was finite—a human conception and an anthropomorphic projection. With the death of his finite image, God went underground and became unconscious for man.[24] To be unconscious is to be unmanifest, unrealized—a symbol of the unawakened potentiality of Being. This unconscious God is vaster, deeper, and more vital than the limited God of rational thought. The unconscious God puts us in contact with the archetypal forces that govern our evolution. The entombed God of the Underground Man, whose spiritual resurrection is in the making, will be the Infinite God of a spiritually awakened humanity —of a humanity evolving toward Cosmic Consciousness. With the death of materialistic man and the birth of spiritual man must come also the death of his anthropomorphic God, and the resurrection of

[24] See Viktor Frankl, *The Unconscious God.*

God as a spiritual reality: "The hour is coming, and now is, when the true worshiper will worship the Father in spirit and truth, for such the Father seeks to worship him. God is spirit, and those who worship him must worship in spirit and truth" (John 4:23–24).

In the spiritual drama of our age, the death of transcendence heralds the birth of immanence and a recognition that God's kingdom is within! By means of an inward-moving "negative transcendence of the human,"[25] modern artists such as Rothko have contacted the Primal Ground and unveiled somewhat the mystery of darkness. Only by destroying surface values, engaging in violence against specious good, and exploring the mysteries of the night has it been possible to rediscover the true Ground of Being—that place where men and gods alike are reborn.

> . . . the bold spirit, like an eagle
> Before the tempests, flies prophesying
> In the path of his advancing gods.
> FRIEDRICH HÖLDERLIN

[25] Lionel Trilling.

12 The Labyrinthian Search

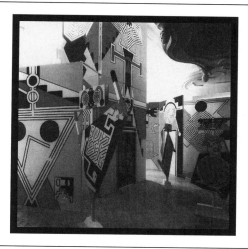

Walter Gaudnek,
*Nomaze, Standing
Labyrinth,* 1984
See plate 11

Walter Gaudnek (1931–)

In the theme of the broken center we have the origin of the labyrinth—the lost way and the beginnings of the search for the way back to the Center of Being. The laybrinth or maze is a symbol of the Quest in its many forms. Not only the story of Theseus and the Cretan laybrinth, but the story of Ulysses, the legend of the Wandering Jew, the quest of King Arthur and his knights for the Holy Grail, and Wagner's musical drama, *The Flying Dutchman*—all concern one and the same theme, the quest of man for what has been lost, his own soul or essential Self.

A *labyrinth,* properly defined, consists of seven circuits without intersecting paths or dead ends. There is only one path, which leads eventually to its center, and it is impossible to go astray. Since the third century BCE, *mazes* have also been called labyrinths. Mazes consist of underground tunnels or passages with intersecting paths that wander chaotically, often winding back on themselves or merging with

The Garden of Forked Paths *is an enormous riddle, or parable, whose theme is time; this recondite cause prohibits its mention. . . . I have guessed the plan of this chaos. . . . The Garden of Forked Paths is an incomplete, but not false, image of the universe . . . an infinite series of times in a growing, dizzying net of divergent, convergent and parallel times. This network of times which approached one another, forked, broke off, or were unaware of one another for centuries, embracing all possibilities of time. . . . Time forks perpetually toward innumerable futures.*

JORGE LUIS BORGES

161

other passages or terminating in dead ends.[1] While recognizing the distinction, I shall treat both in this essay under the term *labyrinth*. The first type (or true labyrinth) is an initiation chamber in which one undergoes a spiritual transformation, while a maze is symbolic of the wanderings and confusion of man during earthly life up until the time when he is ready to tread the path of initiation—that is, until he undertakes his spiritual quest. Only then does he enter the first type of labyrinth. One could say the maze becomes the labyrinth when man *ceases wandering* and *awakens to the quest* for his own true being. Hence, I've woven the two concepts together in this essay, as has the artist whose work we shall be discussing. A quote from Hermann Kern's account of the labyrinthian journey sets the stage.

> A certain level of maturity is required to understand the shape of, as well as to make the decision to venture into, a labyrinth. . . . Before deciding to enter a labyrinth, several hurdles appear, which can be overcome only by those who have reached a certain level of maturity. Once past the entrance, the "tortuous path principle" takes effect. The interior space is filled with the maximum number of twists and turns possible—meaning the greatest loss of time and the most physical exertion for the walker on his or her way to the goal, the center. The experience of repeatedly approaching the goal, only to be led away from it again, causes psychological strain. Since there are no choices to be made on the path to the center, those who can stand this strain will inevitably reach the center. . . . Once at the center, our subject is all alone, encountering him- or herself, a divine principle, a Minotaur, or anything else for which the "center" might stand.[2]

While labyrinths are often constructed above ground, they always have an *underground* or *underworld* significance. The symbolism of

[1] The most authoritative source on labyrinths is Hermann Kern's monumental work, *Through the Labyrinth*.

[2] Ibid., 30.

the earth and the significance of the labyrinth as an underground maze concern man's life in the material universe. In the ancient symbolism of the four elments—Earth, Water, Fire, and Air—Earth represents the physical world and body of man, Water the emotional life, Fire the mental life, and Air the spiritual life and worlds. The subterranean world of the labyrinth symbolizes the life of man as an incarnate being, a dweller in the lowest of the worlds beneath that of Pure Spirit. In this world man is subject to space and time. Here he encounters innumerable experiences and is forced to make constant choices. This endless confrontation with new experiences and choices—the sheer multiplicity of life's options—constitute the labyrinth within which he must search for meaning and direction and ultimately find the Path of Liberation that leads out of the labyrinthian life. Each new path leads to new ventures, new explorations, and often dead ends, forcing us to try other paths. Even the kaleidoscope of human emotions, the maze of ideas, and myriad "states" of consciousness we experience are so many labyrinths of feeling, thought, and awareness in which we easily become trapped or lost. And the puzzling world of dreams—what is this but a symbolic labyrinth through which we must thread our way to grasp the meaning of the buried life of the subconscious? To dwell in space and time and a body of flesh is to be a wanderer, a seeker, a labyrinthian man. To be labyrinthian is also to be a sufferer. The myth and religion of Orpheus concerns man's descent into the underworld, the land of sufferers, and his struggle to bring his own soul out of the depths and back into the realm of light.

Underground caves and caverns have also an oracular significance. The revelations of Mother Earth were spoken by oracles in caves. As Raymond de Becker puts it, "From the Delphi cave where the Python dwelt to the grotto of Lourdes in which the Virgin appeared, an oracular or therapeutic meaning has been attached to caves."[3] As a "womb," the cave has the symbolic significance of giving birth to what is buried within it. The labyrinthian wanderer as a "cave-dweller" has, by virtue of his underground experience, assurance that his searching will eventually lead to freedom from his earthly prison. "Who knows but that

Not everyone can or will enter the Maze. Thus it is called the Royal Maze, relating to the Royal Way or path.

JOHN COOKE

[3] Raymond de Becker, *The Understanding of Dreams and Their Influence on the History of Man*, 331.

our soul, in the unknown secret of its essence, has power some day to throw light on its successive journeyings," wrote the philosopher Jean Reynaud.[4]

One more aspect of the symbolism of the labyrinth must be mentioned before we take up Gaudnek's labyrinthian art, and that is its function as a prison of the soul. Like the characters in Sartre's play *No Exit,* many who experience earthly life as a hellish endurance wonder if our being here isn't all "some ghastly mistake." The philosopher Thomas Hobbes said, "Life is solitary, poor, nasty, brutish and short." On deeper reflection, life takes on the character of a web in which we are all trapped together for good or ill. No one journeys through the labyrinth alone. This view is expressed by Garcin in *No Exit:*

> Inez, they've laid their snare damned cunningly—like a cobweb. If you make any movement, if you raise your hand to fan yourself, Estelle and I feel a little tug. Alone, none of us can save himself or herself; we're linked together inexorably.[5]

The web is another image for the labyrinth—one that adds to its symbolism of imprisonment the linking together of the imprisoned ones. This recognition of existential imprisonment becomes a key motivating factor in the wanderer-seeker's attempt to free himself from the labyrinth. As Eliot Deutsch put it, "An awareness of being in bondage is necessary to inspire one to make the quest for freedom."[6] On the Spiritual Path one learns that liberation comes only as one recognizes the universality of life and the brotherhood of all living things and resolves to serve others.

The only modern artist to my knowledge who has concerned himself in a major way with the symbolism of the labyrinth is Walter Gaudnek (1931–). We shall look briefly at two of several major works dealing with this theme. The first, *Labyrinth* (1960), is regrettably now lost. Its disappearance is lamentable, as I consider it one of the artist's most important works. The meandering lines of *Labyrinth*

Poor intricated soul!
Riddled, perplexed,
labyrinthical soul!

JOHN DONNE

[4] Quoted in Sylvia Cranston and Joseph Head, compilers, *Reincarnation: An East-West Anthology,* 208.

[5] Jean-Paul Sartre, *No Exit and Three Other Plays,* 29.

[6] Eliot Deutsch, *Advaita Vedanta: A Philosophical Reconstruction,* 77.

have a quality that is almost dancelike, at once sensual and musical. The passages are full of inventiveness and surprises as they wind, twist, become dead ends, set out anew, and return to their origins. Their riverlike twistings also suggest to us the rivers of time, uniting the symbolism of time with that of space as an essential element of the labyrinthian theme. At visual center a large, almost entire black area appears, giving a "center" to the work. Yet we find by its blackness and by the fact that the labyrinthian passages wind through it, that it is an unrecognized center; the wanderer can pass through the center of the maze and never realize he has been there. Gaudnek has been a personal friend for many years. As I am a very center-oriented person in my thought and he is not, we've had many arguments over the symbolism and significance of the center. Gaudnek regards it as "hypnotic" and therefore dangerous to creativity, which he sees as "polymorphic" and adventurous. And he also thinks of the center as a "dead" point. Hence, it is not surprising that in this early work he has veiled the center in near-total darkness. Yet, had he done otherwise, his *Labyrinth* would be less of a maze. The essence of this image is our sense of lostness—a quality Gaudnek himself seems to reflect in this photo.

In a second labyrinthian work, *Abraxas* (1960–61), we have one of Gaudnek's standing labyrinths—works consisting of large canvas panels that can be arranged in a free-standing mazelike pattern so that viewers

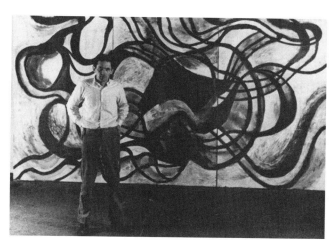

When astray—your wanderings are limitless.
SENECA

Walter Gaudnek,
Labyrinth, 1960

experience the work by wandering amid the panels. The physical as well as psychological involvement of the viewer acts upon consciousness much the way architecture does—that is, as real space, it defines his experience of himself and his environment. *Abraxas,* unlike Gaudnek's Purdue labyrinth of 1970, consists of canvas panels with cut-out circles in them. Like waters circling the eye of a hurricane, swirls of black and white paint create a vortex surrounding these holes that acts to suck consciousness in, only to confront it beyond with still another chamber of the labyrinth! If, for a moment, these openings seem to offer hope of escape, the thought proves deceptive. They only intensify our sense of being trapped. Yet at the same time, they lure us on. One is reminded of Poe's description in "A Descent into the Maelström": "I became possessed with the keenest curiosity about the whirl itself. I positively felt a *wish* to explore its depths, even at the sacrifice I was going to make; and my principal grief was that I should never be able to tell my old companions on shore about the mysteries I should see."[7] Thus does the labyrinth draw us on, encouraging our search with the promise of some new adventure just around the next bend. The search itself takes on the symbolism of new dimensions and new depths.

The many symbol-laden labyrinths Gaudnek has created (nineteen between 1961 and 1983, after which he stopped counting) serve to

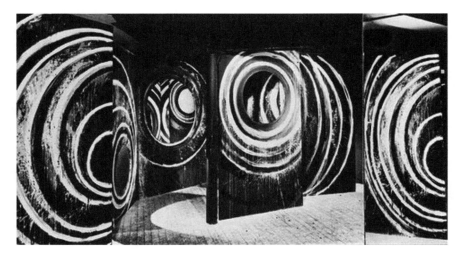

Walter Gaudnek, *Abraxas Labyrinth,* 1960–61

[7] Poe, *The Works of Edgar Allan Poe,* 563.

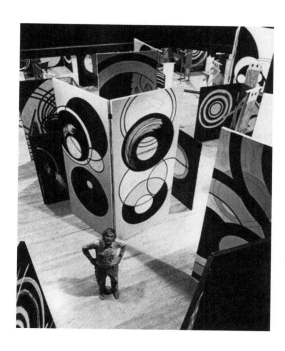

Gaudnek in another
Labyrinth

remind us that though we may wander in the darkness of material existence, all around us are the symbols of a higher life and the keys that unlock the mysteries of earthly existence. (See plate 11.) Many years ago I had a dream in which I found myself in a narrow passageway flanked on both sides with high stone walls. On both sides the walls were profusely covered with strange, undecipherable symbols from which emanated a potent energy so intense that I found it difficult to make my way past them. The symbols seemed to demand that I decipher their meanings as a condition of passage, yet I could not. Not surprisingly, a few days later I dreamed I approached the entrance of an ancient mystery school, seeking admission, only to be told, "You are not yet ready."

Gaudnek's labyrinths often consist of large panels covered with mysterious symbols, some born from the depths of his own creative psyche, others variations of ancient and well-known symbols of search and salvation. The wanderer in these labyrinths, like me in my dream, is confronted with the task of deciphering these symbols, without which the soul must remain labyrinth-bound. Ability to decipher the mysteries of life is a condition of escape from the labyrinth.

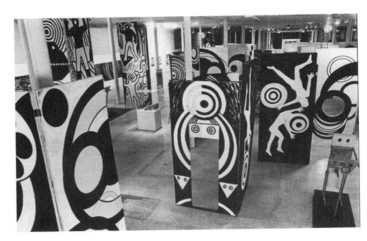

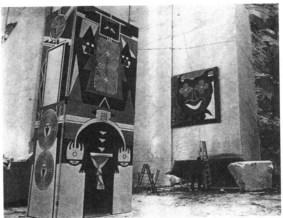

Two Gaudnek symbol-laden *Labyrinths*

Theseus slaying the Minotaur

8 Leonard Cottrell, *The Bull of Minos*, 106.

To fully grasp the symbolic meaning of the labyrinth, let us now turn to the Cretan labyrinth and the myth of Theseus. The labyrinth of Gnossus on the island of Crete, according to legend, was designed and built by Daedalus at the direction of King Minos as a place to imprison the Minotaur, a fabulous monster whose lower half was human and whose upper half was that of a bull. The Minotaur was finally slain by Theseus with the help of Ariadne. "She gave Theseus a clue [thread] when he went in. Theseus fastened it to the door, and, drawing it after him, entered in. After having found the Minotaur in the last part of the Labyrinth, he killed him by smiting him with his fists; and, drawing the clue after him, made his way out again."[8] We have already referred above to the symbolism of the Minotaur and Ariadne's "clue," which Theseus used to find his way out of the

labyrinth. Ariadne symbolizes the soul of man himself, which, being of a more spiritual nature, cannot fully incarnate in the human body and earthly personality, which is to say that man's spiritual nature transcends all earthly physical limitations. Therefore, in the Theseus myth, as in all esoteric Wisdom Teachings, the soul is represented as remaining *above* man during his earthly pilgrimages (often symbolized as a guardian angel), yet linked with man via a "thread of life"—in actuality, two threads, one of life and one of consciousness. We verge here on esoteric science. It may be of some interest to sample the literature on this subject, as it also composes part of the basic teachings of Rāja Yoga:

> The soul informs the mechanism in two ways and through two points of contact in the body:—
>
> a. The "thread of life" is anchored in the heart. The life principle is there to be found, and from that station it pervades the entire physical body through the medium of the blood stream, for "the blood is the life".
>
> b. The "thread of consciousness" of our intelligence is anchored in the head, in the region of the pineal gland, and from that station of perception it orders or directs the physical plane activities, through the medium of the brain and nervous system.
>
> The directing activity of the soul, or its authoritative grasp upon the mechanism of the body, is dependent for its extent upon the point of development, or upon the so-called "age of the soul". The soul is ageless from the human angle, and what is really meant is the length of time that a soul has employed the method of physical incarnation.[9]

By fully awakening and joining the heart and head "centers," one is able eventually to achieve spiritual illumination and transcend the many limitations of earthly existence. Of this we shall have more to say. The point here is to show that the Theseus myth is in fact a veiled symbol of a process by which man overcomes his finitude and frees himself from the labyrinth of earthly life. The "clue" or "silver cord"

[9] Alice A. Bailey, *Esoteric Psychology*, vol. II, 62.

is his link with his soul, Ariadne, who becomes his helpmate in slaying the Minotaur (the lower self) and escaping the labyrinth.

The times in which we live are, above all, labyrinthian. The seekers are everywhere! What are the many travels and "mind trips" of today's youth if not externalized and internalized expressions of the ancient labyrinthian search for the Way that leads from lostness to self-discovery and from death to spiritual rebirth? And what of the search for identity through therapy and encounter groups, and what is the urge to self-realization in the black, women's, and third world liberation movements, and what of the search for ethical integrity stirring at the heart of our national life—what are these except the age-old labyrinthian search written large upon our age? Alienation, lostness, and meaninglessness are not new to our time, but perhaps no other period in human history has been so conscious of its lostness. From artists, poets, playwrights, philosophers, psychologists, and theologians, even politicians, we have had a constant outpouring of lament over man's loneliness, loss of identity, loss of meaning, loss of values, loss of integrity, and so forth. Books with titles like *Man's Search for Himself* and *Man's Search for Meaning* became instant best-sellers. Ours is truly an age of Quest. Gaudnek, like so many others today, is a man engaged in the Great Search, though largely on a subconscious level. In his complex "polymorphic" art, we see many of the paths he has tried, for what is any work of art but an image from the artist's own soul? In his greatest works, such as *Rebirth,* which will be considered later, we find ourselves face to face with the fundamental issues of our age—issues of death and transformation. What are we to become?

It is not my intention here to study Gaudnek's work *Dying Bull* except to suggest that it is undoubtedly connected subconsciously with Theseus's slaying of the Minotaur. Its silent, agonizing cry of suffering and death, its archetypal associations with the slain Dionysus and Christ (both represented as bulls), the three spikes in the bull's head evoking association with the three spikes with which Christ was crucified and the three arms of the cross in the halo of *Christ Pantocrator,*

Walter Gaudnek, *Dying Bull,* 1960

and the unavoidable phallic or generative associations these spikes also call forth—all suggest that we are dealing with the symbolism of death and regeneration. Man's task in the labyrinth is to slay his own animal nature so that his spiritual nature can manifest. The essence of labyrinthian wisdom is to find and vanquish the Minotaur in oneself. For this reason the labyrinth is so designed that, as Kierkegaard expressed it, one "constantly seeks a way out and finds only a way in, through which he goes back to himself." A labyrinth is a device designed for self-discovery; it *returns us to ourselves*. Once having found the Minotaur, the most difficult part of all is to slay him. Theseus had to slay the Minotaur with his fists, which is to say, in a direct confrontation. The dark side of human nature cannot be vanquished by remote means; it is a close-up battle that engages us at the very core of our being. There's something nostalgic, almost lovable, and always alluringly sensuous about man's animal half when it isn't being destructive. It is an easy temptation to want to keep our Minotaur-nature—well hidden, of course, in the deepest part of our labyrinth. But until we are ready and willing and have acquired sufficient self-mastery to smite with our fists the animal-man, the embryonic god that he hides cannot be born. I have suggested that ours is a labyrinthian age, an age of searching. Yet greed, crime, pornography, terrorism, and evils of all kinds are on the increase. The paralleling of the intensification of man's quest for his true identity and the expression of what is most lawless and unresolved in his nature show how closely connected the labyrinth and the Minotaur are in the human psyche. Another way of seeing this is to say that as we intensify our efforts to bring to birth the higher spiritual man, the earthly man, seeing his own death prefigured, makes a final desperate effort to prevent spiritual rebirth by summoning all that is animalistic in his nature. If true of the individual confronting spiritual rebirth, why not also of an age—our age? Can this be the meaning of all the many evils we see today—that they are a last-ditch effort to block the spiritual awakening and transformation of humanity? In *Fearful Symmetry,* his definitive study of William Blake, Northrop Frye tells how Blake saw human history as a slow

evolution of contrary forces that would eventually meet in an ultimate and final confrontation. In Frye's paraphrase:

> Every advance of truth forces error to consolidate itself in a more obviously erroneous form, and every advance of freedom has the same effect on tyranny. Thus history exhibits a series of crises in which a sudden flash of imaginative vision (as in the French Revolution) bursts out, is counteracted by a more ruthless defense of the *status quo,* and subsides again. The evolution comes in the fact that the opposition grows sharper each time, and will one day present a clear-cut alternative of eternal life or extermination.[10]

Finally, the labyrinth becomes the Royal Maze when it ceases to be a prison for animal-man and becomes the initiatory chamber of the spiritual man. We saw in our previous chapter how fragmented man makes contact in the depths with the Underground God and becomes chthonically charged. But he remains as yet fragmentary and knows God only in his dismembered state. Spiritual rebirth is not yet an accomplished fact. In the labyrinth man is first of all a wanderer, then a seeker of the Way. After contact with the Underground God, he becomes a synthesizer. He begins the labor of gathering up the fragments of himself and God, which, as it were, are found scattered throughout the labyrinth. He seeks a new unified vision that enables him to synthesize all that he has learned during his dark sojourn in the realms of earthly existence. The Underground God, initially experienced in a fragmented state, is nevertheless the One *whose center is everywhere*—an Infinite Unity. And it is this One who becomes the source of the subconsciously infused power by means of which the Underground Man—the victorious Theseus—succeeds in gathering, assembling, and synthesizing the fragments of himself and the Hidden God into a new Whole Man—a spiritual man—and begins his resurrection from the depths of earthly existence. It is to achieve this work that we were born into this labyrinthian space-time world, and only a victory over ourselves will get us out!

[10] Northrop Frye, *Fearful Symmetry.*

13 The Dance of Life

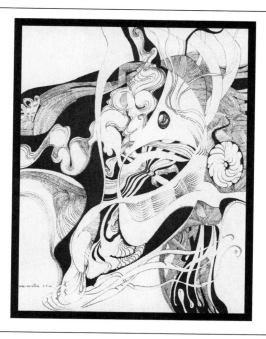

Arlé Sklar-Weinstein, *Inside a Seed*, 1966
See plate 13

Arlé Sklar-Weinstein (1931–)

To dance is to live! If the essence of death is the stillness of the tomb, the essence of life must be joyous movement. And where is movement more joyous than in the dance? Surely it is the supreme celebration of life—life as living art!

Dancing, which unites space and time in rhythmic motion, has close analogies to the labyrinth, and Theseus is said to have invented the crane dance following his escape from the labyrinth—a dance that imitated his journey into and escape from the labyrinth, complete with the symbolism of Ariadne's thread.[1] In a profounder sense, dance is a labyrinth in process of continuous creation and dissolution—which is true of the dancing cosmos itself. In Hinduism, Shiva, the transformer,

[1] See H. Kern, *Through the Labyrinth*, 44–47.

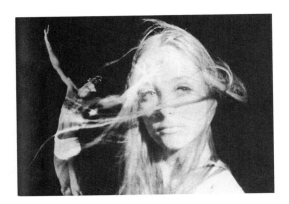

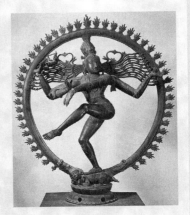

Shiva as Nataraja, Lord of the Cosmic Dance

is frequently portrayed as Nataraja, Lord of the Dance. As a symbolic act of creation or cosmogenesis, dance reveals by its analogy with the labyrinth the hidden meaning of the labyrinth as a cosmos. Viewing the cosmos as a vast labyrinth, dance may truly be said to have its origins in the labyrinth. The wanderer-seeker in the labyrinth, as we've noted, simulates dancelike movements in his journey. Bacchus, in Greek mythology, is also reported to have danced in his mother's womb; and, as Eliade has noted, all underground caverns are symbols of the womb of Mother Earth. Like nature's seeds that vibrate underground with the stirrings of new life in spring and may be said to dance before the first green shoots break forth into the open air, so the soul of man may be said to feel its first impulse to dance while still underground, labyrinth-bound. Once the dance commences, we know a metamorphosis has begun. He who journeys through the underground is awake and alive!

In the depths he finds himself partnered with "a dancing god." This god is Dionysus, who creates not by sublimation but by incarnation—Dionysus, the god whose eternal energy continually transforms and renews the world. He is the god of ecstasy, and what is ecstasy if not a joyous dance of never-ending self-transformation? Dionysus is the universe in a state of ceaseless becoming, change, flow, never-ending self-transformation and regeneration. His three identifying art forms are music, dance, and prophecy—prophecy because metamorphosis contains within itself the seed of its destiny. Once the dance of life begins

below, we know life will soon manifest above. Finally, dance—an inbreathing of life's energies from unseen spiritual realms—renders these energies, abstract and invisible in music, visible through the movements of the human body. The ecstatic life of Dionysus incarnates itself in this, his most typical art form. When dancers perform together, linked arm in arm, they symbolize the interlinking of all lives from the least to the greatest—a cosmic matrimony termed the Great Chain of Being, the unity of the Whole. This theme is beautifully portrayed by the Hindu circle dance known as the Rasalila, in which Krishna is seen dancing with the gopis under the full moon (plate 12).

To find the dance of life in contemporary art, we must turn to a movement that was never accepted by the art establishment—Psychedelic Art. Its orphan status is probably accounted for by (1) the association of Psychedelic Art with the drug culture, and (b) the fact that relatively little Psychedelic Art reached those levels of high creative expression we demand in all true art. In painting as in poetry, what distinguishes true art from mere talent and true poetry from mere verse is a power of creative vision and transcendent imagination—an inner vision originating within the artist's own soul. A work of art differs from a photograph only to the degree that an artist transforms his vision of the world through creative insight, depth of vision, and imagination. Much Psychedelic Art proved to be little more than a "photographic record" of states of consciousness produced by mind-altering drugs. A notable exception is the visionary art of Austrian-born painter and sculptor Ernst Fuchs. So enamored were many so-called Psychedelic Artists by the novelty and beauty of their drug-induced visions that little creative artistic imagination was brought to bear to interpret and transform their experiences into high art. Inner visions are as legitimate a theme for art as external vision, as the art of William Blake long ago demonstrated. Drug-induced visions consist largely of astral-plane phenomena. Hence, the failure to elevate psychedelic vision by means of poetic imagination into fine art is comparable to a photographer taking snapshots of whatever falls in front of her camera without regard for the organizing principles or mythic

power of true art. Nevertheless, Psychedelic Art *did* produce some important innovations in the visual field, which have been overlooked by the art world to its own impoverishment.

The work we shall consider now is an ink drawing by Arlé Sklar-Weinstein (1931–) titled *Inside a Seed,* 1966 (plate 13). At first glance the work appears to have many similarities to Gaudnek's *Labyrinth.* And, indeed, the labyrinthian interweaving of lines and forms does communicate to us the sense that we are still within a maze. But there are several important differences: first, whereas in Gaudnek's *Labyrinth* there is a strong visceral-tactile quality that calls to mind the interior of the Lascaux caves, in Sklar-Weinstein's work we feel we've entered through a microscope into the unseen world of micro-organisms. There is a multidimensional depth to *Inside a Seed* that hints of the hidden recesses in which life takes root. Second, Sklar-Weinstein's shapes and lines are clearly organic. The center of the work is dominated by a womblike space in which various biomorphic forms appear—some twisting and curling like smoke or intestines, others spanning like fibrous tendons, still others unfolding progressively like stages of embryonic growth. At upper-right of center a small, dark opening houses a "seed." At the extreme right a sinewy landscape appears, from which a kind of embryonic flower emerges. At bottom-right, semenlike forms swim in another dark space. The use of seriate line throughout suggests growth, unfoldment, expansion, development. A pleasant, rhythmical, dancelike quality governs the use of lines and forms. There is none of the angst of the Abstract Expressionists or the cool aloofness of Op or Minimal Art. In Sklar-Weinstein's *Inside a Seed* we are no longer suffering but are witnessing the dance and flow of life. Robert E. L. Masters and Jean Houston, in their *Psychedelic Art,*[2] appear to find it strange that the government should have passed punitive laws against experimentation with psychedelic drugs.

That psychedelic art should encounter these pressures is somewhat ironic when one considered that here is an art almost totally free

[2] The only book on this subject, to my knowledge.

of the preoccupation with neurosis, the ugly, and the sordid—with, that is, man at his sickest—that saturates so much of the artistic expression of our time. Instead, this art typically aims at providing or communicating spiritual and aesthetically beautiful experience.[3]

Regrettably, the optimism of this statement does not fit the facts, as man's sickness found expression in Psychedelic Art just as it did in art before the drug era. I knew several artists when living in New York and collected some of their works during the early days when the drug culture was still very much underground. It would be easy to produce examples to show the other side, which the Masters-Houston book does not represent. Bad trips and bummers had their artists also. Schizophrenic states were not uncommon under drugs.

Returning to Sklar-Weinstein's *Inside a Seed,* I wish to emphasize the organic vitality, the dancelike rhythms, and the participatory vision of this work. The artist's title for this drawing suggests that she wants us to view the environment in which the seed is set as though we're seeing it from within the seed itself—to see its dance of life and creative unfoldment as taking place *inside* the seed. The seed, it should be noted, gives us a point or center once more. In the oldest known manuscripts of mankind, a single point of light in the center of a black page symbolized the cosmic seed and the beginning of creation. In contrast to Gaudnek's *Labyrinth,* with its center veiled in darkness, *Inside a Seed* gives us a germinal point, then attempts to tell us visually what is happening within this center.

I don't claim *Inside a Seed* as a great masterwork (though it is quite well done), but it is important as an example of the Psychedelic Art that, after two generations of nihilistic and abstract art, set its face once more toward life. Whatever the failings and limitations of Psychedelic Art, *it was alive,* as was the music of the era. In it the heart and mind dance the way our joyful bodies danced to the music of the 1960s and '70s. Indeed, I must not leave this topic without a passing reference to *Cerebrum,* a short-lived (ten months) environment designed to promote "an ecology of the mind," to borrow Gregory

[3] R. E. L. Masters and J. Houston, *Psychedelic Art,* 21.

Bateson's phrase. *Cerebrum* provided three- to four-hour sessions in a light-and-sound created environment designed to simulate altered states of consciousness. Moods were very much group-governed, and the atmosphere could range from a Zenlike meditative quiet to near-orgiastic ecstasy. In an all-white room with white carpeting, designed to accommodate a maximum of fifty persons, shoes were removed and white flowing robes donned, under which, if one chose, clothing could be removed. The sense of freedom, the modulation of moods from a meditative calm to ecstatic dancing joy, and the sense of closeness that often developed between total strangers all contributed to a heightened sense of life and unity among participants. At times a rose—the Western equivalent of the Eastern lotus, the symbol of the unfolding soul—would be projected on the surrounding walls. *Cerebrum* closed immediately following Woodstock in 1969. Like discotheques such as the Electric Circus and Cheetah in New York, *Cerebrum* sought by more intimate means to duplicate with external stimuli the inner states produced by drugs, without their adverse effects. One has only to listen to the music of the "flower children" era, or an extremely popular group such as the Rolling Stones, to realize both the vitality of the era of the mid-sixties and early seventies and to recognize also the vastness of the journey still ahead before illumined Self-Realization is achieved. No total vision of life's possibilities can be attributed to the drug era, though musicians such as the Moody Blues did for us in music something akin to what Hermann Hesse did in his novels by taking us on spiritual journeys. The pilgrimage is still onward, but the resurrection of life following the dark night of the soul of the postwar years had clearly begun for much of a generation.

Ironically, the youth of the late sixties failed to see the roots of their transformation in the events of the preceding existentialist generation. What I'm attempting to show here is the *continuity* of the transformative process that began, in one sense, with the nineteenth-century Romantics, but continued more explicitly with the generation of the Second World War and will doubtless extend well into the twenty-first century and beyond. The mind-expanding-drug genera-

tion, whatever one's opinion of it, did make its contribution to this transformative process. It awoke us to the dance of life lurking in our psychic depths. It rolled back the stone at the entrance of our grave. As for the vision it beheld, it is too soon to judge its merits. The seed planted by any subculture seldom comes to full fruition within the lifetime of its pioneers, and the flower-children generation—inspired by visions of love, unity, peace, brotherhood, and respect for nature—clearly planted the seeds of a new era. They were the forerunners of a joyous, more spiritual and inclusive age to come. Some, like Richard Alpert (Ram Dass), were led by drugs to seek an established spiritual Path and have contributed much to the spiritual nurture of Western culture, while others, like Alex Grey, turned their psychedelic experiences into magnificent works of art and spiritual vision, such as his *Chapel of Sacred Mirrors*.[4] "How are we to distinguish heavenly instigation from hellish temptations? . . . Neither you nor I, sitting here, can tell how to do it. We can lay down no law by which infallibly to recognize a messenger from God."[5]

<hr>

[4] See Alex Grey, *Sacred Mirrors: The Visionary Art of Alex Grey*, with essays by Ken Wilber and Carlo McCormick; and the DVD, *CoSM the Movie: Alex Grey and the Chapel of Sacred Mirrors* (2006), directed by Nick Krasnic.

[5] Mark Rutherford.

14 The Way of Regeneration

Adolph Gottlieb,
Blast 1, 1957
(See plate 14)

Adolph Gottlieb (1903–1974)

The abstract paintings of Adolph Gottlieb (1903–1974), beginning with the "Blast" series in 1956, appear to have baffled the art world, if one is to judge by the absence of good writing about his work. For most of a decade Gottlieb and I were friends. Adolph hoped I would do more writing on his art,[1] yet this is my first interpretative piece of any length. Regrettably, he didn't live long enough to see it.

[1] Following my review of joint one-man shows of Gottlieb's art at the Solomon R. Guggenheim Museum and Whitney Museum of American Art in 1968, Adolph wrote me saying, "In this brief note I must tell you that what I particularly value is to have ideas expressed that reveal me and help me to understand myself. I work out of feeling and intuition and when you observe that my art is 'an art of regeneration, of perpetual descent and return,' I am simply floored, because this is the story of my life, yet I never thought of it in the terms you use."

See my other articles on Gottlieb's art, including my review following the joint Whitney-Guggenheim one-man exhibition of his work in 1968 and Gottlieb's letter to me in response to my review, at my website: www.lighteagle.net.

Nevertheless, this chapter is dedicated to a warm friendship and a great artist.

Jacob Landau once spoke of contemporary Western man's "repeated attempts to eliminate all contraries from the image" in the hope thereby of ridding himself of the experience of "ambiguity and pain."[2] The dialectic that characterized Western thought from the time of the Babylonian myths and dramas of Aeschylus has become, for contemporary man, a polarization, an irreducible conflict of opposites. It's not surprising, therefore, that a work such as Gottlieb's *Blast 1, 1957* (plate 14), which seeks to hold together the polarities of life and consciousness, would have few interpreters. The very fact that Gottlieb's art has been so poorly understood makes it all the more important for us, for it contains the seeds of an awakening to neglected dimensions of our existential, psychological, cultural, and ontological situation. It points us beyond our present cultural crises. When I felt suicidal in 1965, it was this painting, viewed often for lengthy periods, that gave me hope and pulled me through! Such is the power of a great work of art in the life of the soul.

At first glance, *Blast 1* appears simple in composition. We see a delicately counterpoised double image—a chaotic blast, a symbol of chaos,[3] surmounted by a red sun. This red irregular sphere with its atmospheric rings recalls a line from a friend's poem in which he speaks of the "primal sun—its blooded crimson turning white in trackless time." The richly brushed texture of this sun and its irregular organic shape give it a vital urgency and poetic beauty that captures our vision and imagination. Beneath the sun is a black and gray "blast" image. Its slightly washed texture and smokelike surroundings divest it of those calligraphic qualities one finds in Gottlieb's early pictographs and the later lithographs. *Blast 1*'s composite image is of a sun rising over the smoking, twisted debris of some inwardly destroyed Hiroshima. Here again is violence and negation, yet over the Night a marvelous sun has risen.

Blast 1 is primal, an image felt not so much consciously as viscerally and intuitively. Its meaning and power emerge through the simplicity of

[2] Jacob Landau, "Yes-No, Art-Technology," *Motive* (Mar.–Apr., 1967), 31.

[3] Chaos (Χάος), from the Greek root *cha* (Χά), has the twofold meaning of holding and releasing; hence chaos is both the holder and releaser of all that comes into being.

its abstraction as an image devoid of historical and cultural content. It is at once existential and archetypal—an image of primordial conflict, of heroic struggle and conquest, and of the ultimate victory of the night to which all life returns, only to renew itself again in conflict at each new dawn.

Pollock's ecstatic disintegration, De Kooning's devouring Earth Mother, Smith's rigid "tomb," Reinhardt's nihilism, Gorky's agony of impotent stillness, and Rothko's divine darkness all give way here, in Gottlieb's *Blast 1,* to birth, light, order, new being. With this work we enter for the first time in the Abstract Expressionist movement into the open, or what Heidegger calls "The Clearing." In *Blast 1* we move visually and symbolically from the earth as the self-enclosing mystery and ground of existence to the creation of a world that is open, free, and towering above the mystical darkness of the earth—a world of light.

A DIALECTICAL ART

In Gottlieb's art the fundamental ambiguity and ambivalence of existence resolves itself into a conscious dialectic. If Rothko's dialect is implicit in his all-embracing mysticism, Gottlieb's is explicit and dramatic. Transcending "the logic of ambiguity," Gottlieb's dialectic initiates an open interaction in consciousness between the forces that, in the unconscious, cohere in an amorphous and ambiguous relationship. All pairs of opposites—light and darkness, male and female, love and hate, pleasure and pain, sacred and profane—are interfused in the depths of the psyche and do not possess the antithetical character or degree of separation we imagine. It is only as consciousness dawns that man is able to distinguish the multitude of opposites that make up his experience of the world. As Neumann says:

> Only in the light of consciousness can man know. And this act
> of cognition, of conscious discrimination, sunders the world into
> opposites, for experience of the world is only possible through
> opposites.[4]

[4] Erich Neumann, *The Origins and History of Consciousness,* vol. I, 104.

Midnight decides whether the sun will be born again as the hero, to shed new light on a world renewed.

ERICH NEUMANN

"Subjectivity is truth," wrote Kierkegaard. Subjective perception unquestionably dominates the art of Pollock, Gorky, De Kooning, and Rothko. In Gottlieb's art something new is born of his, as he said, "impulse, at first, to paint only dark and brooding pictures"—namely, an upper world defined by light and order. The romantic spell of subjective feeling is broken and, in *Blast 1,* a dialectical interplay between subjective and objective, inner and outer, upper and lower comes into being. *Blast 1* is a visual poem of antiphonal relationships. In it we escape for the first time from the subterranean world and the devouring unconscious! "Without Contraries is no progression," says William Blake. "Attraction and Repulsion, Reason and Energy, Love and Hate, are necessary to Human experience."[5]

THE PRIMAL CREATIVE ACT

In *Blast 1* we also have an iconographic representation of the primal act of creation. The image is archetypal. As Eliade expressed it, "Every creation repeats the pre-eminent cosmogonic act, the Creation of the world." Out of the formless, the undifferentiated, the unmanifest, comes order. Every creative act, however small or vast in scale, has this cosmogonic character. Let us explore for a moment the nature of the creative process.

According to R. G. Collingwood, the creative act has its inception in the sensations and emotions of psychic experience. These feelings in turn are made the focus of conscious attention. Consciousness, in his view, is the act of becoming aware of sensuous-emotional experience, made conscious by the mind. Once awareness has done its work of focusing our attention on immediate feelings and experiences, imagination comes into play, taking hold of what has been made conscious and transforming it into ordered feelings, thoughts, images, and ideas. In this way imagination creates the work of art. Or as I would put it, the symbolic and iconographic power of imagination takes hold of primal experience and enables man to overcome the inertia of his primordial condition and consciously reshape the universe to human

The unlike is joined together, and from differences results the most beautiful harmony, and all things take place by strife.

HERACLITUS

[5] William Blake, *The Marriage of Heaven and Hell.*

ends. It is significant that Collingwood sees the creative act as having the character of *necessity*.

> An imaginative construction which expresses a given emotion is not merely possible, it is necessary. It is necessitated by that emotion; for it is the only one which will express it. The work of art which on a given occasion a given artist creates is . . . created by him not merely because he can create it but because he must.[6]

For Collingwood the creative act is nonrational, blind—born in darkness. "To form an idea of a feeling is already to feel it in imagination. Thus imagination is 'blind'" and "cannot anticipate its own results by conceiving them as purposes in advance of executing them."[7] Similarly, Neumann notes that the myth, the symbol,

> the work of art also, the dream in all its meaningfulness, rises up in the same way from the depths of the psyche and yields its meaning to the discerning interpreter, though often enough it is not grasped spontaneously by the artist or dreamer himself.[8]

I've called attention to the creative process and its beginnings in the dark, amorphous, subjective realm of sensuous-emotional-primal experience, its spontaneous eruption from the unconscious, and its compelling and illuminating character because I wish to show that this dialectic is at the heart of *Blast 1*. Note, however, that the creative act or process of ordering the content of consciousness involves a splitting-off process. Collingwood observes that the sensuous-emotional content of the final work of art is removed from the immediacy of the sensation that stood at its beginning. This splitting-off is what Heidegger calls the rift-design (*Riss*). We shall return to Heidegger later.

With this brief introduction to the creative process, it is now possible to see in *Blast 1,* with its sun emerging from the amorphous darkness of the chaos below, a visual dramatization of the creative act.

[6] R. G. Collingwood, *The Principles of Art*, 286–87.

[7] Ibid., 244.

[8] Erich Neumann, *The Origins and History of Consciousness.*

The rift by which the sun gains independence from the night is what permits the ordering act of creation to arise. All creativity, therefore, is to be viewed as *dialectical*—as the victory of order and awareness over the formless and unconscious. Gottlieb has given us a painter's vision of the dawn of consciousness, the birth of the world, the origin of dreams and symbols, and the creation of every work of art.

Behind *Blast 1*, and behind every creative act, stands a dialectical consciousness. The archetypal war of opposites, the conflict of Eros and Thanatos,[9] is the theme of a thousand myths of battle between sun-god heroes and dragons of the deep.

In a thoroughgoing Existentialism that denies transcendence, there is no awakening from the slumber of our existential situation.[10] A dialectical consciousness is essential to self-transcendence. If man is to attain victory over his angst-ridden existence, over his nihilism, consciousness cannot be bound to a single pole of the dialectic and denied the power to awaken to other possibilities, other realities. Death itself is but one pole of the dialect of Life-Death. If we are to experience a resurrection from the depths, we require Gottlieb's vision of the creative dialectic. It is a vision that opens the door to rebirth, the Path of Return.

HERO-WORK: SLAYING THE UROBOROS

A hero is one who willingly and courageously undertakes the journey into the depths, into the dark abyss, to conquer the power of the

[9] *Eros* (ἔρως érōs) in ancient Greek = Love as passionate desire. *Thanatos* (θάνατος) = Death. The Greek poet Hesiod tells us Thanatos was a son of Nyx (Night) and Erebos (Darkness) and the twin of Hypnos (Sleep). Love and death, desire and the cessation of desire are the twin forces governing the cycles of manifest existence. In the Creation Hymn (Nāsadīya, 10. 129,4) of the Rig Veda, we read: "Desire came upon that one in the beginning; / that was the first seed of mind. / Poets seeking in their heart with wisdom / found the bond of existence in non-existence."

[10] With Heidegger, Existentialism resumes its search for the way back into the ground of metaphysics. See Heidegger, "The Way Back into the Ground of Metaphysics," in *Existentialism from Dostoevsky to Sartre*, edited by Walter Kaufmann, 206–21; and "What Is Metaphysics?" in *Existence and Being*, 325–561.

unknown. The literature of our age is filled with antiheroes; yet, paradoxically, ours is perhaps the most heroic of all ages, for we have plunged ourselves into the abysmal depths (via psychoanalysis, depth psychology, existentialism, nihilism, genocide, war, and global terrorism) where all hero-work is done. We stand at the great pivotal point of the ages where the battle with evil must finally be won. Yet, blinded by the depths in which we dwell, we fail to discern the heroic nature of the work in which our souls are engaged. Why should heroes be aware of their true nature at the nadir-point of their journey with its outcome as yet far beyond their vision?

The first task of the hero is that of slaying the Uroboros, separating the World Parents, or sundering the opposites. The hero himself is identified with the emergent sun and is often regarded as a god. However, this solar identity of the hero belongs to him *as hero* only at the end of his arduous and victorious journey through the regions of Night, when his work is done. For the hero this Night is primal. It is his origin as hero. Once in the depths, he must lose all memory of the world he left behind and deal with the primordial darkness as one standing at the very dawn of the world.

The original union of opposites prior to the world's birth and the dawn of consciousness is symbolized by the Uroboros—a serpent or dragon that forms a circle by swallowing its own tail. This primordial unity of opposites is also symbolized by the World Parents, represented as an undifferentiated union of Earth and Sky. The sundering of opposites is linked in mythology with the slaying of the Uroboros dragon, Marduk's slaying by Tiamat in Babylonian myth, and the separation of the World Parents by the son-hero—a separation that must be accomplished before the world can come into being. In Egyptian myth, Shu, the son, steps between Nut (Sky) and Geb (Earth), lifting the sky into place. A similar separation takes place between Rangi (Sky) and Papa (Mother Earth) in Polynesian myth, and West African myth tells of the separation of Obatala and Odudua (Heaven and Earth) by a son who was no other than man himself. It is clear, therefore, that until the Uroboros or chaos dragon has been slain and the World Parents

Uroboros

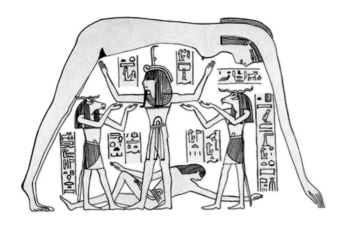

Shu separating
Nut and Geb

separated, there can be no world, no *place* where man can stand or life unfold.

"Because light, consciousness, and culture are made possible only by the separation of the World Parents," says Neumann, "the original Uroboros dragon often appears as the *chaos dragon*"[11] that must be slain before order can arise. The slaying of the Uroboros (the unity of the Unmanifest), however, precipitates "a great crisis, a rift, [which] splits the created world into two apparently contradictory planes of being."[12]

Gottlieb's *Blast 1,* as we now see, belongs to the tradition of the imagination—universal and archetypal—that discovers the beginnings of creation in the sundering of opposites, recounted in myth as the slaying of the chaos dragon by the sun-god hero. As a work of art, *Blast 1* belongs to our stylistic period. Yet its kinship with the art, myths, and experiences of all peoples and ages cannot be denied.[13] "The most we can do," to quote Jung again, "is to *dream the myth*

[11] Erich Neumann, *The Origins and History of Consciousness,* 108–9, my italics.

[12] Joseph Campbell, *The Hero with a Thousand Faces,* 281.

[13] In addition to the myths cited, see "The Candlestick of the Tabernacle Supported by the Beast," The Kennicot Bible, 1476, Bodleian Library, Oxford; "The Madonna and the Beast," Cathedral at Genoa, Italy; the Indian Shiva Dancer encircled by fire and standing upon the Demon Child; and "The Unfettered Opposites in Chaos," from Marolles, *Tableaux du temple des muses,* reproduced in C. G. Jung, *Psychology and Alchemy,* 305.

onward and give it a modern dress." The universality and timelessness of *Blast 1* recalls these ancient words of the Rig Veda:

> *At first there was only darkness wrapped in*
> *darkness. . . .*
> *The one which came to be, enclosed in nothing,*
> *arose at last born of the power of fire.*[14]

THE WORLD REESTABLISHED

In Pollock's art of the broken center, the world fell away into chaos, and in the artists whom we have since considered it has remained underground, buried in the night, lost in a maze, or germinating as a seed of future possibilities. We come now for the first time to the reemergence of the world as a world of order and light. "World" in this context does not refer to what is exterior to man but to the *world-as-meaning* emerging in human consciousness. "Only consciousness is immediately given," says Schopenhauer; "all that we know lies within consciousness."[15] All that we know or can know of the world resides within us and is real only insofar as it is also meaningful, giving us an account for our existence. It is therefore a *Weltenschauung*—an image of reality in terms of which man understands himself, his environment, his culture, his age, and his place in history. It is his *worldview*—a worldview he carries in his consciousness. In short, we define the world as we see it and are in turn defined by it.

The hero, by slaying the Uroboros or separating the World Parents, allows the world to come into being. *He makes way for consciousness,* and the resulting dialectic makes it possible to shape a world that previously lay veiled in darkness and the unconscious. He makes possible the rise of a human reality, a creative worldview. Compared with the ambiguity of preconscious experience and the security of the maternal night and womb, this newly created world is, indeed, to quote Rilke, "a hybrid thing and windy"—a world composed of ten-

[14] Rig Veda, X, 129.

[15] Arthur Schopenhauer, *The World as Will and Idea*, selections in A. Hofstadter and R. Kuhns, eds., *Philosophies of Art and Beauty*, 450.

sions and conflicts, a world painfully conscious and marked by the risks of a perilous freedom upon open horizons. How did this world come about?

You recall from our discussion of Pollock's *Number 1* that the loss of the center led to a disintegration of the world. When the world-center—cosmic axis, sacred stake, *axis mundi*—disappeared, man and his world regressed into chaos, a time before creation. Anxiety and despair marked the sinking away of the world into nonbeing.

In *Blast 1*, the center, broken in Pollock, is reestablished, making possible the birth of a new world order. This center is established by the self-contained concentration of life-energies of *Blast 1*'s sun. All roundness, you will recall from Worringer's discussion of the column in classical architecture, concentrates its forces inward toward its center—the positive center being the source and abode of life in every living form and the place where man encounters the Infinite. By exploring the mystery of light, we may learn something of the relationship between light and centering. Light radiates outward from a central point of propagation. When one at last experiences Illumination, its first manifestation is as a brilliant point of light breaking through into the center of consciousness. All living things, according to their capacity, seek the light, and human consciousness is evolved by means of a progressive revelation of light. Light, or the coming of light, is central to all creation myths. "Again and again we come back to the basic symbol, light," says Neumann. "This light, the symbol of consciousness and illumination, is the prime object of the cosmologies of all people."[16] One recalls the Genesis story where the world is created through the separation of light from darkness. Also, in the Upanishads we read:

> The sun is brahma—this is the teaching. Here is the explanation:
>
> In the beginning, this world was nonbeing. This nonbeing became being. It developed. It turned into an egg. It lay there for a year. It burst asunder. . . .
>
> What was born of it, is yonder sun.[17]

[16] Erich Neumann, *The Origins and History of Consciousness*, 104.

[17] Chhāndogya Upanishad 3, 19.1–3.

The birth of light, symbolized in *Blast 1* as a sun emerging from amorphous darkness, sets up a dialectic of opposites where, formerly, only formless chaos and blackness existed. Without such distinctions and demarcations, the world cannot show itself. Only in the presence of light can the formless take form, the measureless become measured, and the world stand revealed. "The dawning world," says Heidegger, "brings out what is as yet undecided and measureless and thus discloses the hidden necessity for measure and determination."[18] In an obscure work of unknown origin, one finds this interesting passage:

> [Light] goeth forth into darkness pressing Order
> before it.
> In that Light vibrateth, harmony maketh order;
> Light hath power to achieve: it goes up and down
> the universe,
> verily impelling creation before it;
> Light is the word of the Father saying, Be . . . lo,
> matter is![19]

Radiant light, emanating or fanning out from its source, diminishes in brilliance by the inverse square of the distance photons travel from their point of propagation. Speaking symbolically, or truly of what is veiled, the soul, as it incarnates, journeys away from its divine center and natural home, entering a dark world where all memory of its spiritual origins and identity are forgotten. But when we undertake the journey back toward our divine Source, we experience at first an intensification of the conflict between light and darkness, good and evil, and this conflict intensifies the further we progress. Just as things in nature respond to light according to their capacity, so also does consciousness open itself to the growing light of the spiritual worlds as the soul evolves, and it does so by drawing ever closer to the divine light-center within. Light, as noted, is the sole condition of there being any consciousness at all. As we

[18] Heidegger in A. Hofstadter and R. Kuhns, eds., *Philosophies of Art and Beauty*, 686.
[19] *Golden Scripts*, 30:218–21.

approach the divine center of our being, the light of consciousness increases in intensity, calling us back to its emanating Source, which is Light, not darkness. Put another way, the centering of consciousness and its illumination are complementary processes. The circle and sphere—forms that concentrate their forces toward the center—stand as symbols of light. In astrology the sun is symbolized by a circle with a dot at its center. This same image, used in meditation, helps produce a centering of consciousness and serves as the ground plan for all mandala designs. Every action evokes a corresponding response. Hence, as consciousness becomes increasingly centered, it becomes more illumined, and with progressive illumination, the power to center consciousness increases. Lighting and centering are interactive processes. An illumined mind is centered and well focused. Christ said, "When thine eye is single, thy whole body also is full of light." Centering and enlightenment are also indications of true spiritual power. As Buddha said, "To him who is one-pointed nothing is impossible."

The sun in Gottlieb's *Blast 1* works not only as a symbol of order and light but, as a light source, restores the center lost in Pollock's arabesques. The *axis mundi* or center of the world is reestablished. Night is formless, a chaos without boundaries or demarcations. *Blast 1*'s sun stands in sharp contrast to the formless void beneath. Out of the primordial chaos, the boundless night, a new center of light has emerged, and the world is reestablished. From this dialectic of light and darkness a new center of life and consciousness is born.

When applied to the individual, the *axis mundi* represents the recovery of the center of one's own being and sense of identity. Life reacquires its meaning, a new sense of selfhood is established, and, with this rebirth, something of the Higher Self begins to shine through.

THE SACRED AND THE PROFANE

Eliade has much to say about demarcations between sacred and profane space, about sacred space as cosmogonic or world-creating space,

and about the center as the *sine qua non* of the sacred. Without a center, space cannot be structured, ordered, or protected against the ubiquitous powers of chaos. In esoteric philosophy we find cosmogenesis described in terms of a Ring-Cosmos and a Ring-Chaos, with a Ring-Pass-Not between them that prohibits the forces of chaos from invading the order of the universe. In the Rig Veda (X, 149), the universe is spoken of as spreading out from a central point. The world order, as Eliade says, is conceived as having its foundation "at the center of the world": "The creation of man, which answers to the cosmogony, likewise took place at a central point, at the center of the world."[20]

For the world to come into being, a rift must have arisen between the formless and the formed. In Heidegger's thought this rift (*Riss*— rift-design) serves a dual purpose: (1) it sets up a split and a conflict between what remains hidden and what is revealed or brought to light, and (2) as rift-*design* it gives a design, order, "a unity of elevation and ground-plan, breach and boundary" to the newly emergent world. The sun in *Blast 1* stands forth as the new world, a rift-design within defined boundaries standing in contrast to the amorphous blast below.

Note also that the sun stands forth in openness, free of the reaching arms of the blast. As Heidegger says, "*lighting* of openness and *establishment* in the Open belong together." Existence is what *stands out* (*ex*, out of + *sistere*, to stand), enters into openness, into unconcealment, reveals itself as existing.

Before leaving these comments, it's worth noting that worlds come into being not only through light but also through fire. We've already mentioned the generative symbolism of fire in connection with Gorky, and sparks have been viewed from ancient times as germinal seeds.[21] Eliade notes that in Roman and Vedic myths, the motif of the renewal of the world through the rekindling of the fire at the winter solstice constitutes a renewal that is equivalent to a new creation. And, finally, the Vedic myths of India identify the erection of an altar to Agni (the fire deity) with cosmosizing or taking possession of a territory: "who-

[20] Mircea Eliade, *The Myth of the Eternal Return*, 16.

[21] See E. Jacoby's image *The Fire Sower*, which appears in Jung's *Psychology and Alchemy*.

ever are builders of fire-altars are 'settled'" (*Śatapatha Brâhmana*)—established in a world.

Gottlieb has painted for us symbolically the birth of a new world order rising up and standing triumphant over the nihilism of our present history. The birth of every new order comes out of the shapeless mystery of the not-yet-known and the not-yet-formed. In *Blast 1* this new world is created, first, by establishing a new center of light; and then by creating a rift-design around that center that marks it off from the eternal chaos. There is no question that this accomplishment was intuitive on the part of the artist, which in no way lessens its significance. Lack of self-conscious awareness in an artist is not a fault. On the contrary, it shows us to what extent he has abandoned himself to the inspiration of creative and spiritual forces greater than himself. Are we not always at our greatest when we serve as open doors for forces more divine than our limited comprehension can explain?

THE RETURN OF GOD

The failure of historical thinking is that it forgets transcendental realities, archetypal truths. The failure of scientific thinking is that, in seeking universal laws, it forgets the pregnant moment. Only in mythopoetic and archetypal thinking—in symbols: narrative, poetic, musical, and visual—do we find the universal and the unique combined to give us archetypal history full of present meaning. Symbols have power to reveal the hidden depths of the present moment along with unique experiences under the light of the eternal destiny of the soul. Gottlieb's *Blast 1* is such a symbol. We find in it the essence of creation, the heroic struggle to attain victory over chaos, darkness, and evil, and the world's rebirth. At the same time it addresses our present historical and cultural experience and our crises of faith by revealing to us the very God many had come to believe dead. It unveils a resurrection.

Let us return to the underground—here, as symbolized in *Blast 1*.

As a symbolic chaos, the blast in the lower half of the painting carries the weight of negative meanings within the dialectics of the picture. It is a visual symbol of chaos, violence, night, death, the demonic, the profane, the abyss, nonbeing, darkness, mystery, formlessness, the unknown, the underworld, unconsciousness, restlessness, unbounded energy, orgy, and primal waters. It also carries the positive meanings of the Eternal Feminine, such as creative source, ground, origin, and womb. When we spoke of Pollock's arabesques, we noted the positive role played by the vitalism of his fluid lines and said nothing can endure that is not animated. The blast here has a dual significance as both Void and Vital Ground. The mothering aspect and creative power of the blast is clearly implicit in the sun standing above it, for out of its night a marvelous sun has risen.

Earlier we found that darkness hides an Underground God. Consequently, anything emerging from the underground or primal darkness and splitting itself off in a dialectical relationship does so by virtue of the inherent power of the divine in the depths. We must now speak in symbols. With the emergence of light from the Void, the Hidden God of the depths reemerges as the manifest God of Light whose eternal symbol is the sun. Since it is through the hero that God is reborn, let us return briefly to the hero. Having gone underground and voluntarily died, the hero proves he can take his initiation "like a man." In doing so, while sleeping the sleep of death, he is chthonically recharged—infused with the hidden power of the Underground God. He draws upon the regenerative power of the Infinite that pervades all things, yet hides itself in the manifest worlds. Having merged his being with that of the Hidden God, the hero can no longer leave the depths as a mere man. Having survived death, he proves *there is no death* and returns to the world victorious, a spiritualized man, an immortal, a hero or man-god. A day may come when he will undergo another transformation "above" and become a God-man, a Christ or Buddha. To that we shall come. Meanwhile, when the hero returns, he comes as a divine messenger informing us that the God who veils himself in his creation is

alive and well and awaiting all who come to him. The light the hero brings back from the Abyss proves that God travels with him, resides in him, and is revealed through him. For the God of All is a God of Light, and wherever we see light, we know *God lives!* Light is Life shining through.

As finite man, the hero has no power to separate the World Parents or slay the Uroboros. Only through the infusion of power from the Underground God is the hero able to accomplish his cosmogonic task. By way of his death and rebirth, he becomes a world-maker. Not *as man* but *as a god,* he sunders the polarities and creates a new world. The hero, reborn through the power of the Hidden God, returns from the underworld bringing God with him. His resurrection is the effect of the divine power now working through him. Hence, the hero returns not alone but joined by his Divine Companion, who, in union with the hero, returns to the world as a Resurrected God who has once again given birth to Himself. Just as the hero is now a spiritualized man, so also is the God who emerges from the Night with the hero a spiritualized God—a God corresponding no longer to our finite, anthropomorphic conceptions, but a God corresponding to the expanded consciousness of the Higher Man—the God of Light who illumines the consciousness of him who is reborn. Having given birth to himself out of his own depths, God shows thereby the ultimate unity of depths and heights, a matter to which we shall return. The Father of Lights turns out to be his own mother and womb, giving himself a second birth, proving by his resurrection his androgynous identity. Only by means of God's dying and rising again can we know that depths and heights are *one.* Otherwise, man would ever regard God as external and transcendent to himself and his world, as Wholly Other.[22] By his journey into the depths the hero serves God, as God serves the hero. *Death and resurrection prove divine immanence.* With the reappearance of the God of Light from Darkness, we are shown the Ground from which a Shining ever shines forth: "The light shines in darkness, and the darkness has not overcome it" (John 1:5). From the deepest Blackness there comes

[22] The view of thinkers such as Søren Kierkegaard and Karl Barth.

a shining *out of,* a shining *through,* a shining *from below.* Night proves itself to be merely a veil with which the Infinite has clothed itself to give birth to the polarities needed to create the world. Were all infinite light, the effect would be the same as infinite darkness. Where no contrasts exist, no world can appear. To exist, to "stand out of Being," requires a polarization of opposites.

Paradoxically, the hero who sunders the world into light and darkness, earth and sky, has *by his own dying and rising reunited these opposites within himself.* He proves the ultimate unity of all. So also with the dying and rising God. By creating darkness to veil the light, he makes possible the creation of the worlds. Then by entering the darkness and rising again, he shows the two—Light and Darkness and all polarities—to be as One within himself. He establishes himself as the Infinite All. Hence, the dialectic of opposites ultimately works for unity in man, in nature, and in the revelation of the Infinite Ground of Being. Of both God and the hero it may be said:

> *In this form he gains yonder world,*
> *In that form he experiences this world.*
> AITAREYA-ARANYAKA II.3.7

With the completion of the hero's journey underground, both God and man stand forth reborn, and the mystery of death stands revealed. It is not a drama of termination, but a drama of unification —a unification of God and man, of depths and heights, of death and life.

> *And then did all the Muses sing*
> *Of Magnus Annus at the spring,*
> *As though God's death were but a play.*
> W. B. YEATS,
> "TWO SONGS FROM A POEM"

THE HERO'S TRUTH

Those who have not made the hero journey into the depths know but the single truth of the one-dimensional man. Blake called it "single vision." And where only the shadow side of man is known, as Neumann points out, we get calamities such as the Nazi regime. Rational consciousness, lacking a knowledge of its own dark and hidden depths, rests on a time bomb. As Goya put it, "The dream of reason breeds monsters." To aspire to the heights *without a knowledge of the depths* is to build one's house over a yawning abyss by which it can be swallowed at any moment. This is a lesson for nations as well as individuals.

The hero's truth, by contrast, grows out of an experience of profound depth. It is at once dialectical and unitive. Nor is it static. The very essence of heroic wisdom is that it is transformative—a knowledge that can make heroes of ordinary mortals. Truth, once known, never leaves us as it finds us. It possesses a creative power that changes everything.

As to the dialectical nature of truth, the hero knows that even the greatest hero can bring only a small part of the wisdom veiled in darkness into the light of day—that darkness hides more than can ever be revealed in a finite world to finite minds. All one can achieve is an open center—a place where revelation can occur. And what is revealed serves only to remind us of the vastness of what remains concealed. "Man cannot master much of what *is*," said Heidegger. "Only little gets known. What is known remains inexact, and what is mastered insecure."[23] Between the veiled and the revealed, the primal conflict continues, and truth *is* this conflict. Truth, notes Heidegger, is "the opposition of lighting and concealing." In what lies unconcealed within the light, we have openness—a clearing—and it is within this clearing that man's world is established. But because it is a world that is as much the product of what is concealed, unknown, and unmastered as of what is revealed, known, and mastered—a world that rests on darkness even as it towers up into the light—it poses for humanity decisions and choices.

[23] Heidegger in A. Hofstadter and R. Kuhns, eds., *Philosophies of Art and Beauty*, 678.

As a world opens itself, it poses for the decision of an historical humanity the question of victory and defeat, blessing and curse, mastery and slavery. The dawning world brings out what is as yet undecided and measureless and thus discloses the hidden necessity for measure and determination.[24]

Hence, the primal conflict between light and darkness ends by forcing upon man himself the decisions about his world that make him a moral and responsible being. In Gottlieb's *Blast 1,* all this is implicit—the dialectical nature of truth as revelation and concealment, the attainment of a place of openness and light, and the recognition of polarities that confront us with choices.

The hero's truth is also a truth of unity; or, to phrase it differently, he has learned how to hold together a double vision. We've spoken of Western culture's tendencies to extremes and its lack of balance. Referring to the equally valid claims of the creative and the destructive, of light and darkness, upon consciousness, Jung lamented our inability to make "concessions to both worlds," saying:

> Unfortunately, our Western mind, lacking all culture in this respect, has never yet devised a conception, nor even a name, for the union of opposites through the middle path, that most fundamental item of inward experience, which could respectably be set against the Chinese concept of Tao.[25]

The double vision of *Blast 1,* if not the Middle Way, at least recognizes the equally valid claims of opposites and the necessity of holding both together in our vision. Here we see both chaos and order. The sun reveals to us its origin in the formless, restless void, and the victory of light over darkness. Yet, by virtue of the ambiguous positioning of the sun near the central horizon of the painting and the upward-reaching arms of the chaos below, we recognize the possibility of the sun's return to formless night. In recognizing the rightful place of both order and chaos, both light and darkness, both life and death,

[24] Heidegger in A. Hofstadter and R. Kuhns, eds., *Philosophies of Art and Beauty,* 686.

[25] Quoted in Morris Philipson, *Outline of a Jungian Aesthetic,* 42.

THE ART

198

we approach the possibility of balance and health—emotional, mental, and spiritual. As Jung said, "It is, rather, between the conscious and the unconscious that wholeness is brought about, and not by one dominating the other, but by a reciprocal interdependence."[26] Such is the hero's accomplishment:

> Every culture-hero has achieved a synthesis between consciousness and the creative unconscious. He has found within himself the fruitful center, the point of return and rebirth. . . . From the union of the hero's ego consciousness with the creative side of the soul, when he "knows" and realizes both the world and the anima, there is begotten *the true birth, the synthesis of both.*[27]

The hero's truth is also creative in that he who sunders the opposites achieves his own creative destiny by reuniting these same opposites again within himself, achieving wholeness. He knows, as Dylan Thomas says,

> *Light and dark are no enemies*
> *But one companion.*[28]

Here then is Camus's "renaissance beyond the limits of nihilism"— a renaissance that is, in fact, a rebirth—a rebirth ever vigilant of the dangers of the eternal void.

THE VOID AS PRIMAL GROUND

We come now to a point that is difficult to explain and comprehend— namely, the Void as the Primal Ground. Years ago, when jet-fighter planes first came into use, I read that when a plane breaks the sound barrier, its controls *work in reverse.* Analogously, when consciousness crashes the sound barrier between rational and intuitive knowledge, the ways of knowing reverse themselves. The whole process of understanding is radically altered. Reason thinks from the outside, intuition

[26] Quoted in Morris Philipson, *Outline of a Jungian Aesthetic,* 8.

[27] Erich Neumann, *Origins and History of Consciousness,* 212–13. My italics.

[28] "Find Meat on Bones," from *The Poems of Dylan Thomas,* 75. © 1953 by Dylan Thomas. Reprinted by permission of New Directions Publishing Corp.

from inside. As we try to grasp the nature of the Void, it is good to keep this in mind.

All that exists—atoms, men, galaxies, light, mind itself—is finite, changeable, and perishable. No matter how far we penetrate into the foundations of life and the universe, we find nothing that is unchanging, nothing that eternally endures. The law of the conservation of mass/energy does not speak of a changeless substance, but of metamorphosis. All finite things carry their end within themselves. *No-thing* is eternal. To seek to build one's house upon Existence in any of its forms is to build on quicksand—a ground that is continually *becoming*.

At a sufficiently advanced stage, the mystic encounters and experiences the Void—the No-thing-ness of Being. What he encounters as the Void is not, however, as many Westerners assume, a dead emptiness. Nor is it a pure abstraction. Rather, on achieving the absolute clarity of That in which nothing is left to cast its veil over consciousness, one finds a groundless Ground infinite in every respect. It is the Ultimate Reality. "The unreal has never existed; the Real never ceases to be," declares Krishna in the Bhagavad Gita. The Void is but a name we give to That which is infinite, eternal, and unfathomable—the ultimate Ground of Being. In ancient thought, this Boundless Reality was called by the Vedic Rishis simply *Tat* (That), as no human conceptions could define or describe it. The Brihadāranyaka Upanishad describes it as *"neti, neti"* (not this, not that). Tibetans called it Tong-pa-ñid, the unfathomable Abyss of the spiritual realms. Mahāyānā Buddhists call it Sūnyatā or the Great Emptiness. The Hebrew bible calls it Theōm, the Deep, or Waters of the Abyss. In Chinese cosmology it is Tsi-tsai, the Self-Existent. The Greek school of Democritus and Epicurus called it To Kenon, the Void. By whatever name, ancient thinkers all agreed that Ultimate Reality is boundless and unknowable to men and gods alike. It is truly the Unfathomable. Yet all existing things from atoms and men to gods and galaxies come to be and pass away within it.

There is one Boundless Immutable Principle; one Absolute Reality which antecedes all manifest conditioned Being. It is beyond the range and reach of any human thought or expression. The manifest Universe is contained within this Absolute Reality and is a conditioned symbol of it.[29]

Eternally Unmanifest, the Primal Ground is That from which all things mysteriously emerge and to which, when their cycle has run, they return. It is the one and only sure foundation, there being nothing having power either to shake or destroy it. As such "the infinite No-thing, so far from being the opposite of things, is their essential ground" (Alan Watts).

> *The Nameless is the origin of Heaven and Earth;*
> *The Named is the mother of all things.*
> *Therefore let there always be non-being so that we*
> *may see their subtlety,*
> *And let there always be being so we can see their*
> *outcome.*
> *The two are the same,*
> *But after they are produced, they have different*
> *names.*
> *They both may be called deep and profound*
> *Deeper and more profound,*
> *The door to all subtleties!*
>
> LAO-TZU, *TAO TE CHING* 1.5

The Clear Vision in which no-thing changes allows us to peer into the depths of eternity where all is transparent, there being neither existence nor nonexistence, neither light nor darkness, neither life nor death to befuddle or obscure our view. Only then do we see existing things in their true light. Perhaps only in deep meditation it is possible to feel oneself united with this Primal Ground and to feel its absoluteness and its imperturbability and know that one has touched the Eternal—the

[29] Alice A. Bailey, *A Treatise on Cosmic Fire*, 3.

one and only sure GROUND on which one can set one's foundation and build an eternal life.[30] With this reversal of the controls of consciousness,[31] we realize that the Void *is* the Primal Ground—the Fountain-Source of All that has ever been, now is, or ever can be.

It seems to me, in a way almost too abstract for the symbolism of *Blast 1,* that Gottlieb's painting does point us to this ultimate mystery and paradox. Perhaps the white background in which Gottlieb's images of polarity are suspended best symbolizes this groundless Ground in which both chaos and order make their periodic appearance. In itself it is eternally unseen and unknown.

THE HERO AS REPRESENTATIVE MAN

Having traversed two worlds, the hero has gained a special wisdom about both. He understands their interrelationships, their antagonisms, and their potential for creative and destructive contact. Holding together this double vision requires a special courage rightly called heroic. For man, as T. S. Eliot reminds us, cannot bear too much reality. The mind as well as the body shield themselves against too much pain, including the pain of excessive awareness. The hero, therefore, precisely because he is a hero, has a responsibility to society to serve the common good by keeping his consciousness open at the center so that the transformative and regenerative forces of creation can pass

[30] We shall have more to say on this subject.

[31] G. de Purucker expresses a similar idea: "In order to understand and spiritually to *feel* the true nature of prajñā [Intuitive Wisdom], it is necessary to abandon the 'this side' view, and in spiritual comprehension to go over to the 'other shore' (pāra), or other manner of looking at things. On 'this side' we are involved in a sphere of consciousness of brain-mind analysis and particulars, which becomes a world of attachments and lower-plane distinctions. When we achieve this inner 'reversal,' this shifting of our consciousness upwards to the mystic 'other shore' of being, we then enter more or less successfully into a world of transcendent realities, from which we can view things in their original and spiritual oneness, beyond the maya of the deceptive veils of multiplicity, penetrating into the essential nature of these realities and cognizing them as they truly are." *Foundation-Source of Occultism,* 47.

through him to benefit all. In a sense he becomes a *representative man*—one who, in our times, has suffered the agonies of night and death in order, as Ernst Barlach puts it, to "awaken the sleeping images of the future which can and must come forth from the night, in order to give the world a new and better face." The hero, like Emerson's definition of genius, "is more like, not less like, other men." He embodies something of all men and women by virtue of the archetypal nature of his experience; hence, he benefits all in that he aids man and nature in their evolution. Before proceeding to our final point about regeneration, let's pick up briefly on Emerson's thoughts about representative men. Of those who, by virtue of a broader, deeper experience, are more like other men, Emerson says, "These teach us the qualities of primary nature,—admit us to the constitution of things. . . . What they know, they know for us." He continues:

With each new mind, a new secret of nature transpires. . . . These men correct the delirium of the animal spirits, make us considerate, and engage us to new aims and powers . . . with the great, our thoughts and manners easily become great. We are all wise in capacity, though so few in energy. There needs but one wise man in a company, and all are wise, so rapid is the contagion. . . . There is, however, a speedy limit to the use of heroes. . . . The more we are drawn, the more we are repelled. There is something not solid in the good that is done for us. The best discovery the discoverer makes for himself . . . the law of individuality collects its secret strength: you are you, and I am I, and so we remain.

This is the key to the power of the greatest men,—their spirit diffuses itself. A new quality of mind travels by night and by day, in concentric circles from its origin, and publishes itself by unknown methods: the union of all minds appears intimate: what gets admission to one, cannot be kept out of any other; the smallest acquisition of truth or of energy, in any quarter, is so much good to the commonwealth of souls. . . . We have never come at the truth and best benefit of any genius, so long as we believe him an original force. In

the moment when he ceases to help us as a cause, he begins to help us more as an effect. Then he appears as an exponent of a vaster mind and will. The opaque self becomes transparent with the light of the First Cause.

. . . Great men exist that there may be greater men.[32]

The hero, therefore, benefits us doubly—both by the spirit of wisdom that he has gathered and diffuses through himself, and by teaching us that the hero's journey is one of lonely inwardness that can only be taken up by each woman and man working alone, agonizingly alone, in the silence of the innermost self.

REGENERATION: THE CYCLES OF EVOLUTION

The double vision of *Blast 1* is a heroic vision. It is also archetypal and profoundly so. Let us explore.

Physicists tell us that the universe is tending toward an ultimate state of chaos. They refer to it as the law of entropy:

As entropy increases, the universe, and all closed systems in the universe, tend naturally to deteriorate and lose their distinctiveness, to move from the least to the most probable state, from a state of organization and differentiation in which distinctions and forms exist, to a state of chaos and sameness. In Gibbs' universe order is least probable, chaos most probable.[33]

According to this view the universe is a vast graveyard of decay.

But when we turn to the science of the Ageless Wisdom, our cosmic vision takes on an entirely different perspective. I've defined Gottlieb's art as "an art of regeneration, of perpetual descent and return." Let us now delve into the deep mystery of regeneration—the creative cycles of evolution—and see in what sense transformation and regeneration are omnipresent and eternal processes.

[32] Ralph Waldo Emerson, *Representative Men,* vol. IV in *The Works of Ralph Waldo Emerson,* 8–32.

[33] Norbert Wiener, *The Human Use of Human Beings: Cybernetics and Society,* 12.

The Ground of Being or Boundless All is Space itself, a living entity, eternal in duration, infinite in expanse.[34] In itself it is the One Absolute—the Source of the Unity interconnecting all lives within the cosmos through eternity. Space is inseparable from the eternal plastic Root or One Element, described in *The Mahatma Letters* as "the eternal *Essence,* the Swabâvat,[35] not as a compound element you call spirit-matter, but as the one element for which English has no name. It is both passive and active, pure *Spirit Essence* in its absoluteness, and repose, pure matter in its finite and conditioned state."[36] Or, as Blavatsky noted:

> Whatever quits the Laya State, becomes active life; it is drawn into the vortex of MOTION . . . ; Spirit and Matter are the two States of the ONE, which is neither Space nor Matter, both being the absolute life, latent. . . . Spirit is the first differentiation of (and in) SPACE; and Matter the first differentiation of Spirit. That, which is neither Spirit nor matter—that is IT—the Causeless CAUSE of Spirit and Matter, which are the Cause of Kosmos. And THAT we call the ONE LIFE or the Intra-Cosmic Breath.[37]

In its manifest state, the One Element is Spirit-Matter. The higher or positive pole manifests as Spirit and the lower or negative pole manifests as Matter, yet the two are One. Between these poles infinite gradations of Spirit-Matter or vibrating energy—the one indestructible

[34] Here we offer but hints on a subject that represents the most profound thinking and loftiest teachings to which humanity is heir. The periodic and eternal cycles of life, death, and transformation, of which our universe and every other is a manifestation, hold the key to every cycle of change, from the least to the greatest, throughout eternity.

[35] Swabâvat, the mystic Essence, equivalent to Mulaprakriti, Father-Mother, the primordial Spirit-Substance from which all manifest existence proceeds and into which all returns at the end of a cosmic cycle of manifestation, or Day of Brahma.

[36] *The Mahatma Letters to A. P. Sinnett,* compiled by A. T. Baker, 60.

[37] H. P. Blavatsky, *The Secret Doctrine,* vol. I, 258.

Life—provide the vehicles and serve as home to the countless evolving lives of the cosmos, seen and unseen.

Motion is eternal.[38] In regular periodic fashion, the cosmos emerges from its Ground of Being, undergoes a vast and lengthy period of evolutionary unfoldment, then returns again to the bosom of the Infinite for an equally lengthy period of rest. Hinduism refers to these grand cycles as the Days and Nights of Brahma. When a Night of Brahma ends, the cosmos reemerges into manifestation and resumes its evolution at the precise point where the previous cosmic cycle concluded. A Day of Brahma or period of cosmic manifestation is called in Sanskrit a *manvantara*, a Night of Brahma, or a rest cycle, a *pralaya*. This cyclic law governs throughout eternity. The Law of Motion that calls the worlds into being, then dissolves them back into the Absolute, is called the Great Intra-Cosmic Breath. On the Out-breath, worlds reappear, and on the In-breath are reabsorbed into the Unmanifest. The secret of the breath is one of the great mysteries linking the spiritual and manifest worlds, and the science of the breath holds one of the keys to meditation. The impulse of the Divine Breath drives the evolution of the worlds and all within them toward ever-higher states of Self-unfolding perfection. With each cycle, life advances higher in the ever-evolving hierarchy of Life—the great Chain of Being. Ours is a journey without end. Each period of rest brings on a new day.

At the end of a manifest cycle, each life withdraws into a Zero-Point known as a *laya center* to await its next period of manifest life. Mystery of profound mysteries, all that has been accomplished through all past life-cycles is preserved in this laya center like a dormant seed, awaiting rebirth. *Nothing is ever lost.* This laya state is often identified with Nirvana—a state generally misunderstood by Western minds.

To see in Nirvana annihilation amounts to saying of a man plunged in a sound *dreamless* sleep—one that leaves no impression on the physical memory and brain because the sleeper's Higher Self is in its original state of absolute consciousness during those hours—that he, too, is annihilated. The latter simile answers to one side of the

[38] "The existence of matter is a fact; the existence of motion is another fact, their self existence and eternity and indestructibility is a third fact." H. P. Blavatsky, *The Secret Doctrine, Vol. 1, 56.*

question—the most material, since *re-absorption* is by no means such a "dreamless sleep," but on the contrary *absolute* existence, an unconditioned unity, or a state, to describe which human language is hopelessly inadequate. . . . Nor is the individual—or even the essence of the personality, if any be left behind—lost, because re-absorbed. For, however limitless—from a human standpoint—the paranirvanic state, it has yet a limit in Eternity. Once reached, the same monad will *re-emerge* therefrom as a still higher being, on a far higher plane, to recommence its cycle of perfected activity.[39]

The Creative Force is eternal. While men and worlds have their beginnings and must have their end, as with all things finite, the inmost center of each and every life, however small or great, is an indestructible center in the One Infinite Life, inseparable from its eternal Ground. Nor is identity ever lost. The self-same divine spark that inhabits an atom and will become in time a plant, an animal, a man, a Buddha, may in some distant cosmic cycle become a star or a Spiritual Intelligence of an order inconceivable to us. One Life and One Life only pervades the infinite cosmos and through cyclic existence is continually unfolding its power and potential, which, being likewise infinite, is forever inexhaustible. Birth and death merely mark the cycles of life as it weaves shuttle-like through the manifest worlds.

If one asks what this has to do with Gottlieb's *Blast 1,* the answer is fairly simple given the archetypal symbolism of this work. The sun of *Blast 1,* poised precariously above the blast below it, can be read alternatively as rising out of the chaotic night and returning to it. Hence, my designation of Gottlieb's art as "an art of regeneration, of perpetual descent and return." The cosmos itself is continually reborn from the mystery of its unknown Ground of Being and unfolds itself in the full light of a Brahmic Day, only to pass again into a Night of rest, then reappear, evolve, and disappear again in unending cycles. The patterns and rhythms of eternity reflect themselves in all manifest and earthly things. Transformation and regeneration is an eternal process—all things arising and returning, all renewed in cyclic

[39] "Pralaya," *Theosophy* 42, no. 11 (September 1954), 515.

rebirth. That Gottlieb was unaware of the depth of his symbolic vision is, I'm sure, without dispute. But that he intuited an eternal truth and presented it to us in a superb work of art is the stuff of which great art and great artists are made—proof that when we are at our best, we are under the inspiration of muses beyond our knowing.

Life continually regenerates itself. And consciousness, as we've taken some pains to show, is recharged each time it makes contact with the chthonic underground symbolized by the formless unconscious. One of the distinctive features of mind and consciousness is that their vitality is not directly dependent on the physical body. As Northrop Frye has noted, the imagination can be contemplative at ten or youthful at eighty. A physical cripple can be a mental or creative giant. Therefore, when we speak of the regeneration of life, we are not limited to scientific theories that see death as the inevitable end of all. We know another truth.

One of the first things anyone notes about a great work of art or music is its ability to *inspire*—to infuse the emotional and mental life with new energies and aspirations, to ignite us with a new fire! In my case, I find my thinking and writing flows most easily and is most inspired when listening to Beethoven's *Symphony No. 2 in A Minor*. Works of art have a special power, like symbols, to evolve the deeper and higher forces latent in consciousness and release them into our lives, thereby simulating consciousness and its evolution. Great art also enhances the life force within us by its creative vision and power. The sun of *Blast 1*, rising victoriously out of chaos, visually acts to recharge us. With every viewing, our consciousness rises again out of the opposing darkness, each time a bit higher. The opposing darkness intensifies our ascent. "In strife, each opposite carries the other beyond itself," says Heidegger.[40] But as the sun sits close to the central horizon, the arms of the blast reaching up toward it, we must ask, Do they *release* the sun like a loving mother, or are they there to *receive it back*? We've already said both. What we have is "the intimacy of opposites that belong to each other" (Heidegger). The light

40 Heidegger in A. Hofstadter and R. Kuhns, eds., *Philosophies of Art and Beauty*.

above is always qualified—rising, now setting, now rising again, now setting. Gottlieb has given us a dialectical vision—an art of regeneration, of perpetual ascent and descent, of journeying into the depth followed by return, an art of eternal renewal. The blast moves to the left, the sun to the right, establishing a clockwise motion, like yang and yin, ever circling round and round in an endless alteration of day and night. Today, the sun is in the ascendancy; tomorrow all will be chaos. Today, the hero returns from his death; tomorrow another will make the descent. "There is one mind common to all individual men," wrote Emerson. "Every man is an inlet to the same." So in the end it does not matter who is the hero, for on one day it will be you, on another me, on a third a soul unknown to either of us. But as we are eternally one, all benefit from each descent and return—me by yours, you by mine. With each return we are brought nearer the Great Rebirth—that of humanity itself! When your turn comes for the Orphic descent, remember to sing to us from your depths.

> *Only one who has lifted the lyre*
> *among the shadows too,*
>
> *may divining render*
> *the infinite praise.*
>
> *Only in the dual realm*
> *do voices become*
> *eternal and mild.*

<div align="right">

RAINER MARIA RILKE,
SONNETS TO ORPHEUS, 33

</div>

15 The Spiral or Infinite Journey

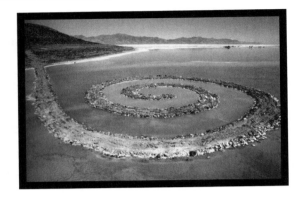

Robert Smithson, *Spiral Jetty*, 1970
See plate 15

Robert Smithson (1938–1973)

In the Labyrinth we searched for the Way that would lead us out of the quandary and confusion of our lostness. Once the Way is found, it must still be traveled. The finding of the Way is the starting point of another journey!—also long and arduous and even more trying and demanding than the sojourn in the nether world, the dark depths. This second journey is the true journey of ascent. Indeed, it is only by ascent, by a resurrection at the center, that the Labyrinth is escaped. The work of art studied here concerns centering, but once more we require a context broader than the artwork.

The true labyrinth is so constructed that it functions as a spiral leading the wanderer-seeker to its center. Thus does nature herself work. Under the Law of Cycles or repetitive experience, she always leads us back to ourselves, producing self-confrontation, self-discovery, and responsible choice. Her symbol is the evolutionary spiral. Each time the karmic fruits of earlier choices and actions "come home to roost," they find us a little further along the path of evolution,

more mature, more conscious, and more advanced than when prior choices and actions were taken. This means we're able to respond to events and experiences in a somewhat more mature manner this time around, make better choices and take wiser actions. The spiral symbolizes the recycling of life's experiences in the context of an ever-widening consciousness and growing capacity to benefit from life's lessons. It represents a simultaneous centering in and expansion of the unfolding hidden depths of our being. We see this process at work throughout nature. As organisms advance, they demonstrate greater complexity and increased integration at the same time. In like manner, we are able to incorporate ever-richer and wider experiences into an ever-more-integrated and unified Self as we evolve, demonstrating a growing capacity to absorb life's experiences and build them into an ever-more-coherent and unified worldview. We see the same process occurring with humanity on a world scale today—another sign of humanity's evolving consciousness. The spiral therefore symbolizes a repetitive winding of experience back on itself, fostering in the process an ever-deepening grasp of life's meaning and complexity, leading steadily toward an increasingly integrated and individualized ego marked by a steady expansion of consciousness. *The center is eternally open, the paradigm of the heart.* From its hidden depths—the Source of our being—our potential for life and consciousness cyclically and eternally unfolds, bringing a progressive revelation of what lies within. The spiral represents the unfolding of our hidden creative powers and symbolizes both self-realization and boundless expansion. Its secret is beautifully dramatized by the chambered nautilus, whose indwelling life unfolds cyclically and periodically, mirroring in itself the expanding spirals and eternal patterns of the evolving cosmos: As above, so below.

The Spiritual Path is a spiral path leading to and from the heart of Being. In the spiritual literature of the world, the Path has been called by many names: the Middle Way, the Razor-Edged Path, the Straight and Narrow Way, the Way of Return, the Lighted Path, the Path to the Center, Tao, and so forth. All refer to the Unitive Way, the Path

Chambered Nautilus, photo by Harold Davis

to Attainment, the Way of Liberation. All demand *centering*. All are traveled by means of human aspiration and effort. All require courage, perseverance, and unfaltering commitment. A farmer, plowing a field, to keep his furrows straight, will fix his eye upon some tree or object at the opposite end of the field and use it to guide him in a straight line. It was in this context that Jesus, speaking of the Straight and Narrow Way, said, "No man who puts his hand to the plow and looks back is fit for the kingdom of God" (Luke 9:62). No one can or should seek to travel the spiritual Path until he or she is fully ready to accept all the trials and responsibilities that commitment to the spiritual life entails. Anyone, however, who has made the hero-journey into the depths will likely find himself ready and eager for the journey to the heights. "Nature compels nothing to advance that is not driven forward by its own mature strength," wrote John Amos Comenius, the seventeenth-century educator.[1] And Emerson said:

> God screens us evermore from premature ideas . . . we cannot see things that stare us in the face, until the hour arrives when the mind is ripened, then we behold them, and the time when we saw them not is like a dream.[2]

When, therefore, a person's interest in the Path is aroused and he feels an urge to "know more," it is a likely sign the time has come for this supreme human adventure. But we must emphasize that the Way is *not easy!* "Arise! Awake! Approach the great and learn. Like the sharp edge of a razor is this path, so the wise say—hard to tread and difficult to cross" (Katha Upanishad).[3]

Most people today are like swimmers treading water. They manage to stay afloat, but they aren't going anywhere. Knowledge of the great Spiritual Way could, for many, open new vistas and provide motivation for achievements at present beyond their wildest imaginings. The Path reveals the vista of the Infinite and annihilates our sense of limitations, of finiteness. Oliver Cromwell said, "A man never rises so high as when he knows not whither he is going." Emerson adds, "Whilst we

[1] John Amos Comenius, *Educational Ideas,* 7th principle.

[2] Ralph Waldo Emerson, *The Works of Ralph Waldo Emerson,* vol. I, 106.

[3] Swami Nikhilananda, *The Upanishads,* 76.

converse with what is above us, we do not grow old, but grow young." Those who choose the path of mind-drugs cannot by that means attain the great and lofty heights that only self-mastery, self-evolution, and cosmic Illumination brings forth. "Mind-blowing" is rarely the best method of mind-awakening. In nature, any shock produces a recoiling action, and growth can be retarded rather than advanced. The quick path of drugs may prove the slower. Says Brunton, "If easier ways are followed, then lesser results must be expected."[4] Gradual illumination through personal growth, guided by wisdom and nurtured with compassion, affords the best opportunity for spiritual awakening.

THE JOURNEY INWARD: UNVEILING THE HIGHER SELF

Only by means of the hero-journey into the depths, fusion with the Underground God, and resurrection in union with God can finite mortal man discover that he is, indeed, not so finite—that he is, in fact, an embryonic god being nurtured in the womb of earthly life, yet destined some day to leave this womb! "That Self hidden in all beings does not shine forth; but It is seen by subtle seers through their one-pointed and subtle intellects," the Katha Upanishad tells us (I.iii.12). The following yogic exercise, used to unveil the Hidden Self, is one means we can employ to travel the spiral path leading to the center of Being.[5]

We know that we *are*. *Self-awareness* is immediate and direct, spontaneous and ever-present in our waking and dreaming life. We are gifted with the mystery of consciousness, but is this consciousness *identical* with the physical body?

If we place the body on a dissecting table and search, with surgical instruments, for the "I" within the sense of self, we shall not find it. Were we identical with our bodies, loss of limbs in accidents would diminish our sense of self, but it doesn't. So is the self identical with the five senses? When deeply absorbed in thought, one is often oblivious to sights and sounds in the environment. For all

[4] Paul Brunton, *The Spiritual Crisis of Man*, 20.

[5] The main line of thought here is derived from yogic practices of ancient origin. See Paul Brunton, *The Quest for the Overself*. That book is an excellent starting place for metaphysical analysis of the Self.

practical purposes, sight and hearing cease functioning. Were the self and body identical, how do we explain the self's possessive attitude toward the body as when we say, "my hands," "my eyes," or "my body"? Recognition of ownership implies a secondary or *higher self* that sees a distinction between itself and the body, over which it claims ownership.

What of the self in dreams and dreamless sleep? If we would arrive at a valid notion of the nature of the self, we must examine all states of experience—wakefulness, dreams, and dreamless sleep.

In dreaming, our sense of self or personality endures. Impressions, memories, feelings, thoughts, hopes, and fears are all present. The dreamer creates mentally as does the waking person; we see, hear, smell, touch, and taste in dreams. During dreams the dreamer regards the dream world as real every bit as much as the waking self regards the waking world. Nature is responsible for both states of consciousness —waking and dreaming. Hence, one cannot be discounted as less real than the other. Dream consciousness is no less *consciousness* than waking consciousness. The test of reality for both seems to be self-awareness. In dreams, the physical body does not declare, "I am the self." The basis of self-awareness appears, therefore, not to be physical, but mental. The ego exists *in consciousness,* not the body. This is further reinforced when we consider that the dreaming self does not use the physical body for its travels and adventures. When awake we remember our dreams. The consciousness of man-awake and that of the dreamer is therefore *the same consciousness.*

In deep sleep, on the other hand, awareness and mental activity cease. Give a command to a person in deep sleep, and you'll get no response. Consciousness appears to have abandoned its house. The body would be unable to get its needed rest if we were fully conscious twenty-four hours a day, if consciousness could not separate itself from the body. We can now safely say that while man *has a body,* he is not *identical with the body.* He is a force more subtle than physical matter. So if the body is not the self, what is the body? It is the vehicle or instrument of the self, without which the inner man would be unable

to make contact with or function in the physical world. It is his link between the inner and outer worlds.

So if the self is something intrinsically immaterial in nature, is it the emotions? The body undergoes change slowly, but the emotions can change with the speed of a flickering flame, moment to moment. One has but to yield to a sudden impulse such as anger or irritation to feel one has betrayed one's true nature. Such emotions, we say, misrepresent the "true self." What of the emotions of childhood, now long past and forgotten? Had those early emotions been the real self, the true "I," the self that knew itself in these childhood feelings would not exist today. Yet you *are* still here. When you say, "*my* hopes and dreams," you have again acknowledged the independence of the inner self that stands above emotions, feelings, and dreams as their *possessor*. To *feel* and to be *aware of feelings* are different. The kaleidoscope of human emotions is not the enduring self you know yourself to be. Brunton says:

> This feeling of selfhood inheres within man so strongly, persists so deeply at the very core of his being, that he is forced to admit that of all feelings this is the only lasting one. . . . All emotions, in the end, are but surface agitations on this ocean of "I AM."[6]

If the self is not the body or emotions, can it be the mind—the thoughts, ideas, notions, impressions, and mental sensations that make up our mental experience? In thought we seem to move closer to the stuff of reality. We don't say, "My brain thinks so and so," but "*I* think." With "*I*-consciousness" we approach more closely the interior living self. Yet thoughts are fleeting, changing even more rapidly than emotions, and this is so whether our thoughts are derived from outer world impressions or arise within ourselves. Last year's opinions are not this year's. No thought is guaranteed permanence. The wise man or woman is constantly outgrowing yesterday's limited ideas. Only one thought—"I"—remains constant. No single set of thoughts can ever represent the whole man or woman. Thoughts are like so many pearls strung upon the thread of self. All thoughts

[6] Paul Brunton, *The Quest for the Overself*, 68.

arise and pass away within our self-consciousness and cannot arise apart from our awareness that they arise in us and partake of our consciousness.

Now what of the self? Though all sense of self expires in deep sleep, coma, or trance, and thinking as an activity ceases, the self is not annihilated. Its life-current still pulses through the body, and on waking or returning from a coma or trance, the first awareness to emerge is that of the self. Had the self expired, whence does the mind again pick up this ego-thread? We are compelled to conclude that the self never really disappeared. It is rather like a magical tree with body, emotions, and thoughts coming and going through infinite seasons of change. The one persisting reality is consciousness itself, self-consciousness—an indestructible knowing that *I am!* Once one begins to realize that he or she is a larger reality than body, emotions, and thoughts, an inner revolution begins to take place, and consciousness begins to expand in unfamiliar ways. Maybe Jonathan Livingston Seagull was right after all!

We have thus far said what the self is not, not what it *is*. Consciousness is the ever-present companion of self-identity. To be aware is to be *a self aware of being aware*. In man and nature, life and sentient awareness in some form always coexist, manifest together in the physical world, and pass out of the disintegrating forms together. We never encounter life in the absence of consciousness, however elementary, or consciousness in the absence of life. Life and consciousness are as inseparable as two sides of a coin.

If man—a conscious life within a physical form—is not identical with the form through which he manifests, but experiences himself as a higher, independent, enduring reality, may we not infer that all life and consciousness must belong to a higher reality? If consciousness only manifests in companionship with life, who is to say this union does not continue onward after the disintegration of the forms through which life and consciousness seek expression and experience? Is not consciousness itself immortal? Indeed, the Wisdom Teachings tell us that the soul, the immortal element in man, is the seat of consciousness—a point to which we'll return. The self says "I *Am*,"

not "I exist"—posing the unavoidable question of a higher identity and destiny than mere earthly life.

BEING HERE: THE ETERNAL NOW

Having peeled away the earthly veils surrounding the self, we must now tear away the veils of time. By means of these analyses we approach more closely to the center of our being, making analysis carry us as far as it can on our journey inward.

The intellect is finite and, as such, can think of time only in terms of finite, measurable periods. Einstein's theory of general relativity called into question all our normal assumptions about time. Consequently, in the twentieth century, time became one of the fundamental puzzles confronting man.[7] Time influences our thoughts and observations. Consciousness, which is at the root of self-consciousness, engages us in a dialectical interplay with a sense of time. To understand the true nature of the self, therefore, we must understand time.

As soon as we explore our relationship with time, we discover that we live and are conscious only in present time. When we recall the past, it is as a "past" remembered in present consciousness. When we imagine the future, it is a "future" anticipated in present consciousness. Past and future are able to enter our thoughts only as present states of awareness. All past events, when experienced, were present ones to consciousness at the time, and when anticipated future events occur, they, too, will be experienced as present events in consciousness. While remembering the past and anticipating the future, we are forced to live always and only in present time. Lived time is always NOW. We stand at its center, a center without temporal duration. The present moment cannot be defined with parameters saying it lasts for a minute or ten seconds or a millisecond. Present time is a razor's edge separating past time and future time. It cannot itself be measured in terms of duration, for it is time's Zero Point.

All events and experiences occur in present time, not past or future time. Brunton says:

[7] See J. B. Priestley, *Man and Time*; Hans Meyerhoff, *Time in Literature*; Georges Poulet, *Studies in Human Time*; and Bob Toben, *Space-Time and Beyond*.

Past and future, when analyzed, are therefore seen to be manifestations of present time, resting entirely upon it, and possessing no independent existence of their own. *Therein lies the crux of the whole question.*

In other words, time is an unbroken chain formed by successive links of present events only. It cannot be truly split up into an absolute past and an absolute future for it is itself indivisible; it is an everlasting NOW. The relationship which exists between past and future has been created by the unifying power of man's memory; it exists in man, not in time.[8]

He goes on to say:

It is certainly a strange truth that one is immovably fixed in the present moment, that time's secret lives here alone.

Everything one has done in former years and everything one will do in the years to come, will be deposited in the eternal present.

The present alone is *real* time.[9]

All events, ideas, and experiences are so many *states of consciousness*. Because we experience qualitative differences between different states of consciousness—between joy and sorrow, ignorance and enlightenment—we create time or duration to account for the passage between these different states of consciousness. Time, however, exists *within man*, not man in time.

Brunton says, "Because we are always living through all our experiences in the present it implies that we may know time only as a form of self-consciousness."[10] By allowing consciousness to constantly sink away from itself in thoughts of the world, we come to believe in time as duration, forgetting that all our experiences have their unity within ourselves. To quote Brunton again:

We are not normally aware that the present moments really permeate each other in a timeless Absolute and do not extend side by side.

[8] Paul Brunton, *The Quest for the Overself*, 85.
[9] Ibid., 86.
[10] Ibid., 87.

. . . If our awareness could *experience* two moments which were completely identical there would be no transmission of memory from the first to the second.[11]

Under such conditions there would be no movement of the intellect, and consciousness would experience a timeless state of awareness. Hence the focus on stilling the restless "monkey mind" in meditation. When the mind is focused in deep meditation, the time-sense typically vanishes.

Concentration is the first step in acquiring skill in meditation. Just as an ice pick can more easily pierce a sheet of cardboard than can a large-surfaced object such as a basketball, so a centered, concentrated, focused mind can more easily penetrate and unveil the mysteries of life than a mind that is distracted, restless, and unfocused.

Present time is *subjective* time, time as perceived within the consciousness of the observer. Asked for a definition of the relativity of time, Einstein once said, "When you sit with a pretty girl for two hours you think it's only been a minute. But when you sit on a hot stove for a minute you think it's been two hours. That's relativity." Now we understand: time is how we think of it! Only what is experienced in present-tense consciousness has for us any sense of being real—past and future being creations or re-creations of memory and imagination. By learning to stay focused in the present and achieving that state of "mindfulness" of which Buddha spoke, we move closer to a timeless state of being, which is the true meaning of "eternity." By learning, as Ram Dass said, to *Be Here Now,* at the center of existence, where time and eternity intersect, we begin to discover what it means to be eternal beings. *We see our lives and work in their true light only when we see them under the eye of eternity, for all that we create becomes a permanent possession of our eternal being.* A wise person thinks and acts with his or her eternal destiny always in mind.

All that is finite exists in space-time, but the Self, that which identifies with the thought *I Am,* resides and is rooted in the Eternal Now. Identity cannot be divorced from consciousness. The Real Self, the "I"

[11] Paul Brunton, *The Quest for the Overself,* 89.

behind consciousness, does not change in time but remains anchored in the Eternal Now. Occultly, this Self is called the Silent Watcher. For this Watcher, time does not exist. Conscious only of eternity, it is unperturbed by our earthly struggles and suffering, for it sees their outcome in eternity. The timeless present is an open passageway between the Self and the Infinite, the eternal Ground of Being. Eternity is our true home. We have never known and will never know another.

THE COSMIC INTERIOR

We have traced the spiral of thought inward and come another step closer to knowing the Real Self. Our quest for the Center led us first to man's consciousness, then his existence in a timeless present. Let us now seek the true Center of Being, after which we shall return to art.

Much is said today of "expanded awareness" and "cosmic consciousness"—implying that man's consciousness expands until it embraces the cosmic whole. Paradoxically, however, the expansion of consciousness is achieved not by going *outward* into the universe but *inward* into the Real Self. In other words, Cosmic Consciousness is achieved inwardly, not outwardly. If one could take a journey in space as an astronaut, say a journey a million light-years from earth, one would still occupy a definite, finite location in cosmic space. Likewise, no matter how far one may stretch the mind in thought, one is still thinking finitely. The infinite is not "out there" to be grasped if only we can push the mind far enough! Only by turning inward and bringing consciousness to a one-pointed centering does one suddenly transcend space and time and realize the Eternal Now in which Being is Absolute. Allow me to illustrate. Imagine a sphere twenty inches in diameter filled with an inert gas that exerts an internal pressure of 100 pounds per cubic inch. Imagine shrinking the sphere to a diameter of ten inches while preventing any gas from escaping. What happens? The internal pressure rises dramatically. Without gas escaping, imagine continuing to shrink the sphere to a diameter of six inches, then one inch, one tenth of an inch, then one one-thousandth of an

Kozmic Kapers

inch. By now the internal pressure in our sphere is stupendous, nearly incalculable!

In a final act of imagination, imagine compressing this stupendous force into the sphere's absolute center, its Zero Point. What happens? This awesome pressure, still finite within the sphere, is suddenly raised into the infinite and becomes *infinite force or energy—an Absolute Power.* That which is finite in its manifest state is inseparable from the Infinite in its unmanifest state. This experiment can only be conducted by an act of imagination, but it illustrates my point that at the center of all finite things we find the Infinite. In like manner, bringing consciousness to a one-pointed concentration is tantamount to rupturing the planes of space and time and achieving a sense of infinite, timeless Being. Through perfect concentration, consciousness achieves an awareness of the eternal Absolute. Here a curious thing happens. Through one-pointed concentration, consciousness experiences a limitless expansion, awakening to a sense of the Cosmic Whole. The highest consciousness knows no sense of separation. For it, Life is ONE. It recognizes that the Infinite, the Absolute, has its center everywhere. For such a consciousness, all finite things lose their finiteness and are seen as Life-centers in the infinite, eternal Ground of Being. As consciousness attains inwardness, it begins to unfold the boundless Mystery of all that is manifest. The revelation of the Infinite, precisely because it is infinite, launches us on a journey that is boundless and eternal.

To attain such consciousness, one gradually brings one's attention to a central point within oneself—usually the heart center or crown chakra. No division in consciousness is set up between the inner self and the outer space-time world. One becomes aware only of the center within. *All is inwardness.* Such centering may take many years or lifetimes to achieve, but its rewards are obvious. Even before taking up meditation, one can make it a practice in daily life to be fully aware of one's thoughts and actions, of others, and of all that is taking place in one's environment. In this way we sharpen and focus our awareness in preparation for the great adventure.

Saul Steinberg, *Untitled*, 1963

When truly centered, one discovers he or she is no mere finite mortal, but an embryonic god unfolding in space-time. So say the sages of all ages.

I have said, Ye are gods; and all of you children of the Most High.

PSALM 82:6

Is it not written in your law, I said, Ye are gods?

JESUS, JOHN 10:34

Man . . . , though based, to all seeming, upon the small Visible, does nevertheless extend down into the infinite depths of the Invisible, of which Invisible, indeed, his Life is properly the bodying forth.

THOMAS CARLYLE

Of soul thou shalt never find boundaries, not if thou trackest it on every path; so deep is its cause, so profoundly rooted is it in the Logos.

HERACLITUS

God, the maker of all things, the great Self, always dwelling in the heart of man, is perceived by the heart, the soul, the mind;—they who know it become immortal.

ŚVATĀŚVATARA UPANISHAD

The knowing Self is not born; It does not die. It has not sprung from anything; nothing has sprung from It. Birthless, eternal, everlasting, and ancient, It is not killed when the body is killed.

KATHA UPANISHAD

The Path of Return and reintegration, which leads from the labyrinthian depths to the mount of Transfiguration, the Himalayas of illumined consciousness, brings man to his True Self. So long as self-knowledge remains finite, it is not final, for whatever is finite can

be transcended. "Any experience of the self who has not attained Reality," says Deutsch, "is subject to being rejected by a qualitatively higher experience."[12] Only when we encounter the infinite, deathless Absolute at the center of our being do we know the Self that cannot be transcended by a still higher experience. This is the True Self you, I, and every man, woman, and child truly *is*. This Self doesn't say, "I exist." It says, "I AM." How did the Eternal One address Moses from the burning bush? "I AM THAT I AM." Grounded in the Eternal, we are one in essence with Boundless Being, the Infinite All.

Turning now to Robert Smithson (1938–1973) and his *Spiral Jetty*, an earthwork dating from 1970, Great Salt Lake, Utah (plate 15), we take up a work that I've only seen in photos. So I shall confine myself to reflections on its symbolism. *Spiral Jetty* is constructed of black rock, salt, and crystal jutting out into the Great Salt Lake. The term *earthwork* applies to constructions or happenings involving the earth itself—digging a hole, refilling it, and photographing the work at various stages; or constructing a mound or building a spiral jetty into a lake. Early commentators saw earthworks tied to the ecology movement, as both emerged about the same time. While ecological concern may enter in, I suspect the subconscious motivation is deeper and more archetypal and concerns the primordial nature of man's relationship to the earth, the symbolism of the elements, and the sheer power that an artwork created from the elements of nature holds for our emotions and mind. Note the fascination generated by "crop circles."

Earthworks are not new, as can be seen in the ancient figural designs found on the rock plains and plateaus of Latin America. The symbolism of the earth is vast and complex, including such associations as Earth Mother, primal ground, ancestral home, and so forth. Earthworks suggest a need to find one's roots in nature in the most immediate and tactile way possible.

Smithson's *Spiral Jetty*, a rock-spiral extending into the shallow waters of the Great Salt Lake, involves viewers with the symbolism of water, lakes, and spirals. Water symbolizes the primal substance of the

12 Eliot Deutsch, *Advaita Vedanta: A Philosophical Reconstruction*, 24.

Crop circles that have appeared in the British countryside in 2001 and 2007

universe. An ancient symbol for the universe portrays it as a "celestial Swan" swimming in the waters of boundless space. In all cosmologies, water is seen as the source of manifest existence—the primordial substance from which all life emerges: "And the Spirit of God moved over the face of the waters" (Genesis 1:2). It also stands for the unconscious, the abyss, formlessness, the origin of life, the fount of creation,

metamorphosis, transition, transformation, regeneration, immersion, and rebirth. It symbolizes also intuition, unfathomable wisdom, the psychic depths, the collective unconscious, and fertility. Lakes carry a particular occult and mysterious connotation, representing contemplation, the union of the superficial and the profound; they are often linked with the magical powers of mythic characters such as the Lady of the Lake of Arthurian legend. As Melville says, "Meditation and water are wedded forever."[13]

The spiral, as already noted, is symbolic of evolution, growth, and creation. Through its association with the coiled serpent, it symbolizes energy and the Kundalini force at the base of the spine, also wisdom and eternity, as well as cosmic law. The spiral is essentially a macrocosmic symbol. It establishes the relationship between the circle and its center, between outer and inner realities. Whereas the circle is a finite symbol of the infinite, drawing our attention to its center, the abode of the infinite, the spiral is an infinite symbol of the infinite, revealing the infinitude of the center as it unfolds itself cyclically and eternally in boundless space. Its journey knows no end. It is therefore a true symbol of the cyclic, eternal unfolding of Cosmic Life and all manifest lives therein. The spiral also leads us back to the center out of which it unfolds and demonstrates the inexhaustible potentiality latent within and veiled by the center. As earlier noted, the true labyrinth is based upon the spiral and guides us finally to its center as the place of transformation and liberation.

Whether and to what extent Smithson drew consciously upon such archetypal symbolism in creating *Spiral Jetty* is not at issue. No artist can free himself from the archetypal unconscious or escape the influence of cosmic forces on the symbolizing mind. Yet Smithson was not oblivious to the primal depths. He thought we could revitalize our culturally exhausted forms by contacting their archaic roots. "He thought that the art of the future would need a new past, a past before culture," said Philip Leider.[14] Smithson himself said the artist must "go into places where remote futures meet remote pasts." His art is a meditation on nature, in which he found "a past more eternal" than

[13] Herman Melville, *Moby Dick*.
[14] Philip Leider, "For Robert Smithson," *Art in America*, 82.

anything manmade. Through his art Smithson hoped to advance us into this eternal past. He sought in art to return us to the archetypal realm via the earth.

Given the shallowness of the waters around *Spiral Jetty*, the symbolism of reflection and meditation would seem to come into play. For several years in New York City I had an office overlooking the Hudson River. I spent many an hour meditating on the water. The appearance of the river underwent constant transformation, never assuming the same appearance twice. When the angle of the sun was just right, millions of points of light would flash forth, dance, and vanish, followed by others. In those moments one felt as if one were seated in eternity, viewing suns and stars appearing in the cosmos, living out their lives and vanishing in a vastly accelerated metamorphosis. The river conveyed a sense of *cosmic time*. One thinks of Siddhartha at the end of Hesse's novel contemplating the river after a long life and hearing in it "the great song of a thousand voices consist[ing] of one word: Om—perfection." Even the flight of birds over the Hudson River reflected the changing patterns of the water's movements. The mysteries of water are truly inexhaustible.[15]

Smithson's spiral jetty is a left-hand or counterclockwise spiral. In the northern hemisphere, hurricanes and tornados typically rotate counterclockwise. Galaxies appear to rotate in both directions. Evolution typically follows a right-hand spiral or clockwise motion, symbolizing movement from the unformed to the formed, from unconsciousness to consciousness. As Jung pointed out, in many cultures a new temple or building is consecrated by means of a processional that circumambulates it in a clockwise direction. What is the significance of these clockwise and counterclockwise motions? They are based upon the principle of electromagnetic polarity in nature. A movement from left to right or clockwise accompanies growth and outward expansion. A movement from right to left or counterclockwise accompanies centroversion, contractions, or descent. *Spiral Jetty*'s left-hand spiral suggests a movement toward centering within the primal depths and a rediscovery of that fruitful point below the threshold of consciousness and ratio-

[15] Not only is water a profound symbol with deep metaphysical implications, it is also a fascinating aspect of earth science. Beginning in the 1880s, Viktor Schauberger, the Austrian-born water pioneer, began to discover many remarkable properties of water. To begin exploring the mysteries of water, see: Callum Coats, *Living Energies* (Gateway, 2001); Alick Bartholomew, *Hidden Nature* (Floris Books, 2003); Olof Alexandersson, *Living Water* (Gateway 1990); and Mu Shik Jhon, *The Water Puzzle and the Hexagonal Key* (Uplifiting Press, 2004).

Counterclockwise hurricane and clockwise spiral galaxy (inset)

nal life where "a past more eternal" resides. In short, it is an attempt at a reorientation in the depths rather than a symbol of evolutionary expansion. It belongs to that symbology of descent that Northrop Frye says characterizes our age. The left-hand spiral also indicates *involution*. Many of us believe we stand today on the verge of another great spiritual revelation to humanity, a revelation that will occur within the inner consciousness of man himself. This revelation would constitute a greater outpouring or infusion of Spirit into Matter—an infusion already indicated by the spread of the practice of meditation,

psychological introspection, and rising spiritual consciousness of our age. *Spiral Jetty,* in its own way, points to this spiritual infusion at Jung's "fruitful center." In my use of meditation, I've learned one usually centers *inward* to contact the depths within oneself before ascending the Path that leads to higher states of consciousness. The spiral unites inner and outer worlds, the depths with the heights. Smithson's left-hand spiral suggests not only descent but also concentration, centering, a leaving behind of the outer world. By entering realms of water, *Spiral Jetty* appears to hint of a rebirth process in the making—a metamorphosis *below,* which, like all depth transformations, eventuates in a metamorphosis *above.* The spiral also represents the eternal creative process at work. *Spiral Jetty,* like the other works we've considered, speaks in a special way to the regenerative process at work in our culture. Was Smithson's choice of a left-hand spiral conscious or unconscious? I suspect the latter. Yet it is the intuitive right choice for a culture still searching within its depths for its own identity.

Why the Great *Salt* Lake? Those who see the interconnectedness of all things in cosmic unity must believe such choices are not accidental, insignificant, nonsignifying. Salt played an important part in the alchemical process of transformation. Jung quotes the *Rosarium philosophorus:* "Who therefore knows the salt and its solution knows the hidden secret of the wise men of old. Therefore turn your mind upon the salt."[16] It is the heavenly substance in alchemy required to manifest the Philosopher's Stone. The Emerald Tablet calls it "the Glory of the Whole Universe." It represents the action of thought on Matter, be it Cosmic Mind acting on Cosmic Substance or the alchemist meditating in his laboratory. Jung says simply mind and salt are close cousins. Salt is obviously a veiled symbol in alchemical literature, which I interpret as representing the fires of transmutation—the universal solvent. Regarded as one of the three primary "elements" of alchemy, salt is associated with earth, Mother, water, and the Holy Spirit; it is said to be born of the union of water and fire, is referred to as the beginning and end of all things, and is said to concentrate all creation. However we interpret its symbolism, it is clearly funda-

16 Carl Jung, *Psychology and Alchemy,* 244.

mental to the transformative and generative process. So, in light of the rich symbolism of *Spiral Jetty,* one can only conclude that the choice of the Great Salt Lake as an essential part of that symbolism, however intuitive or subconscious it may have been, plays a fundamental role. In the salt waters of the oceans, terrestrial life had its beginning. Its symbolism is primal.

Spiral Jetty, as I see it, is a work concerned with centering and spiritual rebirth. It is not necessary, of course, that we consciously understand all this. Forms work primarily upon the subconscious mind where the forces of evolution and spiritual awakening are constantly at work. For the present, this may be all our age requires—to have available to us art forms and images that infuse us with transformative powers and trigger the necessary archetypes in the psychic depths. From a personal perspective, Robert Smithson's works are among my favorites, especially *Spiral Jetty* and *Leaning Strata.*

I'm unaware of any contemporary American artworks concerned, consciously or otherwise, with the theme of spiritual initiation, a subject belonging to our present discussion. Some works of the Austrian-born artist and sculptor Ernst Fuchs do come to mind—for example, *Sampson Before the Hierophant* and *Moses and the Burning Bush.* We shall return to the latter in our final chapter.

The term *initiation* refers to those graded "awakenings" we experience each time some of our old limitations are shattered and consciousness experiences a significant expansion, deepening, unification, and clarification of its powers. It may come in the form of a profound intuition that serves to unify a vast arena of knowledge or experience, or it may come as a sudden influx of light into consciousness.[17] Djwhal Khul defines initiation thus:

> Initiation leads to the cave within whose circumscribing walls the pairs of opposites are known, and the secret of good and evil is revealed. It leads to the Cross and to that utter sacrifice which must transpire before perfect liberation is attained, and the initiate stands free of all earth's fetters held by naught in the three worlds.[18]

[17] See R. M. Bucke's *Cosmic Consciousness* and the *Enneads* of Plotinus. Paramahansa Yogananda, in his *Autobiography of a Yogi,* describes his enlightenment as a sudden beholding of a light akin to that of numberless suns shining together.

[18] The reference here is to the three realms within which man exists as an incarnate personality —the physical, emotional, and mental realms of his nature.

It leads through the Hall of Wisdom, and puts into a man's hands the key to all information, systemic and cosmic, in graded sequence. It reveals the hidden mystery that lies at the heart of the solar system. It leads from one state of consciousness to another. As each state is entered the horizon enlarges, the vista expands, and the comprehension includes more and more, until the expansion reaches a point where the self embraces all selves, includes all that is "moving and unmoving," as phrased by an ancient Scripture.[19]

An initiate does not experience a single initiation but a series of initiations, each marking a new and higher point of attainment in his spiritual progress and evolutionary unfoldment. Initiation may be likened to climbing a high mountain only to see a still higher mountain in the distance, marking the next goal of endeavor.

1. Expanding consciousness admits the personality into the Wisdom of the Soul and ultimately into that of the Monad or Eternal Self.
2. Illumination allows one to see something of the Path ahead and the Grand Plan of evolution unfolding within our universe.
3. The unity of the Self with all other selves and with the cosmos is understood, begetting a vision of that universal Brotherhood that is a fact in nature, and that humanity is slowly realizing.[20]
4. It awakens and expands the faculty of Intuition or Buddhic consciousness, also called Christ consciousness.
5. It gives birth to a selflessness in which the initiate forgets his personal interests, his own unfoldment and private fate, and devotes himself wholly to the service of humanity and the Greater Plan.
6. It bestows increased vitality, plus enhanced mental, spiritual, and creative power for use in whatever line of work the initiate follows—usually combining three or more areas of service: one concerned with some form of healing, one with the arts, and one contributing in some way to law or the social order.

[19] Alice A. Bailey, *Initiation, Human and Solar*, 14.

[20] The United States is the world's first great experiment in Universal Brotherhood. People from every race, nationality, religion, and political persuasion on earth have gathered together in one nation to learn to live in unity and mutual sympathy, and the lessons of brotherhood learned in the United States will eventually spread worldwide and help bring about the day of One Humanity.

THE GUARDIAN OF THE THRESHOLD

Initiation is not to be entered upon lightly. Before higher Illumination becomes possible, one must face the Guardian of the Threshold and experience "the terror of the threshold." This terror is generally described in terms of a twofold experience: (1) a vision of all the wrongs and evils one has committed over the many incarnations each individual is believed to have had as a human being, and (2) a vision of the utter voidness of existence—a glimpse of "the deep emptiness of the universal round." This is not the Void as Clear Vision of which we spoke earlier, but its terrifying counterpart—the Black Abyss of Nothingness. So profound is the terror associated with these visions, as reported by the East, that many come out of them mentally deranged. Hence, to seek spiritual initiation is to undertake a supreme test of the soul.

RITES OF PASSAGE

The crossing of the threshold, marking the transition from a profane to a sacred life or from death to rebirth, is governed by rites of passage or rites of intensification. "In this respect, man's life resembles nature," says Arnold Van Gennep. "The universe itself is governed by a periodicity which has repercussions on human life, with stages and transitions, movements forward, and periods of relative inactivity."[21] The rite has three main stages: (1) separation from something; (2) crossing a boundary; and (3) incorporation into something new. The Jewish Passover, a rite of passage that marked the liberation of the Jews from Egyptian bondage, is symbolic of the liberation of the spiritual man from the bonds of his earthly confinement.

One work by Abstract Expressionist Robert Motherwell contains, for me, overtones of a rite of passage—his *Elegy to the Spanish Republic, 54* (1957–61), in the collection of the Museum of Modern Art, New York. Three upright black bands or columns, joined by bands across the top, create a post-and-lintel effect reminiscent of

[21] Arnold Van Gennep, *The Rites of Passage*, 3.

Robert Motherwell, *Elegy to the Spanish Republic, 54,* 1957–61

Stonehenge. Two openings or doorways are created, but these are blocked by three black elliptical or egg-shaped forms. Seemingly dead, except for one at right which appears on the verge of vibrating open, these egg-shapes hint remotely of the possibility of birth and life. Jammed in the door openings, they obstruct passage and suggest the necessity of solving the problems that they represent before passage to a new life can be achieved. Ambivalent symbols of death and life, they face two worlds, occupying a threshold position between them. The initiate must ever solve the enigma of life and death before passage to new being is possible.

WISDOM CONFERRED

Finally, initiation confers new wisdom upon the initiate. To cross the threshold and enter a New Reality is to gain knowledge belonging to a New World, new to the initiate, though eternally present. By wisdom

we don't mean human knowledge but intuitional knowledge, primal wisdom, cosmic understanding—wisdom arising from contact with the divine Center within.

> Truth is within ourselves; it takes no rise
> From outward things, whate'er you may believe.
> There is an inmost centre in all of us,
> Where truth abides in fullness.
>
> ROBERT BROWNING, *PARACELSUS*

"There is a distance incomparable between those things that imperfect men think, and those that men illumined by high revelation behold," said Thomas à Kempis. To engage in a discussion of the nature of spiritual Wisdom would take us beyond our present concern—the transformative process. Suffice it to say that Wisdom with a capital *W* concerns eternal Truths and is the result of a higher education than any conferred by our educational institutions. The spiral, as an infinite symbol of the Infinite, represents a ceaseless unfolding of That which is veiled by the Center from which all emerges. It symbolizes the Path of cyclic and eternal evolution and the progressive revelation of Wisdom that accompanies the Divine Unfolding—periodic, boundless, eternal, and inexhaustible.

> We must learn to reawaken and keep ourselves awake, not by mechanical means, but by an infinite expectation of the dawn, which does not forsake us in our soundest sleep. I know of no more encouraging fact than the unquestionable ability of man to elevate his life by a conscious endeavor.
>
> HENRY DAVID THOREAU

16 The Way of the Transfigured Life

Walter Gaudnek,
Rebirth, 1961–62
See plate 16

Walter Gaudnek (1931–)

We come now to one of the supreme artistic achievements of the twentieth century, a work that remains virtually unknown. Some works of art, like prophets, are born before their time and must await coming generations to be understood. Walter Gaudnek's *Rebirth*, 1961–62, is such a work. It requires a generation consciously aware of the spiritual transformations at work in our culture to be fully appreciated.

Adopting a symbolist approach to art,[1] Gaudnek followed his own creative muse. In no other work in the history of art known to me is the complete cycle of death and transformation so completely and clearly conveyed as in Gaudnek's *Rebirth*. Given the profound and often esoteric significance of the symbolism of this work, I shall

[1] Influences on Gaudnek's art include Carl Jung, Existentialism, Christian iconography, and such artists as Fernand Léger, Max Beckmann, Pablo Picasso, and Alexander Calder.

234

attempt a partial unveiling of the underlying meaning. Nevertheless, it should be noted that the significance of the symbolism of *Rebirth* extends into spiritual dimensions far transcending what's written here. Students of ancient and Eastern philosophies and the Ageless Wisdom will be able to follow the indicated clues.

SYMBOLISM: A UNIVERSAL LANGUAGE

All symbols embody a plan, a law, a principle, a truth, and keys to their interpretation[2]—keys that can only be turned by means of intuition and spiritual unfoldment. In a symbol lies "concealment and yet revelation," says Carlyle.[3] Before Divine Wisdom opens its secrets to our evolving consciousness, we must *demand* the truth[4] and do so with purity of motive and the aim of selfless service to others. Until we grasp something of the Archetypal Plan, recognize the governing laws of nature and Spirit, and apply the wisdom available to us in our own lives, the light of Wisdom rightly remains hidden from us. Without effort, nothing is achieved.

In Gaudnek's *Rebirth,* we take up a profoundly symbolic work of art that embodies and unifies much that we've previously discussed. We've spoken frequently in symbols. Now it's time to pause and take note of some of symbolism's fundamental attributes.

THE LANGUAGE OF THE COSMOS. Symbolism is the divine, creative language of the cosmos, the alphabet of the gods, a code of cosmic powers invisibly written in the fabric of space and time and open to interpretation to those who can awaken like powers in themselves.

[2] All symbols can be interpreted seven ways—cosmically, anthropologically, psychologically, metaphysically, mathematically, geometrically, and astrologically—with meanings corresponding to each plane of being: physical, emotional, mental, intuitive, spiritual, and divine.

[3] Thomas Carlyle, *Sartor Resartus,* 198.

[4] "Ask, and it shall be given to you; seek, and ye shall find; knock, and it shall be opened unto you" (Matt. 7:7). The Law of Attraction is a fundamental law in all spiritual work. We attract that to which we aspire and for which we strive. Like attracts like.

The King to whom belongs the shrine at Delphi neither publishes nor conceals, but shadows forth the truth.
HERACLITUS

Those ages are accounted the noblest which can best recognize symbolic worth, and prize it the highest.
THOMAS CARLYLE

The power to interpret symbols ever precedes true revelation.
DJWHAL KHUL

Like can only be known by like. Nature carries within herself the archetypal patterns and symbols of all that will unfold throughout the long aeons of evolution. "Definitely connected are they with the archetypal plane."[5] Consequently, a symbol "stands for a complete truth, and in its comprehension it holds the whole of evolution's story."[6]

Like mathematics, symbolism is a universal language. The truths of mathematics are the same for all, but once these truths are translated into a language of ideas, each age and culture brings to them that thinking style and mode of comprehension distinctive to its own soul. The work of myth scholars such as Mircea Eliade and Joseph Campbell shows us the same symbolic truths constantly recurring across the ages in Asia, Europe, Africa, the Americas, Australia, and the islands of the South Pacific. The same archetypal truths recur again and again, each taking on the coloring of the culture and peoples to whom they belong.

THE LAW OF ANALOGY. The Hermetic law of correspondence—"As above, so below; as below, so above"—when rightly interpreted, provides an infallible analogical key for unlocking all mysteries—human, spiritual, and cosmic—between the lower and higher planes of manifestation, between the lesser and the greater, the outer and the inner, the seed and the flower, the embryonic and the evolved, the revealed and the hidden, man and the cosmos. It is the fundamental key to all symbolic interpretation leading to true revelation. For those with eyes that see and hearts that understand, the most deeply hidden is openly revealed. All truths are taught in parables, symbols, myths, figures, fables, allegories, and fairy tales, enabling the children of the races of humanity to draw from them as much wisdom as they are capable of comprehending, while continuing to hold before them a boundless Wisdom that, as men evolve, will continue guiding them step by step upon the Infinite Way. Common everyday images hold hidden eternal truths.

THE INTERPRETING POWERS OF THE SOUL. The highest wisdom can be imparted only by means of symbols. Logical thinking is analytical, objective, and structure-oriented. Words define and limit. Symbols

[5] Djwhal Khul, quoted in Mary Bailey, *A Learning Experience*, 58.

[6] Ibid., 56.

The royal way that leads to perfection is not marked out; in order that initiates may be able to recognize it, forms are used.

BODHIDHARMA

allow intuition to penetrate beyond the objective, defined, and limited and peer into the depths of eternal Wisdom. They do not limit the Infinite. They call forth the subjective, interpretative powers of the soul and awaken the intuition of the spiritual man, while recognizing that interpretation and comprehension depend on the type of mind brought to the symbols and the point of evolution of the soul of the interpreter. Symbols permit a progressive revelation of Eternal Wisdom as soul experience brings about a deepening of our powers of comprehension and a heightening of the spiritual faculties required to penetrate the unseen realms.

The value of symbolic thinking led Manly Hall to urge the use of symbolism in teaching to evoke a student's latent, creative powers.

> Symbolism should be employed throughout the process of education, for by it two definite ends are attained. First, the student will instinctively reveal to the teacher the constitution of his reasoning part by the interpretation he places upon the symbols; second, the student will be stimulated to originality and thereby preserve the particular technique of his own rational process. The death of originality is the death of genius. Symbolism encourages originality, and hence is productive of genius.[7]

SYMBOLISM AND EVOLVING CONSCIOUSNESS. Symbols impregnate us with the life of the Spirit, releasing powerful creative forces that hasten the evolution of consciousness. They draw in the unseen currents of the cosmos that guide and govern all evolutionary processes and focus them, as through a lens, upon our inner life, much as the sun's rays, when focused through a magnifying glass, produce heat that can ignite any flammable object. Our consciousness becomes a burning-ground of transformation—the arena of enlightenment—as the focused fires of Spirit do their needed work. In this way, Nature and her divine forces intensify their work on the inner side of life. According to Djwhal Khul:

Learn that man infinitely transcends man.
BLAISE PASCAL

We are born into the world of nature; our second birth is into the world of the spirit.
BHAGAVAD GITA

[7] Manly P. Hall, *Lectures in Ancient Philosophy,* 341.

A symbol makes its appeal through the eye and not the ear, and directly tends to develop the intuition. First, it strengthens the imagination . . . which we use to express something which is hidden from us, drawing upon our imagination for its elucidation. Then the imagination leads to the development of the intuition.[8]

During the contemplation of symbols, the subjective mind is stimulated, the soul awakened, its latent powers unfolded, and the outer mind is trained to think in harmony with the unfolding Plan of the Logos. Symbols and archetypes educate us in the true sense of *educate*—drawing out what is latent and unawakened in the depths of our being.

SYMBOLISM AND THE LIFE OF THE SOUL. Symbols have their principal influence on the evolution of the soul. The Teachers of humanity work chiefly with soul-energies, not with our earthbound personalities. It is the task of the soul itself to guide, purify, and perfect the earthly nature. Symbolism, like music and art, has its major influence on the soul. Symbols constitute a language the soul naturally understands. As the earthly man, through evolution, becomes increasingly soul-attuned and soul-infused, the truths of symbolism slowly filter down into mind-brain consciousness and become guiding powers and influences in how we shape our lives. When meditating on symbols, we are building bridges of light between the personality and the soul, between ourselves and the spiritual and cosmic realms of being, between time and eternity. May we, like Shakespeare, be able to say,

> *In Nature's infinite book of secrecy*
> *A little have I read.*

SYMBOLISM AND REALITY: RENDING THE VEIL. "In the Symbol proper, what we can call a Symbol, there is ever, more or less distinctly and directly, some embodiment and revelation of the Infinite; the Infinite is made to blend itself with the Finite, to stand visible, and as it were, attainable there," says Carlyle.[9] Symbols are rooted in the realities they symbolize. Were it otherwise, how could they guide us to the inner

[8] Djwhal Khul, quoted in Mary Bailey, *A Learning Experience*, 56.

[9] Thomas Carlyle, *Sartor Resartus*, 198.

I am child of Earth and starry Heavens; my race is of the Heavens.
ORPHIC FRAGMENT

THE ART

sanctum of those realities? A symbol is a winged messenger of the gods, an oracle of the Mysteries, the outer court of the Holy of Holies, the embodiment of some archetype, a signature in space and time of eternal truths. The realities to which it guides us compose the innermost soul or spirit of the symbol. Like man himself, symbols dwell in two worlds simultaneously—the objective world of the senses, and the subjective world of spiritual Being. But for this common bond between man and symbol, symbols would remain incomprehensible, as *like can only be known by like.* Insight is attained by attuning ourselves to the wisdom we seek. As intuition unfolds and insight deepens, the veils of symbolism slowly part, allowing us entry into, and a direct experience of, the inner Reality. The symbol is not the Reality, merely its avatar and interpreter. Nevertheless, imbued with the spirit of truth, it becomes a winged messenger of that truth, transporting us into the light of Wisdom and lifting the veils that separate us from the awesome Light of the innermost worlds.

With these few remarks on symbolism, we turn now to Gaudnek's *Rebirth,* 1961–62, acrylic on canvas, 114" × 102"—a work belonging to the artist's black-and-white period, 1959–63 (plate 16). The paintings of this period are among the most original and unself-conscious of the artist's works and are often stark and overpowering in their imagery. Their symbolism is typically archetypal, yet there is an inventive originality, as we shall see in our study of *Rebirth,* which sets Gaudnek apart from symbolist painters of the past. Whereas artists such as Wassily Kandinsky and Constantine Brancusi expressed the spiritual dimensions of art through abstraction, Gaudnek's spirituality is more Jungian, subterranean and archetypal. Myth scholar Mircea Eliade once remarked to me in a letter that he thought Gaudnek was doing "very important work," and Joseph Campbell attended a private showing of Gaudnek's art at a New York gathering. His works are in a number of major museum and private collections. One prominent collector I knew replaced a large Picasso in his living room with a Gaudnek. Gaudnek's original take on spiritual symbolism and his

We dream of voyages across the universe; but is not the universe in us? The depths of our spirit are unknown to us. The mysterious way goes toward the interior. It is in us if it is anywhere, that eternity is to be found with its worlds.

NOVALIS

courage in plumbing the depths of the psyche in an age seeking simplistic answers and instant gratification makes him an important and serious artist whose art is worthy of a deeper and more serious look than it has yet received.

THE BACKGROUND SYMBOLISM OF *REBIRTH*

The drama of *Rebirth* takes place within a matrix of short black-and-white brushstrokes that convey the impression of a dancing molecular energy-field—the backdrop of the painting's action. Perhaps it is a symbol of formless Life—the seedbed of emergent life, the ultimate root of existence, or the Ground of Being. However interpreted, it is the container of the drama, *not the contained*.

Within this dancing matrix, the main drama of the painting occurs, confined within a black bone-shaped cavern. The choice of this symbolic shape may have been wholly unconscious on the part of the artist, yet it is intuitively accurate and rich in significance for the theme of the painting. Bones symbolize death, and the choice of black for the bone-cavern of *Rebirth* signifies the darkness into which death plunges us. The light of life has been extinguished.

With these two background symbols—a dancing matrix of unformed energy and a shape suggestive of death—Gaudnek sets up the drama that is the theme of *Rebirth*: LIFE VERSUS DEATH.

Bones are universally associated with death. "The experience of the present moment," says Rudolf Arnheim, "is never isolated. It is the most recent among an infinite number of sensory experiences that have occurred through the person's past life. Thus the new image gets into contact with the memory traces of shapes that have been perceived in the past."[10] To associate *Rebirth*'s bone-shaped enclosure with death comes naturally enough. Yet the symbolism of bones goes far deeper, as a cursory glance at Ezekiel 37 shows. Here men are raised to new life from their bones. According to Mircea Eliade, bones symbolize "the non-temporal source of Life. For the hunting peoples the bone symbolized the ultimate root of animal Life, the matrix from which the flesh

That strange precinct we call "art" is like a hall of mirrors or a whispering gallery. Each form conjures up a thousand memories and after-images.

E. H. GOMBRICH

To those who have the symbol the passage is easy.

MYLIUS

[10] Rudolf Arnheim, *Art and Visual Perception*.

THE ART

240

is continually renewed. It is starting with the *bones* that animals and men are re-born."[11] As the inner hidden and indestructible part of animals and men, bones represent seeds of regeneration. They symbolize a belief in resurrection. As Eliade also points out, in Eskimo shamanism and Tibetan Tantrism, contemplation of one's own skeleton is a spiritual exercise of the highest importance, because the ability to see oneself as a skeleton is basic to the mystical experience of death and resurrection. Again we see the artist's symbolic imagination is intuitively on target, conveying the idea of death *and* resurrection by means of a single symbol.

This bone-enclosure serves an additional purpose as the crypt or cavern within which the process of transformation takes place. It is here that the main drama of *Rebirth* occurs. Just as the caterpillar requires the chrysalis to incubate and become a butterfly, and a seed must be buried in the dark earth, hidden from the sun, to germinate and grow, initiation into new life and higher states of consciousness requires isolation in a dark place to unfold. Confinement, limitation, and darkness ever precede new life. Speaking of this mandatory *dark night of the soul,* Jung says:

> The cave is the place of rebirth, that secret cavity in which one is shut up in order to be incubated and renewed. Anyone who gets into that cave, or into the darkness that lies behind consciousness, will find himself involved in an—at first—unconscious process of transformation. By penetrating into the unconscious he makes a connection with his unconscious contents. This may result in a momentous change of personality in the positive or negative sense. The transformation is often interpreted as a prolongation of the natural span of life or as an earnest of immortality.[12]

Hence the drama seen in *Rebirth*.

Rebirth's background symbolism—an energy matrix surrounding a black bone-shaped cavern—provides the stage setting for a regenerative process pregnant with mystery and archetypal meaning.

[11] Mircea Eliade, *Myths, Dreams and Mysteries.*

[12] Carl Jung, *The Archetypes and the Collective Unconscious,* 135–36.

THE DWELLER ON THE THRESHOLD: THE BATTLE WITH EVIL

In the lower portion or nether region of *Rebirth*'s incubation cavern, we meet two fierce demonic creatures joined at the rear—hellhounds or demon dogs. By their fierce demeanor one can only imagine from what hellish depth of the psyche they were conceived and what soul-suffering may have accompanied their birth. In the context of *Rebirth*, these demonic apparitions represent all the dark, evil, and destructive forces of the underworld that engage the hero in fierce battle and over which he must triumph if spiritual victory is to be attained.

Hounds of hell are a common mythological theme. Hercules' twelfth and most difficult labor[13] required that he defeat Cerberus, the three-headed dog that guards the gates of Hades to ensure the living can neither enter nor the dead depart. The Greek name *Kerberos* means "demon of the pit." Cerberus's three heads symbolize man's threefold earthly nature.[14]

One evening, after several hours of contemplation of Gaudnek's *Rebirth*, I had a nightmare in which I was being pursued—hounded!—by a fierce invisible beast. There was a palpable sense of evil emanating from my pursuer, but I could not see the apparition that brought terror to my dreams. Suddenly I turned and hurled a blazing firebrand in the direction from which I felt my attacker. The firebrand found its mark, entered the monster's mouth, and lodged in his stomach, rendering my unseen pursuer with his internal fire a visible foe. At this point I awoke and realized I had been doing battle with one of the demon dogs of *Rebirth*. Some time passed, however, before it occurred to me that the ingenious method by which I located my foe had been suggested to my dream-mind by the smoke arising from the mouths of *Rebirth*'s dogs! The battle with evil—the

[13] Or the Tenth Labor, according to esoteric tradition, because it takes place in the tenth astrological sign of Capricorn, the sign of the initiate.

[14] Physical, emotional, and mental. At times Orthus, a two-headed dog, is a stand-in for Cerberus. Hercules is also said to have slain Orthus on entering Hades.

Hercules leading Cerberus to Eurystheus

cause of so much human suffering—is archetypal. So likewise is the use of Light to gain the victory.

We know evil exists. What it is and why, like Cerberus, it stands as the Dweller on the Threshold, blocking the advance of the hero striving for greater life and consciousness, needs further comment. Evil is that which is selfish, separative, divisive, that places material interests above spiritual values and weakens us by always following the line of least resistance. It is *anti*-evolutionary. It would turn back the clock and hold to a dead, outgrown past at all costs, opposing the progress of the soul, of humanity, and the Grand Plan revealed to archetypal vision. Referring to materialism, which had its proper place in the scheme of evolution but must now be outgrown, Djwhal Khul says, "Evil is that good we should have left behind, passing on to greater and more inclusive good."[15] And, "Evil is the guarantee of progress, the medium whereby evolution is possible, the great developer, the great purifier, the great educator, the great teacher. Evil and matter are but synonymous terms. Evil is the protecting shell that safeguards the delicate evolving entity."[16] And again, "The domination of spirit (and its reflection, soul) by matter is what constitutes evil."[17]

[15] Alice A. Bailey, *The Rays and the Initiations*, 350.

[16] Quoted in Mary Bailey, *A Learning Experience*, 60.

[17] Alice A. Bailey, *The Rays and the Initiations*, 144.

In the life of the aspirant to spiritual Illumination, as in the life of humanity itself, evil takes on the character of a gigantic thought-form which, esoterically, is called the Dweller on the Threshold.

> Much that is to be seen now of a distressing nature in the world can be directly traced to the wrong manipulation of mental matter by man. . . . The selfishness, the sordid motives, the prompt response to evil impulses for which the human race has been distinguished has brought about a . . . gigantic thought form hovering over the entire human family, built by men everywhere during the ages, energized by the insane desires and evil inclinations of all that is worst in man's nature, and kept alive by the prompting of his lower desires. This thought form has to be broken up and dissipated by man himself. . . . Under the Law of Karma it has to be dissipated by those who have created it.[18]

It is the individual's share in this evil, for which his soul bears karmic responsibility, that he must face on the threshold of initiation and that, as a would-be initiate[19] into the divine Mysteries, he must vanquish as his personal Cerberus or Dweller on the Threshold.

All this is symbolized by the demon dogs of *Rebirth*. To better understand these hellhounds, we return to Cerberus, whose three

[18] Alice A. Bailey, *A Treatise on Cosmic Fire*, 947–48.

[19] In this study of *Rebirth*, we enter for the first time into a discussion of initiates and the Path of Initiation. Some definition at this point will prove helpful. An initiate is one who has attained to a higher state of consciousness by virtue of having traveled further along the path of evolution than the ordinary woman or man. His intuition and spiritual faculties are rapidly unfolding and, as a consequence of undergoing an expansion of consciousness, his identity with his Divine Source is now a fact in his consciousness. Alice Bailey says, "The Path of Discipleship is a difficult one to tread, and the Path of Initiation harder still; an initiate is but a battle-scarred warrior, the victor in many a hard-won fight; he speaks not of his achievements, for he is too busy with the great work in hand; he makes no reference to himself or to all that he has accomplished, save to depreciate the littleness of what has been done. Nevertheless, to the world he is ever a man of large influence, the wielder of spiritual power, the embodier of ideals, the worker for humanity, who unfailingly brings results which succeeding generations will recognize." *Initiation, Human and Solar*, 103.

heads on one body symbolize the three aspects of man's earthly personality—his physical, emotional, and mental life. As man evolves, these become an integrated and functional unity and increasingly powerful for good or evil. It is at this point that a dividing of the ways takes place and a man either follows the left-hand path of evil or the right-hand path—the straight and narrow way or razor-edged path leading to Light and Life. It is only as one advances upon the Path toward initiation that the Dweller makes his appearance and must be vanquished. Until then, the ordinary man or woman is content to live the life of earthly experience, material acquisition, and worldly ambition, and evil per se does not present itself as the major challenge to the progress of the soul. All this changes as one strives for Enlightenment. The greater the emerging light of the soul, the darker the shadows cast by what stands in its way. The earthly personality in its three-fold makeup has a long history, one that includes greed, conflict, low desires, evil intent, deception, dishonesty, injurious and evil thoughts, jealousy, self-interest, and abuses of power and influence—and the list could go on. "The evil that men do lives after them," as Shakespeare said, and a time comes in the life of the soul when its past evil creations must be confronted, repudiated as unworthy of the spiritual man, and dealt a final death-blow. This is symbolized by Hercules smiting and killing the three-headed Cerberus.

The devil dogs of *Rebirth* serve several functions in the life of the spiritual aspirant. As hellhounds (the Dweller on the Threshold), they embody the sum of all the evil thoughts, desires, and actions of the man over his long history of incarnation.[20] They also represent the distorted shadow-side of reality—the Great Illusion that must be

[20] Long taught in Hinduism and Buddhism and a widely accepted belief among Jews in the time of Christ—a view he never challenged!—reincarnation was an accepted doctrine of the early Christian Church, expounded by the Gnostics and numerous church fathers, including Clement of Alexandria, the brilliant Origin (third century), and St. Jerome (fifth century). It was not declared a heresy until the Second Council of Constantinople in 553 CE. Reincarnation is still an accepted belief of two-thirds of humanity.

overcome. They stand as guardians of the Portal of Initiation, for it is their task to focus the problem of evil in our consciousness and establish a clear line of demarcation between good and evil, so that we are confronted with right choices and wise decisions. They also represent resistance and hindrances to our spiritual progress, so that we are forced to work out our problems, for nothing undesirable may enter with us into the spiritual realms. Nothing evil is permitted there.[21] Only one who is sufficiently purified and strong and ready to assume the duties and responsibilities of initiate life is permitted through the Portal of Illumination. Hence, the fires of suffering, which are also the fires of purification, burn deeply, as evidenced by the smoke emanating from the mouths of the hellhounds of *Rebirth*. The light of heaven burns also as the fire of hell. Nevertheless, the appearance of the Dweller in the life of a disciple is a positive sign, a sign indicating that he is approaching more closely the goal of his spiritual endeavors. Now he must take upon himself the karmic responsibility of rectifying the wrongs of his past and proving that he is worthy of the goal to which he aspires. Only then does the Portal of Initiation, the Gate to Light and Life, open to him. Only by vanquishing his Cerberus can he liberate the God of Fire—his imprisoned Promethean soul—long bound and suffering in the stony world of material darkness. Such are the lessons to be drawn from the fierce saucer-eyed devil dogs of Gaudnek's *Rebirth*.

As symbols of the Dweller on the Threshold, the hellhounds of *Rebirth* represent the initiate's battle with the evils of his own nature. This war within can be exceedingly fierce, and the outcome is not always clear. Victory is a determined choice, an act of will, not a given. The same applies today to humanity, viewed as the World Disciple standing before the dawn of a new age. Today we are locked in a battle between good and evil within our own nature. Yet, rather than looking within for the causes of the world's evils, we are prone to project the evils we see onto others, vilify them, and wage self-righteous wars against them, only adding thereby to the evil karma we must ultimately repair. The profound truths dramatized in Gaudnek's *Rebirth*

[21] The same idea is conveyed by the image of the Angel with a Flaming Sword standing guard between man and the Tree of Life at the center of Eden. The fire of the sword purifies and burns away all that is unwanted, while the sword cuts away the evil that cannot be permitted entrance into the Place of Perfection. See Genesis 3:24.

offer lessons not only for the soul of the individual but for the soul of humanity itself, assuming we hope as a race to tread the path of rebirth and witness a spiritual renewal that will change the destiny of our planet. Time and opportunity are ripe for such a rebirth. Which way will we choose to go? The ways of wisdom and the outcome of right choice are the overriding themes of Gaudnek's *Rebirth*. Art can teach deep wisdom and illumine dark corridors of the mind.

No human being is perfect. Those who pretend self-righteousness would do well to remember: "Nothing is hidden that shall not be revealed." On the spiritual Path we are forced to face ourselves again and again; and, in the process, we come to recognize our common frailties and the universality of human suffering. As expressed in *The Rules of the Road*, "Each sees and knows the villainy of each. And yet there is, with that great revelation, no turning back, no spurning of each other." Our task is to clean up our own mess, not judge others. By confronting our Minotaur, vanquishing our Cerberus, and achieving victory over our individual Dweller on the Threshold, we come to learn compassion for the weakness and suffering of others. We learn how truly difficult the path to victory is.

Nevertheless, evil has its place in the grand design, for it sets up the resistance against which we must push to progress toward higher states of being. Were there no evil, nothing to struggle against, there would be little incentive to progress. Evil also brings about crystallization and leads to a more rapid destruction of what has been outgrown and must be left behind. As Djwhal Khul tells us, "Students would do well to broaden their concept as to the purpose of evil and the place the evil forces play in the grand design."[22] Knowing the techniques whereby good is brought forth from evil is one of the mysteries the hero-initiate must fathom during his journey through the dark cycle or descent into the nether realms. In his future life of service to humanity as an Illumined One, transmuting evil into good becomes a large part of his service. It is during his own battle with evil—the Dweller on the Threshold, the devil dogs of *Rebirth*—that he learns how this is done.

[22] Alice A. Bailey, *A Treatise on Cosmic Fire*, 949.

THE CULTURE OF THE WILL OR
WAY OF ASCENT

Arising on the backs of the devil dogs, we see a column that forms a Way of Ascent between the nether regions of *Rebirth*, the home of the hellhounds, and the triumphant hero seen above. As we've noted, force concentrates itself through centering. The hellhounds of *Rebirth*, facing outward away from the center, represent a scattering of forces, a dissipation of energies. Eventual return to a state of chaos is the destiny of evil and all that refuses to evolve.

In the column resting on and ascending from the backs of the hellhounds, we have the opposite dynamic—an ingathering and conservation of force or energy, concentrated along a central axis or backbone. The column's ascent is driven by arrowlike fletchings that propel it upward and by the developing strength of the backbone in its ascent. These symbolize the strengthening willpower of the hero as he struggles against the forces of evil.

The *spiritual will* is the key to the Path of Return or Way of Ascent. Only by means of a highly developed will can the hero-initiate conquer the dark forces of his own nature, master himself, and triumph over the trials and temptations that beset him on every hand. This will is dual in nature. On one hand, it works to destroy all that hinders the hero's progress. Many of his past creations have become a prison from which he must now free himself. To be sure, it is a Herculean labor. On the other hand, his will becomes a creative building force. It must forge the Path of Return by transmuting the elements of his lower nature into those of the higher so the light, life, love, wisdom, and power of the Higher Self can circulate freely through his whole being.

Gaudnek has symbolized via the spinal column that concentration of strength and energy needed to rise above evil and journey back from the depths of suffering and darkness. To stand on the back of evil and overcome it is not for the weak or cowardly but requires the perfect concentration and self-mastery that, in due time, produces a Buddha, Moses, or Christ. The culture of the will is the great occult

principle[23]—the key that unlocks the doors to ultimate spiritual attainment. "All the wonders of magic are performed by Will, Imagination, and Faith" said the great mystic Paracelsus.[24] Within *Rebirth,* the spine of the hero symbolizes the concentrated, transmuting energy that characterizes his spiritualized, triumphant will. Without supreme self-mastery and a concentration of all one's forces, the Higher Self remains unrealized. This perfecting of the Self is the Great Work which, when accomplished, earns the hero the title of *a Son of the Sun.*

In man as in the Logos, will is the highest of his three divine principles—will, love-wisdom, and creative intelligence. It is the vitality of the will, circulating through the whole nature, that imbues it with life, producing stimulation, movement, and direction. At so-called death it is the will that abstracts the life force from the earthly vehicles that have become its prison and limitation, and it is the will that produces resurrection.

So how does *Rebirth*'s hero use the devil dogs, the forces of evil, to bring about a transmutation of his will-nature? As hinted earlier, our hero can lock up the forces of evil to his advantage by using them as a thrust-block or opposing force against which to exercise his growing willpower. He gets his push-off through conflict with what he must vanquish within himself, his own dark shadows.[25] The hero's inner

The will of God and the life of God are esoterically synonymous terms, and when the life aspect of an individual and his spiritual, selfless will are completely synchronized, then you have—in a human being—the full expression of divinity.

DJWHAL KHUL

[23] Roberto Assagioli's *The Act of Will* is probably the best contemporary book on the development of the will. Will is also associated with purpose and has far wider implications than self-evolution, to which it is vital. Alice Bailey hints at the broader will when she says, "The right direction of the will should be one of the major concerns of all true educators. The will-to-good, the will-to-beauty, and the will-to-serve must be cultivated." *Education in the New Age,* 19.

[24] Franz Hartmann, *Paracelsus: Life and Prophecies,* 117.

[25] Djwhal Khul writes, "The problem of evil, over which so many finite minds seek to exercise themselves, is but the Problem of contrast, the problem of opposites. . . . There can be no success, no victory, where naught exists to strive against; yet all is included in the One. Too much the thought exists that evil, or the power of evil, is but something with which we should have naught to do. Much you need—yes, need, brother of mine—to do with it if ever you want to know the power of good. Evil is but part of God, the power of involution, whereas you are all on the path of evolution." Quoted in Mary Bailey, *A Learning Experience,* 59–60.

battles are often fierce, even terrifying. He also attracts to himself the opposing forces of the unregenerate world by virtue of his refusal to compromise spiritual principles for worldly gain and acceptance. His uncompromising integrity is seen as a threat to those who can't measure up, and who may try to destroy him. Nevertheless, the more intense his struggles, the stronger and more spiritualized his will becomes. With each small victory, his will draws down more of the transmuting fire of heaven until nothing of an earthly nature can withstand it. "Only in the stress of circumstances can the full power of the soul be evoked. Such is the law," says Djwhal Khul. Here we have a demonstration of one technique by means of which evil is transmuted into good. "You will always get your push-off from evil," says Dion Fortune. "Every advance to a higher plane is a reaction to evil. . . . When you resist evil you lock up good, you lock up the force of good which holds the evil inert."[26]

The spine also represents a restoration of the cosmic axis lost in Pollock's art. "Hell, the center of the earth, and the 'gate' of the sky are . . . situated on the same axis," says Eliade, "and it is along this axis that passage from one cosmic region to another is affected."[27] By means of his will the aspiring initiate re-creates the cosmic axis that becomes his ladder of ascent, his means of escaping the evils of the underworld and achieving the victory of the higher life. A purified will is the *sine qua non* of spiritual rebirth. Its mastery constitutes training in the use of fire—purifying fire, transmuting fire, illuminating fire, destroying fire, and Divine Fire—for, indeed, "Our God is a consuming fire" (Heb. 12:29).

> *The Master Spirit needeth none*
> *Of brawny force to prove its skill;*
> *It hath the Secret of the Sun,*
> *That cosmic power, Magnetic Will.*
>
> F. Channing Haddock

[26] Dion Fortune, *The Cosmic Doctrine*, 14, 16.

[27] M. Eliade, *The Myth of the Eternal Return*.

THE SUNFISHMAN AND THE NIGHT SEA JOURNEY

Finally, we come to our hero. At a quick glance the central figure of *Rebirth* evokes, strangely enough, memory traces of a fish skeleton —a bony spine surmounted by a fishlike head. When this curious image is allowed to play upon our imagination and sink into our psyche, we see once again that the artist's intuition has hit upon the appropriate archetypal theme, that of the Night Journey Under the Sea. According to this myth, each evening at sundown the sun takes the form of a fish and journeys beneath the night sea from West to East, reappearing the following morning reborn once again as the sun. At other times the myth becomes that of a fire carried in the belly of a whale. The night sea journey symbolizes regression into the watery womb of the Ocean Mother to be incubated and reborn. As the watery depths are the natural home of the fish, it is an appropriate symbol of the Self exploring the dark, hidden reaches of the psyche. It is also the story of the soul incarnate in and journeying through the night sea of material existence, and of the hero's journey into the dark abyss on his way to rebirth.

There are treasures in darkness.

ISAIAH

The fish . . . is the reborn one, who is awakened to new life. With the rising of the reborn sun the fish that dwelt in darkness, surrounded by all the terrors of night and death, becomes the shining, fiery day-star.

CARL JUNG

Hercules' Night Sea Journey in the Vessel of the Sun

In *Rebirth* the fish-head indeed becomes a radiant rising sun sending forth streams of light surrounded by a halo. Since we must resort to poetry to speak of art, I shall call our hero the *Sunfishman*. After journeying through the depths of hell and enduring the dark night of the soul, he has become a radiant resurrected Son of Light, an Illumined One. We encounter a similar idea in Grünewald's Isenheim altarpiece, *Resurrection* (plate 17). A similar dialectic is at play. Here the risen Christ is portrayed as a sun god, his head morphing into a glorious sun set against a star-studded night sky. The fish is, of course, a symbol for Christ, representing as it does *buddhi* or Christ-consciousness. To this day, the bishop's miter retains the shape of a fish-head. In Hindu art Vishnu, in his first incarnation as the fish Avatar Matsya,[28] is depicted emerging from the ocean carried in the mouth of a giant fish and delivering the Vedas to the people (plate 18). The Babylonians also had their fish-man, Oannes, bringer of wisdom and the civilizing arts. By day Oannes lived among men, retiring at night into the depths of the sea. The hero or avatar, depicted as both fish and life-giving sun, is a universal archetype associated with the theme of rebirth.

The nature of the Hidden Wisdom or Secret Science that the Sunfishman discovers on his night sea journey is, of course, a Knowledge available only those who have made the journey. But certain things we do know: One must first lose oneself in order to find oneself. Supreme self-sacrifice is involved. And when his journey is over, the hero-initiate lives no longer for himself but for others and for all who undertake the initiatory journey into the depths in search of the One Reality hidden under the veil of darkness. This hidden Wisdom is the Treasure of all treasures—the priceless Pearl for which all else is eagerly sacrificed. Initiates are so profoundly transformed

[28] The Bhagavata Purana narrates the following: "Long ago, when life first appeared on the earth, a terrible demon terrorized the earth. He prevented sages from performing their rituals and stole the Holy Vedas, taking refuge in a conch shell in the depths of the ocean. Brahma, the creator of the world, approached Vishnu for help and the latter immediately assumed the form of a fish and plunged into the ocean. He killed the demon by ripping open his stomach and retrieved the Vedas."

by what they discover that their lives thereafter are lives of compassion spent teaching, healing, serving, and guiding others along the Path leading to the Great Mystery. They become the Way-Showers of humanity. "The spiritual and divine worlds are hidden within us," says I. K. Taimni. "It is these which constitute the real world which all great spiritual Teachers invite us to enter."

THE MARRIAGE OF WATER AND FIRE

The union of opposites, fire and water, seen in the Sunfishman introduce us to one of the fundamental mysteries of transformation. Divine Fire is the eternal Spirit-Essence, the One Reality—the Creator, Preserver, and Destroyer of all that is manifest. Water symbolizes Matter, the Primordial Substance, the One Element, Swabâvat in its manifest state.[29] During any cycle of manifestation the interplay of the two poles of Spirit-Matter accounts for all that comes into being—all life, seen and unseen. Hence, all that exists is produced by the marriage of water and fire. When we find in a profound symbol such as *Rebirth*'s Sunfishman a marriage of water and fire, we are compelled to explore more deeply the significance of this union of opposites. To us, water and fire seem natural enemies. Water puts out fire, and fire causes water to become steam and evaporate. Each cancels out the other. So what can we mean by their "marriage"?

To focus the issue, we turn to the current debate over evolution. The dispute between biological evolution and de novo divine creation misses the profound truths veiled by evolution. The early church father Clement of Alexandria said, "God works all things up into that which is better." Evolution, in all its infinite variety and innumerable stages of life, seen and unseen, material and spiritual, is the effect of the interplay of Spirit and Matter, giving rise to a vast hierarchy of lives, a Great Chain of Being. Life exists far below us and infinitely above us. We are not alone.

A common household item may serve to illustrate the principle of evolution. The ordinary lightbulb contains a filament that gives off

Without the divine Water, nothing exists.

ZOSIMOS

The knowledge of Fire . . . leads to the attainment of Heaven.

KATHA UPANISHAD

This water endures throughout eternity. It reaches every corner of this world and is the Water of Life which penetrates beyond death. . . . It is found also in the body of man and when he thirsts for this water and drinks of it, the Light of Life shines in him.

JAKOB BÖHME

[29] See page 205

The marriage of water and fire. The four arms of each represent the innumerable interactions of water and fire, Matter and Spirit.

light as electricity is passed through it. A rheostat that controls the flow of electricity will increase the brightness of the light in direct proportion to the increase in electricity passed through the filament. In place of the lightbulb in this analogy, take any vehicle of manifest life—an atom, a plant, an animal, a man, a Buddha, or a solar system—and substitute Spirit for electricity, and you have the key to evolution. The magnitude of the flow of Spirit through the medium of any manifest life determines its place in the vast scale of evolution. As the flow of Spirit increases, the life within the form ascends the evolutionary ladder. *The play of spiritual Life through manifest forms is the cause of all evolution.* The Breath of the One Life is the driving force that compels all lives to advance, and the laws that govern the interplay of Spirit and Matter are the governing laws of evolution. Consciousness itself is a product of this fusion of Spirit and Matter. As the spiritual life unfolds, the light of consciousness increases, eventually bringing about in man that state of being called Enlightenment. Energy follows thought and builds accordingly. Likewise, all manifest forms follow the evolution of the indwelling

consciousness and undergo transmutation accordingly. Succinctly stated, biology follows psychology. Form reflects the evolution of the indwelling soul. As Corinne Heline notes, "The spiritualization of the mind is the pivot point of the entire scheme of evolution." The aim of meditation and of many of the spiritual practices of humanity is to bring about a greater inflow of spiritual life, which is tantamount to turning up the rheostat so that the Light of the One Life can shine more brilliantly through man and the manifest worlds. The earth is a star in the making. The aim of evolution is the gradual adaptation of Matter to the requirements of Spirit so that the One Life, veiled by material darkness, can begin to shine through and reveal Itself. Evolution and revelation are therefore interdependent and companion processes. Too much light too soon would only produce blindness. As humanity advances, the light needed to guide the way forward is always forthcoming. With each new revelation of the divine, the light needed for humanity's next push forward is presented in a living form. This interplay of Spirit and Matter constitute the marriage of water and fire.

On the spiritual Path, bringing about a marriage of water and fire is one of the tasks the hero-initiate must deliberately undertake. The success of such an endeavor is exemplified in *Rebirth*'s Sunfishman. As one "born of water and the spirit," the hero-initiate of *Rebirth* has achieved his goal and undergone a spiritual Rebirth upon a higher plane of being. We should remember that Life *is* Fire—the Builder, Preserver, and Destroyer of the cosmos. Spiritual Fire is the supreme Creative Power of which visible fire is but a dim reflection. Evolution is the gradual and progressive transmutation of the vehicles of life and consciousness under the steady impact of fire upon them. Every manifest form, whether that of an atom, a plant, an animal, a man, a planet, or a solar system, is subject to these creative, transmuting fires. It is perhaps no accident that the planet is getting warmer just as humanity is on the verge of a great spiritual awakening and transformation. All transmutations are accompanied by an increasing sensitivity to fire itself—hence the acceleration of the evolutionary process seen as life

advances to ever-higher stages. The reason for this is that as Matter is refined and purified by fire, its *resistance* is diminished, and the fires of life circulate ever more freely. Herein lies one of the keys to understanding the hero or spiritual man.

The hero hastens his own evolution by using his potent will to invoke and draw down the divine transmuting fires, passing them through his earthly vehicles at an accelerated pace the ordinary woman or man could scarcely withstand. Yet, as is the case with all men, his earthly nature still offers resistance to the divine fires, and the passing of spiritual fire through his vehicles meets with resistance at the same time it burns away obstructions at an accelerated pace. Hence the greater measure of suffering often seen in the lives of heroes. Suffering is always produced by resistance in some form. For this reason the Path of the hero-initiate is called the Burning Ground, as it is a path fraught with much suffering. Yet it is the will of the initiate that is the true burning ground, bringing forth the fires of purification to which he subjects himself. In *Rebirth,* the hellhounds represent the profound suffering undergone by the Sunfishman. The smoke belching from the mouths of the demon dogs hints of the fires of his inner suffering, the fires of hell he endures during his sojourn through the underworld.

If the lives of heroes and initiates are seen to partake of greater suffering than that of the common lot of mankind, we should remember it is a suffering *they chose and accept* to hasten their own evolution and bring about a more rapid spiritualization of their earthly nature. This they do for no selfish purpose but to be able the sooner to pass spiritual power through themselves for the healing and transformation of the world. They sacrifice themselves for the good of humanity. They suffer so the Light of Life itself can shine through them and illumine the Way for others. They are a Light shining in a dark world.

We see now that evolution is a slow, steady spiritualization of Matter that makes possible a fuller expression of divine life and consciousness. Such is the nature of the Divine Unfolding. When

our earthly vehicles become adequate conduits of spiritual energy, no longer setting up resistance to the expression of the Divine Life within, then we have that marriage of water and fire—that blending of Matter and Spirit—through which a Divine Life on earth finds expression. When this happens we get a hero-initiate, a Sunfishman, a Christ, or a Bodhisattva. In them the purely human stage of evolution is transcended, and they go forth as representatives of the next higher kingdom in nature, the spiritual kingdom, whose Initiates, Sons of Wisdom and Avatars, walk among us from time to time. Of these, *Rebirth*'s Sunfishman is an archetypal symbol. The hero-initiate is one who takes upon himself a measure of the world's suffering so as to undergo a more rapid training and preparation for a life of selfless service, which it is his will to render for the sake of a suffering world. He is seen typically as one out of step, but such are the Healers of humanity. "The REBELS are our saviors," says H. P. Blavatsky. "Let the philosopher ponder well over this, and more than one mystery will become clear."[30]

DEATH AND TRANSFIGURATION

Our attachments hold us like a vise. Anyone aspiring to the lofty heights of spiritual transformation or rebirth must pass through the stages of letting go of all that anchors the soul to earthly existence. This doesn't mean one must live in poverty, for all things, even wealth, can be turned to spiritual service. Nor does it mean one doesn't go on loving others. Indeed, love for all is the supreme goal for all. What we must let go of is desire and attachment. To be free, we must die to the chains that bind us. "The Kingdom of God is for none but the thoroughly dead," Eckhart said. With spiritual death, said B. Valentine, "the soul does not cease to live: it goes on to live with the purified body illuminated by the fire, in such a way that soul, spirit, and body illuminate one another with a celestial clarity, and are so embraced that they can never again be separated."[31]

Note that the Sunfishman of *Rebirth* has no body. His form-nature

How is that we have walk'd thro' fires & yet are not consum'd?

WILLIAM BLAKE

[30] H. P. Blavatsky, *The Secret Doctrine*, vol. II, 103.

[31] Quoted in Julius Evola, *The Hermetic Tradition*, 163.

has been transcended, symbolizing a relinquishing of all earthly attachments and identifications. He is now dead to that which served him on his long journey toward Enlightenment. All that remains are the symbols of his transfiguration.[32] His earthly life, with its long bitter struggles, has been left behind, replaced now by his Triumphant Will and Radiant Spirit. Another seldom-realized mystery is also veiled here.

In the course of our earthly journeys, we gradually master our physical, emotional, and mental vehicles, then merge these with the light of the soul, giving birth to the soul-infused personality. Then comes another, higher transformation. "The metamorphosis once seen, we divine that it does not stop," Emerson said. Once mastered, the soul-personality functions automatically. The initiate may still serve the world through his earthly vehicles, but these have now dropped below the threshold of his consciousness. They no longer command his attention. Right action and right response to circumstances have become innate and automatic. We may liken this to a pianist spending years diligently practicing and mastering the keyboard. Once mastered, with great pianists such as Arturo Michelangeli, Claudio Arrau, and Garrick Ohlsson, the acquired facility falls below the threshold of consciousness and becomes as automatic as breathing. The music itself is then their sole focus of attention. At every level of evolutionary unfoldment —physical, emotional, mental, and spiritual—acquired powers, once mastered, function spontaneously. The fact that the Sunfishman of *Rebirth* no longer possesses a physical vehicle merely tells us that he has mastered and transcended his earthly nature. At Transfiguration, the personality as a separate entity disappears, and the Spiritual Man in all his glory begins to shine forth. His spiritualized will now implements

[32] Transfiguration has been defined as "that stage upon the Path of Initiation wherein the third initiation is undergone, wherein the personality is irradiated by the full light of the soul and the three personality vehicles are completely transcended; they have become simply forms through which spiritual love may flow out into the world of men in the salvaging task of creation" (Alice A. Bailey, *The Rays and the Initiations*, 278). Again: "*Transfiguration* concerns the life of the Spiritual Triad [Spiritual Will, Love-Wisdom, and Creative Intelligence] upon its own three levels of identification" (Ibid., 280).

his purposes, determines his motives, and guides his creative activities, while the Light of Life shines through him to tells us he has found and united himself with the Supreme Self, Ātmā, the Monad, or Spirit of Life that had been veiled through long aeons by earthly existence. Having seen the Father, his sole interest now is serving the purpose of the Logos. He lives to implement the plans that lead to the fulfillment of Divine Purpose. His triumphant will and the Light of Life now shining through him are the instruments he uses in his service to humanity.

Was Gaudnek aware of the depth of his symbolic vision? Not likely. But we're told that the soul faces in two directions simultaneously— toward the earthly personality during its evolution and toward the eternal Spirit, which is its Source. When an artist allows himself to be an instrument of his soul, art has power to reveal eternal truths.

The Sunfishman or hero-initiate also serves others by being what he is—a source of Light and Life in the world. Having pierced the veil of darkness that hides the Divine Life from the eyes of ordinary men, the initiate must demonstrate the laws of radioactivity through his own being on the physical plane. He does this by allowing the Light of the spiritual worlds to pass through him.

Radioactivity is a bridge of fire over which the energies of life travel between adjacent kingdoms in nature. It is always found at the boundary where two kingdoms verge on each other and is seen as the magnetic lure of the higher kingdom for the lesser. When a center of life in any one kingdom reaches a high point of evolution, it begins to feel the attractive pull of some center in the next higher kingdom. Once the two centers become attuned to each other, an interplay and exchange of energies begins taking place, with the higher center acting as a stimulating and energizing force, hastening the evolutionary unfoldment of the lesser life. In due time, because of the quickening of life within it, the vehicle of manifestation of the lesser life is felt as a prison and a limitation and is shattered, releasing the indwelling life. The liberated life is then drawn into the orbit of and acquires some of the potencies of the higher life-center. Radioactivity opens a channel or passageway between greater and lesser centers of life and power. As this occurs, the lesser lives in

their turn become supercharged and act as potent stimuli and liberating forces in other lives they contact. Hence the fiery destructive impact of radiation on all forms exposed to it, even as the inner life is stimulated and hastened in its evolution. Every such release of energy is a liberating fire that lifts the tide of evolution a little higher. With each advance, the imprisoning forms must be shattered and transcended. Radioactive stimulation produces in a short amount of time the same results evolution produces more slowly, aiding and accelerating the evolutionary process.

We can draw a parallel to this radioactive process in the spiritual life of humanity from the teachings of Christianity, familiar to most Westerners.[33] According to Christian tradition, following the Crucifixion and Resurrection, Christ ascended to the Father—a statement veiling a profound and little-understood truth. The Ascension, symbolizing the fusion of Christ-consciousness with the Eternal Spirit or Father in heaven, was accompanied by a stupendous release of energy from the highest spiritual levels of our planetary life, resulting in a new inflow of spiritual forces into the world for the hastening of the world's evolution. With the Ascension, Christ's disciples—the "electrons" held within the orbit of his spiritual influence—scattered, each supercharged with new spiritual energy received via the new influx of Divine Life. They, in their turn, like freed electrons, unleashed potent spiritual stimuli in the ancient world—stimuli that contributed to the destruction of the old order and gave rise to a new. Every great spiritual teacher releases new energies into the world, repeating this radioactive process and adding to the stimulating stream of liberating energies that guides the evolution of humanity and all subhuman kingdoms.[34] These teachers build the bridge between humanity and the next higher

[33] The same teaching is found in many forms in other world religions, in Alchemy, Gnosticism, Neo-Platonism, and so forth. We choose Christianity because of the familiarity of its symbolism.

[34] The ancient practice of darshan in India is based on this principle. Simply by sitting silently in the presence of a Self-Realized Teacher, one absorbs spiritual force emanating from his being. In darshan there is a flow of power from guru to recipient that fosters spiritual growth. Sri Ramana Maharshi was a major practitioner of darshan.

kingdom—the spiritual kingdom.[35] During the coming age we shall see this process greatly accelerated with the coming forth, as in ancient times, of many advanced spiritual teachers.[36] "The time has come for the great awakening," says Djwhal Khul.

Rebirth's Sunfishman, symbolizing a liberated Son of Light, has become radioactive. Contact with the spiritual dimensions of his Being has rendered him a transmitter of spiritual energy and Light, as shown by the light rays emanating from his head. The fires of suffering below have undergone transmutation and become the radiant Light of Spiritual Being above. He who descended into the night sea, who dwelt in darkness, who suffered the agonies of hell, has been transfigured. Dead now to his lower nature, he has become a Light-Giver and a Way-Shower, a Guardian of Truth and a Fiery Son of the Sun. Through him new spiritual energies can now enter the world for the world's transformation.

SELF-REALIZATION: SONS OF FIRE AND LIGHT

We come now to the mystery of That which shines *through* the Sunfishman—the Source of the Light of Being. Needless to say, we are approaching subjects that transcend human comprehension. Yet

[35] In like manner, humanity stimulates the subhuman kingdoms. Our magnetic influence is felt especially by the animal kingdom and by domesticated animals in particular. The same radioactive principles are at work, hastening the evolution of the lesser kingdoms. This is the meaning of Genesis 1:26 where man is given dominion over all the lesser kingdoms of life.

[36] In the eighth century BCE, the prophet Isaiah came forth proclaiming the message of a coming Messiah. A century later, within a space of fifty years, the forerunners of five of the major world religions made their appearance: Zoroaster, Lao-tzu, Mahavira, Confucius, and Buddha, as well as the greatest of the Greek philosophers, Pythagoras. In an essay on Pythagoras, Edouard Schuré noted this convergence in time of so many great teachers: "It is not by chance that these reformers appear at the same time among so many different peoples. Their various missions were united in a common goal. They prove that at certain times a single spiritual current mysteriously passes through all mankind. Where does it come from?—From that divine world which is beyond our sight, but whose seers and prophets are its ambassadors and witnesses" (*The Great Initiates*, 269–70).

You have learned, my son, the way of Rebirth. . . . You have been born a God and a son of the One, as I am myself.

HERMES TRISMEGISTUS

[37] Consisting of earthly personality, immortal soul, and eternal Monad or Spirit.

the very effort to imagine transcendent states of Being leads toward their eventual, if distant, attainment. As Oscar Wilde said, "To think a thing is to cause it to begin to be."

Wherever light appears, it must have an emanating source, and this is as true of Spiritual Light as of the light from a candle or the sun: As below, so above. What is the Source of the Spiritual Light that shines through all great spiritual teachers and Sons of Wisdom? What is the Source of the Light shining through our symbolic Sunfishman?

The soul or middle principle of man's triune nature[37] is the seat of consciousness. When the light of the soul illumines the mind, we gain access to the world of meaning and are able to discern and interpret the meaning of experience. Like all else, light unfolds progressively until we stand at last in the Spiritual Light of Being Itself.

There is an illuminating passage on the theme of light in the teaching of Djwhal Khul.

It must ever be borne in mind that the great theme of LIGHT underlies our entire planetary purpose. The full expression of perfect LIGHT, occultly understood, is the engrossing life-purpose of our planetary Logos. Light is the great and obsessing enterprise in the three worlds of human evolution; everywhere men rate the light of the sun as essential to healthy living; some idea of the human urge to light can be grasped if you consider the brilliance of the physically engendered light in which we live when night arrives, and compare it with the mode of lighting the streets and homes of the world prior to the discovery of gas, and later of electricity. The light of knowledge, as the reward of educational process, is the incentive behind all our great schools of learning in every country in the world and is the goal of much of our world organization; the terminology of light controls even our computation of time. The mystery of electricity is unfolding gradually before our rapt eyes and the electrical nature of man is being slowly proven and will later demonstrate that, throughout the human structure and form,

man is composed primarily of light atoms, and that the light in the head (so familiar to esotericists) is no fiction or figment of wishful thinking or of a hallucinated imagination, but is definitely brought about by the junction or fusion of the light inherent in substance itself and the light of the soul. . . . It will also be shown that the soul itself is light, and that the entire Hierarchy is a great centre of light, causing the symbology of light to govern our thinking, our approach to God, and enabling us to understand somewhat the meaning of the words of Christ, "I am the Light of the world." . . . The theme of light runs through all the world Scriptures, the idea of enlightenment conditions all training given to the youth of the world . . . and the thought of more light governs all the inchoate yearnings of the human spirit.

We have not yet carried the concept up to the Centre of Life where dwells the Ancient of Days, the Eternal Youth, the Lord of the World, Sanat Kumara, Melchizedek—God. Yet from that Centre streams what has been called the Light of Life, the Light Supernal. These are empty words as yet until we know, as trained initiates, that light is a symptom and an expression of Life, and that essentially, occultly and in a most mysterious way the terms, Light and Life, are interchangeable within the limits of the planetary ring-pass-not. Beyond those limits—who knows? Light can be regarded as a symptom, a reaction to the meeting and consequent fusion of spirit and matter.[38]

The light that shines through *Rebirth*'s Sunfishman is Monadic light. At the Transfiguration, for the first time, the initiate makes direct contact with the Monad, Ātmā, the Supreme Self, the Father in heaven, and a line of Living Light or Electrical Fire is established between the Monad and the man in incarnation. A light then shines forth. It is this Light that irradiated the face of Moses as he descended Mount Sinai, which shone in the face of Christ at the Transfiguration, and which enlightened the Buddha. Transcending anything properly called *consciousness*, it represents a state of being of which the human mind

By knowing Him who alone pervades the universe, men become immortal. . . . He is the Ruler and the Light that is imperishable . . . the inner Self, ever seated in the heart of man. . . . That Supreme Self is Fire . . . brilliant like the sun.

ŚVATĀŚVATARA UPANISHAD

[38] Alice A. Bailey, *The Rays and the Initiations*, 142–43.

THE WAY OF
THE TRANSFIGURED LIFE

263

knows nothing and that even the highest intellect cannot grasp.[39] Only when *buddhi* or spiritual perception, also called Christ-consciousness, develops is it possible to contact the Logos of the world.

When ready, having met all tests and requirements preparatory to Transfiguration, the initiate is confronted by the One Initiator, the Ancient of Days, the Lord of the World "in Whom we live, and move, and have our being." We're told "we stand where the One Initiator is invoked, when we see His star shine forth"—a brilliant point of light that breaks suddenly into consciousness. It represents a first direct contact with the Monad, Ātmā, and for the first time the initiate is shown the purpose for which the Logos brought forth our little "star of suffering"—the name given to our earth in higher realms.

This moment of attainment is the result of heroic effort and long exercise of an indomitable will. Heaven is taken by storm. The initiate is often compared to a warrior or knight engaged in battle. Note again the spinal column in *Rebirth,* which symbolizes the triumphant will of the Sunfishman. It denotes single-minded concentration, heroic conflict, and an unalterable will.

The Light of Being shines through when the initiate has attained *yoga* or *union* with his Eternal Self, the Monad. With Christ, he can then say, "I and the Father are one."[40] This state of Being, of union with the Eternal Source, can only be hinted at by the inadequate word *Identification.* The initiate no longer sees himself as having any separate existence; he is one with the Whole, inseparable from all that lives. Having realized his identity with the Whole, the Light of Life Itself now shines through him. He now knows that both identity and

[39] Swami Nikhilananda says, "In the Western world a student of philosophy is expected to cultivate truthfulness about facts and intellectual integrity, his aim being to acquire knowledge. But the goal of a student of Indian philosophy is not only to know Reality but to realize it and mould his life according to Reality" (*The Upanishads,* vol. II). In the Māndukya Upanishad, Enlightenment is described as *turiya,* a state of Pure Consciousness identical with Atma, a state of Pure Being. It is a state of *Be-*ness rather than a state of consciousness as we know it.

[40] John 10:30.

identification are eternal. Separateness is but an illusion of the senses, of space and time—an illusion the initiate has overcome.

When the initiate stands for the first time before the Lord of the World and sees his star shine forth, Djwhal Khul tells us:

> For the first time the expanded consciousness of the initiate can contact . . . the Lord of the World . . . bringing something new and different into his equipment, into his nature and his consciousness. . . . It is a blinding conviction of an unalterable will, carrying all before it, oblivious of time and space, aware only of intensity of direction, and carrying with it two major qualifications or basic recognitions to the initiate: a sense of essential being which obliterates all the actions and reactions of time and space, and a focused will-to-good which is so dynamic in its effect that evil disappears. Evil is after all only an appalling sense of difference, leading inevitably to separative action. The dualities are then resolved in synthesis.[41]

Even beyond this, vast stages of Expanded Being leading onto Cosmic Paths, known as the Way of Higher Evolution, extend well beyond humanity and our little earth. Even for Christ and Buddha there are further states of Being yet to be unfolded.[42] Transfiguration, the stage symbolized by *Rebirth*'s Sunfishman, represents the beginning of the end of the purely human stage of evolution and the unfolding of divine creative powers. The Infinite Unfolding is without end. All we can do is stand in awe as we contemplate the infinite reaches ahead and the cycles of eternity available to us. Can Life die? Never.

The Sons of Fire and Light are those who have attained some measure of monadic identification, who have taken heaven by storm. It is by means of their fiery will that they have attained such glorious heights. Their reward is the Light of Being itself. Once acquired, the technique of light becomes a permanent acquisition, and whatever the initiate wishes to know can be discovered merely by focusing the light within himself along the desired line of investigation. This acquired Light progressively reveals the significance of Life and the purpose

[41] Alice A. Bailey, *The Rays and the Initiations*, 175–76.

[42] "It would be well to point out here that beyond the stage of illumination, as it can be achieved by man, lies that which we might call the unfoldment of divine *Insight*." Alice A. Bailey, *Esoteric Psychology*, vol. II, 239.

of Light itself. Moreover, once monadic contact is made, the initiate's focus shifts away from the world of effects to the world of causes. He no longer concerns himself with the world of effects, knowing that *by setting right causes in motion right results are inevitable.* He becomes a worker in causal realms. These few hints tell us something of the profound transformation the initiate has undergone.

Rebirth's Sunfishman demonstrates that we are Creative Gods-in-the-making. This he does by discovering and drawing upon divine creative powers hidden in the deepest, darkest recesses of his being and using them to bring about profound Self-transformation—a creative act of the highest order. As if by divine magic, he brings life out of death, light out of darkness, good out of evil, triumphs over suffering, and unites himself with his Eternal Source. Only gods possess such creative powers. That the Sunfishman *always* possessed these divine powers is proven by the fact that he found them, not outside himself, but buried deep in darkness within his own being where, for untold ages, they lay unawakened awaiting a demand for their unfolding. To seek the priceless pearl, the Holy Grail, the treasury of wisdom outside oneself is to seek it in vain. Only at the unseen center of the circle does the finite meet the Infinite. At the deep center of his own Being, a center unnoticed by those who see only the outer appearance of things, the Sunfishman discovered the divine creative powers by means of which he transformed himself from a mere mortal into a living God. All powers remain dormant until demands are made that call them forth. *Rebirth* shows us the method and process of Awakening. The Sunfishman shows us the destiny of all who seek the Source of Life within.

And what is this creative power but Divine Fire itself? We are indeed Flames of Living Fire. How else could a Light shine forth from within when all worldly obstructions are eliminated from our lives? In *Rebirth,* this inner light is first obscured under the guise of the fires of hell carried by the demon dogs. One of the ingenious compositional elements of *Rebirth,* brilliant for its sheer simplicity, is that of the smoke that emanates from the mouths of the hellhounds and rises up to encircle the head of the Sunfishman, integrating its drama, unifying

Hermes Trismegistus: The fires of transmutation above and below

opposites, and symbolizing the fires of transmutation. In its ascent, the smoke becomes a radiant aura of light surrounding the head of the Sunfishman. Smoke, a maya that once obscured our sight, has now become the light of illumined vision. With this simple shorthand, Gaudnek has chronicled the pilgrimage of fire in the life of an initiate. Such is the journey of those wise sons born of Light and Living Fire.

NEW BEING AND THE LAW OF SACRIFICE

We come now to the New Life seen in the upper portion of *Rebirth*. To the left and right of *Rebirth*'s Sunfishman are two infants—one fluid, feminine, lunar, and receptive, the other solar, masculine, dynamic, and active. Evidence of the new life born of self-sacrifice, these infants also represent a new beginning on the Path of Self-unfoldment and embody the principles of water and fire, which, as we've seen, must be reconciled on the Path of Initiation. Facing toward the Sunfishman, they

Life can only take birth from another life which is sacrificed. . . . Death is creative—in this sense, that the life which is sacrificed manifests itself in a more brilliant form upon another plane of existence.

MIRCEA ELIADE

Achievement is ever followed by sacrifice and the giving of the greater for the lesser. This is an aspect of the Law of Evolution.

DJWHAL KHUL

are magnetically drawn to his spiritual life and radiance. Intuitively, if unconsciously, they recognize in him their destiny. They are now his charge—younger souls the Sunfishman is responsible for guiding on their long spiritual journey toward Self-Realization. What they are, he once was. What he is, they too will become in some distant future. As one who knows the Way, it is his duty now to serve as the Way-Shower.

Rebirth's infants are symbols of all younger souls as yet far from Self-Realization—symbols of humanity—and the Sunfishman stands as a symbol of all enlightened spiritual teachers—Hermes, Pythagoras, Buddha, Lao-tzu, Moses, Christ, all Bodhisattvas, Masters of Wisdom, and Sons of Light whose spiritual will and chosen path is to guide humanity toward its divine destiny. No longer bound by the constraints of space and time, they guide their progeny with an awareness rooted in the Eternal Now that sees the Plan of the Logos in its fullness. They waste no time or energy, yet all is permitted to unfold in accord with Karmic Law and the Grand Design.

The Law of Evolution is the means by which the Will of the Logos is worked out in space and time, while the Law of Karma links all lives together in mutual responsibility. And the Law of Sacrifice determines that those who are more highly evolved shall give of themselves to advance the evolution of the lesser evolved. Of this, the Divine Sacrifice in space and time and the self-sacrifices of all gods and heroes are an archetypal symbol.

The mystery of sacrifice is seldom understood. We think of it as a giving-up of something we cherish, our time, perhaps even our lives. We view sacrifice as loss, whereas in truth it is a joyous taking-on of responsibility toward others, especially younger souls. An aspect of the will to live, it aims at bringing "life more abundant" to all lesser lives. It involves recognition, through identification with the soul in all forms, of the divinity deeply hidden and imprisoned in form and matter, accompanied by a resolve to aid the liberation of these imprisoned lives. It hears the invocative, if inchoate, appeal of those lesser lives for more life, more light. It wills the sacrifice of self-interest for the

larger interests of the Whole. The rewards of sacrifice are the rewards of lifting other lives higher in the scale of evolution, of liberating what is imprisoned, and of serving the Purpose of the Logos—the profound Mystery that motivated the Lord of the World to assume manifestation in our little globe.

It takes little thought to realize the connection between the Law of Sacrifice and the Law of Radiation. By means of wise stimulation that takes into account the point of evolution of each lesser life being aided, the Great Ones slowly and carefully guide "the little ones" along the path of life and light until they too can stand on the mountaintop of Illumination. Such is the responsibility of the Sunfishman of *Rebirth* toward the infants drawn into his aura and orb of influence. He and they together demonstrate the unity and interdependence of all lives.

How little we realize of our true destiny. Lost in darkness, wandering in the labyrinths of earthly life, imprisoned by our fear of death, we fail to focus on what is of greatest importance—the Divine Center hidden within ourselves and in others. The value of a work of art such as *Rebirth* is that it calls us back to what is truly important, reveals to us our hidden potential and true identity, and shows us a Path leading to Self-Realization. The greatness of *Rebirth* lies in showing us that we are Creative Gods-in-the-making *destined to transform the world*.

The Creative Promise of the Coming Age

The past is but the beginning of the beginning, and all that is and has been is but the twilight of the dawn. A day will come when beings who are now latent in our thoughts and hidden in our loins . . . shall laugh and reach out their hands amid the stars.

H. G. WELLS

Blessed are they in this day and time who seek to become the pioneers of the new way of life.

HOWARD JOHN ZITKO

We are living in the time of the transition. All history up to this point has been winter. Now spring is coming for sure.

OSCAR ICHAZO

The earth too is a star, and man, potentially at least, is a divine creator.

ERICH NEUMANN

17 Unlikely Heralds of Spiritual Rebirth

The clarification of an overconcept large enough and vital enough to impel the unfolding of human potentials is of primary importance. Mortal progress is dependent upon immortal ideas.

MANLY P. HALL

People lose their bearings, and rush down blind alleys, seeking escape. Greater souls detach themselves from life; still greater souls try to transfigure life into something higher than mere life as we know it on Earth, and sow the seeds of a fresh spiritual advance.

ARNOLD TOYNBEE

Whenever we see the beginnings of a cycle of transformation, it is reasonable to infer that the cycle will continue to unfold until it is complete. What we have attempted in the preceding pages is to show that a mankind and an age living at the extremities manifest in themselves the lower stages of a transformative process out of which a New Humanity will be born. The negative phase of any cycle allows for the nurturing of the roots of what is to be born, while the positive phase brings forth the flowering of new being. "Men walk as prophecies of the next age," said Emerson. Existential Man, in my view, is prophetic of Spiritually Awakened Man. I wish to outline here in concise terms what appears to me as the compelling logic of the spiritualization process at work in the negativities of our age. How does man's response to the extremities of our age, as seen in Existentialism, serve to set in motion the energies of Spiritual Awakening and Inner Illumination? What evidence supports Shakespeare's saying, "There's a divinity that shapes our ends, / Roughhew them how we will"?

The following analysis begins with the Existentialist point of view because it most truly represents the spiritual and metaphysical exile—life at the extremities—in terms of which twentieth-century consciousness largely defined itself. In philosophy, psychology, literature, and the other arts, Existentialism clearly shows itself the dominant mode of self-

definition in the era emerging from two world wars, to which the political events of the past hundred years form a vast footnote. Any journey, no matter how far, must begin for us where we are. Likewise, any transformation of the spiritual consciousness of humanity must begin with existing conditions and acknowledged states of self-awareness.

FUNDAMENTALS OF EXISTENTIALISM

At the risk of some repetition, the following discussion requires that I briefly outline the fundamental tenets of Existentialism. In the preceding pages, many of its definitive aspects were passed over as not immediately relevant to our discussion. We now require a fuller overview.

Existentialism, briefly defined, is the philosophy of man's intense awareness of his own finitude. All it has to say about man follows from this awareness.

THE DEATH OF GOD. The passage on the death of God that we quoted earlier from Nietzsche's *Joyful Wisdom* continues:

> Do we not hear the noise of the grave-diggers who are burying God? . . . God is dead! . . . The holiest and the mightiest that the world has hitherto possessed, has bled to death under our knife,—who will wipe the blood from us? With what water could we cleanse ourselves? . . . Is not the magnitude of this deed too great for us? Shall we not ourselves have to become Gods, merely to seem worthy of it? There never was a greater event,—and on account of it, all who are born after us belong to a higher history than any . . . hitherto![1]

For Nietzsche, God's death is preparatory to man's passing into a higher dimension—one in which he shoulders responsibility for himself, his values, and his use of power.

MAN IN EXISTENCE. With God's death, man realized he must take his being not from some abstract realm of spiritual essences, but from where he finds himself as an existing human being. "Existence precedes essence" (Sartre). "Essence" no longer points beyond or above

Man has everything locked up within him—every power and energy that exists in the infinite spaces; and all evolution is but the bringing out of these locked-up powers, the unfolding as a flower unfolds, of what is within. . . . The whole purpose of evolution is the thinning of the thick veils of mind and matter, so that the light in the Holy Temple which is the human heart may splendorously illumine man.

G. DE PURUCKER

All that is visible must grow beyond itself, extend into the realm of the invisible. Thereby it receives its true consecration and clarity and takes firm root in the cosmic order.

THE I CHING

[1] *The Complete Works of Friedrich Nietzsche*, sec. 125.

to a realm of spiritual realities. It defines what man makes of himself through his own actions and choices.

MAN ISOLATED, ALONE. Man's loneliness came clearly to the foreground in Existentialism. No longer able to avail himself of the support of a universal Reality, man is thrown back upon himself, *into* himself. The only thing with which he is left is himself. What a weight to be carried! The meaning of this loneliness is conveyed in a poem by Nietzsche:

> *Why hast thou stolen*
> *Into thyself, thyself?*
> *A sick man now,*
> *Sick of the serpent's poison;*
> *A captive now*
> *Who drew the hardest lot:*
> *Bent double*
> *Working in thine own pit,*
> *Encaved within thyself,*
> *Heavy-handed,*
> *Stiff,*
> *A corpse—*
> *Filled with a hundred burdens,*
> *Loaded to death with thyself,*
> *A knower!*
> *The wise Zarathustra!*
> *You sought the heaviest burden*
> *And found yourself.*[2]

THE THREAT OF NONBEING. With the discovery of his own finitude, and bereft of any transcendent Reality to grant him immortality, man came face to face with the possibility of his own nonbeing. Staring into the abyss, he saw his own nothingness. As a result, he came to know as no other age had the meaning of . . .

ANXIETY, DREAD, MEANINGLESSNESS, DESPAIR. In the title of Sartre's

[2] From Friedrich Nietzsche, "Between Birds of Prey."

novel, man felt *nausea* at the sight of the nothingness that surrounded and held his destiny. All the emotions evoked by the recognition of his finitude came into manifestation.

BEING TOWARD DEATH. To be an existing man came to mean one who dies, whose being is destined for death. We may ask to what extent the Existentialist awakening to the inevitability of death may have stimulated the growing interest in death that has emerged in recent decades in fields such as medicine, psychiatry, and law.

ABSURDITY. Along with awareness of all the above comes a sense of the absurd. Life can never be adequately conceptualized. "What the philosophers say about Reality," wrote Kierkegaard, "is often as disappointing as a sign you see in a shop window that reads: PRESSING DONE HERE. If you brought your clothes to be pressed, you would be fooled; for only the sign is for sale."[3]

FREEDOM AND CHOICE. If existence precedes essence, man has no "eternal" nature to which he must conform. A man is what he is because of the choices he makes—his life being the sum of all the choices he has made along the way. Thus man is responsible for shaping himself in the face of a boundless freedom. Berdyaev, Kierkegaard, and Sartre, for example, interpreted man's freedom differently. But for all, man is free to choose his own being.

EXISTENTIALISM AND HISTORY. The philosopher Wilhelm Dilthey, through his search for the formative laws underlying all philosophical systems and worldviews, came to the recognition that all thought has a historical basis:

> Every structure of thought is the expression of a basic intuition elaborated in terms of the prevailing concepts, ideas and values of a given period. Without the elaboration the given intuition remains unrecognized. In the form of its elaboration it is condemned to the fate of historical relativities. But the historically relative elaboration renders permanently valid the intuition which was its occasion for being.[4]

[3] Søren Kierkegaard, *Either/Or: A Fragment of Life.*

[4] J. T. Wilde and W. Kimmel, introduction to Dilthey's thought in *The Search for Being*, 286. See selections, Ibid., plus: Wilhelm Dilthey, *The Essence of Philosophy.*

Heidegger was deeply influenced by Dilthey. But as Heidegger is not a thoroughgoing Existentialist, he holds that Being becomes historical in the process of manifesting and revealing itself. As for our present place in history, Heidegger asks:

> Are we the latecomers of an era which soon is approaching its final ending . . . or, have we arrived at the eve of tremendous transformations of the globe and of the historical realm to which our globe is fastened? Are we in the very eve of a night which leads toward a new morning? . . . Does the land of the eve still lie before us? . . . Are we really the latecomers. . . . Or are we at the same time the predecessors of a new age to come, which has left behind all our present concepts of history?[5]

UNIQUENESS, INDIVIDUALITY, AND AUTHENTIC EXISTENCE. Along with recognizing that no man can die another's death came a realization of man's uniqueness, his individuality. No one is like anyone else. The challenge that lies before each person, then, is to be authentically oneself—to achieve an authentic existence.

SUBJECTIVITY, INWARDNESS. Existential thinking is subjective thinking, concerned with inwardness. Objective thinking seeks results that can become public property, such as the discovery of scientific laws. Subjective thinking concerns the unique thinking process that goes on within the private inwardness of each individual. Objective knowledge can be communicated directly, subjective knowledge only indirectly. Objective knowledge ignores what is unique in favor of what things have in common; subjective knowledge concerns the uniqueness of experience—what an individual learns from his own unique combination of experiences and inward processes. Objective knowledge attempts to fix what is true for all time, ignoring the historical context of growth and discovery. Subjective knowledge is born of continuous striving and is therefore continually changing. Objective knowledge aims at security by fixing attention on what is controllable and dependable. The result is a pseudosecurity that ignores the

5 Quoted in Erich Dinkler, "Existentialist Aspects of Modern Art" in *Christianity and the Existentialists*, Carl Michalson, ed., 113.

comic and tragic aspects of life—hence, scientific knowledge is spiritless. Subjective knowledge recognizes the incongruities between man's finiteness, anxiety, dying, and his longing for immortal life. In ignoring the dimension of inwardness, objective knowledge effectively ignores man himself. Existentialism is above all a philosophy of man, of humanness, of the perils and paradoxes of existence—all because it has learned the value of subjective thinking.

COMMUNICATION. The Existentialists held that argument is powerless as a means of communication, for only those who already share an author's premises will be swayed by his arguments. There is only one way to reach true knowledge of anything, and that is to be involved and experience it for oneself. Hence, Existentialist writers employed drama and the novel as a means of communicating their philosophy. They created dramatic situations in which readers could become involved. Dramatic dialogue and imagination served as a Socratic method for teaching and communicating.

EXISTENTIALISM AND THE PRESENT AGE

The purpose of all forms, as I've frequently stated, is to provide experience for growth. Man's finiteness is a form. Set within parameters called "birth" and "death," it functions like all forms to set limits and thereby create pressure that intensifies experience. Birth and death—our entry into and exit from a finite existence—are also forms of experience. We cannot harvest the true benefits of our finitude, nor realize the purposes of finite life, nor free ourselves from it, apart from a full confrontation, contemplation, and acceptance of our finitude for what it is. Existentialism brought our age to a confrontation with finitude and the finiteness of all that is historical—all that is set between beginnings and endings.

This confrontation with our finitude tells us something very important about our present place in the unfolding spiritual history of humanity. From the esoteric wisdom tradition we learn that each aspect of human nature asserts itself with maximum strength immediately prior

to being transcended. The reasons are clear. On one hand, the aspect of man that is to die seeks desperately to affirm itself before the impending threat of death. On the other, as each phase of our evolutionary unfoldment approaches completion, it attains its maximum strength, reaching its highest point of evolution. In Existentialism we have a profound affirmation of man's finitude. Given the pattern of the transformative process, we may infer that it is just this *finite* aspect of man's nature that is on the verge of being transcended in consciousness and will soon be supplanted by a new self-knowledge: namely, that hidden within finite man is another self—an infinite Self. Existentialism, in my view, prepares the way for and points to this new awareness. The very intensity and depth of its affirmation of man's finiteness suggest that finite consciousness is entering its final hours. Perhaps none would be more surprised than the Existentialists to see themselves as heralds of a new spiritual awakening of humanity, but as I shall now attempt to show, that is how I see them—as forerunners of humanity's spiritual rebirth.

SPIRITUAL IMPLICATIONS OF EXISTENTIALISM

Here we shall outline some of the implications of Existentialist thought for the spiritual transformation of humanity.

Death of God

When Nietzsche asks, "Shall we not ourselves have to become Gods?" and says, "All who are born after us belong to a higher history," he already hints that the death of an "external" God leads toward an *internalized* God—making us gods and participants in a metahistory of the Spiritual Man or God-Man. As a child growing into manhood or womanhood assumes responsibility for himself or herself, so does humanity as it matures assume increasing responsibility for itself. As the child internalizes the parent in adulthood, so does humanity internalize the divine Creator in approaching spiritual maturity. God must die externally in our belief systems to be reborn internally within the human heart.

Man in Existence

As the child is father to the man and brute-man the father of rational man, so is historical man the father of Spiritual Man. Upon the evolutionary arc, the lesser evolved ever serves as the womb from which emerges that which is higher. Hence and indeed, *existence is the womb of essence* for Spiritual Man as for the Existentialist. The whole purpose of earthly life is to nurture and bring forth the hidden life of the inner being. Earth is a schoolroom, and life is to be lived, experienced, and studied, not denied. Only through involution in Matter does the evolution of Spirit unfold its latent powers and infinite possibilities.

Man Isolated, Alone

The lesson of loneliness taught by the isolated self of Existentialism instills self-reliance, which leads toward and prepares the way for mystical experience—the ecstasy that comes only when one is "alone with the Alone." The ability to survive loneliness is one of the major tests of the spiritual Path. One must learn that only within oneself, at the center of one's own being, can one find the love, wisdom, and powers needed for self-transformation. Only when cut off from all external supports and comforts and learning to travel the Path alone does one learn the supreme lessons of inwardness. As we approach an age of increasing spiritual awareness, perhaps it is this lesson that the lonely masses are being taught on a lower turn of the spiral: As above, so below. The spiritual initiate travels a very lonely path, and Christ and Buddha the loneliest Path of all, for They are the razor's edge, pioneering the Way for all humanity.

The Threat of Nonbeing

By confronting the Void, man sees the limits of his finitude. "When you look into the void," says Nietzsche, "the void looks into you." Existence covers Being like a veil, but when we encounter the Void this veil is rent and we stand exposed, open, naked, and defenseless. The Void throws us into the Infinite, where we either recognize our

identity with the Boundless All or cling fiercely to our finite death-certain form. When we give ourselves to the Void, the illusory nature of all that we once thought real is driven home, and we're inspired to seek the true Foundation of all things. To stand naked before Nothingness, as Heidegger said, is to overcome our "forgetfulness of Being." The Void renders us naked to Being, which is No-thing, and allows Being, the Infinite All, to shine through. In confronting the Void, we see once more how contemporary man has been unconsciously preparing himself for the rending of the veil of finite existence in preparation for a moving forward into greater being. His courage in facing the Void prepares him to let go of the securities of his old and familiar finite life.

Anxiety, Dread, Meaninglessness, Despair

Kierkegaard said the torment and sickness of despair is precisely this—that we cannot get rid of ourselves: "The hopelessness . . . is that even the last hope, death, is not available. . . . For dying means that it is all over, but dying the death means to live to experience death." The despairing man despairs "precisely . . . because he cannot consume himself, cannot get rid of himself, cannot become nothing."[6] Out of the anxiety, dread, and despair that existing man experiences before Nothingness comes a profound revelation—*he cannot annihilate himself!* He is faced at the core of his being with a realization—"*I Am*"—that even the choice of suicide cannot eradicate. The very act of choosing suicide reaffirms the Self that he hoped to get rid of. The irreducible self discovered in angst, dread, and despair points to the presence of a center of being and consciousness that cannot be annihilated. At the extremities of self-loss comes self-discovery!—the first essential step upon the path to Self-Realization.

Being Toward Death

Existential man's confrontation with his own death prepares him, through courage, for the "living death" he must undergo as part of the process of spiritual initiation, transformation, and rebirth. It is

[6] Søren Kierkegaard, *Fear and Trembling and Sickness Unto Death*, 151.

the "death" that precedes Awakening. If, as we've argued, all time is but an Eternal Now, nothing dies or ceases to exist by passing over into time past. The past has no reality apart from the inner unfolding of the Self, for whom the experience gained becomes an eternal possession. It is an invention of finite consciousness to account for what has dropped below the threshold of awareness, consciousness itself residing always and only in the Eternal Now. Nor can life depart to some other "place," inasmuch as each of us resides in and *is* a Center in the Infinite All. From that Center we can never depart. If these paradoxes are too deep for the mind to grasp at present, this in no way detracts from their truth. Death, as departure and passing, has no reality. These are but names we give to transcending what is lower in our nature and leaving behind old outgrown forms of experience. With each new day we transcend all our former days, while all they represented, all that they brought to us in the way of experience and growth, remains our permanent possession here and now. Our Higher Self sees beyond time and place—sees all things in the timeless Eternal Now and infinite Being Here—hence, sees the *illusion* of death. Its vantage point is analogous to the point at the center of a circle. Motion in time and space is like the turning of a wheel. At the rim, things appear to move and change, but from its vantage point at the center, the Self sees the turning of the wheel, sees all points of the wheel simultaneously, while abiding unmoved within itself. Like Lao-tzu's *Tao,* it remains motionless, yet is responsible for all that appears, changes, evolves, and disappears. It sees the changing cycles of life but not their annihilation.

As Existential Man looks inward upon his own death, he unknowingly looks toward the center where sits this Higher Self. He needs but to focus his eyes a little further, beyond death, to behold his deathless Self. Having acquired the courage to face death, he is now able to let go of the finite self and approach the Center of Being, accepting the "living death" that will initiate him into a Higher Life and for which the courage to face death has prepared him.

Absurdity

The Existentialists assert that life cannot be rationally explained or conceptualized. Perhaps it should be noted that all human knowledge, being finite, echoes its own end. Yet the fact that we *know it to be finite* means that somewhere within we already stand upon a higher ground and see our finitude from a higher vantage point. Emerson said we always read as superior beings—standing *above* our thoughts in the very act of comprehending them. *To recognize finitude is already to stand above it.* In viewing our own death, we do so as one who stands above the grave as death's Onlooker. Life is a paradox. We live, then die. We die, yet live on! The objective senses cannot make sense of such a paradox, nor can the objective mind reason logically about it. So long as we attempt to make sense of life in terms of conceptual philosophy, the Existentialists are right: we shall fail. By its challenge to conceptual or speculative philosophy (Kierkegaard vs. Hegel), Existentialism opens the door to another form of philosophy that has never found a place in the academies. Nor did the Existentialists pursue this philosophy; yet it is the logical—oops!—*intuitive* next "right step" after Existentialism. This is the ancient Esoteric or Wisdom Philosophy, also called the Perennial Philosophy. This point is so important to our work that I wish to give it some attention. But first let me reemphasize that the Existentialist challenge to the one-sided, life-denying aspect of reason was an essential step toward reopening the door to a new and higher Wisdom, a deeper Path that will allow the human soul to discover its true identity. Phenomenology, by focusing attention not on objective existence, but on a description of the states of consciousness that arise within us in conjunction with experience, took the first step toward a reflective or meditative epistemology. Husserl himself held that phenomenological reflection leads to "pure consciousness" and hence to that "transcendental ego" we call the Higher Self. Phenomenology made it possible to study not only scientific phenomena but also our own "lived world" (*Lebenswelt*). Phenomenology, in my view, is a preliminary form of the science of meditation—a link between Western psychology and true meditation.

Hermes Trismegistus

The Language of Symbolism

Hermetic philosophy, like all Wisdom Sciences, differs radically from speculative philosophy. It is first and foremost a *symbolic* philosophy. Second, its aim is the transformation of life itself. Third, it presupposes the inviolability of human freedom and the right of each person to grow at his or her own pace and in his or her own ways. All that the Existentialists sought in Socratic method and in literary and dramatic modes of communication can be found in symbolism, and much, much more. Here I quote at some length from two writers: first, Oswald Wirth, from *Le symbolisme Hermétique*.

> A symbol can always be studied from an infinite number of points of view; and each thinker has the right to discover in the symbol a new meaning corresponding to the logic of his own conceptions.

As a matter of fact symbols are precisely intended to awaken ideas sleeping in our consciousness. They arouse a thought by means of suggestion and thus cause the truth which lies hidden in the depths of our spirit to reveal itself.

In order that symbols could speak, it is essential that we should have in ourselves the germs of the ideas, the revelation of which constitutes the mission of the symbols. But no revelation whatever is possible if the mind is empty, sterile and inert.[7]

For this reason symbols do not appeal to everyone, cannot speak to everyone. They especially elude minds which claim to be positive and which base their reasoning only on inert scientific and dogmatic formulas. The practical utility of these formulae cannot be contested, but from the philosophical point of view they represent only frozen thought, artificially limited, made immovable to such an extent, that it seems dead in comparison with the living thought, indefinite, complex and mobile, which is reflected in symbols.

It is perfectly clear that symbols are not created for expounding what are called scientific truths.

By their very nature symbols must remain elastic, like the sayings of an oracle. Their role is to unveil mysteries, leaving the mind all its freedom.

Unlike despotic orthodoxies, symbols favor independence. Only a symbol can deliver a man from the slavery of words and formulae and allow him to attain to the possibility of thinking freely. It is impossible to avoid the use of symbols if one desired to penetrate into the secrets (mysteries), that is to say, into those truths which can so easily be transformed into monstrous delusions as soon as people

[7] There are two important consequences of this last-stated idea: first, symbols obviously could not produce their insights if the mind of man were in fact a blank tablet. The Platonic notion of *innate ideas* that are "remembered" seems to be implied, or something akin to the Jungian archetypes of the collective unconscious. A second important notion is that the more richly educated with ideas and experience any individual is, the more he or she will benefit by the use of symbols—that is, be able to make far more valuable symbolic associations.

attempt to express them in direct language without the help of symbolical allegories. The silence which was imposed on initiates finds its justification in this. Occult secrets require for their understanding an effort of the mind, they can illumine the mind inwardly, but they cannot serve as a theme for rhetorical arguments. Occult knowledge cannot be transmitted either orally or in writing. It can only be acquired by deep meditation. It is necessary to penetrate deep into oneself in order to discover it. And those who seek it outside themselves are on the wrong path. It is in this sense that the words of Socrates "Know thyself" must be understood.

In the realm of symbolism one must not attempt to be too exact. Symbols correspond to ideas which by their very nature are difficult to embrace, and which are quite impossible to reduce to scholastic definitions.

Scholastics bring to the ultimate analysis only words, that is to say, something artificial. By their very nature words are instruments of paradox. Any theme can be defended by means of argumentation. This is so because every discipline deals not with realities reaching our consciousness by themselves, but only with their oral representations, with the fantasies of our spirit which often allows itself to be deceived with this false coin of our thought.

Hermetic philosophy is distinguished by its being able to move away from words and to immerse itself in the contemplation of things taken by themselves, in their own essence.

And there is nothing surprising in the fact that under these conditions philosophy divided into two streams. One had its origin in the logic of Aristotle and maintained the possibility of arriving at truth by way of reasonings based on premises regarded as incontestable.

This was the official philosophy that was taught at (ordinary) schools, whence the term "scholastic."

The other philosophy followed another direction, always more or less occult, in the sense that it was always cloaked in mystery and passed on its teachings only under the cover of enigmas, allegories and symbols. Through Plato and Pythagoras this philosophy claimed

to have come down from the Egyptian Hierophants and from the very founder of their science, Hermes Trismegistus, whence it was called "Hermetic."

The disciple of Hermes was silent, he never disputed nor did he try to convince any one about anything. Enclosed within himself, he was absorbed in deep meditation and finally by this means penetrated into the secrets of Nature. He earned the confidence of Isis and entered into relations with the true Initiates. Gnosis opened to him the principles of the holy ancient sciences, from which Astrology, Magic and the Cabala were gradually formed.

These sciences officially called "dead" all refer to the same subject, to the discovery of hidden laws which govern the universe. And they differ from the official science of physics by their more mysterious and transcendental character. These sciences constitute the Hermetic philosophy.

This philosophy is further distinguished by the fact that it was never content to be purely speculative (theoretical). As a matter of fact, it always followed a practical aim, seeking for actual results; its problem was always concerned with what is called the Realization of the Great Work.[8]

Our second quote from Oswald Wirth is from *L'imposition des mains.*

A special reason explains why theories which were so famous in the Middle Ages and down to the 18th century have lost credit in our eyes. We have lost the key to the languages in which these theories were expressed. We have quite a different way of speaking. In past times people did not pretend to assume that they used strictly exact terms about everything. They considered that approximations were quite sufficient, because the pure truth was fatally inexpressible. The ideal truth will not allow itself to be confined to any formula. It follows from this that in a certain sense every word is a lie. The inner side of thought, its fundamental spirit, eludes us. This is the Deity,

[8] Quoted in P. D. Ouspensky, *A New Model of the Universe,* 195–97.

which continually reveals itself and which nevertheless allows itself to be seen only in its reflections. For this reason Moses could not see the face of Jehovah.

It follows from this that when it is necessary to express transcendental ideas one is forced to have recourse to figurative language. It is impossible to do without allegories and symbols. This is not at all a matter of choice, very often there is no other way of making oneself understood.

Pure thought cannot be transmitted, it is necessary to clothe it with something. But this clothing is always transparent for him who knows how to see.

Therefore Hermetism addresses itself to those thinkers who are compelled by an inner voice to go into the depths of all things and remains incomprehensible to those who stop at the external meaning of words.[9]

Our final quote is from Stanislas de Guaita's *Au seuil du mystère*:

To enclose all truth in spoken language, to express the highest occult mysteries in an abstract style, this would not only be useless, dangerous and sacrilegious, but also impossible. There are truths of a subtle, synthetic and divine order, to express which in all their inviolate completeness, human language is incapable. Only music can sometimes make the soul feel them, only ecstasy can show them in absolute vision, and only esoteric symbolism can reveal them to the spirit in a concrete way.[10]

We focused earlier on the Existentialists' insistence that life is absurd because rationally inexplicable. But being beyond rational explanation does not make life meaningless or absurd. The incongruities of existence, when viewed symbolically and meditated upon inwardly, are found to have deeper meanings. The very fact that they outwardly defy reason and appear absurd to the outer consciousness provides an incentive to focus inwardly to greater depths. Symbolism

[9] Quoted in P. D. Ouspensky, *A New Model of the Universe*, 197.

[10] Stanislas de Guaita, *Au seuil du mystère*. We should at least note in passing that poetry often stands closer to truth than the most profound philosophical insights, and this precisely because poetry employs the symbol-language of the soul and reverberates at deeper levels of being. To quote James Russell Lowell in "Columbus": "And I believe the poets; it is they / Who utter wisdom from the central deep, / And listen to the inner flow of things."

employs "blinds"—inversions, displacements, readings from multiple directions, numeric and color codes, and so forth—as a way of preventing superficial readings of symbols and forcing the mind to search ever deeper for the truth. Symbolic philosophy concerns "esoteric" (inner) or "occult" (hidden) truths that require meditation and the awakening of intuition. Existentialism, in holding before us the absurdity of finite existence, serves a similar function. It forces us to search beyond the absurd for the real meaning of life. However unintentionally, this philosophy of finitude points us toward the realm of the Infinite. By showing us the limits of traditional, speculative philosophy, it forces us to search onward for another path to truth, inadvertently preparing our age to be open and receptive to a more symbolic or Hermetic wisdom.

Freedom and Choice

Existentialism reacted against the "mass man" produced by modern technology, emphasizing once again human freedom and personal choice and responsibility. One point often overlooked both by Existentialists and by critics of mass society such as David Riesman, William H. Whyte, Michael Harrington, and Erich Fromm is that in the unfolding course of human evolution, mass movements—whether in the form of labor unions, proletarian revolutions, democratic conformity, mass opinion-forming, and so forth—do contribute to the shaping of social interdependence and unity and prepare the way for eventual world community and brotherhood. In the voice of the masses we also hear a cry for liberation, and it grows louder each day.

As for individual freedom and choice, the Existentialist once again points in the same direction as the wisdom-seeker. For the mystic-occultist, man is never wholly free until he has attained Illumination and Liberation, and even then he is still under the rule of Cosmic Law. Furthermore, with each life he inherits the karma—good and bad—accumulated in the course of his long evolution. Karma, in the form of problems to be solved and opportunities for further growth,

sets the stage for his earthly life. But what he does with his problems and opportunities is always open to free choice. So important is it that each human being have the right and opportunity to shape his or her life freely and responsibly that no wisdom-student or initiate is ever permitted to interfere in the life-process of another human being, even when he sees that person courting personal disaster. One can give help when requested, but one may never violate the free will of another. Since man is a deathless spirit whose earthly life is an occasion for learning and growth, even the most horrendous experiences cannot destroy life and often serve as the most important of our learning experiences. Human freedom, then, is one of the inviolable principles of the true spiritual man. This is not to suggest that one should be indifferent to the sufferings of others, for whatever is done by each of us to improve the quality of earthly life makes the earth a better "schoolroom" for all mankind. Indirect help—in the form of medical advances, the creation of great works of art, improvements in the legal and political system, improved education and humanitarian endeavors, giving birth to higher visions and noble thoughts—all aid the whole of struggling, growing mankind. Yet individuals remain free to choose or reject what is available in their earthly environment, so freedom is still served—indeed enhanced—because the quality of the choices available is greater.

The Existentialists held that we create what we are by the choices we make. The esoteric doctrine of karma goes one step further and says we are free in our choices but bound by the consequences of those choices. In other words, every thought, emotion, and action sets in motion forces in the cosmos, which return to us in like kind: "As a man sows, so shall he reap." The eternal laws of compensation and cyclic progress provide the basis for karmic law. With choice comes responsibility. We cannot escape the consequences of our choices. This same law eliminates the unknown and the absurd by assuring us that as we choose, think, and act, the dependability of law will return to us the just fruits of our choices. Life thereby loses its arbitrariness, its absurdity. It is therefore the better part of wisdom to live with an

eye focused on one's eternal destiny. The Existentialists held that we become what we choose, and this is true in a profounder sense than their philosophy ever espoused. We each create our own destiny, now and throughout eternity.

Since no significant spiritual advancement is possible until one recognizes the roles of freedom, responsibility, and choice in self-evolution, the Existentialists, by emphasizing freedom and choice, once more point us in the direction of the higher spiritual life—a life built on self-mastery.

Existentialism and History

From the standpoint of the Eternal Now, there is no history—past, present, and future are all Now. But from the viewpoint of the finite evolving man, we may speak of the progressive unfoldment of the soul and of consciousness—hence, of their "history." In this sense, every type and level of consciousness represents a corresponding measure of historic unfoldment. Wisdom-students often speak of "young souls" and "old souls" as a way of distinguishing between average humanity and its more spiritually evolved members—initiates, saints, and creative geniuses in all fields. The latter have covered more evolutionary ground than the masses—hence, they are regarded as "older."

Heidegger's view of our present historical period as "the eve of tremendous transformations of the globe" and ourselves as perhaps "the predecessors of a new age to come" is in line with the esoteric view that sees humanity as preparing to leave behind its preoccupation with the materialistic life and enter upon a great new age of spiritual awakening and global unity, which will render real the brotherhood of humanity. Materialism as a philosophy and way of life is reaching its highest point of development prior to being transcended by the emergence of Spiritual Man. Each phase of evolution peaks immediately before its decline. The same is true for the wars of the past hundred years and the birth of the antiwar movements. By whatever route we read the signs, it is clear humanity and the planet are undergoing a profound transformation.

Uniqueness, Individuality, and Authentic Existence

In his essay "The Oversoul," Emerson expressed the common view of mystics and esoteric philosophers that all humanity shares in One Universal Soul: "There is one mind common to all individual men. Each man is an inlet of the same. . . ." Belief in the brotherhood of humanity derives from the spiritual unity of Life on the higher planes of being and the Oneness of the Source of Being. Each individual is a "spark" of that One Life in manifestation. But we cannot manifest that oneness until we have progressed through the required evolutionary process. On the involutionary arc, the One Unmanifest Life fragments and scatters itself throughout the cosmos. On the evolutionary arc, each spark of that Life begins to unfold within itself the Universal Whole.

In man, individualization occurs, and he becomes self-conscious. This process leads to successive identification with the mortal ego, the immortal soul, and finally the eternal Monad[11]—the spark of the Divine Life individualized in each human being. Man's goal in evolution is to contact and manifest the Life of the Monad, his God-Self. Paradoxical as it may sound, man's spiritual unfoldment leads simultaneously to authentic selfhood and identification with all that lives. As consciousness expands and becomes all-inclusive, the True Self is seen to include all other selves.

Existentialism, in emphasizing individuality and authentic selfhood, once again points the way to spiritual attainment. "If I am truly authentic," says Alexandre Koyré, "then I can reveal Being as it is."[12] The choice of authentic selfhood is impossible apart from a sense of *identity*—an awareness of an inner unity that is the "seat" of one's consciousness and Selfhood. To choose this inner unity authentically over and over again, as opposed to choosing things that compromise us, is akin to peeling away the layers of an onion—it leads steadily inward toward integration and centering, bringing us eventually to the Center itself. The choice of an authentic existence, when followed to its logical conclusion, means choosing in all cases and absolutely to be oneself—one's authentic self, what one truly *is*. It means choosing

[11] See C. W. Leadbeater, *The Monad.*

[12] From a discussion of Existentialism in Jean Wahl's *A Short History of Existentialism,* 41.

to be a centered person. Psychoanalysis and Existentialism set the twentieth century on a journey inward that, if carried through, must arrive at the Center. But the Center is Infinite, and existence itself is but a veil hiding the Infinite the same way a circle, always finite in its dimensions, veils the truly infinite at its center. The circle is a mere symbol of what the center conceals. A line projected from the circumference toward the center, if extended far enough, must inevitably reach the circle's center, uniting inner and outer. In like manner, authentic selfhood, carried out with absolute integrity, will in due time reveal the Divine Self hidden within the human heart. But as we know, the Center is infinite—the abode of the Essence of all existence. Thus an authentic existence becomes the womb within which our own Eternal Essence unfolds. The authentic selfhood of the Existentialist leads, in the final analysis, to the Eternal Self at the core of our being, which is our Divine Identity—God enthroned in the human heart. Put another way, the choice of authenticity leads to honesty and integrity, and these, in turn, awaken consciousness and bring one at last to the Voice of Silence that is the Divine Voice, the Oracle of Truth within.

To speak of metaphysical or transcendent Truth no more conflicts with Existentialism than light conflicts with fire. Light is but the "transcendence" of fire, a revelation of the transforming power that lies hidden in the heart of all true Being. Illumined Consciousness—consciousness attuned to the Infinite—is but the spiritual transcendence of an authentic existence, authentic selfhood, the carrying through of the project of subjectivity to its inevitable outcome. To go less than all the way in seeking inwardness and authenticity is to betray the Existentialist project. But going all the way means becoming *wholly centered*, which brings union with the Infinite and results in Self-Realization and Self-Transcendence.

Subjectivity, Inwardness
Existentialism leads inevitably to transcendence, to metaphysics, to inward Illumination and spiritual attainment. It cannot be otherwise.

Subjectivity leads to union with the All. By focusing on the finitude of man's earthly nature, Existentialism has prepared the way for the discovery of the infinitude of his inward Being. By ceasing his search for Eternal Being beyond himself, he set himself up to find it within. Existentialism, therefore, is not an announcement of the death of God, metaphysics, and spiritual life, but their *radical reorientation—* even if the Existentialists themselves failed to understand this. *All that was once external to man is being internalized—God, man's self-understanding, his philosophies.* Even the sciences are becoming internalized and spiritualized, and when the inner life is realized to be as scientific in its development as all that science studies in the physical world, then the Way will open for the Divine Science to be embraced once again by humanity, even as in ancient times. Spirit and Matter progress in obedience to the same universal and eternal laws.

To place what I've been saying into an equation for spiritual unfoldment: *Existentialism = subjectivity = inwardness = self-discovery = striving for authentic selfhood = becoming centered = union with the Infinite = Self-Realization = Spiritual Rebirth.* In Kierkegaard's words, "The passion of the infinite is precisely subjectivity, and thus subjectivity becomes the truth."[13]

If, as Kierkegaard says, "Subjectivity is the truth," how we get to that truth becomes an all-important question. It is here that the mystic and esotericist provide an answer—meditation. The art and science of meditation is the sole technique by means of which a bridge of living light can be constructed inwardly, linking the subjective being of man with his soul and, finally, with the Monad itself. Meditation is a subject too vast to be taken up here, but it should be stated that it is a scientific technique that relies upon an understanding of energies and the governing laws according to which all energies operate. It is a spiritual technique because it puts us in touch with the spiritual dimensions of our being. And it is an art in that it requires the use of the creative imagination and acquired skill in working with forces and energies that transcend the visible world. It is the technique *par excellence* for penetrating the subjective realms of life.

[13] Søren Kierkegaard, *Concluding Unscientific Postscript,* 181

We have left untouched in our discussions of centering one point that puzzles many. The mystic or esotericist has always held that spiritual transformation and Liberation depends upon our own efforts, self-mastery, and successful treading of the spiritual Path. Christianity in particular has emphasized the role of divine grace, but in ways that often seem to relieve man of all responsibility for himself. The Christian doctrine of the Atonement has been challenged as fundamentally immoral. But rightly understood, self-evolution and grace are entirely compatible. When, through long effort, we finally touch the center of our own being, it is a moment of profound grace. Having given all we have into becoming one-pointed and centered, we discover that our finite abilities cannot achieve the Infinite alone and unaided. Grace is needed to carry us into the Center itself. As in the story of the Prodigal Son, That toward which we strive comes out to meet us and embrace us. It is as if the Infinite reaches out and centers itself in us, embracing us and all our human efforts within its boundless circumference. This reaching out to us and making possible what we cannot achieve alone and unaided is true Grace—Infinite, all-embracing Love. The final step into Illumination comes suddenly, unexpectedly, effortlessly. It is the Father coming out to meet the returning prodigal son. The Buddhist symbol for this moment of Illumination is the *dorje*—a "thunderbolt"—which symbolizes the suddenness with which Illumination comes. Occultly speaking, this occurs in the hour when we are subjected to the Rod of Initiation wielded by the Lord of the World, the Father of Lights. Grace is the fulfillment of earned destiny, aided by the One in whom "we live and move and have our being."

A CLOSING LOOK AT THE CYCLE OF TRANSFORMATION

Existentialism, as I've attempted to show, prepares us for ontological Rebirth—that is, for reentry into True Being.

Within the timeless-spaceless Here and Now, there is no death!

What then are these of *stages of transformation* involving "death" and "rebirth"?

The transformative cycle belongs to the created order of space and time that we experience so long as we dwell in existence. Transformation—the transformative "death"—is an opening leading beyond time into Being Itself. Once experienced, consciousness knows its true origin and identity, even while the initiate continues to function in existential time.

We found in studying Gottlieb's *Blast 1* that duality is essential for consciousness to emerge out of the darkness of unconsciousness. But on reaching an Awakened superconscious state, duality is again overcome. Unity, achieved through centering, permits the opposites to be reunited, freeing consciousness from the space-time world. At the beginning there was the unity of unconsciousness. Then came duality—awareness of self and not-self, consciousness and the fields of experience. Finally, with spiritual rebirth, consciousness again attains unity, a unity *above*. In the primal unity of the unconscious all was darkness and ignorance. In the higher unity, the unity of Cosmic Consciousness,[14] all is Light and Wisdom. Man's journey has taken him between the Pillars of Hercules—the opposites of darkness and light. His journey takes him from the uncreated, through the created, to the Source of Creation.

The seven Stages of Transformation that lead from primal chaos (the broken center) to Initiate Consciousness are steps of passage through the manifest world. They hold the keys to a successful journey from inchoate nature to Superconscious Infinite Spirit. What lies hidden in unconsciousness cannot be transmuted. Before transmutation is

[14] The term *cosmic consciousness* is a bit of a misnomer inasmuch as it represents a stage of consciousness far in advance of even the most evolved of our humanity. I suspect that the term entered popular usage in the West by way of the 1901 classic *Cosmic Consciousness*, authored by Dr. Richard Maurice Bucke, a contemporary and friend of American poet Walt Whitman. What Bucke describes in his work corresponds more accurately with the Illumination that takes place at what is esoterically called the Transfiguration Initiation, the first of seven major expansions of consciousness, only the highest of which is truly cosmic.

possible, what is to be transfigured must be brought up out of the primal darkness and made conscious. Hence the journey downward and inward marking this age of preparation for a Great Transformation. It is readily apparent that both the probing of the depths and the raising of the hidden contents of the unconscious, through transformation, into a higher Light must involve a vast expansion of the consciousness of humanity.

I see the present age as the great turning point in human evolution. Man is both Nature and Spirit, both created and Uncreated. Heretofore, through millions of years of evolution, his life and consciousness have been dominated from the side of nature, by his finiteness. As the hinge of time now swings and brings to birth a new consciousness verging toward cosmic awareness, his earthly, finite nature will slowly and steadily recede. Increasingly, his being will come under the rule of the One Infinite Spirit. He will come to understand himself, space and time, death and life, consciousness and the creative powers resident within him as manifestations of an Infinite Life of which he is an expression. His unity with all humanity and all life, terrestrial and cosmic, and his ultimate identity with the Infinite Ground of Being will bring forth a radically new way of seeing all things—nature, his fellow human beings, and the purpose of existence. The knowledge that we share in the destiny of Life itself, that cosmic paths open before these journeying feet and that a Supreme Order receives us into its heart— these are the searching man's promise and hope. We can now look forward to a New Age, born not in a single night to be sure, and not without suffering the trials and tribulations of transformation. But a New Age rises on the swelling tides of human consciousness as surely as does evolution itself.

In looking for a statement of a new philosophical faith that can serve the birthing of this New Age—the universal age—I can do no better than a passage from Will Garver's *Brother of the Third Degree*.

There is one God, one man, one brotherhood, one truth; these are our corner-stones, upon these we erect our structure.

God is the Infinite and all-pervading Spirit, formless, immutable, eternal and incomprehensible to all save itself.

Man is an individualized manifestation of God in self-imposed conditions; a center in the Infinite Essence around which the spirit vibrates and through which it flows forth and reveals itself in the world of forms and things.

The one Brotherhood is humanity, the sum total of all the individualized centers of the divine activity, which, while appearing separately, are one in life and essence.

Truth is the full, self-conscious realization of God within its individualized manifestations and the illumination that comes to each therein.

God comprehends all truth; and man, as God individualized, can comprehend all truth through God in him.[15]

[15] Will L. Garver, *Brother of the Third Degree*, 222.

18 Spiritual Foundations of the Creative Life

The Human Imagination . . . appear'd to Me . . . throwing off the Temporal that the Eternal might be Establish'd.

WILLIAM BLAKE

In beginning this discussion, I can't help recalling lines from a William Butler Yeats poem, "The Choice":

> *The intellect of man is forced to choose*
> *perfection of the life, or of the work,*
> *And if it take the second must refuse*
> *A heavenly mansion, raging in the dark.*[1]

Variations of this mindset have pervaded bohemian cultures and artistic communities in Western nations for much of the past 150 years. Indulging the darker sides of life has often been associated with artistic and literary genius. A rebellious attitude toward the dominant society, as we've observed, always figures significantly in artistic creativity precisely because genuine creativity is always ahead of its time and the prevailing culture, is seldom recognized or supported at the outset, and must shape itself in the face of indifferent or opposing forces. The will to create must be strong if a writer, painter, musician, poet, actor, or creative individual is to survive and succeed in such a climate. Van Gogh is a perfect example of the heroic struggle often required.

This is only half the story. The other half concerns the sources of

[1] W. B. Yeats, "The Choice," *The Collected Poems of W. B. Yeats,* 246.

298

The spiritual pilgrim discovering another world. "Flammarion woodcut," anonymous nineteenth-century wood engraving.

creative power that manifest in genuine creativity of a high order and in creative genius. It concerns the "muses" of inspiration. And this is where I hope to set forth a new understanding of the nature of the creative life.

THE SOUL AS ARTIST

In my view, all true inspiration is derived from and by way of the soul, to which I've alluded numerous times in preceding pages without defining the soul. No vague, unknown "something" to be equated with the psychologist's "unconscious," the soul is the seat of consciousness. As light is produced when electricity is passed through the filament of a lightbulb, consciousness is produced when Spirit meets Matter. Their place of meeting is the soul, which, in man, stands as the middle principle between eternal Spirit, the Monad,

Psychology has for long years been based on the past or the lower aspects of human nature, on digging into and analyzing the darkness of human errors and the baser instincts, instead of looking up and forward into the light, to the future, and working to establish a link, or alignment, with the one and only true source of transformation and redemption—the soul, the spiritual self.

MARY BAILEY

That art is best which to the soul's range gives no bound,
Something beside the form, something beyond the sound.

LI PO

and the reincarnating ego or personality. The union of Spirit and Matter is the generating cause of the light of consciousness. Hence, the soul is the divine-human element in man, a marriage of both, and is therefore the vehicle of what we may call Christ-consciousness or Buddha-consciousness when fully awakened. So long as our attention is wholly focused in our earthly personalities and we care only for earthly concerns, the soul's light shines rather dimly. But once our attention turns to higher things and we open ourselves to spiritual realities, the light of the soul begins to shine more brightly, and with this growing brightness the soul's creative powers can find expression through the earthly man and manifest in our creative work along whatever line we have chosen for creative expression. In the creative arts, true creative power, vision, and creative genius are ever the result of soul attunement—openness and receptivity to inspirations and insights filtering down from the soul via the heart and mind to the man or woman in incarnation. (See plate 19.) One may or may not be conscious of this source of insight and inspiration, yet the more one becomes soul-conscious and soul-attuned, opening up to and invoking the light and wisdom of the soul during the creative process, the more divinely inspired the work becomes. *The soul is the true creative power in all creative work*—the origin of wisdom, clear vision, deep insight, and creative energy, endowing creative works with significance and a power that lifts them above all other mundane activities and transforms true art into a guiding light that uplifts humanity, culturally and spiritually. The sooner the artist understands the soul is the true source of his or her creative power and opens up to it, the more rapidly will he or she advance as a creative artist and give birth to works of art that honor and uplift all that is highest and best in human nature. To indulge the dark side of human nature in the arts is to work on the side of the forces of evil that seek to retard the evolutionary advancement of humanity. I have deep concerns over the plethora of horror movies and games of graphic violence to which many of today's youth are exposed. Exposing evil *as evil* has its place, but the truly great artist always

stands as a representative of the soul, the Angel of the Presence or Divine Self, and ennobles us by his or her creative vision. He shows us the power that triumphs over evil. For the artist, this is also good karma. Moreover, the more receptive any artist is to the inflow of inspiration from soul levels, the more the soul itself will seek to influence the creative work, taking advantage of an available channel, enabling the muses of inspiration to pour out their creative powers and uplift the artist in the creative process. To be a great artist is to be soul-infused,[2] divinely inspired. While a foundation in talent is absolutely essential for any art, it is only when the soul speaks through the artist that we get a *Faust* or *Starry Night* or Beethoven symphony. They only are creative geniuses through whom the soul can work freely, wisely, and passionately, teaching us of human destiny and revealing a world transcendent to our own.

The soul, known by many names including the Solar Angel, the Higher Self, the Son of Mind, the reincarnating Jiva, the Son of the Father, the Angel of the Presence, and the Christ Principle, is the principle in man that is responsible for building all forms in the three worlds—physical, emotional, and mental.[3] It is therefore the creative force behind all that the artist creates or can create. It follows that the more potent the soul energies working through into manifest form in any of the arts, the greater its efficacy in stimulating the consciousness and soul life of those who are open and responsive to its creative vision. Like awakens and stimulates like. These are statements with far-reaching implications worthy of deep thought.

[2] The nature of the soul is a subject too vast for in-depth discussion here. Those wishing a deeper understanding are referred to Alice A. Bailey, *Esoteric Psychology*, vols. I and II, and *The Light of the Soul.*

[3] The soul builds its own vehicles of incarnation—physical, emotional, and mental—before inhabiting them in each new incarnation, and it builds them under karmic law to serve the soul's purpose during the coming incarnation. For example, a soul coming into incarnation to become a great pianist and composer will not build for itself short, stubby fingers. The vehicles built by the soul for each lifetime are designed to serve the purpose for which it incarnates. In like manner, the soul continues creating during incarnation—art, music, culture, nations, civilizations, and so forth.

The following quotes from Alice Bailey on the nature of the soul may prove enlightening:

> Matter is the vehicle for the manifestation of soul on this plane of existence, and soul is the vehicle on a higher plane for the manifestation of spirit, and these three are a trinity synthesized by life, which pervades them all. Through the use of matter the soul unfolds and finds its climax in the soul of man.[4]
>
> . . . The soul is the *quality* which every form manifests. . . . It is the intangible essential nature of the form which . . . distinguishes the varying species of the animal kingdom, and makes one man different from another in appearance, nature or character.[5]
>
> . . . The soul . . . is neither spirit nor matter but the relation between them. The soul is the mediator between this duality; it is the middle principle, the link between God and His form. Therefore the soul is another name for the Christ aspect. . . . The soul is the form-building aspect, and is that attractive factor in every form . . . which drives all God's creatures forward along the path of evolution, through one kingdom after another, toward an eventual goal and a glorious consummation.[6]

> The light of the soul is like an immense searchlight, the beams of which can be turned in many directions, and focused on many levels.[7]

> The study of the soul will before long be as legitimate and respectable an investigation as any scientific problem, such as research into the nature of the atom. The investigation of the soul and its governing laws will before long engross the attention of our finest minds. The newer psychology will eventually succeed in proving the fact of its existence, and the paralleling intuitive and instinctive response of mankind to soul nurture, emanating from the invisible side of life, will steadily and successfully prove the existence of a spiritual entity in man,—an entity all-wise, immortal, divine and creative.[8]

[4] Alice A. Bailey, *A Treatise on White Magic*, 13–14.

[5] Ibid., 33–34.

[6] Ibid., 35.

[7] Alice A. Bailey, *Glamour: A World Problem*, 144.

[8] Alice A. Bailey, *Esoteric Psychology*, vol. I, 104–5.

The soul attained *self-consciousness* for the first time in man, and the progressive evolution of consciousness by means of life experience is the compelling motivation for the soul's reincarnation. The soul is the learner and storehouse of all experience extending back over its many incarnations. Hence, the whole history of the soul's aeonic long journey is stored up in its consciousness, only a small part of which we recall in each new incarnation. The soul comes into incarnation with certain latent powers and abilities already developed in prior lives, with a certain potential and life-direction already chosen for this lifetime, and with certain problems and difficulties that must be surmounted to achieve one's goals. As a rule, we do not remember the experiences we passed through in the process of awakening the talents and powers we bring into the present lifetime, but in the case of great artists, flashes of creative insight may come, born of past soul-experience, whether remembered or not, that open like a floodlight on present events and reveal their deeper and often archetypal dimensions. These insights are then translated into works of art. The genius of Shakespeare, Goethe, Michelangelo, and Beethoven is due both to their vaster vision and their ability to bring that vision through in their work. Any artist, as he or she becomes more soul-attuned and soul-infused, can experience something of this enriching of the creative vision and expansion of creative powers by cultivating a deeper alignment and openness to the inflow of inspirations from soul levels. The soul is the true artist. Given talent, dedication, and perseverance, and an openness toward the divine life of the Higher Self, all who wish to be artists, poets, musicians, architects, actors, or creators in any realm of human endeavor have the potential to realize their aspirations. We all have souls wise in experience. We have but to attune ourselves to them and listen.

MEDITATION AND CREATIVITY: INVOKING THE MUSES

Soul-attunement is both a science and a learned art. All of us, through earthly experience, are gradually unfolding the latent powers of the

soul, beyond which lies the Monad and its threefold expression, the Spiritual Triad.[9] The evolutionary unfoldment that comes naturally over time to all can be accelerated by the practice of meditation. Meditation is a science in that it works with energies and follows exact laws. It has been said that Wisdom is the science of the right use of energy. All energy is essentially fire, and one of the attributes of fire is its destructive power. The old adage about "not playing with fire" is not to be taken lightly when it comes to the practice of meditation, as meditation is a means of using fire to bring about a gradual transmutation, transformation, and transfiguration of the earthly man. Overhasty efforts, undue strain, impatience for results, disregard for the need for slow and steady progress, lack of discipline and sound judgment, and attempts to awaken the force centers known as chakras by means of focused stimulation—all carry dangers for the unwary meditator. It is always best to err on the side of caution and view the practice of meditation as a lifelong commitment. As of this writing, I'm now in my thirty-eighth year of daily meditation. The benefits of a lifetime of meditation cannot be overvalued. In the absence of an enlightened teacher to guide, it is best to confine oneself to the more elementary forms of meditation, especially in the early years, until one has gained considerable experience and can wisely judge one's own progress.[10] That said, let us now

[9] Just as the soul creates a threefold personality, consisting of a physical, emotional, and mental life, to serve as its vehicles of experience and expression on the three lower planes of our system, so the Monad projects its three divine aspects—Will or Power, Love-Wisdom, and Creative Intelligence—on the three planes above the soul. These three form a unit known as the Spiritual Triad: As below, so above. The Monad is to the Triad what the soul is to the personality: As above, so below. The soul marks the lowest point of the intelligence aspect of the Triad. Following Transfiguration, the life of the Triad gradually supercedes that of the soul until, with the fifth great expansion of consciousness known as the Fifth Initiation, awareness becomes permanently polarized in the Monad itself.

[10] Two excellent books that will provide a good foundation for anyone wishing to understand and take up meditation are Lama Anagarika Govinda's *Creative Meditation and Multi-Dimensional Consciousness*, and Mouni Sadhu's *Meditation*. There are many others written from the perspective of different spiritual traditions. Seek and you shall find the one that is right for you.

Art and meditation are creative states of mind, both are nourished by the same source, but it may seem that they are moving in different directions: art toward the realm of the sensuous and outward manifestation, meditation toward inward realization and integration of forms and sense-impressions. But this difference pertains only to secondary factors, not to the essential nature of art and meditations.

LAMA
ANAGARIKA GOVINDA

focus on some of the fundamental principles any intelligent and creative person can make use of. These same truths apply to the discipline of meditation.

The first fundamental to understand is that *energy follows thought.* The character, focus, quality, intensity, and depth of the thought-life determines its creative effectiveness. To quote Oscar Wilde again, "To think a thing is to cause it to begin to be." In all creative work, as in meditation, one can direct the energies with which one works by means of thought and visualization, using them to guide the work in progress or direct them along any chosen path. *Like produces like.* The results of thought always conform to the type of energies set in motion. Angry thoughts produce angry results, noble thoughts noble results, and creative thoughts creative results. Ponder these truths and shape your life and work accordingly.

The second fundamental to understand is that *every response is an answer to a prior demand.* Unless preceded by a demand, no response will be forthcoming. This is an aspect of the Law of Attraction governing our universe. If you wish to strengthen a muscle, just thinking about it won't do the job. You must place a demand upon it by exercising it. No Olympic gymnast ever won a gold medal without long, demanding practice and self-discipline. An artist, writer, dancer, architect, philosopher, or anyone wishing to achieve in any field of human endeavor must make demands upon him- or herself before the required talents and powers can be awakened and refined. Hence, the need to cultivate willpower. Only perseverance will bring success.

The third fundamental concerns *the building of the Antahkarana,* also known as the "rainbow bridge" or "bridge of light" that links the earthly man, the personality, with the soul and eventually the Monad. There is a break in consciousness that prevents most of us from becoming aware of the experience-rich life of the soul and recalling past-life experiences. This gap exists between the mind and soul. By abstract thought, spiritual aspirations, and specifically by means of meditation and visualization, a thread-bridge of living light connecting soul and personality and known as the Antahkarana is slowly constructed,

The use of the creative imagination and the fruits of its endeavor will work out into the many fields of human art according to the ray of the creative artist. . . . True creative art is a soul function; the primary task, therefore, of the artist is alignment, meditation and the focusing of his attention upon the world of meaning. This is followed by an attempt to express divine ideas in adequate form.

DJWHAL KHUL

bringing about continuity of consciousness between the soul and personality. Once built, the soul's memories become accessible. The science of the Antahkarana concerns the techniques by means of which this work is carried forward. As this bridge is built, the soul will be more and more able to attract the attention of and influence the man on the physical plane. Creative inspiration and spiritual insights will become increasingly common experiences. For the creative personality working in any medium, inspiration—the power to "invoke the muses"—is associated with the bridging of this gap between soul and personality.

The fourth fundamental concerns *the law of Invocation and Evocation*. Closely allied to the law of demand and response, this law concerns our ability to call upon and receive help from Sources other and higher than ourselves. In the great hierarchy of Intelligent Lives, the Great Chain of Being, there are many lives far more advanced than we humans, and among them are beings who assume responsibility for overshadowing and guiding humanity along paths that will eventuate in humanity's fulfillment of the Logoic Plan for our little planet. Prayer and invocation, as practiced in the world's religions, is based on an intuitive, if unscientific, acceptance of the belief that higher aid will come when sought. The chief problem is that most of our requests for aid are selfish and self-centered. It is little realized that the more selfish and self-centered the prayer or request for guidance, the less potent the energies evoked. Selfless love attracts the highest powers. When seeking guidance from these Higher Intelligences for the greater good and in line with Divine Purpose, help in some form will always come. In seeking guidance, first examine your motives. Ask yourself whether what you seek will benefit others and serve a higher good, and if the answer is "Yes," visualize that which you wish to see accomplished and invoke the Great Ones to your aid. With a final out-breath, send your visualization into the universe and forget it. At the appropriate time that which constitutes the right response to your request will find you and evoke a corresponding response from you, enabling you to rise to the demands of the occasion. *Like answers to like.* This invocative practice can be car-

ried out by individuals, families, groups, or entire nations. The invocative appeal of humanity, when carried out on a wide scale and in line with Divine Purpose, will bring about world transformation.

The fifth fundamental concerns *visualization*. Years ago, in working with others to develop their creative potential, I discovered that visualization is the most effective of all techniques for achieving creative results. All artists understand visualization. In attempting to achieve a goal, get into the habit of visualizing the desired outcome, including the steps required for its realization, and visualize in the mind's eye the final result as if accomplished. See the work completed. Some years ago I had a friend who was friends with the pianist Liberace. He told her how his career began, and this is the story she passed on to me. Trying to choose a career, Liberace decided he would like to make his living as a pianist. So he rented a tuxedo, grand piano, and candelabra and had them delivered to a nearby stadium. He hired a photographer to photograph him playing the piano at center field. He then found a photo of the same stadium filled with spectators and, cutting out the photo of himself at the piano, placed it in the crowded stadium. Several times each day, he would sit before the photo visualizing himself performing to such an audience. One month later, according to his story, he performed in that very stadium to a capacity crowd. So began the musical career of Liberace. Such is the power of visualization.

The last fundamental I wish to touch on is *sound*. All forms come into manifestation through energy vibrations, and sound is at the root-cause of all vibration. This is a vast and interesting subject. Human hearing exists within a very narrow range, but in the hour of Illumination the initiate hears the sound of the cosmos itself for the first time. Throughout the literature of the ages we find references to "the music of the spheres," "the celestial song," and "the cosmic OM." These are not mere metaphors: "The world to a thinker is the magic motion produced by the Orphic singer."[11]

The value of sound in meditation and creative work is that it opens us up to avenues of inspiration and allows "diviner" forces to play through us in ways we rarely comprehend. Human beings respond to sight. Hence

[11] *Some Thoughts on the Gita*, by A. Brahmin, 94.

the power of visualization and the creative influence of the visual arts in the life of humanity. The deva or angelic evolutions respond to sound, and it is they who constitute the building forces of all that comes into manifestation. The use of mantras in meditation is of immense value and another vast subject of study. To keep this short, I've found the best known and most widely used of Sanskrit mantras—OM MANI PADME HUM[12]—to be exceedingly powerful and effective in achieving deep states of meditation. No exact translation of its meaning is possible. It is typically viewed as the mantra of the thousand-armed Bodhisattva of compassion, Avalokiteshvara, also known as Kwan Yin in China and Chenrezig among Tibetan Buddhists. Visualizing the thousand-armed Bodhisattva while silently repeating OM MANI PADME HUM is a powerful spiritualizing and heart-opening experience.[13] I also find music, especially classical music, a powerful stimulus to the creative process.

Deep thought along any line—music, mathematics, art, philosophy, science, poetry, and so on—is a form of meditation and aids the building of the Antahkarana between the soul and earthly personality. But as a precise science, meditation can greatly hasten the bridging of the gap between the spiritual and earthly man and make invoking the muses of inspiration—achieving creative insights—far easier. Many insights in

[12] Of this mantra, Djwhal Khul says, "The most sacred of all the Eastern mantrams given out as yet to the public is the one embodied in the words: 'Om mani padme hum.' Every syllable of this phrase has a secret potency, and its totality has seven meanings and can bring about seven different results. . . . The potency of a mantram depends upon the point in evolution of the man who employs it. Uttered by an ordinary man it serves to stimulate the good within his bodies, to protect him, and it will also prove of beneficent influence upon his environment. Uttered by an adept or initiate its possibilities for good are infinite and far-reaching." Alice A. Bailey, *A Treatise on Cosmic Fire*, 926, n. 85. See also Thomas Ashley-Farrand, *The Ancient Power of Sanskrit Mantra and Ceremony*, 2nd ed., vol. 1 (Portland, Ore.: Saraswati Publications, 2002).

[13] Those who resist what is true and beneficial in other religions of the world deprive themselves of much that is of spiritual value. It is good to remember the teaching of the Rig Veda: "Truth is one; men call it by many names." And the words of Krishna in the Bhagavad Gita: "Mankind comes to Me along many roads, and on whatever road a man approaches Me, on that do I welcome him, for all roads are Mine." The compassion of the Bodhisattvas and the love of Christ partake of the same Divine Love.

this book came directly out of meditation. Anyone pursuing a creative life in the arts or any field of human endeavor will benefit from meditation and use of the principles just outlined.

Alex Grey (1953–), in *Theologue*, 1984 (plate 21), has dramatized the outcome of a meditative life. A visionary artist, Grey is deeply concerned with the spiritual dimensions of human experience in all its aspects. In the foreground of *Theologue* is a Self-Realized, fully Illumined figure engaged in deep meditation. Behind him, stretching as far as the eye can see, is a craggy landscape of dark hills and valleys that may represent his aeonic journey through earthly incarnations. "The valley of the shadow of death" of the Twenty-third Psalm alludes to our sojourn through the realms of earthly existence. Death is termed a "shadow" because it lacks ultimate reality.[14] The barrenness of the landscape suggests that it no longer offers anything of a life-sustaining nature for the Illumined One. It recalls the high arid landscape of the Capricorn initiate. In the foreground, just behind the meditator, we see the flames of the burning ground over which he has passed on his way to enlightenment. The fire has done its work and is now behind him.

Grey's figures, like those of Pavel Tchelitchew, are typically translucent, enabling us to see into them. In *Theologue*'s figure, the seven chakras or force centers along the spine are open and fully illumined. He is encircled by his aura, and a golden halo surrounds his head.

Divine Creative Energies, seven in number, circulate throughout our universe, in and through the smallest atom, through all the kingdoms of nature, within man himself, through races, religions, nations, the planets, and the entire solar system. These same energies circulate through the seven chakras and govern everything from physical health to spiritual enlightenment in man. Variously known as the Seven Rishis, the Seven Rays, the Seven Creative Builders, and the Seven Spirits Before the Throne of God, these Seven Energies are distinguished by their qualities, which are:

Ray 1. Will or Power, Logoic Purpose
Ray 2. Love-Wisdom

14 "The last enemy that shall be destroyed is death" (I Corinthians 15:26).

Ray 3. Creative Intelligence or Activity
Ray 4. Harmony Through Conflict
Ray 5. Concrete Science
Ray 6. Devotion or Idealism
Ray 7. Order or Ceremonial Magic

These are the energies that govern us, our planet, and our solar system throughout the course of our long evolutionary unfoldment. The open, illumined chakras along the spine of the meditator in *Theologue* inform us that he has mastered these seven energies within his own physical and spiritual vehicles, giving him power to wield these energies and work with them as he carries out his planned service in the world. As hinted in our discussion of Gaudnek's *Rebirth,* this represents a creative achievement of the highest order and reveals the hidden divinity within man.

From the *ajna* center or "third eye" in the region of the pituitary gland, rays of light stream forth, forming a grid embracing the entire scene. Visualization and creative imagination are closely related, and it is through the ajna center, which opens when the threefold personality becomes fully integrated, that these creative powers come into their full function and usefulness. The use of geometric grid lines in *Theologue,* emanating from the third eye, suggests to me the order and precision of thought that characterizes and directs the activities of the Illumined man in whom divine and human consciousness are united. They hint also of the perfect law and order that underly the whole of creation and with which the Illumined man fully cooperates. The world envisioned by the spiritual Initiate exists in perfect harmony with the Whole. He works always within the law, cooperating perfectly with the Divine Plan.

ART AND ARCHETYPES

Archetypes express the Eternal Ideas that guide and govern all evolution for the whole of a greater cycle of manifestation. We're told by Djwhal Khul that form

originates upon the archetypal plane, through the agency of divine thought, and from thence (through directed streams of intelligent energy) acquires substance as it is reproduced upon each plane, until eventually (upon the physical) the form stands revealed at its densest point of manifestation. No form is as yet perfect, and it is this fact which necessitates cyclic evolution, and the continual production of forms until they approximate reality in fact and in deed.[15]

In this solar system with its seven planes of manifestation—physical, emotional, mental, intuitional, spiritual, Monadic, and Divine or Logoic—the Logoic plane, also called Adi, is the Archetypal Plane. On this plane Divine Mind formulates the Ideas, complete from the beginning, that guide the creative processes of the world through all stages of manifestation and evolution until all reaches that perfected state of Being expressed in the archetypes. The end is foreseen in the beginning, and what came first in the divine creative process—the archetypes—will, in the end, shine forth in infinite glory, having brought all manifest life to a full and perfect expression of the divine archetypes. As with man, the Idea precedes its manifestation and fulfillment. Then comes the labor of attaining—the struggles of the creative process: As above, so below; as below, so above.

Archetypes can be explored psychologically as Jung and Neumann have done, culturally through myths and symbols, philosophically as Plato and the Neo-Platonists did, spiritually through the teachings of Avatars who have come to guide humanity, scientifically and mathematically by studying the formative patterns of all that comes into manifestation, and mystically or esoterically by awakening intuition and the spiritual insight that lead to direct perception. A fully illumined consciousness will perceive the archetypes behind all things and the striving of all lives, by means of evolution, to conform to the eternal Idea.

Archetypes are independent of space and time and the vehicles of mind and matter through which they manifest, and yet are inseparable from the divine creative processes governing the universe. They represent the universal and eternal in manifest existence. To the extent

Before the visible universe was formed its mold was cast. This mold was called the Archetype, and the Archetype was in the Supreme Mind long before the process of creation began. Beholding the Archetypes, the Supreme Mind became enamored with its own thoughts; so, taking the Word as a mighty hammer, It gouged out caverns in the primordial space and cast the form of the spheres in the Archetypal mold, at the same time sowing in the newly fashioned bodies the seeds of living things. The darkness below, receiving the hammer of the Word, was fashioned into an orderly universe.

The Divine Pymander

[15] Alice A. Bailey, *A Treatise on Cosmic Fire*, 925.

THE SEVEN PLANES OF OUR SOLAR SYSTEM

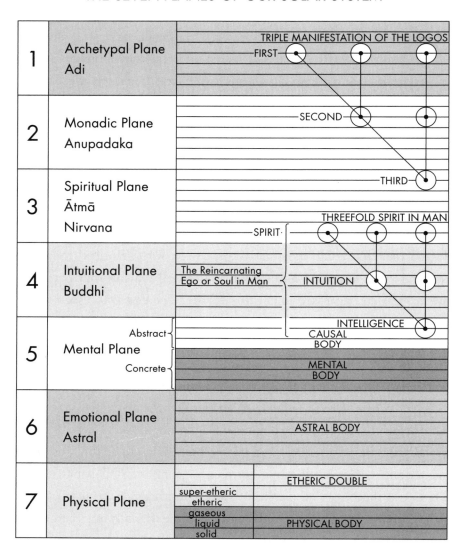

1	Archetypal Plane Adi		TRIPLE MANIFESTATION OF THE LOGOS — FIRST
2	Monadic Plane Anupadaka		SECOND
3	Spiritual Plane Ātmā Nirvana		THIRD — THREEFOLD SPIRIT IN MAN — SPIRIT
4	Intuitional Plane Buddhi	The Reincarnating Ego or Soul in Man	INTUITION
5	Mental Plane	Abstract — Concrete	INTELLIGENCE — CAUSAL BODY — MENTAL BODY
6	Emotional Plane Astral		ASTRAL BODY
7	Physical Plane	super-etheric etheric gaseous liquid solid	ETHERIC DOUBLE — PHYSICAL BODY

any work of art gives expression to an archetype, it partakes of the timeless, universal, and eternal truth of things. As expressions of the perfected state of being, they elevate all that is imperfect and reveal the inherent perfectibility of manifest existence as it unfolds in time and space. Being timeless, archetypes belong to the past, present, and future and reveal the future in the present, thereby giving substance to hope by revealing the foreordained Plan toward which all things are

moving. To put it paradoxically, by means of archetypes the future is ever drawing the present toward itself. The Eternal Now undergoes constant transformation as what is hidden in the depths of Being is slowly brought forth and actualized in an ever-moving Present. Like a circle expanding outward from its center, the eternal Monad slowly unfolds itself before our very eyes!

One of the mysteries of art concerns this power of archetypes, reflected in forms and images, to draw us toward those higher states of being of which archetypes are the perfected expression. Each effort to attune ourselves to the perfection of the archetypes lifts us a little higher in the scale of evolution, acts as a liberating influence in our consciousness, and releases those hidden forces Manly P. Hall called "fiery whirlwinds" to bring transformations in our lives. Only when we understand the power of archetypes and their function in art can we fully understand the role played by art in the spiritual evolution and liberation of humanity.

From the moment the Divine Spark or Monad began its evolutionary unfolding in space-time, its development has been under the influence of the archetypes, and their influence is an ever-present and all-pervading factor in all evolution. The archetype of the Christ or God-Man that symbolizes the union of the divine and human dimensions of our being—the merging of the Spiritual Triad and the threefold personality, of which the interlaced triangles of the Seal of Solomon are also a symbol—stands as an archetype of human destiny. Were it otherwise, how do we account for the power these images of divine-human Wholeness and godlike perfection have in human consciousness and their continuing influence across the ages? These archetypes hold before us the ideal toward which we are ever striving, consciously or unconsciously. Knowledge is power, and knowing the archetypes that govern our destiny and to which our lives are intended to conform during their earthly pilgrimage throws light on our path and helps accelerate our progress. Once we catch the archetypal vision, we can cooperate consciously with Divine Purpose and shape our destiny accordingly.

When one sees eternity in things that pass away, then one has pure knowledge.
BHAGAVAD GITA

And how do we catch the archetypal vision? By means of intuition. Art is ever the out-working of a deeper insight. Every artist, knowingly or not, is at work on the problem of immortality. As he strives to perfect his forms for the purpose of expressing his creative vision and "ensouling" that vision in a work of art, he labors to bring eternity into time, Spirit into Matter. To the extent any work of art reveals some archetype, it speaks the soul's language, and no matter how blind any man or woman may be, he or she cannot help feeling something of the awesome power that streams forth steadily from archetypes. The consciousness of all who encounter such works is raised and attuned in lesser or greater degree to the Divine Idea. Art elevates the soul through its vaster vision and creative power, striving after the Infinite in finite form.

ART AND THE EVOLUTION OF CONSCIOUSNESS

Consciousness invests itself in various forms, evolving through its experiences with the form-side of life—thought forms, emotions, and interactions with the physical world. Think, by way of analogy, of consciousness as "incarnating" itself temporarily in some idea, emotion, or concrete experience for the purpose of awakening new insights and unfolding latent powers. The contemplation of a work of art constitutes such an experience. As long as attention is invested in any experience, consciousness will continue to be stimulated by that experience. Hence the value of developing one's powers of concentration. Forms serve to focus, define, qualify, and limit consciousness, engaging it in an interplay that channels experience along the chosen line of activity. In this way dormant or quiescent powers are stimulated, awakened, and called out of latency into activity, made conscious. The soul, the seat of consciousness, is thereby aided in its unfoldment, and latent powers are transformed into conscious, active powers. Forms, whether in the form of ideas, emotions, or interactions with objects such as works of art, evoke a response in consciousness that corresponds to the nature of the stimuli they provide. This is a simple matter to illustrate.

Draw a circle and place a dot off-center as in Figure 1. A circle seeks naturally to balance its hidden forces. Hence, the off-center dot sets up a disturbance in its energy field—an imbalance experienced as a disturbance in consciousness.

Figure 1 Figure 2

To resolve this tension, reposition the dot at the circle's center as in Figure 2. Harmony is restored. Our circles are visual images that, when perceived in consciousness, are felt as dynamic forces operating within consciousness itself. *Any change in an image produces a corresponding change in the consciousness of the perceiver.* What is inner (consciousness) invests itself in what is outer (the image), engaging in a dynamic exchange to awaken what lies veiled and as yet unawakened more deeply within. Consciousness requires a challenge to unfold its latent powers. Whatever the eyes see enters awareness and becomes a dynamic force transforming consciousness. The nature and power of the image and the focus and receptivity of consciousness each play their part in this exchange.

All forms are energy equations,[16] each of which sets up corresponding

[16] Dan A. Davidson, a physicist and mathematician, demonstrates in his book *Shape Power* that shapes, lines, forms, and images give off a subtle but measurable energy, much like that of a pyramid. He notes that energy moves in the direction in which lines are drawn, that curved lines are more potent than straight lines, and that mandala patterns radiate a high-energy field extending several feet in all directions. A number of physicists have confirmed Davidson's scientific measurements. Artists would find Davidson's *Shape Power* a useful study.

Like music, lines, shapes, and images are dynamic energy equations creating corresponding changes in human consciousness.

energy vibrations in consciousness, reproducing itself in the subtle matter of the mental plane and the even more subtle matter of the soul, for it is the soul that interprets to the mind what it sees. Every shape, movement of a line, hue, and shade of color, positioning of an element in a work of art, choice of medium, or use of texture produces its own unique effects in consciousness and evokes its own specific responses. *Like calls to like, stimulates like, gives birth to like.* How we interpret what we see depends on the content of our own life experiences and the associations we make based on these experiences. In this way the forms in which consciousness invests itself act as stimuli, shaping and driving the evolution of consciousness by means of new and ever-changing patterns of experiences.

When these ideas are applied to the role of art in the evolution of consciousness, not only is the visual image itself, which interacts with consciousness, a stimulus awakening new powers and insights, but all that went into the creation of the work of art—the artist's inspirations and ideas, emotions and intuitions, values and beliefs, use of myths and symbols, soul energies and spiritual insights—are inseparable from the image they create, and the resulting energy equation "incarnates" these influences in the work of art much the way the human soul incarnates itself in the earthly personality, shaping and defining it. Thereafter, they act through the image as creative forces awakening dormant powers in the soul's depths and furthering the evolution of consciousness.

Whenever a work of art is ignited by the fire, light, wisdom, and love of the soul, you have works of art of true creative genius.

Part of the function of these energy equations or works of art is to call up and make demands on our intuitive powers in the hope of awakening corresponding creative powers and insights in us and teaching us to see as the artist sees. In learning to decipher the mysteries of art, we are also learning to decipher the mysteries of nature and life all around us, for the same intuition that lifts the veil of one also lifts the veil of the other. Art is a powerful educator of the soul. The more profound the artwork and potent the soul-forces finding expression through it, the more powerful and lasting will be its stimulating effects in consciousness and its hastening effect in the evolutionary unfoldment of that consciousness. Man is a transmitter of soul energies into the threefold world of forms, and through these forms he communicates his vision and spiritual insights to others. Art forms a bridge between souls and allows for the communication of subjective experience, enabling soul to speak to soul.

All that we say about the visual arts applies equally to the other arts—dance, drama, film, the novel, poetry, music, and architecture—each mode of creative expression serving as a medium for unique creative visions and insights and avenues for spiritual communication.

Giving expression to the Divine Self within is a profoundly creative act. The more spiritually attuned the artist to his own soul, the more potent will be the spiritual energies finding expression in and through his art, and the more he will be able to uplift the hearts, minds, and lives of all who see and respond to his vision and work.

The energies transmitted by any work of art receive their impetus from the highest point within the artist contacted during the creative act. *Like expresses like.* If only emotional levels are touched, only emotional energies will be transmitted. If the realm of mind and ideas is touched, these will find expression. If the soul or Spiritual Triad is touched by way of a highly developed intuition, the energies of these more subtle spiritual realms will be transmitted to the work. All who view works of art likewise respond according to their own level of development. If

a viewer has awakened no response to the soul within him- or herself, a work of art through which the soul speaks with inspired power will evoke no corresponding response. *Like is perceived by like.*

An artist will always create from that place within that is awake and seeking expression during the creative act. In many cultures, artists prepare themselves to work by means of meditation or some ritual of purification to open to and bring through high inspirational energies. For many artists, art is a form of meditation, and in certain cultures artists are known to work themselves into a state of ecstasy prior to engaging in creative work. Seldom is every work of art a masterpiece, as few artists are able to work constantly at their peak or maintain a high pitch of inspiration at all times. A rare example might be a Michelangelo. Most artists go through dry spells when it seems nothing will come, but these are usually times when new ideas are gestating "underground," when the roots of vision are being nourished in darkness. The more open the artist to the higher dimensions of his own being, the more inspired will his work be, and the more easily will visions, insights, ideas, and energies from the highest part of himself seek and find expression in his art. When the muses inspire from on high, great art is born, art that can withstand the tests of the ages. It follows, therefore, that when an artist lives a life attuned to the higher dimensions of his own being, whether by way of meditation or other spiritual practices, or as a result of an awakened intuition or inspired imagination, he will be able to bring through in high moments of creative inspiration works of great power, of high spiritual vibration, works endowed with deep symbolism and meaning, works that act as liberating forces in the consciousness of all who are touched by them. However intuitive or unconscious this creative process may be on the part of the artist—and in high moments of creativity, the artist is very often an open channel for his own soul or inspirations coming to him from other high sources—what passes through him is what enters the artwork and takes up residence there, stimulating the heart, mind, soul, and consciousness of all who pass that way with open eyes—eyes that pierce the veils of vision.

Every artist transforms the world, and he transforms it not only materially but also spiritually. In *Starry Night* (plate 22), Van Gogh shows us nature seen through the eyes of the soul and reveals something of the divine creative power pulsing through the natural order. In his painting, the transcendent origins and spiritual forces of man and nature meet and radiate, revealing something of that glory toward which all life aspires and moves upon the evolutionary path. As an artist, he has done for Nature what she cannot yet do for herself—unveil her depths and allow her hidden light to shine through. Whatever the artist's subject, be it portrait or landscape, symbolism or abstract image, dreamscape or visionary realities, it becomes great art to the degree, and only to the degree, that realities transcending our mundane daily lives take up residence there and impart their secrets to the eyes and souls of viewers and lovers of art. The task of the artist is to see and reveal what most of us walk past blindly day after day.

Therefore, if the artist would aid the evolution of consciousness, he has a moral duty, not to preach to us with his paintings or sculptures, but to *reveal* in some manner in his art new, previously unrevealed depths and heights of the One Truth that underlies All. His vision may be tragic or comic or symbolic or visionary or revelatory, but it must always offer us something beyond our everyday world. It must speak to the soul. It must open our eyes to realities of which we would have remained unaware but for this work of art. It must help us penetrate the secret depths of our own being and inspire us to nobler hopes, dreams, and goals in our own lives. Whenever it does this, art becomes a force directly affecting the evolution of consciousness in the viewer. It enables us to leave behind former things and move forward via new experiences into wider horizons. We imprison ourselves only when we refuse to grow. Each artist who brings us a vision of experiences we have not had ourselves becomes our mentor, guiding us through open doors into new arenas of experience. Art expands us. It is a powerful and liberating force in the evolution of human consciousness.

IMAGINATION AND INTUITION

The creative imagination (see plate 20), as yet underdeveloped in the average person, is described by Djwhal Khul as a faculty "latent in all men." He goes on to say:

A flash of light breaks through to the aspiring mind; a sense of unveiled splendor for a moment sweeps through the aspirant, tensed for revelation; a sudden realization of colour, a beauty, a wisdom and a glory beyond words breaks out before the attuned consciousness of the artist, in a high moment of applied attention, and life is then seen for a second time as it essentially is. But the vision is gone and the . . . man is left with a sense of bereavement, of loss, and yet with a certainty of knowledge and a desire to express that which he has contacted, such as he has never experienced before. He must recover that which he has seen; he must discover it to those who have not had his secret moment of revelation; he must express it in some form, and reveal to others the realized significance behind the phenomenal appearance. How can he do this? How can he recover that which he had once had and which seems to have disappeared, and to have retired out of his field of consciousness? He must realize that that which he has seen and touched is still there and embodies reality; that it is he who has withdrawn and not the vision. The pain in all moments of intensity must be undergone and lived again and again until the mechanism of contact is accustomed to the heightened vibration and can not only sense and touch, but can hold and contact at will this hidden world of beauty. The cultivation of this power to enter, hold and transmit is dependent upon three things:

1. A willingness to bear the pain of revelation.

2. The power to hold on to the high point of consciousness at which the revelation comes.

3. The focusing of the faculty of the imagination upon the revelation, or upon as much of it as the brain consciousness can bring

through into the lighted area of external knowledge. It is the imagination or the picture-making faculty which links the mind and brain together and thus produces the exteriorization of the veiled splendor.[17]

. . . The use of the imagination will appear to you immediately as constituting, in itself, a definite field of service.[18]

Imagination is that faculty in man born of a poetic sensitivity to unseen realms, an awareness of the creative powers of the soul, and the ability to visualize—a capacity we all possess in our dreams. In all creative work, motive is a decisive factor, playing a major role in the soul's response to our efforts to bring through wisdom, beauty, and deep creative insights. An artist motivated by money and fame will never touch the same creative heights as an artist who seeks to serve a vision larger than himself, a vision capable of healing and uplifting others. Where personality and self-interest dominate, as opposed to an open and inclusive heart, they serve to constrict the flow of those high energies required to create great art. "The purer the agent, the better will be the functioning of the imagination."[19] Those who create for the love of humanity or to bring something meaningful into the world tend to create the works of art to which we attach the greatest value. As a man thinks, hopes, dreams, and wills, so he creates. Creative thinking is "as if" thinking, which imagines the desired results, for imagination is a factor directly affecting the energy substance of the manifest worlds. *Like gives birth to like.*

Imagination and will are evidence of the divinity in man, and when motivated by love and scientifically developed, there is no creative challenge they cannot meet, no problem they cannot solve.

The creative imagination . . . is one of the great building attributes of deity. It is brought about by the evocation of the love nature and . . . brings in soul power in full tide. In the world of phenomenal appearance, the soul is the creating agent, the major building factor, the constructor of forms, and through the Technique of Fusion, the

The world of imagination is the world of eternity. . . . This world of imagination is infinite and eternal, whereas the world of generation, or vegetation, is finite and temporal. There exists in that eternal world the permanent realities of every thing which we see reflected in this vegetable glass of nature. All things are comprehended in their eternal forms in . . . the human imagination.

WILLIAM BLAKE

[17] Alice A. Bailey, *Esoteric Psychology*, vol. II, 248–49.
[18] Ibid., 400.
[19] Ibid.

power to imagine or to use imaginative thought power (in conjunction with the faculty to visualize, to dream into being) is definitely and scientifically developed.[20]

God and man create by like methods: As above, so below; as below, so above. It follows that the more man unfolds his hidden divinity and attunes himself to the highest dimensions of his own being, the more his creative powers will flourish, and the greater will be the creative work he accomplishes. All great artists, knowingly or not, are divinely inspired.

Intuition is the development of an inner vision that enables the seer to see into the heart-essence of all that he beholds. This is so because the Self recognizes itself in and under all other forms. Recognizing this fundamental unity between all selves, intuition identifies with whatever it beholds. Intuition is therefore *born of love,* for love alone overcomes all divisions. In all creative work, therefore, identification is a very useful technique for getting at the inner essence or hidden meaning of whatever one wishes to know. When creating a work of art, *become* the work in progress and try to feel intuitively what works. By getting at the inner essence, you will know when the outer form fails to measure up.

Duality—Self and not-self—no longer holds sway in the consciousness of one in which Buddhic[21] or intuitional consciousness functions.

[20] Alice A. Bailey, *Esoteric Psychology,* vol. II, 387–88.

[21] Concerning Buddhic consciousness, I. K. Taimni says, "Buddhi stands for the particular manifestation of consciousness which takes place through the Buddhic body. . . . Its field of expression, therefore, lies just beyond the mind, not only the lower concrete mind but also the abstract mind which deals with general principles. . . . This fact should make it clear why the functions of Buddhi transcend those of the mind and cannot be judged by the criteria of the intellect which are taken to be final and conclusive by the ordinary intellectual man. This also accounts for the fact that the mere intellect cannot understand those finer perceptions which have their origin in Buddhic consciousness. The only state of consciousness which transcends and embraces Buddhic consciousness is that of the Ātmā which is, as it were, the very centre of our life, the core in which lie buried all our divine possibilities." *Self-Culture,* 133.

You have the same intuition as I, only you do not trust or cultivate it. You can see what I do if you choose.

WILLIAM BLAKE

Intuition is the immediate, synthetic gasp of truth as it essentially is, beneath the veil of external forms, and leads to clear vision, perfected insight,[22] and the ability to comprehend something of the Divine Plan as it works itself out in the course of evolution. And it brings about a capacity to cooperate consciously with that Plan.

Like all else in man—who is a composite of energies in a world of energies governed by universal laws—intuition is subject to scientific development and modes of training that aid its unfoldment. It is nurtured by love and understanding and a growing selflessness. It is stimulated by music, color, rhythmic movement, mathematics, and sound vibrations, such as those of mantras. A spiritualized will capable of drawing down the transmuting fires of the higher realms helps purify and heighten the vibratory responsiveness of the lower vehicles, reducing resistance to the subtler vibrations of intuitive consciousness. In all progress patience, perseverance, caution, and common sense are essential. Undue haste will only cause problems and delay progress. Yet visual artists are in a unique position to develop intuition, because *sight* is the foundation upon which intuition unfolds. As the artist struggles to perfect his or her work, intuition is naturally stimulated. In the course of evolution, imagination is slowly transmuted into intuition, and the power to visualize gradually passes over into the power to see all things as they truly are, giving birth to ever-expanding vision. Visualization is therefore excellent training for the intuition.

By piercing the veils of external form, intuition provides a unified vision of the underlying reality—unified because consciousness is no longer split between outer and inner. Intuition elevates the personality, enabling it to become the expressive instrument and agent of the soul. It enables the artist to respond to higher inspirations by opening the mind

Intuition concerns unity and is the capacity of the Self to contact other selves.
DJWHAL KHUL

[22] Taimni also says: "It is true that the attainment of Buddhic consciousness is a matter of perception of the inner realities but this perception is possible only through vehicles which are pure, tranquil, and harmonized. These conditions are brought about not merely by wishing but by prolonged and rigorous self-discipline which means transmuting our spiritual ideals into right living and right thinking." *Self-Culture*, 154.

to periods of illumination. Wisdom has been termed the illumination of the mind by intuition. It represents a blend of two divine aspects—*buddhi,* or intuition, and *manas,* or mind—producing spiritual understanding and bringing together identification and insight, understanding and the power to interpret. Intuition requires for its development a high degree of intelligence, the functioning of the higher or abstract mind, and the ability to comprehend what is not tangible or concrete. As man evolves, his lower or concrete mind becomes slowly attuned to abstract ideas and universal concepts, resulting in the ability to think abstractly. The abstract mind, in its turn, is gradually superceded by intuition, the transcendental mind; and the centers of awareness shift upward from the brain-mind to centers in the subtler matter of man's higher vehicles and eventually into the Buddhic or intuitional vehicle, whose essence is Love-Wisdom. Then you have the manifestation of Christ-consciousness or Buddhic consciousness, call it by whatever name you choose.

In Eastern philosophy, we are often told that "the mind is the slayer of the real." So long as we are bound by the limitations of the finite mind, in spite of all efforts to grasp Reality, we shall err through ignorance of the underlying truth. Only when intuition begins to awaken and we can perceive somewhat the inner essence of things and grasp something of the archetypal Plan do the illusions of the mind begin to dispel. Ignorance is slowly transformed into knowledge, then Wisdom. Intuition is the means of overcoming the illusions of the lower mind and arriving at clear, accurate vision.

Many people tend to confuse emotional responses with intuition, but there is an easy way to distinguish between them. Emotions are transient, and any "take" based on an emotional response will dissipate with time. Intuition sees reality as it is and is incapable of error. Hence, it will withstand the passage of time, growing clearer and stronger.

It is because artists and all creative persons are engaged in work that makes demands on the development of intuition that we so often find them on the cutting edge of evolutionary progress, able to envision future possibilities and function as the "boundary rid-

ers of evolution" scouting the way ahead for the rest of humanity. Culture—the works of the creative imagination—sets the pace and points the way forward for every advancing civilization. Art is a light on the path ahead.

STYLE: THE SIGNATURE OF THE SOUL

Style is one of the more mysterious and interesting aspects of any culture or work of art. Many attempts have been made to explain it. Style has been attributed to the influences of climate, racial temperament, psychological makeup, even astrological influences. Nor do I disagree that all these elements play their part. Certainly, Van Gogh's fiery, energized style owes much to the artist being an Aries, a fire sign under the influence of Mars. And spiritual influences certainly play their part. Not only is a huge portion of the world's art, perhaps the greatest part, religiously inspired, but one can trace the slow evolution of humanity toward ever more spiritual modes of expression by studying the progressive developments of art and architecture from ancient Egypt, through Greece, to the Gothic period, and finally into the developments of modern art and architecture. A slow, steady *dematerialization of matter* can be seen taking place—both psychologically and technologically—as humanity aspires spiritually, grows intellectually, and consciousness shifts gradually upward along the evolutionary path.[23]

Here, however, I wish to set forth a new theory of style. One contemporary critic defined style as "the surplus information in a work of art." My aim is to show that style is the signature of the soul impressing itself on all that it creates. It reveals that point in the evolution of consciousness attained by any age, culture, or artist and shows the type of consciousness in process of awakening or unfolding. Emerson said, "All is nascent, infant." Whatever is new and in process of unfolding out of the hidden depths of being, where latent powers are struggling to awaken within the hidden life of the soul, is always at first "nascent, infant." The evidence of a new type

All is nascent, infant.
RALPH WALDO EMERSON

Whenever the truth is unveiled, the artist will always cling with rapt gaze at whatever still remains veiled after the unveiling.
FRIEDRICH NIETZSCHE

[23] For a particularly interesting study of architecture, see Claude Bragdon, *The Beautiful Necessity: Architecture as "Frozen Music."*

of emerging consciousness first appears *in the style of the artist or culture.* If you study the early works of any artist and follow his or her progress over the course of a long career, the stylistic elements that appeared in early works will be seen to develop progressively until they emerge as the dominant, defining characteristics of the artist's mature years. Style defines the consciousness of an artist or era. Occasionally, radical changes in style are seen, but even then elements of style from the immature years tend to find their way into the new modes of creative expression.

Just as a person's signature and handwriting reveal his or her character, inclinations, state of mind, intelligence, buried impulses, and hidden motives, style in art reveals the buried life of an artist, culture, or age—what is working its way up from the depths of the soul and seeking conscious expression. *Style reveals the hidden depths of what is in process of awakening.* At the outset, these newly emerging soul-powers are always embryonic and largely unconscious. Hence, they do not find expression in the formal elements of the artwork—its central idea, compositional arrangement, dramatic theme, use of light, color, texture, and so forth. Rather, they hover just below the threshold of consciousness and influence the work stylistically, becoming conscious only as the artist, culture, or age matures. As a rule, only in retrospect are we aware of all that has been awakened in human nature and consciousness by their passage through a particular stylistic age and culture. The forms and experiences of that culture served as means of awakening specific soul-powers needed for humanity's next step along the path of evolution. The unfolding of these latent powers in the depths of the human nature becomes the *raison d'être* for a particular cultural style to appear at a specific time in history. If we could read the history of style, we could follow the evolution of human consciousness. This insight came to me while viewing a retrospective of Kandinsky's art years ago at the Guggenheim Museum; nothing in my observations of art in the years since has given me reason to alter this view. The soul speaks *directly through style* while remaining, as with the soul of man, half-hidden

from view—its existence to be inferred by the pervasive power of its influence upon the work of art.

So what is the significance of this idea of style? If we acquire an intuitive sensitivity to style and learn to read it much the way we've learned to read the hidden meanings in handwriting and body language, or the way we read the "soul" of another person through his or her eyes, perhaps we may become more aware of what it is in the depths of our being that is seeking to come into manifestation. The more we can cooperate with our own growth, rather than fight against it (as every society seems to do during periods of profound change), the more rapid will be our maturing and development as human beings, as artists, and as a society. Greater maturity is certainly something our age can use as we struggle with change.

As Nietzsche noted, the artist is always entranced by and "will always cling with rapt gaze" to what remains hidden, undiscovered, after all that his creative efforts have succeeded in bringing into the light. It is this which drives the restlessness of the creative spirit. It is in the elements of style, I suggest, that the artist will find the keys that unlock the mysteries of his own soul and creative energies. Study and explore style. It is precisely here, in the nascent, emerging consciousness of the artist, seeking that mode of creative expression unique to himself and his times, that he will find encoded the secret roots of his own creative life and the destiny of the culture and age to which he belongs. Style both veils and reveals the destiny of the soul of the man and of the times.

THE TRANSFORMATIVE VISION

In coming centuries, art will achieve a beauty and magnificence of vision as yet unimaginable, and this precisely because the soul of humanity is on the verge of awakening new and hitherto dormant powers, including new powers of seeing. The resurgence of interest in all things spiritual over the past 125 years is but the twilight heralding a new dawn. We've witnessed this resurgence in both East

Just as the hand held before the eyes conceals the greatest mountain, so does petty earthly life conceal from view the vast lights and mysteries of which the world is full, and he who can withdraw it from his eyes, as one withdraws a hand, will behold the great light of the innermost worlds.

RABBI NACHMAN OF
BRATISAVA

and West. Within this same period, we've seen the invention of all the technologies responsible for unifying our world—the automobile, airplane, telephone, film and other recording media, television, space exploration (giving us a view of our earth from outer space), global satellite communications, the computer, and the Internet—and politics and economics are increasingly global. Freedom movements, human rights movements, and the ecology movement are also sweeping the globe. "The times they are a-changin'." We typically externalize change prior to internalizing it—partly, I suspect, in order to visualize where we are headed, and partly because the inner life requires more work and sustained effort to bring about deep and enduring change. We live in an age of transformations, and evolution is an accelerating process. As H. G. Wells said, all that has taken place up until now is but the twilight of the dawn. The changes that have taken place since the late nineteenth century merely foreshadow deeper and more far-reaching changes still to come. All these transformations serve as powerful stimuli to our evolution as well as to inner growth. A new sun is rising. A new humanity approaches, *new because differently oriented.*

By the 1970s, the visual arts in the United States seemed to have fragmented and gone in numerous directions. No clear aesthetic or philosophy of art has since emerged to guide the creative imagination. This is due in no small part to the complexity of world events and the constant need of the creative spirit to find its own path and direction. The cross-fertilization of many diverse cultures has been most evident in music. Yet as we enter a new global era in which we must eventually learn to live together as One World and One Humanity, I would expect to see among the creative pioneers of the race in the decades and centuries ahead a growing emphasis on unity, synthesis, and the awakening of the powers of intuition. As we share our cultures, we will see more emphasis on cross-cultural themes and finding unity in diversity. Symbolism, etherealizing abstractions, and visionary forms of art that seek to reveal inner and transcendent dimensions of human and divine-human experience will almost

THE CREATIVE PROMISE
OF THE COMING AGE

328

certainly increase. As life steadily speeds up, an awareness that *all is energy* will somehow find greater expression via the visual arts. What forms the art of the future will take are entirely open to the human imagination and the levels of inspiration that guide the artist's creative vision. One thing is certain—our age, with its obsessive greed and materialism, will be transcended and replaced by a vision of the higher possibilities of the human spirit.

In bringing this work to a close, I would like to comment on two artworks of the twentieth century that may serve as indicators of directions some new art of the future may take. Both works reveal the high sources of inspiration behind their creation and show us what is possible. These are Constantin Brancusi's sculpture *Bird in Space,* and Ernst Fuchs's painting *Moses and the Burning Bush.*

The first is *Bird in Space* (plate 23 a, b, c), a sculpture by Romanian-born artist Constantin Brancusi (1876–1957). In 1908 Brancusi began his *Maiastra* series, depicting a magical bird endowed with perpetual awareness and the power to see into people's hearts. Less than a decade later he undertook his *Golden Bird* series, followed in 1923 with *Bird in Space*—a sculptural program he continued until the early 1950s. Relentless in his efforts to portray a sense of flight, ecstasy, and transcendence, Brancusi said, "Like everything else I've ever done, there was a furious struggle to rise heavenward." The mythological and metaphysical roots of his inspiration are readily apparent. Speaking of Brancusi's birds, Mircea Eliade said:

> Myths, tales, and legends that tell of heroes and magicians who can move freely at will between Heaven and Earth are universal. There exists a whole series of symbols connected with spiritual life, particularly with the experience of ecstasy and powers of the mind that are interdependent with bird-images, wings and flight. The symbolism of flight indicates a rupture in the universe of everyday experience. Its dual implication is self-evident; by "flight," transcendency and freedom are attained.[24]

24 Quoted in Radu Varia, *Brancusi,* 197.

Commenting on various occasions, Brancusi said:

Bird is a symbol of flight liberating Man from the narrow confines of lifeless matter. I had to face two quite different problems. I needed to express in plastic form the spirit inherent in matter and, at the same time, I had to insure unity. . . . I wondered in my solitude how I was going to educe these forms and give the *Bird* the sense of effortless flight.[25]

. . . Only the essence of the *Bird* remains—idea and spirit, a few lines, a certain angle, flexures that render the vertiginous upward thrust; only the idea of the bird remains.[26]

. . . It is not the bird I want to express, but the gift, the soaring, the upward thrust. . . . God is everywhere. One is the Godhead when one forgets oneself, when one is humble. When one offers up oneself, God resides in one's work. It becomes magic.[27]

Bird in Space is less about outer space—flight in the boundless reaches of the cosmos—than about *inner space*: awakening to the center within ourselves where we touch the Infinite. Brancusi made this clear with a series of photos of *Bird* in which a blazing light is reflected off *Bird*'s tip, hinting of a transcendental enlightenment and supernal glory awaiting anyone able to realize *Bird*'s "flight." Guiding viewers toward some form of illumination became Brancusi's obsession as he worked relentlessly for three decades at perfecting *Bird in Space*.

Erected on a base in the form of a Greek cross—a symbol of material existence and mundane life—the pulsating stem designed to support and launch *Bird in Space*[28] is reminiscent of the breathing one does in preparation for meditation. And just as a meditator brings consciousness to a one-pointed focus when preparing for deep meditation, *Bird* concentrates all its forces before beginning its ascent. In viewing *Bird,* one allows one's consciousness to glide upward along its slowly expanding curvature, then again gently ingather its forces. But instead of reaching a culminating point at the

[25] Quoted in Varia, *Brancusi,* 272, col. 3, n. 11.

[26] Ibid.

[27] Ibid., col. 3, n. 12.

[28] Brancusi labored relentlessly on this "stem," describing it as "as difficult to attain as the bird itself!"

apogee, one suddenly encounters *Bird*'s sliced tip, which unexpectedly releases consciousness into its own "space." The effect is similar to that of the Beatles' song "I Want You" on the *Abbey Road* album. The music builds steadily toward a crescendo only to end abruptly in utter silence, leaving the listener feeling that the music will continue forever in that silence. *Bird*'s sliced tip produces a similar effect visually, propelling the viewer's ascent into the Infinite. The slight flexure of *Bird* suggests the arc of a projectile while also functioning as a catapult ready to thrust consciousness into orbit.

I've experienced something of what Brancusi wanted for his viewers. While contemplating *Bird,* I allowed my consciousness to slowly follow its contours. On reaching the sliced tip, I closed my eyes. Suddenly and unexpectedly, I found myself floating in a peaceful awareness far removed from earth. My consciousness seemed to open out and embrace a vast expanse of space. For several minutes I remained in a clear, rarefied, peaceful state of consciousness. It was a moment of profound lucidity. *Bird in Space* had indeed sent me into "flight." Brancusi succeeded in creating a work of art that facilitates self-transcendence, enabling us to breaking the bonds of earth and soar into the Infinite, demonstrating once again the awesome power of art as an agent and servant of the soul.

The final work to concern us is *Moses and the Burning Bush* (plate 24) by the Austrian-born painter and sculptor Ernst Fuchs (1930–).

The chief representative of the Vienna School of Fantastic Realism, born to a Christian mother and a Jewish father, Fuchs combines visionary symbolism with a neo-Gothic style. In *Moses and the Burning Bush* we have the convergence of two moments of divine revelation—Yahweh's appearance to Moses from the burning bush and Buddha's experience of Enlightenment—their conjunction demonstrating the ultimate unity of all Divine Revelations.

On the right, Moses is shown kneeling before Yahweh, his sandals removed because he is on holy ground. His gesturing hands show he has shut out the world and is focused solely on the revelation

he is receiving. At left, the burning bush takes the form of a flaming menorah—a reminder that the universe is sevenfold in creation.[29] The seven flames or lights of the menorah, like the seven chakras in the subtle vehicles of man portrayed in Alex Grey's *Theologue,* relate to the Seven Rays or Seven Spirits before the Throne of God. From the flames of the menorah, Yahweh emerges—three-handed, reminding one of the multiarmed deities of Hinduism and Buddhism. One hand points above to the Eternal Source, one hand is upturned receiving the light of heaven, and one is outstretched to Moses as Yahweh gives him the Teaching of the Law.

In the background are the crumbling remains of the Tower of Babel, a symbol of the failure of human pride. Around it are deep

[29] Emanating from the One Absolute Reality as a unity, the universe unfolds as a sevenfold manifestation. The First Logos (call it *A*) is ever unmanifest; the Third Logos (call it *B*) gathers the primordial matter needed for manifestation; and the Second Logos (call it *C*) undertakes the creative work of building and evolving the manifest universe. The interaction of the three Logoi produces a sevenfold field of evolution resulting in seven planes or dynamic spectra of Spirit-Matter, *seven states of consciousness*—seven because that is the maximum number that can unfold from a Unity-made-manifest.

$$A^1 \qquad B^2 \qquad C^3 \qquad AB^4 \qquad AC^5 \qquad BC^6 \qquad ABC^7$$

Each unity can then undergo a secondary septenary unfolding of its own and, in our solar system, does—creating energy fields analogous to the notes of the diatonic music scale, each octave being analogous to a plane of manifestation, and the seven notes of each octave corresponding to the seven subplanes of one of the systemic planes. While the planes of manifestation are hierarchically ordered, as are all energies according to their quality, potency, rates of vibration, and range of influence, they coexist together in space-time just as heat, light, air, gravity, sound, and motion can all coexist together at the same points in space, differing only in their vibrational frequencies. Or as with the musical notes of different octaves, which can be sounded together in harmony or dissonance, yet heard simultaneously, we relate to the energies of multiple planes of our being simultaneously. Likewise the Seven Rays or Spirits Before the Throne govern all things together. Attuning ourselves to any plane or ray energy is a matter of correct alignment and synchronous vibration or harmonic attunement.

The sheer vastness of this subject precludes our delving into it in this work, though my next book will focus extensively on it. Meanwhile, those interested in exploring the more esoteric aspects of the manifest universe are referred to the five volumes of Alice Bailey's works, known as *A Treatise on the Seven Rays.* This is deep material. Other Bailey works, including the earlier-cited volumes on *Esoteric Psychology,* are a good source of information on the influences of the Seven Rays in human development.

ruts. Perhaps they represent the labyrinth, or merely symbolize the long pilgrimage of the human soul through earthly life with all its struggles and suffering—ruts worn deep by time. At upper left is a small hill with a few trees reaching skyward, the only reminders in an otherwise barren landscape of the life left behind. Both Moses and the transfigured Christ are symbols of the Capricorn initiate who ascends the mountain of initiation, a barren place where little remains in the way of worldly sustenance. Life is now entirely about the Light of Revelation shining through them.[30]

Lastly, the face of Buddha, depicting the supreme moment of his Enlightenment, is superimposed over the whole scene. Whereas Yahweh emerges from a flaming menorah, Buddha wears a crown of fire that closely resembles the crown worn by Yahweh: "Our God is a consuming fire." Fire, as we've noted, is the supreme creative and transmuting agent of the universe. What is portrayed for us in Fuchs's *Moses and the Burning Bush* is a moment of profound transformation—a transformation embracing both East and West. Once Illumination comes, all things are forever changed. Once the vision of other worlds is seen, this one is seen as a world in need of salvaging. With Illumination comes the utter and absolute commitment of oneself to the service of others.

In this fascinating work, Fuchs hints at the identity of all spiritual Truth, the underlying unity of all revelations of the Divine, and the inevitable convergence of the world's religions once the identity of the Source of all revelations is realized. There is but One Reality, One Humanity, and One World. Just as humanity, scattered across the earth for countless ages, has developed many languages, so each culture has interpreted Divine Truth according to its own experiences and understanding. We are now moving toward an interdependent, unified world, and no event takes place anywhere that cannot be instantly communicated worldwide. Our cultures and religions are meeting and discovering each other, often for the first time, and the idea that any one religion holds exclusive rights to all truth is no longer tenable for those with open, informed minds. Just as the truths of great art are visible only to those capable of seeing art with the eyes of the soul, and

[30] We're told that when Moses descended from Mount Sinai after his encounter with Yahweh, "His face did shine as the sun" (Exod. 34:29).

SPIRITUAL FOUNDATIONS OF THE CREATIVE LIFE

for whom artforms are vehicles of revelations from the inner life, so must we come to view the cultural and religious diversities of humanity with spiritual eyes and recognize their underlying unity. Men have dreamed the dream of Universal Brotherhood before, but today our world is facing us with the challenge of making these dreams a reality. To survive and evolve, we must succeed. Fuchs makes the point with his painting that maybe, just maybe, we should seek the source of our unity in the unity of our spiritual Truths. So passionate are we for our various faiths that were we to recognize their underlying Unity—their roots in One Eternal Wisdom—we would be driven by an equal passion for the One Humanity.

In these pages we've explored the journey that leads from darkness to light, from the unreal to the Real, from death to immortality. We have examined the role of the creative arts as instruments of revelation and explored somewhat the mysteries of the creative life. We've attempted to lift a corner of the veil that conceals the deeper mysteries of life we seldom reflect on as we go about our mundane daily tasks. But let us remember, *our journey is an eternal one,* and we sell ourselves short if we settle for what we see around us, amassing property, seeking worldly power or fame, or just getting by. All that's needed to achieve heights of unimaginable glory resides within the depths of our own being and requires only to be nurtured to unfold. Nurture the roots of being. The flower of Life will unfold.

Vision grows with expanding consciousness, and as life is without finality, the vistas before us will be forever changing and enlarging. It is the nature of consciousness to continually transform itself through new experience. Life fulfills itself through self-revelation and a growing inclusiveness. Today, our culture and world are passing through times of profound change. Often the clouds on the horizon seem dark and foreboding, but this is no time for pessimism or discouragement. Like the proverbial phoenix, a new world will rise out of the ashes of our present conflicts and suffering. *Our souls are indestructible.* As Meng-ste said long ago, "The wheel of time has turned once more; the

race is on a higher plane of thought. The sons of men are looking for a greater light. They see the beams of coming day and yet they comprehend them not."

The value of the arts as a means of vision and visualization should not be underestimated. Art is a moment of awakening, a record of ecstasy, a revelation of mystery, a ritual of rebirth, a recovery and realization of childhood, a return to eternal origins. The depth and expanse of the artist's vision determines the enduring value and revelatory power of the artwork and its theurgic value as a healing agent for the human heart. Art, like truth, must change us, not merely please or entertain us. In a world where change remains the only constant, the creative life—the power to envision the future and give it form and the power to uplift through inspiration and revelation—is a value we cannot afford to discard. Educators, listen. The enduring values of a society are to be found in its ideas and its arts. Its economic, social, and political structures eventually pass away, but we still marvel today at the Egyptian pyramids and Sphinx, the Athenian Parthenon, Michelangelo's Sistine Chapel, Leonardo da Vinci's *Vitruvian Man,* and Van Gogh's *Starry Night.*

In all true art something of the eternal shines through.

The sight of the seer is never lost, being eternal.
BRIHADĀRANYAKA UPANISHAD

Bibliography

Abrams, M. H. *The Mirror and the Lamp*. New York: W. W. Norton, 1958.

Arnheim, Rudolf. *Art and Visual Perception*. Berkeley: University of California Press, 1971.

———. *Toward a Psychology of Art*. Berkeley: University of California Press, 1972.

———. *Visual Thinking*. Berkeley: University of California Press, 1971.

Assagioli, Roberto. *The Act of Will*. Baltimore: Penguin Books, 1973.

Auden, W. H. *The Age of Anxiety*. New York: Random House, 1947.

———. *The Collected Poetry of W. H. Auden*. New York: Random House, 1945.

Aurobindo, Sri. *The Mind of Light*. New York: E. P. Dutton, 1971.

Avalon, Arthur (Sir John Woodroffe). *The Serpent Power*. New York: Dover Publications, 1974.

Babbitt, Edwin S. *The Principles of Light and Color*. Edited by Faber Birren. New Hyde Park, N.Y.: University Press, 1967.

Bachelard, Gaston. *The Poetics of Space*. Boston: Beacon Press, 1994.

———. *The Psychoanalysis of Fire*. Boston: Beacon Press, 1964.

Bailey, Alice A. *Education in the New Age*. New York: Lucis Publishing, 1971.

———. *Esoteric Astrology*. New York: Lucis Publishing, 1971.

———. *The Externalization of the Hierarchy*. New York: Lucis Publishing, 1957.

———. *Glamour: A World Problem*. New York: Lucis Publishing, 1967.

———. *Initiation, Human and Solar*. New York: Lucis Publishing, 1922.

———. *Letters on Occult Meditation.* New York: Lucis Publishing, 1950.

———. *The Light of the Soul.* New York: Lucis Publishing, 1972.

———. *Ponder on This.* New York: Lucis Trust, 1974.

———. *The Rays and the Initiations.* New York: Lucis Publishing, 1960.

———. *A Treatise on Cosmic Fire.* New York: Lucis Publishing, 1962.

———. *A Treatise on White Magic.* New York: Lucis Publishing, 1969.

Bailey, Mary. *A Learning Experience.* New York: Lucis Publishing, 1990.

Baird, James. *Ishmael.* New York: Harper & Bros., 1956.

Baker, A. T., comp. *The Mahatma Letters to A. P. Sinnett.* Pasadena, Calif.: Theosophical University Press, 1997.

Barrett, William. *Irrational Man.* New York: Doubleday, 1962.

Barth, Karl. *The Humanity of God.* Louisville, Ky.: Westminster John Knox, 1960.

Battcock, G., ed. *The New Art.* New York: E. P. Dutton, 1966.

Bays, Gwendolyn. *The Orphic Vision.* Lincoln: University of Nebraska Press, 1964.

Becker, Ernest. *The Denial of Death.* New York: Free Press, 1973.

Berdyaev, Nicolas. *The Meaning of the Creative Act.* New York: Harper & Bros., 1955.

Bernanos, Georges. *Sous le Soleil de Satan.* Translated by Helmut Kuhn.

Besant, Annie. *A Study of Consciousness.* Madras, India: Theosophical Publishing House, 1938.

———. *Thought Power.* Wheaton, Ill.: Theosophical Publishing House, 1966.

Besant, Annie, and C. W. Leadbeater. *Thought Forms.* Madras, India: Theosophical Publishing House, 1925.

Blake, William. *Selected Poetry and Prose of William Blake.* New York: Modern Library, 1953.

Blavatsky, H. P. *The Secret Doctrine,* vols. I and II. Pasadena, Calif.: Theosophical University Press, 1970.

Bogan, Louise. *Collected Poems*. New York: Noonday Press, 1954.

Bragdon, Claude. *The Beautiful Necessity: Architecture as "Frozen Music."* Wheaton, Ill.: Theosophical Publishing House, 1978.

Brahmin, A. *Some Thoughts on the Gita*. Talent, Ore.: Eastern School Press, 1983.

Brunton, Paul. *The Quest of the Overself*. London: Rider, 1970.

———. *The Spiritual Crisis of Man*. New York: Samuel Weiser, 1974.

———. *The Wisdom of the Overself*. Revised edition. New York: Weiser Books, 1983.

Bucke, Richard Maurice. *Cosmic Consciousness: A Study in the Evolution of the Human Mind*. New York: E. P. Dutton, 1969.

Bugental, J. F. T., ed. *Challenges of Humanistic Psychology*. New York: McGraw-Hill, 1967.

Burckhardt, Titus. *Sacred Art in East and West*. Bloomington, Ind.: World Wisdom, 2001.

Campbell, Joseph. *The Hero with a Thousand Faces*. New York: World Publishing, 1956.

———. *The Mythic Dimension*. Novato, Calif.: New World Library, 2007.

Camus, Albert. *Actuelles: Chroniques 1944–1948*. Paris: Gallimard, 1950.

———. *The Rebel*. Translated by A. Bower. New York: Alfred A. Knopf, 1954.

Carlyle, Thomas. *Sartor Resartus*. London: Walter Scott, 1888.

Cirlot, J. E. *A Dictionary of Symbols*. New York: Philosophical Library, 1962.

Clive, Geoffrey. *The Romantic Enlightenment*. New York: Meridian Books, 1960.

Collingwood, R. G. *The Principles of Art*. Oxford: Oxford University Press, 1958.

Common, T., trans. *The Complete Works of Friedrich Nietzsche*. London: Allan & Unwin, 1909.

Cook, Roger. *The Tree of Life*. New York: Avon Books, 1974.

Cottrell, Leonard. *The Bull of Minos*. Stroud, U.K.: Sutton Publishing, 2003.

Cranston, Sylvia, and Joseph Head, comps. *Reincarnation: An East-West Anthology.* Pasadena, Calif.: Theosophical Publishing House, 1968.

Davidson, Dan A. *Shape Power.* Sierra Vista, Ariz.: Rivas Publishing, 1997.

de Becker, Raymond. *The Understanding of Dreams and Their Influence on the History of Man.* New York: Bell Publishing, 1968.

de Ropp, Robert S. *The Master Game.* New York: Dell Publishing, 1968.

Dewey, Edward R. *Cycles: The Mysterious Forces That Trigger Events.* New York: Hawthorn Books, 1971.

Deutsch, Eliot. *Advaita Vedanta: A Philosophical Reconstruction.* Honolulu: East-West Center Press, 1969.

Digby, George Wingfield. *Meaning and Symbol.* London: Faber & Faber, 1955.

Dilthey, Wilhelm. *The Essence of Philosophy.* Translated by S. A. and W. T. Emery. Chapel Hill: University of North Carolina Press, 1954.

Dionysius the Areopagite. *Mystical Theology and the Celestial Hierarchies.* Translated by the Editors of the Shrine of Wisdom. Surrey, U.K.: The Shrine of Wisdom, 1923.

Dobzhansky, Theodosius. *The Biology of Ultimate Concern.* New York: World Publishing, 1969.

Dostoevsky, F. *Letters from the Underground.* London: J. M. Dent & Sons, 1913.

Dudley, W. H., and R. A. Fisher. *The Mystic Light.* London: Rider, 1939.

Edinger, Edward F. *Ego and Archetype.* Baltimore: Penguin Books, 1973.

Eliade, Mircea. *The Forge and the Crucible.* New York: Harper & Row, 1971.

———. *Myth and Reality.* New York: Harper & Row, 1963.

———. *Myths, Dreams and Mysteries.* New York: Harper & Row, 1967.

———. *The Myth of the Eternal Return.* Translated by W. R. Trask. New York: Pantheon Books, 1954.

———. "The Prestige of the Cosmogonic Myth." *Diogenes* 23 (Fall 1959): 1–13.

———. *Rites and Symbols of Initiation*. New York: Harper & Row, 1958.

———. *Yoga, Immortality and Freedom*. Princeton, N.J.: Princeton University Press, 1970.

Eliot, T. S. *The Complete Poems and Plays*. New York: Harcourt, Brace, 1950.

———. *The Complete Poems and Plays, 1909–1950*. New York: Harcourt, Brace, 1952.

———. *Selected Essays*. New York: Harcourt, Brace, 1950.

Emerson, Ralph Waldo. *Essays*. New York: National Library, n.d.

———. *The Works of Ralph Waldo Emerson*. New York: National Library, n.d.

Esslin, Martin. *The Theatre of the Absurd*. New York: Doubleday, 1961.

Evola, Julius. *The Hermetic Tradition*. Rochester, Vt.: Inner Traditions, 1995.

Fallico, Arturo B. *Art and Existence*. Englewood Cliffs, N.J.: Prentice-Hall, 1962.

Fortune, Dion. *The Cosmic Doctrine*. Toddington, U.K.: Helios Book Service, 1966.

———. *The Mystical Qabalah*. London: Ernest Benn, 1935.

Fowlie, Wallace. *Age of Surrealism*. Bloomington: Indiana University Press, 1950.

Frankl, Victor E. *Man's Search for Meaning: An Introduction to Logotherapy*. New York: Touchstone, 1973.

———. *The Unconscious God*. New York: Washington Square Press, 1985.

Freud, Sigmund. *An Outline of Psychoanalysis*. New York: W. W. Norton, 1949.

Frye, Northrop. *Fables of Identity: Studies in Poetic Mythology*. New York: Harcourt, Brace & World, 1963.

———. *Fearful Symmetry*. Boston: Beacon Press, 1962.

———, ed. *Romanticism Reconsidered*. New York: Columbia University Press, 1963.

Fulcanelli. *Fulcanelli: Master Alchemist.* Translated by Mary Sworder. Las Vegas, Nev.: Brotherhood of Life, 1990.

Fuller, R. Buckminster, and John McHale. *World Design Science Decade, 1965–1975.* Carbondale, Ill.: World Resources Inventory, Southern Illinois University, 1963.

Garver, Will L. *Brother of the Third Degree.* Alhambra, Calif.: Borden Publishing Co., 1964.

Gasset, Jose Ortega y. *The Dehumanization of Art and Other Essays on Art, Culture, and Literature.* Princeton, N.J.: Princeton University Press, 1968.

Germinara, Gina. *Many Mansions.* New York: New American Library, 1967.

Goethe. *Faust* Part I (The Harvard Classics, vol. 19). Edited by Charles W. Eliot. New York: P. F. Collier & Son, 1909.

Golden Scripts. Noblesville, Ind.: Fellowship Press, 1973.

Goldwater, Robert. *Primitivism in Modern Art.* Cambridge, Mass.: Belknap Press (Harvard University Press), 2002.

Goossen, E. C. *The Art of the Real.* New York: Museum of Modern Art, 1968.

Gordon, William J. J. *Synectics: The Development of Creative Capacity.* New York: Harper & Row, 1961.

Govinda, Lama Anagarika. *Creative Meditation and Multi-Dimensional Consciousness.* Wheaton, Ill.: Theosophical Publishing House, 1976.

Greeley, Andrew M. *Ecstasy: A Way of Knowing.* Englewood Cliffs, N.J.: Prentice-Hall, 1974.

Grey, Alex. *Sacred Mirrors: The Visionary Art of Alex Grey.* Rochester, Vt.: Inner Traditions, 1990.

Guardini, Romano. *The End of the Modern World.* New York: Sheed & Ward, 1956.

Haddock, F. Channing. *Power of Will.* Meriden, Conn.: Delton Publishing, 1907.

Hall, Manly P. *Lectures on Ancient Philosophy.* Los Angeles, Calif.: Philosophical Research Society, 1947.

———. *Studies in Dream Symbolism.* Los Angeles, Calif.: Philosophical Research Society, 1965.

Hanna, Thomas. *The Thought and Art of Albert Camus*. Chicago: Henry Regnery, 1958.

Hartmann, Franz. *Paracelsus: Life and Prophecies*. Whitefish, Mont.: Kessinger, 1997.

Heidegger, Martin. *Being and Time*. London: SCM Press, 1962.

———. *Existence and Being*. Washington, D.C.: Henry Regnery, 1949.

———. *An Introduction to Metaphysics*. New Haven, Conn.: Yale University Press, 1959.

Heline, Corinne. *Sacred Science of Numbers*. La Canada, Calif.: New Age Press, 1971.

Heller, Erich. *The Disinherited Mind*. Cambridge: Bowes and Bowes 1952.

Hersey, John. *Hiroshima*. New York: Alfred A. Knopf, 1946.

Herskovic, Marika. *New York School Abstract Expressionists: Artists Choice by Artists*. Franklin Lakes, N.J.: New York School Press, 2000.

Hess, Thomas B. *Willem de Kooning*. New York: George Braziller, 1959.

Hesse, Hermann. *Siddhartha*. Translated by H. Rosner. New York: New Directions Publishing, 1951.

Hofstadter, Albert, and Richard Kuhns, eds. *Philosophies of Art and Beauty: Selected Readings in Aesthetics from Plato to Heidegger*. Chicago: University of Chicago Press, 1976.

Hopper, S. R., ed. *Spiritual Problems in Contemporary Literature*. New York: Harper & Bros., 1957.

Hunter, Sam. *Art Since 1945*. New York: Washington Square Press, 1962.

Huxley, Aldous. *The Perennial Philosophy*. New York: Harper & Row, 1970.

Ivanov, Vyacheslov. *Freedom and the Tragic Life*. New York: Noonday Press, 1957.

Jansen, H. W. *History of Art*. Englewood Cliffs, N.J.: Prentice-Hall, Inc., 1968.

Jones, W. T. *A History of Western Philosophy*. New York: Harcourt, Brace, 1952.

Josephson, Eric, and Mary Johnson, eds. *Man Alone*. New York: Dell Publishing, 1962.

Joyce, James. *A Portrait of the Artist as a Young Man*. New York: Viking Press, 1964.

———. *Ulysses*. New York: Modern Library, 1992.

Jung, C. G. *The Archetypes and the Collective Unconscious*. Princeton, N.J.: Princeton University Press, 1968.

———. *Civilization in Transition*. (The Collected Works of C. G. Jung, vol. 10.) Translated by Gerhard Adler and R. F. C. Hull. Princeton, N.J.: Bollingen/Princeton University Press, 1964, 1970.

———. *Memories, Dreams, Reflections*. New York: Vintage, 1961.

———. *Modern Man in Search of a Soul*. New York: Harcourt, Brace, 1933.

———. *Psychology and Alchemy*. London: Routledge & Kegan Paul, 1953.

———. *Symbols of Transformation*. (The Collected Works of C. G. Jung, vol. 5.) Translated by Gerhard Adler and R. F. C. Hull. New York: Harper, 1962.

Kahler, Erich. *The Tower and the Abyss*. New York: George Braziller, 1957.

Kandinsky, Wassily. *Concerning the Spiritual in Art*. New York: George Wittenborn, 1947.

Kant, Immanuel. *Foundations of the Metaphysics of Morals*. Indianapolis: Bobbs-Merrill, 1959.

Kaufmann, Walter. *Existentialism from Dostoevsky to Sartre*. New York: Meridian Books, 1956.

———. *Nietzsche*. Princeton, N.J.: Princeton University Press, 1950.

———, ed., and trans. *The Portable Nietzsche*. New York: Viking Press, 1954.

Kegley, C. W., and R. W. Bretall, eds. *The Theology of Paul Tillich*. New York: Macmillan, 1956.

Kern, Hermann. *Through the Labyrinth*. New York: Prestel, 2000.

Kierkegaard, Søren. *Concluding Unscientific Postscript*. Translated by D. P. Swenson. Princeton, N.J.: Princeton University Press, 1941.

———. *Either/Or: A Fragment of Life*. Translated by Alastair Hannay. New York: Penguin Books, 1992.

———. *Fear and Trembling and Sickness unto Death.* Princeton, N.J.: Princeton University Press, 1941.

Landau, Ellen G., ed. *Reading Abstract Expressionism: Contest and Critique.* New Haven, Conn.: Yale University Press, 2005.

Landau, Jacob. "Yes-No, Art-Technology." *Motive* (March–April 1967).

Lang, R. D. *The Divided Self.* New York: Pantheon Books, 1960.

———. *The Politics of Experience.* New York: Ballantine Books, 1974.

Langer, Susan. *Philosophy in a New Key.* New York: New American Library, 1951.

Lao-tzu. *Tao Te Ching.* Translated by Wing-Tsit Chan. Indianapolis: Bobbs-Merrill, 1978.

Lawrence, D. H. *Studies in Classical American Literature.* New York: Doubleday, 1951.

Leadbeater, C. W. *The Monad.* Wheaton, Ill.: Theosophical Publishing House, 1974.

Leider, Philip. "For Robert Smithson." *Art in America* (November–December 1973).

Levin, Harry. *The Broken Column: A Study in Romantic Hellenism.* Cambridge, Mass.: Harvard University Press, 1931.

———. *The Power of Blackness.* New York: Vintage Books, 1960.

Lippard, Lucy R. *Ad Reinhardt: Paintings.* New York: Jewish Museum, 1967.

———. "Homage to the Square." *Art in America* (July–August 1967).

Lucie-Smith, Edward, "Minimal Art," in *Concepts of Modern Art.* Edited by Tony Richardson and Nikos Stangos (Harper & Row, New York, 1974).

Marcel, Gabriel. *Being and Having.* Translated by K. Farrer. London: Dacre Press, 1949.

Martin, P. W. *Experiment in Depth: A Study of the Work of Jung, Eliot and Toynbee.* London: Methuen, 1955.

Maslow, Abraham. *Religions, Values and Peak Experiences.* Athens: Ohio State University Press, 1964.

Masters, R. E. L., and J. Houston. *Psychedelic Art.* New York: Grove Press, 1969.

Matson, Floyd W. *The Broken Image: Man, Science and Society.* New York: Doubleday, 1966.

May, Rollo. *Existential Psychology.* 2nd edition. New York: Random House, 1969.

———. *Man's Search for Himself.* New York: W. W. Norton, 1953.

Melville, Herman. *Moby Dick.* New York: New American Library, 1961.

Menninger, Karl A. *Man Against Himself.* New York: Harvest Books, 1958.

Meyerhoff, Hans. *Time in Literature.* Berkeley: University of California Press, 1960.

Michalson, Carl, ed. *Christianity and the Existentialists.* New York: Scribner, 1956.

Monroe, Robert A. *Journeys Out of the Body.* New York: Doubleday, 1971.

Naranjo, Claudio. *The Healing Journey.* New York: Random House, 1973.

Neumann, Erich. *The Archetypal World of Henry Moore.* New York: Pantheon Books, 1959.

———. *Depth Psychology and a New Ethic.* New York: Harper & Row, 1973.

———. *The Great Mother.* Princeton, N.J.: Princeton University Press, 1972.

———. *The Origins and History of Consciousness.* New York: Harper & Bros., 1962.

Newton, Eric. *The Romantic Rebellion.* New York: Schocken, 1962.

Nietzsche, Friedrich. *The Birth of Tragedy and the Genealogy of Morals.* New York: Doubleday, 1956.

Nikhilananda, Swami. *The Upanishads.* New York: Harper & Row, 1964.

Ouspensky, P. D. *A New Model of the Universe.* New York: Vintage Books, 1971.

Pascal, Blaise. *Pensées and the Provincial Letters.* New York: Modern Library, 1941.

Percival, H. W. *Thinking and Destiny.* New York: Word Foundation, 1946.

Peyre, Henri, ed. *Baudelaire*. Englewood Cliffs, N.J.: Prentice-Hall, 1962.

Philipson, Morris. *Outline of a Jungian Aesthetic*. Evanston, Ill.: Northwestern University Press, 1963.

Plotinus. *Enneads*. Available online at http://classics.mit.edu/Plotinus/enneads.html.

Poe, Edgar Allan. *The Works of Edgar Allan Poe*. New York: P. F. Collier & Son, 1927.

Polcari, Stephen. *Abstract Expressionism and the American Experience*. Cambridge: Cambridge University Press, 1991.

Poulet, Georges. *Studies in Human Time*. New York: Harper & Bros., 1959.

Praz, Mario. *The Romantic Agony*. New York: Meridian Books, 1956.

Priestley, J. B. *Man and Time*. New York: Dell, 1968.

Prince, George M. *The Practice of Creativity*. New York: Collier Books, 1970.

Purce, Jill. *The Mystic Spiral*. New York: Avon Books, 1974.

Purucker, G. de. *Fountain-Source of Occultism*. Pasadena, Calif.: Theosophical University Press, 1974.

Raleigh, A. S. *Occult Geometry*. Chicago: Hermetic Publishing, 1931.

Randall-Stevens, Hugh C. *The Teachings of Osiris*. London: Order of the Knights Templars of Aquarius, 1958.

Ravindra, Ravi. *The Gospel of John in the Light of Indian Mysticism*. Rochester, Vt.: Inner Traditions, 2004.

Reyes, Benito F. *Scientific Evidence of the Existence of the Soul*. Wheaton, Ill.: Theosophical Publishing House, 1970.

Richardson, Tony, and Nikos Stangos, eds. *Concepts of Modern Art*. New York: Harper & Row, 1974.

Rieker, Hans-Ulrich. *The Yoga of Light*. Translated by E. Becherer. Los Angeles: Dawn Horse Press, 1974.

Rilke, Rainer Maria. *Duino Elegies*. Translated by J. B. Leishman and Stephen Spender. New York: W. W. Norton, 1939.

———. *Sonnets to Orpheus*. Translated by M. D. H. New York: W. W. Norton, 1962.

Rimbaud, Arthur. "A Season in Hell," in *Baudelaire, Rimbaud, Verlaine*, ed. by Joseph Bernstein. New York: Citadel, 1962.

Roberts, David E. *Existentialism and Religious Belief*. New York: Oxford University Press, 1957.

Rodman, Selden. *Conversations with Artists*. New York: Capricorn Books, 1961.

Rubin, William. "Jackson Pollock and the Modern Tradition." *Artforum* V, no. 6 (February 1967).

Sadhu, Mouni. *Meditation*. North Hollywood, Calif.: Wilshire Book, 1968.

Sartre, Jean Paul. *Being and Nothingness*. New York: Philosophical Library, 1956.

———. *No Exit and Three Other Plays*. New York: Vintage Books, 1955.

Schopenhauer, Arthur. *The World as Will and Idea*. Translated by R. B. Haldane and J. Kemp. London: Trubner, Ludgate Hill, 1886.

Schuré, Édouard. *The Great Initiates*. West Nyack, N.Y.: St. George Books, 1961.

Sewall, Richard B. *The Vision of Tragedy*. New Haven, Conn.: Yale University Press, 1959.

Shahn, Ben. "In Defense of Chaos." *Ramparts* (December 14, 1968): 12–13.

Shirer, William L. *The Third Reich*. New York: Simon & Schuster, 1960.

Sontag, Susan. *Against Interpretation and Other Essays*. New York: Picador, 1966.

Steiner, Rudolf. *Color*. Translated by John Salter. London: Rudolf Steiner Press, 1970.

Taimni, I. K. *Self-Culture*. Wheaton, Ill.: Theosophical Publishing House, 1970.

Taylor, John A. F. *Design and Expression in the Visual Arts*. New York: Dover Publications, 1964.

Thielicke, Helmut. *Nihilism*. New York: Harper & Bros., 1961.

Thomas, Dylan. *The Poems of Dylan Thomas*. New York: New Directions Publishing, 2003.

Tillich, Paul. *The Courage to Be*. New Haven, Conn.: Yale University Press, 1952.

———. *The Religious Situation*. New York: Henry Holt, 1932.

Toben, Bob. *Space-Time and Beyond*. New York: Bantam, 1983.

Toynbee, Arnold. *A Study of History*. Oxford: Oxford University Press, 1972.

Trismegistus, Hermes. *The Divine Pymander*. Translated by J. D. Chambers. New York: Samuel Weiser, 1972.

Tucci, Giuseppe. *The Theory and Practice of the Mandala*. Translated by A. H. Brodrick. New York: Samuel Weiser, 1970.

Tuchman, Maurice, ed. *The Spiritual in Art: Abstract Painting 1890–1985*. New York: Abbeville Press, 1986.

Tzu, Chuang. *A Source Book in Chinese Philosophy*. Translated and compiled by Wing-Tsit Chan. Princeton, N.J.: Princeton University Press, 1963.

Unamuno, Miguel de. *The Tragic Sense of Life*. Translated by J. E. C. Flitch. Mineola, N.Y.: Dover Publications, 1954.

Underhill, Evelyn. *Mysticism*. Cleveland: World Publishing, 1955.

Van Gennep, Arnold. *The Rites of Passage*. Chicago: University of Chicago Press, 1960.

Varia, Radu. *Brancusi*. New York: Universe Publishing, 1995.

Vivekananda, Swami. *Rāja-Yoga*. New York: Ramakrishna-Vivekananda Center, 1973.

Wahl, Jean. *A Short History of Existentialism*. New York: Philosophical Library, 1949.

Watson, Robert I. *The Great Psychologists*. New York: J. B. Lippincott, 1971.

Watts, Alan. *The Supreme Identity*. New York: Vintage Books, 1972.

———. *The Two Hands of God*. New York: Collier, 1969.

Wiener, Norbert. *The Human Use of Human Beings: Cybernetics and Society*. New York: Doubleday, 1954.

Wilde, Jean T., and William Kimmel, ed. *The Search for Being: Essays from Kierkegaard to Sartre on the Problem of Existence*. New York: Twayne Publishers, 1962.

Wilhelm, R., trans. *The Secret of the Golden Flower*. New York: Harcourt, Brace & World, 1962.

Worringer, Wilhelm. *Form in Gothic*. New York: Schocken Books, 1964.

Yeats, W. B. *The Collected Poems of W. B. Yeats*. New York: Scribner, 1996.

Yogananda, Paramahansa. *Autobiography of a Yogi*. Los Angeles, Calif.: Self-Realization Fellowship, 2006.

Zitko, Howard John. *New Age Tantra Yoga*. Tucson, Ariz.: World University Press, 1975.

Art Credits

page ii. Francois Auguste Rene Rodin, *The Prodigal Son,* ca. 1885. Allen Memorial Art Museum, Oberlin College, Ohio; R. T. Miller, Jr. Fund, 1955.

page v. Griffin by Marcia Thompson.

page vi. Michelangelo Buonarroti, *Awakening Slave / Awakening Prisoner,* ca. 1536. Accademia, Florence, Italy. Photo credit: SCALA / Art Resource, N.Y.

page 7. Rembrandt Harmensz van Rijn, *Doctor Faust,* ca. 1652. Etching. Fondazione Magnani Rocca, Corte di Mamiano, Italy. Photo credit: SCALA / Art Resource, N.Y.

page 13. Jim Crane, "Every day the cracks get a little deeper," cartoon ca. 1960.

page 25. Jim Crane, "Hey, man, don't you feel the rhythm of the tensions of our times?" cartoon ca. 1960.

page 34. Artist unknown, "Modern man following in the footsteps of Mother Nature," date unknown.

page 37. Jim Crane, "A New Age is upon us," cartoon ca. 1960.

page 41. Jim Crane, "A New Age is upon us?" cartoon ca. 1960.

page 47. Theodore Roszak, *Anguish,* 1947.

page 65. Artist unknown, "Alchemy as a seven-stage process of transformation," date unknown.

page 84 / plate 1. Jackson Pollock, *Number 1, 1948.* Oil and enamel on unprimed canvas, 68" × 104". The Museum of Modern Art, New York. © 2008 Pollock-Krasner Foundation / ARS, N.Y. / Digital image © The Museum of Modern Art / Licensed by SCALA / Art Resource, N.Y.

page 87. Detail of handprints at top right of Jackson Pollock's *Number 1, 1948.*

page 92. Eadfrith, cross-carpet page from the Lindisfarne Gospels, ca. 700 CE.

page 95. Edvard Munch, *Madonna,* 1895–1902. Lithograph and wood-cut, printed in color, composition 23¾" × 17½". The William B. Jaffe and Evelyn A. J. Hall Collection. The Museum of Modern Art, New York. © The Munch Museum / The Munch-Ellingsen Group / ARS, N.Y. / Digital image © The Museum of Modern Art / Licensed by SCALA / Art Resource, N.Y.

page 102 / plate 3. Willem de Kooning, *Woman 1,* 1950–52. Oil on canvas, 6'3⅞" × 58". Purchase. The Museum of Modern Art, New York. © The Willem de Kooning Foundation / ARS, N.Y. / Digital image © The Museum of Modern Art / Licensed by SCALA / Art Resource, N.Y.

page 108 / plate 6. Tony Smith, *Die,* 1962, fabricated 1998. Steel, 6' × 6' × 6'. Gift of Jane Smith in honor of Agnes Gund. The Museum of Modern Art, New York. © Estate of Tony Smith / ARS, N.Y. / Digital image © The Museum of Modern Art / Licensed by SCALA / Art Resource, N.Y.

page 111. Leonardo da Vinci, *Vitruvian Man,* ca. 1492. Drawing of ideal proportions of the human figure according to Vitruvius' first century CE treatise "De Architectura." Accademia, Venice, Italy. Photo credit: Alinari / Art Resource, N.Y.

page 119 / plate 7. Ad Reinhardt, *Abstract Painting,* 1960–61. Oil on canvas, 60" × 60". Purchase (by exchange). The Museum of Modern Art, New York. © Estate of Ad Reinhardt / ARS, N.Y. / Digital image © The Museum of Modern Art / Licensed by SCALA / Art Resource, N.Y.

page 128 / plate 8. Arshile Gorky, *Agony,* 1947. Oil on canvas, 40" × 50 ½". A Conger Goodyear Fund. The Museum of Modern Art, New York. © ARS, N.Y. / Digital image © The Museum of Modern Art / Licensed by SCALA / Art Resource, N.Y.

page 137 / plate 9. Mark Rothko, *Black, Brown on Maroon,* 1957 #20. Oil on canvas, 91⅝" × 76". National Gallery of Australia, Canberra. © 1998 Kate Rothko Prizel & Christopher Rothko / ARS, New York.

page 161 / plate 11. Walter Gaudnek, 1984. *Standing Labyrinth,* Collection of the artist. Used by permimssion of the artist.

page 165. Walter Gaudnek, *Labyrinth,* 1960. Used by permission of the artist.

page 166. Walter Gaudnek, *Abraxas Labyrinth,* 1960–61. Used by permission of the artist.

page 167. Gaudnek in another *Labyrinth.* Used by permission of the artist.

page 168. Two Gaudnek symbol-laden *Labyrinth*s. Used by permission of the artist.

page 168. Artist unknown, "Theseus slaying the Minotaur," date unknown. Mosaic.

page 170. Walter Gaudnek, *Dying Bull,* 1960.

page 173 / plate 13. Arlé Sklar-Weinstein, *Inside a Seed,* 1966. Ink on paper, 9" × 12". Collection of the artist, used by permission. © Arlé Sklar-Weinstein.

page 174. Robert Joffrey Ballet, *Astarte,* ca. 1960.

page 174. Artist unknown, "Shiva as Nataraja, Lord of the Cosmic Dance," date unknown.

page 180 / plate 14. Adolph Gottlieb, *Blast 1,* 1957. Oil on canvas, 7'6" × 45⅛". Phillip Johnson Fund. The Museum of Modern Art, New York. © VAGA, N.Y. / Digital image © The Museum of Modern Art / Licensed by SCALA / Art Resource, N.Y.

page 186. Uroboros. Origins unknown.

page 187. "Shu separating Nut and Geb." Image from the Book of the Dead of Nesitanebtashru, Thebes twenty-first dynasty, ca. 1025 BCE.

page 210 / plate 15. Robert Smithson, *Spiral Jetty,* 1970. Mud, salt crystals, basalt rocks, and earth, 1500' × 15'. Great Salt Lake near Rozel Point, Utah. Photograph © 1989 Gianfranco—Gorgoni / Contact Press Images, Inc.

page 211. Harold Davis, *Chambered Nautilus.* Used by permission of the photographer.

page 220. Robert Crumb, *Kozmic Kapers,* 1967 comic.

page 221. Saul Steinberg, *Untitled,* 1963. Ink on paper, 14⅜" × 22⅞". The Menil Collection, Houston. Originally published in *The New Yorker,* February 23, 1963. © The Saul Steinberg Foundation / Artists Rights Society (ARS), New York.

page 224. Lucy Pringle, "Crop circles that have appeared in the British countryside in 2001 and 2007." Used by permission of the photographer.

page 227. "Counterclockwise hurricane" and "Clockwise spiral galaxy," public domain.

page 232. Robert Motherwell, *Elegy to the Spanish Republic, 54,* 1957–61. Oil on canvas, 70" × 7'6¼". Given anonymously. The Museum of Modern Art, New York. © VAGA, N.Y. / Digital image © The Museum of Modern Art / Licensed by SCALA / Art Resource, N.Y.

page 234 / plate 16. Walter Gaudnek, *Rebirth,* 1961–62. Acrylic on canvas, 114" × 102". Photo by the artist. Private collection.

page 243. "Hercules leading Cerberus to Eurystheus." Black figure hydria from Roma, ca. 530–525 BCE. Louvre, Paris, France. Photo credit: Réunion des Musées Nationaux / Art Resource, N.Y.

page 251. "Hercules' Night Sea Journey in the Vessel of the Sun," ancient Greek image from base of an Attic vase, 5th century BCE.

page 254. "The marriage of water and fire." From an Indian painting in Mueller, *Glauben, wissen und kunst der alten Hindus.*

page 267. "Hermes Trismegistus," from Michael Maier, *Symbola aureae mensae,* Frankfurt, 1617.

page 283. "Hermes Trismegistus," from Zadith, *De chemia Senioris.*

page 299. Artist unknown, "Flammarion woodcut," nineteenth-century wood engraving.

page 335. Buddha head, Gupta Style, India, ca. 400 CE.

PLATES

plate 1. Jackson Pollock, *Number 1, 1948.* Oil and enamel on unprimed canvas, 68" × 104". The Museum of Modern Art, New York. © Pollock-Krasner Foundation / ARS, N.Y. / Digital image © The Museum of Modern Art / Licensed by SCALA / Art Resource, N.Y.

plate 2. Jackson Pollock, *Blue Poles*: *Number 11, 1952.* Enamel and aluminum paint with glass on canvas, 83.5" × 192.5". National Gallery of Australia, Canberra. © Jackson Pollock, 1952 Pollock-Krasner Foundation. Licensed by ARS & VISCOPY, Australia.

plate 3. Willem de Kooning, *Woman 1,* 1950–52. Oil on canvas, 6'3 ⅞" × 58". Purchase. The Museum of Modern Art, New York. © The Willem de Kooning Foundation / ARS, N.Y. / Digital image © The Museum of Modern Art / Licensed by SCALA / Art Resource, N.Y.

plate 4. Willem de Kooning, face detail of *Woman 1.*

plate 5. *Venus of Willendorf,* Limestone, Stone Age, Aurignacien, twenty-fifth century BCE. Naturhistorisches Museum, Vienna, Austria. Photo credit: Erich Lessing / Art Resource, N.Y.

plate 6. Tony Smith, *Die,* 1962, fabricated 1998. Steel, 6' × 6' × 6'. Gift of Jane Smith in honor of Agnes Gund. The Museum of Modern Art, New York. © Estate of Tony Smith / ARS, N.Y. / Digital image © The Museum of Modern Art / Licensed by SCALA / Art Resource, N.Y.

plate 7. Ad Reinhardt, *Abstract Painting,* 1960–61. Oil on canvas, 60" × 60". Purchase (by exchange). The Museum of Modern Art, New York. © Estate of Ad Reinhardt / ARS, N.Y. / Digital image © The Museum of Modern Art / Licensed by SCALA / Art Resource, N.Y.

plate 8. Arshile Gorky, *Agony,* 1947. Oil on canvas, 40" × 50½". A Conger Goodyear Fund. The Museum of Modern Art, New York. © ARS, N.Y. / Digital image © The Museum of Modern Art / Licensed by SCALA / Art Resource, N.Y.

plate 9. Mark Rothko, *Black, Brown on Maroon,* 1957 #20. Oil on canvas, 91⅝" × 76". National Gallery of Australia, Canberra. © 1998 Kate Rothko Prizel & Christopher Rothko / ARS, N.Y.

plate 10. Mark Rothko, *Red, Brown and Black,* 1958 #16. Oil on canvas, 8'10⅝" × 9'9¼". Mrs. Simon Guggenheim Fund. The Museum of Modern Art, New York. © ARS, N.Y. / Digital image © The Museum of Modern Art / Licensed by SCALA / Art Resource, N.Y.

plate 11. Walter Gaudnek, *Nomaze, Standing Labyrinth,* 1984. Collection of the artist, used by permission.

plate 12. "Krishna and the Gopis dancing the *Rasalila* or Dance of Love." Paint on cloth, 32" × 31". Collection of the author.

plate 13. Arlé Sklar-Weinstein, *Inside a Seed,* 1966. Ink on paper, 9" × 12". Collection of the artist, used by permission. © Arlé Sklar-Weinstein.

plate 14. Adolph Gottlieb, *Blast 1,* 1957. Oil on canvas, 7'6" × 45⅛". Phillip Johnson Fund. The Museum of Modern Art, New York. © VAGA, N.Y. / Digital image © The Museum of Modern Art / Licensed by SCALA / Art Resource, N.Y.

plate 15. Robert Smithson, *Spiral Jetty,* 1970. Mud, salt crystals, basalt rocks, and earth, 1500' × 15'. Great Salt Lake near Rozel Point, Utah. Photograph © 1989 Gianfranco—Gorgoni / Contact Press Images, Inc.

plate 16. Walter Gaudnek, *Rebirth,* 1961–62. Acrylic on canvas, 114" × 102". Photo by the artist. Private collection.

plate 17. Mathias Grünewald. *Resurrection,* from the Isenheim Altarpiece, ca. 1515. 105⅞" × 120⅞". Musee d'Unterlinden, Colmar, France. Photo credit: Erich Lessing / Art Resource, N.Y.

plate 18. *Matsya, Vishnu as the Fish Avatar,* from a devotional text.

plate 19. Alex Grey, *Painting,* 1998. Oil on linen, 30" × 40". Reproduced by permission of the artist.

plate 20. Photographer unknown, "Illumined Crystals, Symbolizing the Creative Mind at Work," date unknown.

plate 21. Alex Grey, *Theologue: The Union of Human Consciousness Weaving the Fabric of Space and Time in Which the Self and Its Surroundings Are Embedded,* 1984. Acrylic on linen, 60" × 180". Reproduced by permission of the artist.

plate 22. Vincent van Gogh, *The Starry Night,* 1889. Oil on canvas, 29" × 36 1/4". Acquired through the Lillie B. Bliss Bequest. The Museum of Modern Art, New York. Digital image © The Museum of Modern Art / Licensed by SCALA / Art Resource, N.Y.

plate 23. (a) Constantin Brancusi, *Bird in Space,* 1941. Polished bronze, h. 6.34'. Photo by Alam Rzepka. Musee National d'Art Moderne, Centre Georges Pompidou, Paris, France. Photo credit: CNAC / MNAM / Dist. Réunion des Musées Nationaux / Art Resource, N.Y.

(b) Constantin Brancusi, *Bird in Space,* 1927. Silver print, 11.73" × 9.41". Photo by Bertrand Prevost. Musee National d'Art Moderne, Centre Georges Pompidou, Paris, France. Photo credit: CNAC / MNAM / Dist. Réunion des Musées Nationaux / Art Resource, N.Y.

(c) Constantin Brancusi, *Bird in Space,* 1941. Bronze, 6' high on two-part stone pedestal 17⅜" high. Gift of Mr. and Mrs. William A. M. Burden. The Museum of Modern Art, New York. © ADAGP, Paris / ARS, N.Y. / Digital image © The Museum of Modern Art / Licensed by SCALA / Art Resource, N.Y.

plate 24. Ernst Fuchs, *Moses and the Burning Bush,* 1956. Oil and tempera on wood. © Ernst Fuchs. Reproduced by permission of the artist.

Index

Page numbers in *italic* refer to illustrations.

BOOKS OF RELATED INTEREST

Sacred Mirrors
The Visionary Art of Alex Grey
by Alex Grey, with Ken Wilber
and Carlo McCormick

Transfigurations
by Alex Grey

Surrealism and the Occult
Shamanism, Magic, Alchemy, and the Birth of
an Artistic Movement
by Nadia Choucha

The Hermetic Tradition
Symbols and Teachings of the Royal Art
by Julius Evola

Painting the Dream
The Shamanic Life and Art of David Chethlahe Paladin
by David Chethlahe Paladin

Messenger of Beauty
The Life and Visionary Art of Nicholas Roerich
by Jacqueline Decter, Ph.D.

Crystal and Dragon
The Cosmic Dance of Symmetry and
Chaos in Nature, Art, and Consciousness
by David Wade

Ritual Art of India
by Ajit Mookerjee

Inner Traditions • Bear & Company
P.O. Box 388
Rochester, VT 05767
1-800-246-8648
www.InnerTraditions.com

Or contact your local bookseller